DOCUMENTS
IN
CANADIAN ART

Karina

DOCUMENTS
IN
CANADIAN ART

edited by
Douglas Fetherling

broadview press

Canadian Cataloguing in Publication Data

Main entry under title:

Documents in Canadian art

ISBN 0-921149-04-2

1. Art - Canada - History. 2. Art, Canadian - History.
 I. Fetherling, Douglas, 1949-

N6540.D82 1987 709'.71 C87-093475-9

broadview press in the U.S.: broadview press
P.O. Box 1243 421 Center St.
Peterborough, Canada, K9J 7H5 Lewiston, N.Y. 14092

Printed and bound in Canada by
Gagné Ltd.

Typeset by
Menestung Enterprises Incorporated

Cover design by Falcom Design and Communications

Table of Contents

v

vi

Acknowledgements

"The Arts of French Canada" and ["On Krieghoff"] by Marius Barbeau, by permission of the Estate of Marius Barbeau.

"Group Portrait" by A.J. Casson, by permission of A.J. Casson.

"Nudes and Prudes" by Bertram Brooker, by permission of the Estate of Bertram Brooker.

"Something Plus in a Work of Art" by Emily Carr, by permission of Irwin Publishing Ltd.

"Canadian and Colonial Painting" by Northrop Frye, by permission of Northrop Frye.

"From Spring Fever to Fantasy" and "Feeling in Painting" by David Milne, by permission of the Estate of David B. Milne.

"I Love the Army" by Molly Lamb, by permission of Molly Lamb Bobak.

"Global Refusal" and "Global Refusal: Ten Years After" by permission of François-Marc Gagnon and H. Dennis Young.

"D'une certain peinture canadienne, jeune...ou de l'automatisme" by permission of the Estate of Maurice Gagnon. Translated into English for this volume by Christl Verduyn.

"The Canadian Group of Painters" by Robert Ayre, by permission of the Robert Hugh Ayre Estate.

"What is Wrong with Canadian Painting" by Barker Fairley, by permission of Mrs. Nan Fairley.

"Recent Trends in Montreal Painting" by Paul Dumas, by permission of Paul Dumas.

"In Search of Contemporary Eskimo Art" by James Houston, by permission of James Houston.

Preface

"No kind of book is easier to attack than an anthology."

Northrop Frye

What follows is in no sense a documentary history of Canadian art, however attractive (if difficult) such a project might be, but merely a collection of important or representative texts relating to Canadian painting, sculpture and the like. The distinction is crucial, for the purpose is to show the history contained within the documents, not to document the history they reflect. As such, this is a book that easily could be much larger or much smaller than it is. Nearly everyone may agree on the significance of *Refus global*, even the revisionists who argue that Paul-Emile Borduas was primarily important as a painter and teacher and that the true value of his great manifesto is less than commonly supposed. But the inclusion of most of the other pieces inevitably assumes a good measure of subjectivity and personal interest, though every attempt has been made to show the broad currents of Canadian art over a long period. This is not to deny, however, that these selections, with at their best a tactile sense of recent art history, carry some sort of collective statement. It's tempting to draw conclusions from the existence of some of them as well as from the absence of certain others. Of necessity, the process involves redressing minor imbalances.

Much has been written about the roots of Quebec art in the folk tradition and in ex-voto paintings and the like. Comparatively little has been written about the military impetus of early art in English Canada, though many testify to its consequence. Very early on the Royal Engineers trained at Woolwich gave art in Canada a different cast from that in the United States, but they were merely the most easily identifiable adherents to what was already a long tradition.

1

John Graves Simcoe, the first lieutenant-governor of Upper Canada, and his wife Elizabeth Posthuma Simcoe, come to mind as obvious examples. She was a skilled watercolourist because she was a gentlewoman and it was expected of her, whereas he had a solid training in drawing as one of the martial necessities. It's a telling fact that the large collection of military science books built by Simcoe and his father and now in the Thomas Fisher Rare Book Library, University of Toronto, includes John Dryden's edition of Alphonse Du Fresnoy's *De arte graphica* (London, 1695) and a work by Robert Morris, first published in 1728, entitled *An Essay in defence of the ancient architecture; or, A Parallel of the ancient buildings with the modern: shewing the beauty and harmony of the former, and the irregularity of the latter, with impartial reflections on the reasons of the abuses introduced by our present builders....* To remember that even such no-nonsense aesthetics as these are an important factor in early Canadian art is a refreshing counterweight to Frye's insistence on the constrictive nature of "the garrison mentality". When I encounter the mathematical precision of Lawren Harris, for instance, I see figures surveying with a sapper's eye the landscape in which they stand, with a view towards exploiting the natural advantages of the terrain. A braver soul might venture to find traces of the engineer's special perspective throughout the whole history of Canadian landscape painting.

Another and more obvious generalisation about the sociology of Canadian art comes through more clearly in this anthology, and it concerns patterns of collective behaviour. Despite the importance of *Refus global*, Canadians have not on the whole been a manifesto-making people. It is true up to a point that the art scene in Quebec, with its adroit shouting, acknowledges the European tradition of the manifesto as a literary form, in a way that English Canadian art, with its tentative and apologetic mumbles, does not. It is true also that there has been the usual duel of manifesto and anti-manifesto. It was inevitable that Borduas's *Refus global* should materialise in the same year as Pellan's *Prisme d'yeux* manifesto, for that is one way dynamic tension is achieved and extended. It was just as ineluctable, in the normal leapfrogging of the genera-

2

tions by which humanity carries on, that as early as 1955 the *plasticiens* manifesto, merely by existing, denounced the *automatistes* as corrupt and almost criminally misguided. But groups did not actually come together in order to produce manifestos, like minor revolutionaries coming together simply in order to seize the radio station as the only means of making their grievances heard. Like so many of the other documents whose existence is hinted at by the limited number included here, manifestos and similar depositions, when they have been issued at all, have been by-products of complicated groupings formed in response to a peculiarly Canadian reality.

Generally speaking, Canadian art is more the product of shared achievement and less the result of individual initiative than is, for instance, American art; and this is hardly surprising. When Canadian art has been dominated by its nationalistic mode, as most obviously with the Group of Seven, it has assumed shapes designed to work against outmoded international fashion still lingering in Canada. Conversely, when Canadian art has been led by its internationalist impulse, it has fostered groups who separate themselves from what they consider the prevailing isolationism or simple lack of contemporaneity. In Central America the important fact about the Group of Eight (*el Grupo Ocho*) is that they knew one another and were of a certain generation; in Canada the important fact about the Group of Seven is not that they knew one another but that the work they produced as individuals is a collective accomplishment more impressive than the sum of its parts.

It is for self-protection as well as for self-promotion, for their own survival as artists as well as for the advancement of certain visual ideologies, that painters formed the many associations, societies and bands whose skeletons now litter the trail. From the vantage point of today's feminist art, for instance, it is easy to recognize the protofeminist intent of the Beaver Hall Group of 1924. Similarly, one can best see how the pioneering Calgary Group or later the Regina Five relate to what was around them, and to one another, by thinking of them in the context of group manoeuvring to make abstract expressionism the currency of Canadian painting,

3

as it was that of other countries'. It is typical that such movements remain small and local in order to be effective exponents of what's big and international. Putting aside the fact that Painters Eleven, like so many other groups past and present, was first an exhibiting convenience, the thought remains that it wouldn't have worked if it had been Painters Ninety-three. Surely part of the reason the Canadian Group of Painters did not make the impact it might have made can be traced to the fact that its membership was drawn from across the country, as well as to the fact that its precepts were no longer fresh. The Canadian way is for pockets of activity to spring up and to coexist but not to merge with other such pockets which, taken together, inform and decorate the environment. Everyone knows precisely what Harold Town meant when he said that Canadian painting began with Borduas and Riopelle, but the fact that the *automatistes* didn't have a group show in Toronto for almost 40 years was and is irrelevant to the way they were instantly acknowledged nationally and otherwise.

Many of the readings here are available in other books but are widely scattered, and it seemed worthwhile to bring them together because, like the pockets of art, they benefit by being segregated in close proximity to one another, though they seem to carry their own context with them, hidden in the language in which they're expressed. Robert Motherwell's off-hand remark that abstract expressionism should actually be called abstract surrealism takes on special relevance in Canada when one actually reads *Refus global* and, in so doing, conjures up the climate out of which it came. Of course Borduas ("a bald little man in a hound's tooth jacket": *Time* magazine, October 18, 1948) believed that creation resided in the unconscious, just as Pellan, with links through Picasso to another world, did not. Of course Borduas lost his teaching position for publishing his famous document! His friend Gauvreau had been sacked from his own teaching job in the late 1930s simply for having Baudelaire and Rimbaud on his bookshelves (one is reminded of the person whose copy of a work on cubism was confiscated during the October Crisis because the Montreal police supposed it was favourable to Cuba). We all make little empires; it is the way

4

we convince ourselves to survive. Canadian art often has flourished by the extension of this principle to groups set within regions. It is necessary for Canadian artists to believe that where they live and do what they do is the hub of such activity or the centre of resistance to the absence of it—if not utopia, then the last stop before the void. There is no limit to the number of these venues and no restrictions on their movement. This concept of variable centrality, so to call it, is what these documents, as I read them over now, appear to suggest.

Fewer than half of the articles and such reprinted here are by artists, because it was thought advisable to show also the byplay of critics and artists, of government and public, and so on. Readers will note and perhaps be surprised, as I was, by the number of pieces that appeared in the original *Canadian Art* and in *artscanada*. As memory of *artscanada* recedes, and the art world it reflects is supplanted (at the moment) by parallel galleries, post-minimalism, the Young Romantics and the other neo-expressionists, etc., the magazine and its achievement come into clearer focus. The publication Barry Lord reinvented and rechristened in the Centennial year is the repository of a great many major statements. One even grows downright nostalgic about the problems that marked its final years: the maddening thematicism, the chronic typographical lapses, the uncertain publication schedule (who could forget the combined numbers 244, 245, 246 and 247?). One turns to it to recapture the febrile 1960s and 1970s the way some future anthologist, searching for what seems to us now the contemporary scene, will no doubt turn to *Parachute* and, especially, *C. Canadian Art*, out of which *artscanada* grew, was completely different in that it addressed a middle-brow public. The element of direct communication which that fact suggests, to say nothing of the way the magazine stood alone for so long, makes it a rich source of exposition and comment (more often than of criticism or argument).

For editorial reasons it has been necessary to create titles, or assign new ones, for some of the selections. Such additions have been put in square brackets. My thanks to Don LePan for his encouragement and advice.

1.

"THE ARTS OF FRENCH CANADA"
by Marius Barbeau

The intense nationalism of Quebec politics following the Second World War inevitably affected art in Quebec and perceptions of how it evolved through folk art on the one hand and ecclesiastical traditions on the other. The turmoil that produced the automatistes' rebellion also caused many Canadians to form new reactions to Quebec's heritage and permitted others, elsewhere, to become aware of it for the first time. The following thumbnail history by the folklorist Marius Barbeau (1883-1969) introduced the catalogue of "The Arts of French Canada, 1613-1870", organized in 1946 by the Detroit Institute of Arts. The show, one of two major Canadian survey exhibitions mounted in the US that year, later travelled to the Cleveland Museum of Art, the Albany Institute of History and Art, the Art Association of Montreal, the National Gallery of Canada, and Le musée du Québec.

When Samuel De Champlain erected his wooden *habitation* at the foot of the high cliffs of Quebec close to the tidewaters, he could not forget the earlier experience of Jacques Cartier on the same shore. At the command of Francis I, Cartier, a pilot of St. Malo in Brittany, had twice wintered in Canada, in 1536 and 1541. After having enjoyed the good will of the Indians occupying the St. Lawrence, he had aroused their hostility. Because of this, Champlain built a palisade, dug a moat around his fort, and placed guns in the bastions. Then he hopefully faced the future.

Unlike the Breton pilot serving a king whose dream had been treasure hunting across the seas—for those had been the days of Charles V of Spain and Cortez, who had discovered an El Dorado farther south—Champlain entertained less spectacular ambitions; he wanted only to secure a firm foothold on unexplored rivers and woodlands, bring out new settlers, initiate the conversion of the

infidels to Christianity and make them loyal subjects of the King, and allow the trade in beaver pelts to provide benefits essential to the new venture.

Such was the modest debut of a French empire in the wilderness. Eventually this empire was to cover the whole of the St. Lawrence watershed from the northern Atlantic to the Great Lakes and the prairies beyond, to the foothills of the Rockies, to the Missouri and the Mississippi, down to Louisiana and the territories held by the Spaniards in the Southwest. Its paths were to be dotted by stopping places with such names as Oswego, Detroit, Sainte-Geneviève, Nouvelle-Orléans, Grand-Portage, Rivière-Rouge. The British conquest of Canada in 1759, and the purchase of Louisiana from Napoleon in 1803, were to mark the end of the enterprise initiated by Champlain and slowly expanded by explorers, by missionaries and *coureurs de bois*, some of whose names are still familiar: La Salle, Marquette, Iberville, Radisson and Groseillers, Dulhut, Lamothe-Cadillac, and La Vérendrye.

Before engaging in exploration to the south and west, Champlain had to secure his foothold in Quebec. As soon as he had entered his *habitation* in 1608, he cleared the land around it, planted vines in its garden, built a wooden chapel dedicated to the Virgin, and granted some space to the merchants and fur-traders of the Cent Associés. The settlement at once was beset by difficulties; the brothers Kirke captured it in 1629 for the King of England. But New France was restored to its founders after 1632, and some progress was then achieved. Two orders of nuns, the Ursulines and the Hospitalières de l'Hôtel-Dieu, landed in 1639, and established their convents; the former had vowed to educate and civilize Indian girls, the latter, to care for the sick both white and redskinned. Soon the space at the foot of the Quebec cliffs became too small and a cluster of stone buildings arose on the heights above, near the spot where Hébert, the first settler, had cultivated the soil for some years, even during the Kirke occupation. Outstanding among the new buildings were the Chateau Saint-Louis for the first governor, the convents of the Ursulines and the

Hospitalières, the Jesuit and Recollet colleges, and the first church of Notre-Dame.

Craftsmen, many of them, were required for this enterprise. Their services were enlisted in France, mostly in Paris: from 1640 on, they arrived in fair numbers at Quebec. These workers— masters, *compagnons*, apprentices, labourers—would not soon forget the customs of the motherland. At the annual processions of the Fête du Saint-Sacrement in June, their appointed representatives marched, each carrying a torch, according to the rank of his guild in Old France. In the procession of 1646, there figured a carpenter, mason, tool-maker, baker, brewer, and sailor. Two years later, in 1648, their numbers had jumped from six to twelve, including joiner, carpenter, mason, turner, locksmith, gunsmith, tool-maker, shoe-maker, cooper, baker, wheelright, and nail-maker (*cloutier*). A decade later in 1658, the master joiners established their guild of Sainte-Anne in Quebec on the pattern of that in Paris; it survived through the two centuries that followed, until 1855. Craftsmen of various callings, after their settlement in the colony, practised their art, established families, and in most cases passed on their name and activities to the following generations down to the present, through eleven or twelve generations. The manual arts of later Canada are close derivatives of French fountain-heads, with allowances for creative adaptation to new demands, materials and surroundings.

The simple pursuits of the earliest pioneers were not the only ones implanted in New France. In the highly cultured motherland, the fine arts throve in town and village alike. There the Renaissance, fostered by an Italian stimulus, had absorbed many of the former Gothic arts, native to the land. But independent and creative craftsmanship prevailed everywhere. Canada likewise, small and poor though it remained, fell heir to a common heritage deeply rooted in the race; the craftsmen still belonged to ancient guilds; even the plain labourers and the rustic folk tilling the soil, and the forest and river rangers in search of pelts or booty, could not help but share to some extent in this distinction.

9

The flower of French art entered New France as early as 1639, along with the founders of the Ursulines in Canada. Among the pioneers of culture in the New World, these nuns have occupied the front rank. Not only did they contribute much to the evangelisation of the natives, but they trained Indian girls in the handicrafts with a perseverance worthy of greater success than they actually achieved. Their cultural influence, felt immediately after their landing at Quebec, has since spread from their cloisters to almost every point on the American continent. The unique story of this transfusion of culture still has to be told.

Marie Guyard—Mère Marie de l'Incarnation—and Madame de la Peltrie, founders of the Ursulines in New France, and three other nuns, busied themselves with their task of education. "It is a pleasure," confessed Marie de l'Incarnation, "to see the Indians around the viola when we play it; they are spell-bound. We use it only to draw these people to us." A few years after the foundation of the convent, the number of native novices rose to impressive numbers; they included Huron, Algonkin, Iroquois children. And the Jesuit Lalemant acknowledged: "These good mothers have truly succeeded. Their seminary is a great blessing for the French and Indian girls." Mère Marie, looking back upon her work, was happy to write: "They sing with us in unison, they quickly learn all that we want to teach to them and are most supple in our hands. Born though they were in the wilderness, they can easily be cast in the very mould of the daughters of France."

Of all the teachings of the Ursulines and of the other nuns in Quebec and Montreal who became their imitators, the most enduring in its material effects and repercussions were those in the arts and handicrafts. Many women, native or white, over much of North America, still owe a debt of gratitude to the Quebec educators who, long ago, initiated their ancestors into what was then called the science of crafts (*la science des ouvrages*), also to read, write, play the viola, and "a thousand other small accomplishments (*mille autres petites adresses*)." The programme of training, as mapped out from the first, included: "good French manners,

housekeeping, needlework, drawing, painting, music, some notions of architecture and other fine arts (*arts d'agrément*)."

As embroidery, in those days, was a useful art of the first importance for cultured women, the Ursulines implanted it among their pupils, both French and Indian, who showed great aptitudes. Circumstances in this were most helpful, because the churches and chapels in the colony required embroidered garments, then in general use.

Not only did Madame de la Peltrie—she was from Alençon a home of fine lace work—and Mère Saint-Joseph teach embroidery to the children, but Marie de l'Incarnation herself was an outstanding artist in this avocation. The daughter of a silk merchant in Tours, she belonged to the noted family of the Babous de la Bourdaisière, tapestry-makers and instrumental in the establishment of a shop in Fontainebleau under Francis I, which shop later formed part of the Gobelins.

The most remarkable disciple of the Ursulines of Quebec was Jeanne Le Ber, of Ville-Marie (now Montreal). She was trained at the cloister from 1674 to 1677. From what remains of her gorgeous work, with gold, silver, and coloured silk threads, we may judge the tradition imparted to her by her teachers. Other nuns of the following generations, within the order or outside, preserved the tradition while introducing a new style and fresh patterns. In their embroidery we discern no less than three or four contrasting periods. Later freed of their responsibilities towards the Indians, the nuns focused their attention upon the education of French-Canadian girls, whose numbers constantly increased. In need of revenues for their mission, they turned their crafts to practical use. Many tabernacles and statuettes from their hands, statues and altars from the shops of wood carvers, were sent for gilding to their shops; they retained the secret of this ancient craft. They even engaged in wood carving, in which pursuit some of them proved skilful.

Several minor crafts also provided the nuns with a much needed income, mostly after the conquest of Canada by the British; for instance, the making of birch-bark boxes and dishes, fine leather

11

work, book binding, library equipment; also the manufacture of artificial flowers, wax fruit, hair pictures, and painting. The making of birch-bark and "incense" boxes became, for the Ursulines as for other nuns in Quebec, Three Rivers and Montreal, quite remunerative at one time. This work was particularly serviceable and attractive. The bark was sewn with *watap* (spruce) roots, and the outer surface was decorated with dyed porcupine quills or moose hair, much like the bark work now made in a derivative way by the Micmacs and other Indians in the Eastern Woodlands.

While the colonists of New France laboured to earn the daily bread that sustained their bodies, they strove to achieve something of beauty that would uplift their immortal soul. Mgr. de Laval, first bishop of Quebec, pleaded with the authorities in France to obtain support for the settlements of the St. Lawrence. Not only the settlers' homes must be made fit habitations, but their churches must be embellished, since public welfare was linked with spiritual salvation.

The first bishop of Quebec engaged thirty craftsmen in Paris and elsewhere, and in the ten years that followed, Mgr. de Saint-Vallier, his successor, continued to foster the advancement of arts and handicrafts. Architecture and wood carving soon rose to great artistry. The style and decoration of the churches and public building followed the taste of the seventeenth century of the motherland. So that one may now come upon a church or manor-house in Quebec that looks for all the world like a wing of some church or chateau north of the Loire River.

The first master carvers of the Cap Tourmente school, established by Mgr. de Laval, seem to have been southern rather than northern in their affiliation. Jacques Leblond de Latour, the leading master of the foundation, was engaged at Bordeaux by Mgr. de Laval to implant into the New World the best traditions of the old France.

The school of arts and crafts at Cap Tourmente was in part an experimental farm where boys learned how to read and write and devoted much of their time to farm labour and handicrafts. The masters there and at the shops of the Séminaire de Québec taught

their apprentices useful crafts, like joinery, lock-making, painting, wood carving, and tailoring. A fair number of young men, recruited from among the settlers, showed unusual dexterity in their accomplishments.

"Advanced students in letters and theology," Mgr. de Saint-Vallier recorded, "also learn a craft as a diversion from their usual work." Another chronicler added, "The arts are allotted to the seminarists according to their natural talents; they quickly respond, and they cleverly fashion many small articles not only for current use, but also for the altars which they decorate with taste and discrimination (*avec beaucoup de génie et de propreté*)."

Most of the masters engaged in France by the first two bishops of Quebec eventually settled in the colony, practised their calling, and became the heads of families which spread the traditions of craftsmanship far and wide on this continent; among them we find Baillif, Jourdain, and others. One of the early Cap Tourmente men, Claude Baillif, landed at Quebec in 1675, while still a young man, and later became one of Quebec's leading builders. He constructed the walls of the first basilica and the chapel at the Bishop's palace, of which M. de la Potherie, a distinguished French visitor, wrote that it was reminiscent of the reredos of the Val-de-Grâce in Paris.

Among the contingent of masters brought over to New France before or about 1690, we find Leblond de Latour, Samuel Genner, Michel Fauchois, his apprentice Mallet, and Le Prévost, all of them sculptors. They were not the only art practitioners in the colony. Brother Luc, a Franciscan, was a painter of note, whose work is known in France. And several masters of the Confrérie de Sainte-Anne, to begin with the Le Vasseurs, were carvers and sculptors.

A specimen of the Cap Tourmente work, at the Seminary chapel, finished in 1698, was described as follows: It was "40 feet long by 30 wide. The wood carvings, estimated at 10,000 écus, to use the words of M. de la Potherie, were very fine. It was built by the seminarists, who spared no love or labour to bring it to

perfection. The high altar was a work in the Corinthian style. The walls were panelled and decorated with sculptures and large paintings. The cornice and the vaulted ceiling, divided into bays, were embellished with painted and gilded ornaments."

Some of the apprentices at Cap Tourmente—probably the first school of its kind anywhere later entered the priesthood, among them Descormiers, a talented priest and missionary, who continued to work until 1711. If Leblond de Latour and Le Prévost, both leaders at Cap Tourmente in the 1690's, represent the whole group, they were certainly most gifted masters, the first as painter and carver, the second as carver of statues. From their hands we still have a few statuettes and at least one painted portrait.

Leblond and Le Prévost left the school after the disastrous fires which destroyed the Seminary of Quebec twice, in 1701 and 1705. Ordained into priesthood, they became curates, and their departure, no less than the death of Mgr. de Laval, in 1708, reduced the school to a farm and summer residence for priests. But the educational work of the early masters had fulfilled its founder's expectations. Traditional arts and crafts on the St. Lawrence passed from master to disciples from that moment, if not earlier, down almost to our time.

The population of French Canada, after the conquest in 1759, soon began to expand, and to alter its tastes. The need for larger churches everywhere became insistent. The craftsmen, under constant practice while rebuilding the churches burnt or ravaged during the siege, grew more numerous and skillful. New fashions in architecture developed out of what had been sheer necessity.

Some years before the end of the French domination, the Le Vasseurs of Quebec had introduced a "rocaille" style which reflected the evolution of architecture in France under Louis XIV and Louis XV. Many fine examples of their art are still preserved, for instance, the choir reredos and altars of the Ursulines' chapel, and the high altars of a number of churches in and around Quebec.

The race for reconstruction, after the conquest, brought about a feeling of rivalry between two groups of wood carvers, one

14

located in Quebec—the Baillairgés, and their numerous fellow-workers; and the other, the Quévillon school at Ile-Jésus, near Montreal. Once before, rivalry had developed between towns in France as to who would excel the others in the building of Gothic cathedrals. Just so once here, in a humbler habitat, the parishes vied with each other in the embellishment of their churches. The collaboration among the common people, the builders, and the authorities, made the growth of architecture and sculpture in French Canada possible, and brought the work to a high point of perfection. This is true of the accomplishments of de Léry, the architect for the King in New France; of Paul Labrosse, wood carver, near Montreal (*circa* 1720 to 1750); of Francois and Thomas Baillairgé, carver-architects; also of the work of François Ranvoyzé and Laurent Amiot, silversmiths (*circa* 1770 to 1839).

The old French ways and outlook still survived among the people in their comparative isolation. Churches, colleges and monasteries were the centre of Canadian culture; places of worship, to be made attractive, must be embellished. Nothing was spared to make them beautiful. Art was an essential, as in mediaeval times and during the Renaissance, not a mere luxury as it has become in modern life; hence its vitality, when most of America still remained a wilderness.Many wood carvers and sculptors, scores of silversmiths and potters, trained by the masters of the French period, went on working during the Le Vasseur, the Baillairgé, and the Quévillon periods. Their activities spread in various directions, as far as Detroit, Ste. Geneviève in Missouri, and Louisiana, and included the decoration and equipment of public buildings, private houses, sailing ships, and the carving of fine furniture. This explains the abundance of antique materials of varied character along the St. Lawrence, and the survival of the arts in scattered form, including rural handicrafts, down to the present day.

2.

["DRAWING INSTRUCTION"]

by John Hassell

The following are excerpts from The Speculum: or the Art of Drawing in Water Colours; and Instructions for Sketching from Nature *by J. Hassell (died 1825), published in London in 1809, the year after the Royal Military Academy was established at Woolwich. The book is typical of the manuals from which English officers were taught and which, taken together, had enormous influence on the direction of Canadian art.*

Trained in topographical and architectural drawing, several generations of military engineers left extensive pictorial records of early Canada (see, for example, The Drawings of James Cockburn: A Visit Through Quebec's Past, *edited by Christina Cameron and Jean Trudel [Toronto Gage, 1976]). Being gentlemen as well as amateur artists, they also engendered a climate for arts patronage. And partly by their example a basic appreciation and working knowledge of sketching and water colour became standard middle-class equipment, not jettisoned until well into the age of photography.*

Painting is the art of imitating nature by combining proportional lines with correspondent colours, so as to represent the life, objects of every description and under every variety of form.

PROPORTION

may be considered as a primary object in painting, and is a rule so easily obtained that very little practice will give a facility of representing objects as they appear to the eye. In this first essay of sketching from nature, it will be always necessary to introduce before the sight some prominent object, neither too close, nor too distant from your position; by these means all objects beyond this

mark will naturally appear to diminish as they recede from the sight, whilst those which are nearer will of course enlarge.

In drawing, where a strict adherence to the rigid rules of perspective must be enforced, necessity will oblige you to form your proportions from the object nearest the sight. This rule may also be followed whenever your foregrounds constitute the principal subject, in which case all other parts may be considered as auxiliaries only, collectively forming a component whole. Why I recommend fixing on some particular object from which to draw and take proportion is, for the sake of avoiding any thing that may appear stiff and pedantic. In this, however, the artist must consult his own fancy, regulated by judgement: scarcely any two in the profession adopting exactly the same method.

It may perhaps be as well to refer the pupil to the old established principle of attending to perspective, and although in a first attempt, at least, it will not be expected that a young artist can attend implicitly to every branch of this science, he will nevertheless do well to observe, that the horizontal line should occupy about one-third of the height of the drawing.

All objects that are above, should fall to the point of sight, and all parts that are beneath the horizontal line should rise accordingly to the same point.

A young artist by conforming to this easy rule in his first essay to sketch from nature, will give simplicity and grace to his drawing....

Who can mistake Saddleback, Skiddaw, Snowden, Cader Idris, or Plinlimmon? Their peculiar forms are ever distinguishable, and will stamp a character to your landscape, though the component parts of your view are not an absolute portrait of the place—Here let me remark how the pencil of Mr. Loutherbourg courted these prominent beauties, and omitted only what was regular, stiff, and unpicturesque. His excellence combined every thing that can add either to the interest or beauty of the scenes; his admirable choice of nature has never been excelled. My late unfortunate friend, Mr. Morland, had altogether another manner: his guide indeed was nature, but he would rarely submit to copy; he conceived the most correct ideas of the simple and the rural, but would

17

admit no shackle; from this circumstance he could hardly be said to have ever painted any particular spot. Except the scenery of the Isle of Wight, I can hardly charge my memory with any accurate view he ever did: like the bee, he culled from every sweet, and made nature alone his art.

Episode may always be allowed, when we can, by comparison, lead to truth, and accessible means attaining perfection....

Nature sometimes presents innumerable scenes that answer the artist's purpose; yes, and she often groups the whole assemblage of the work by the aid of light and shadow, so as to leave a finished picture; but this is rarely to be met with; you must pursue your researches with avidity, for such coy materials as nature composed [scenes with] shun the general eye, and [are] only to be found by the industry of the votaries of genius and enthusiasm....

SIMPLICITY,

than which in the arts nothing is more conducive to please, all accomplishments to landscape should partake of. I mean by simplicity a natural, easy, unaffected representation, giving to all we describe the garb of nature; it admits of no prescription. The same plain unornamented dress should accompany your figures; the wild Irish peasant is, in a picturesque light, the very acme of perfection; it is the same with the Welsh peasantry, their habiliments, as loose and tattered as the mountains they dwell upon, give a consonant and appropriate representation in a picture; their unconstrained gait has a simplicity ever to be courted; cattle rude and unfettered with harness, correspond with the different vehicles they draw after them; the sledge, the low three-wheeled cart, the car and the waggon, are alike picturesque, nor are the pack-saddle and panniers otherwise. In representing the various trees of the forest, a due attention must be paid to the playfulness of their foliage; it must apparently give to the gale, and bend with ease; and even the unwedgable and knotted oak must sweep and wave to the breeze that chequers it.

Figures, the accompaniment of landscape, as I have before observed, are to be selected for their simplicity. The village maiden,

loosely attired, performing her domestic duties, is always a sketch for the artist; hardly any of her employments but will admit of a subject: milking, nursing, washing, by or in the brook; as a gleaner, a wood-binder, reaper, or a haymaker, each has a character well adapted for landscape ornament. The avocations of the rustic are alike suitable for the purpose of enlivening rural scenery; ploughing, sowing, reaping, moving, carting, pitching, threshing, fishing, shooting, coursing, have all the respective advantages of embellishing the picturesque and the rural....

...Perfection is not the lot of the mortal, either in a mental or corporeal sense; and the ancients, aware of the circumstance, wisely sought for the *ne plus ultra*, by combining all that was excellent in the various parts that nature presented to them.

For this reason many statues far exceed the life.

Who can view the interesting and lovely figure of the Venus de Medicis, and believe that so much perfection ever was possesed by one mortal? It is more than probable that this figure, according to the pean of Zeuxis, is a combination of beauties selected from a plurarity of the sex. Ovid bears me out in my affirmation when he avows that Pygmalion carved the snow white image of ivory with such exquisite effect that it was altogether impossible such a paragon of female excellence should ever have existed.

My next recommendation to you is *emulation*; without this laudable spur I cannot congratulate myself on any considerable advancement you will ever be likely to make in the arts. I think it was Scipio Africanus who observed that every magnanimous spirit ought to emulate the first characters of the day, and endeavour to rival the past: this I allow is very broad reasoning, but as a stimulus by no means to be objected to.

Emulation is the proof of a great mind, whereby our imitation is provoked by envy and admiration. From either cause they lead as it were imperceptibly to perfection. This emulation and confidence, aided by simplicity and taste, will ever produce works worthy of applause; and how substantially repaid is that artist who arrives at the goal, from the presentiment that by industry he shall attain his object.

19

3.

["ON KRIEGHOFF"]

by Marius Barbeau

The career of Cornelius Krieghoff (1815-1872), the prolific Dutch-born, German-educated painter of genre pictures and anecdotal scenes, often with a habitant flavour, swung wildly from success to failure and back again. His posthumous standing, however, has known only slow steady growth. One plateau of this reputation was Marius Barbeau's monograph Cornelius Krieghoff *(Toronto Macmillan of Canada, 1934) from which the following is taken. It was only natural that an anthropologist should have become a primitive kind of critic in order to champion Krieghoff, whose folk impulses were so strong. Barbeau's work with native peoples of the West Coast, incidentally, earlier had caused him to support Emily Carr.*

Seventy years after the passing of Cornelius Krieghoff, the time has come for an impartial estimate of the value of his work, of its place in our historical records, and of its function in the development of art in our midst.

The aesthetic quality of his work finds present-day opinion somewhat at variance. Hostility has shown itself, in the past ten years, from unforeseen quarters—Quebec itself which he had taken to his heart and painted with a searching eye for its varied facets in an age now gone by, with a fine brush ever attuned to keen outlines and neat craftsmanship, and with a palette that never was short of clean colours, bright effects for the snow scenes, and of sumptuous reds for March sunsets and maple foliage at its late September best. M. Gerard Morisset for one has repeatedly turned him thumbs down for having slandered his French-Canadian hosts whom, to his own taste, he has shown too often as revellers and

topers or in habitant garb, or because of his pot-boilers—the Provincial Museum in his town owns little else, some of them not even from his hand—and last of all because he was a Jew, although the records show that his mother (Van Wouters) was Dutch, and he found himself congenially at home with French and English Canadians. A fair knowledge of the vast repertory of the painter's work—over 700 numbers have never been seen in or near Quebec—would no doubt have dispelled such prejudice or misconception.

The career of Krieghoff as a Canadian painter of genuine worth was much better appraised in A. Y. Jackson's estimate, which springs from thorough knowledge—the Jacksons have known of Krieghoff since 1847, a full hundred years—and a sound appreciation of quality from professional experience. I quote him:

Krieghoff was the leading pioneer painter of Canada. Our museums would show foresight in collecting his best works, of which the value is incontestable. He was a penetrating observer; nothing escaped his sensitive eye; and in every sense of the word he explored the St. Lawrence. There was something wild in him, something of the coureur-de-bois and of the colonist. In his paintings we find many authentic details which have since disappeared. The life of the habitants and the Indians animates the winter and summer scenes, the forests, the lakes, the rivers, the villages, and also the interiors of the tents and the houses. Though he was Dutch, he became one of us, and knew and understood Canada better than most of our people. He awakened around him a taste for painting and a sense of self-expression. Our debt to him is greater than most people imagine. Study his *Ice Bridge,* for instance, and compare it with the *Ice Bridge* of J. W. Morrice and of Clarence Gagnon, painted about sixty years later. In the one you find sincerity and liveliness, in the others, subtle art. For a long time after the death of Krieghoff, painting

21

in this country produced nothing of consequence; our painters, in turning their backs on their own surroundings and staying in Paris, were seduced by exoticism. Of them there remains hardly a souvenir.

It is incorrect to describe Krieghoff—it has often been done— as a Dutch painter of "petits genres," and to assume that his art was too mature, when he arrived in this country, to adapt itself fully to new surroundings. Actually his earliest work was crude and amateurish; he could hardly have received any studio tuition in his youth, nor have been aware of the career awaiting him. He had been a roving musician in Europe first, then had joined the American army for three years, and had made sketches of the Florida everglades in the Seminole war. In his army record, he is described as "By occupation a clerk." When, about 1842, he settled at Longueuil with Gautiers dit Saint-Germain, he naturally grew interested in the Caughnawaga Indians a few miles away, and began to put on to canvas some of their wild activities.

His *Shooting the Rapids* (13x18) now preserved in Toronto, shows an Indian running the Lachine rapids in a birch-bark canoe. Foaming water tosses the canoe, while conventional trees stand on the far shore. This early effort, dating back to 1843-1844, is so drab and awkward, that we can hardly accept it as from the same hand as produced, at a much later date, in 1859-1860, other river scenes of the same type, for instance *Shooting the Rapids* (18x20) owned by the late Ward C. Pitfield, and other canvases of similar type painted on the Montmorency River near Quebec.

In a number of sketches, Caughnawaga Indians posed for him. Stiffly standing on snowshoes or in the snow, they all go back to the early years of 1845-1848, and show a marked progress on the previous ones. His aim there was static portraiture in the Dutch style, familiar to him from his school days. The trees were nondescript and the atmosphere still; deep green served as background for the summer, and grey blue for the winter. From portraiture he slowly passed to illustrations of daily life in Indian camps or of fishing or of the hunt. Now the young painter,

through practice and a keen sense of observation, entered the second phase of his development. It is only some ten or fifteen years later that he reached his stride, in the forest scenes of 1858 and 1859, near Quebec. Among the Lorette Hurons in the Laurentians, his brush at last was freed; it dashed semi-detached pigments of contrasting colours on the canvas, somewhat in the manner of the impressionists of a later day; it gave to the texture of those pictures a freshness and a transparency that is remarkable. For instance, in *The Hunters,* two Hurons in a birch-bark canoe pursue a deer amid flickering autumn foliage and grasses. And his tableau *Indians Hunting Deer* was considered in England, where it was taken, as unreal and unbelievable, the people overseas never having seen our autumn foliage.

The Indian theme was only one of several strings to the painter's resilient bow. More important still was that of the French-Canadian settler and habitant. Even before 1846, Krieghoff had begun to use his hosts the Gautiers as models sitting for him, either within the house, or in their picturesque red or blue sleigh outside. Like the Indian sketches of the same period, these are still amateurish. When he placed his models in a summer setting, his greens were dull and his trees unrecognizable; he had not yet become interested in them; when he preferred the winter, the snow, dead white, failed to reflect the subdued tints of the sky and the horizon, which eventually would tantalize his sensitive eye. More at home in interior scenes in an "petit genre," he enjoyed depicting his folk around a table playing cards and cheating— a little story to tell!—as in his *Canadian Habitants Playing at Cards*. Then he brought out his humorous *Picture Pedlar* and *Breaking Lent*. Gradually as we pass from 1845 to 1849, in his Longueuil period, his style broadens and his mastery over setting, details, and colour, grows livelier and more original.

Everywhere we look in Krieghoff's large repertory taken as a whole—I have recorded more than 700 items, and many more are still to be traced or have been destroyed by fire—progress was steady, while he gradually reached the peak of fullness in several varied treatments of the same subject; then a recession set in, in

later repetitions; and canvases were reduced to pot-boiler size for indifferent customers.

No need to mention here a considerable number of portraits—more are discovered yearly—although they stand to his credit, and reveal his versatility. He was counted among the best Canadian portrait painters, at a time when other gifted portraitists—Berthon, Plamondon, and Theophile Hamel—disputed the clientèle. For instance, his *William Williamson* (42x33), painted about 1845, and preserved in Winnipeg, and *Mrs. W. Williamson with Her Daughter* (of the same size), show that his main achievement, at that date, was portrait painting. He enjoyed a certain reputation among the snobbish Montreal bourgeois and well-to-do merchants. They had him represent them in full regalia, sitting in fancy carioles and driving their fine steeds on the ice in front of the town. Later, he occasionally reverted to studio painting, but it did not appeal to him, for he was too sincere to cater to make-believe and false pretence. His preferences were for outdoor life and folk, waterfalls, and spring or autumn scenery, hunting and revelry.

After he had moved down the river to Quebec, in 1853, he felt great enthusiasm for the old town, its society, and picturesque surroundings, and the Lorette Hurons readily replaced the Iroquois of Caughnawaga. For days he worked with great intensity, almost as if in a trance. This joy of creation, as the work advanced, spread to his friends, who did not know what to admire most, the bright pictures of familiar scenes, or the dash of the artist whose wizardry astounded them. He became part of the country around him, and it made a great difference to his sensitive mind. Quebec was taking him to its warm and generous bosom, and he repaid it in pictures that would record its unique features for posterity.

The Montmorency Falls of 1853 to him were a foretaste of the Laurentians, like a challenge to venture beyond the doorstep into the heart of the country. On the way, he had to stop at farm houses, like his *Habitant House*, Beauport, 1853. Reverting to an earlier Longueuil theme with greater experience, he composed winter scenes with a house, a barn, a sleigh with a farmer returning from the market and bringing gifts from town for his family to enjoy.

The French Canadians have a sense of fun that appealed to an artist, like him, of Dutch origin. They were the stuff, kermesse-like, for a Breughel and a Teniers. He enjoyed the company of the habitants. Mingling with them, he wandered off into the old parishes, where he heard amusing yarns, and disappeared for days. These were fuel for his humour and imagination, for instance in the trick of *Billing The Pike* or *Cheating the Toll*, at the gate out of town.

Krieghoff's Habitant Homesteads introduce the snowy settings that are most typical of Eastern Canada. His outstanding examples of Quebec Farm Houses in the winter developed out of his Longueuil period; the peak of this series was reached after its actual close, for instance, in *Habitant Home in the Winter*, of 1855, the National Gallery's *The Habitant Farm* of 1856, and the two or three splendid compositions, *Playtime, Village School*, and *Lorette in Winter*, of 1856 and 1857. They crown the artist's admirable contribution to Canadian art. Within their field, they remain unsurpassed.

The series of more than a dozen *Settler's Log Houses in the Winter* (1856-1862) characterizes the new settlements of Stoneham and Laval in the Laurentians, where the artist often went with Lorette guides and Quebec sportsmen to hunt the moose and the wild deer. It also explores as has never been done since a chapter in picturesque forest life which has left deep traces in the pioneer personality of many French Canadians.

Frontier life was not all work and pioneering. It relaxed at times into jollifications all its own for those who knew how to enjoy winter sports in the hill-side settlements, and the thrills of the hunt to replenish the larder. It bred a sense of values which comes from awareness in the struggle for existence and surplus energies in the slack season.

If the settlers were hard-working most of the year, they looked for entertainment as soon as sleigh bells jingled in the crisp air, and the whip cracked over the heads of sturdy little Canadian horses trotting down the road. The whole family started off in the berline to visit neighbours, where a demijohn on the table awaited

25

their coming, and tumblers clinked in the midwinter celebrations. Here we find the artist amidst rustic hosts, sharing their simple pleasures and indulging in the revelries of carnival.

The ice and the snow, true enough, brought back to Krieghoff's memory the skaters of Holland, his native country; they had been painted by Breughel, Jan Steen, and other Dutch craftsmen. They were also enjoying favour in New England and Pennsylvania, where the artists employed by Currier and Ives treated the same subject at about the same time, but less broadly. The superiority of Krieghoff's pictures made the Pennsylvania engravers prefer him to their own. This accounts for about a dozen of his best tableaux having been found or recovered in recent years by William R. Watson, of Montreal, in Philadelphia. Among these are the two, *Playtime, Village School,* 1856; the best-known *Habitant Farm,* 1856, now the property of the National Gallery of Canada; and his outstanding *After the Ball, Chez Jolifou,* 1856, of Mrs. Ward C. Pitfield.

If a prolonged period of sterility followed Krieghoff's intense production, as A. Y. Jackson has stated above, it was due to the unnatural bias of the Canadian painters who forsook their elder's example, and turned their back one and all on their surroundings, and went to Paris, where exoticism seduced them for their own loss.

Figures, architecture, and human activities held the foreground in European art and occupied the centre of every composition, until Turner, Constable, and Courbet, in England and France, had enough power to dislodge these master themes from their stronghold. These painters were the first to subordinate man to surroundings or to dismiss him altogether. Even the familiar story-telling in pictures was discarded. With them the winds and rhythm of nature became the main subject, occupying the whole stage. Whether or not Krieghoff, in his Quebec period, owed anything to them is a question—their work had not yet travelled far away from their studios. Modern art in Paris and London had hardly forced itself into the foreground. Only with Bartlett's pictures of Laurentian life and scenery, splendidly engraved at

London in 1840, could it have been known in Canada and conveyed indirectly to the Canadian artist the wide influence which Turner was to exert on landscape painters of the coming generation.

His *River Ste. Ann*, a pure landscape without human figures in the most up-to-date style of the time, is not a derivative composition; it is individual and inspired. It opens up the North and embraces it with a powerful vision. It somehow reaches out in one sweep as far as 1913-1922, in the growth of Canadian painting, when A. Y. Jackson, his direct heir no less than Cullen, Morrice, and Gagnon, painted *Night, Georgian Bay*. This initial utterance of Jackson in the wilderness was to be prophetic in a new art movement. It opened the gates of the northern expanses to Tom Thomson and those who later followed him. In Krieghoff's *River Ste. Ann*, the rocky foreground, eroded by age and tilted to the left, is set off in high-light against a background lashed by wind and storm from the great West, as in Tom Thomson's *West Wind*, dated 1917, Lismer's *September Gale*, and Varley's *Georgian Bay*, the last two painted in 1922. The mountain stream of the Ste. Ann keeps on carving its bed into the rock, as in J. E. H. MacDonald's *Falls on the Montreal River, Algoma*, 1920. And its tormented tree, aged and leafless, is akin to the dead trunks in the "brûlés" of Lawren Harris' *Country North of Lake Superior*, and Jackson's solemn *November*.

In this and other pictures of the same type and period, Krieghoff strikes a note that is in complete harmony with our North-Eastern Woodlands. Like the members of the Group of Seven and later painters of the Canadian wilds, he faced the lakes and virgin forest without prejudice, and uttered their colour and rhythm in forms so true that they still remain vital, despite the passing of time and the changing standards of art. Indeed, our Laurentian school began with Krieghoff and, after a prolonged Barbizon pause, resumed its course, at first tentatively, with J. W. Morrice and Maurice Cullen, then to the full with Henry Jackson's grandson, A. Y.—Henry was Krieghoff's friend at Longueuil. Canadian painting continued its advance first with the Toronto group in the

Georgian Bay district, and then with many artists all over Canada who now follow in their footsteps. Even Emily Carr's late awakening, after 1928, was due to her encounter, when brought over to Ottawa and Toronto for the exhibition of North-West Coast Art organized by the National Gallery and the National Museum, with some members of the Group of Seven, particularly with Lawren Harris, whose advice guided her in her search for self-expression. Thus we find, in the development of Canadian art, that the efforts of its master craftsmen are linked together like the rings in a chain.

Krieghoff was more than an aesthetic painter; he may also be considered a historian. In the light of his published Catalogue raisonné (1) of about 500 numbers, plus over 200 items discovered since, he fully deserves the caption once attached to his name by William Colgate: 'Cornelius Krieghoff, Pictorial Historian'. The main headings in the classified and descriptive list of his work bear this out, for a conclusion here. Most of these numbers abound in neatly drawn and colourful details: physiognomy, costume, surroundings, which are as many accurate historical documents for a period which has now passed away.

4.

["OSCAR WILDE
ON HOMER WATSON"]

Wilde visited a number of Canadian cities and towns during his North American speaking tour of 1882, posturing for a mocking press and lecturing, on the crafts revival and on aestheticism, to appreciative audiences. The curious spectacle and its effects are given full treatment in Oscar Wilde in Canada: An Apostle for the Arts *by Kevin O'Brien (Toronto: Personal Library, 1982). When Wilde was in Toronto, the work of the landscape painter Homer Watson caught his attention and subsequently won his patronage. Watson (1855-1936) had an early debt to the Hudson River School in the US and later one to Constable and the Barbizon painters, but at length became something of a nationalist, a founder of the Canadian Art Club and the president of the Royal Canadian Academy. The two notes below are found in the* Toronto Evening Telegram *of May 25, 1882, and the* Toronto World *of May 26, 1882, respectively.*

OSCAR AT THE ART GALLERY
Visit of Mr. Oscar Wilde to the Gallery this Afternoon.
What he thought of the Drawings. What he wore.

By invitation from the Society of Artists, Mr. Oscar Wilde this afternoon viewed the paintings now on exhibition at the rooms of the society, King-street west. He wore a pair of gray tweed trousers, somewhat longer than usually worn but short enough to display the foot and ankle, mouse coloured velveteen coat and vest, a dark green tie loosely fastened and handkerchief of the same colour. A flowing coat of black, trimmed with velvet, hung from his back, and was secured by a cord tied across his chest. Among those present were Capt. Geddes and a few members of the Lieut.-Governor's family. His criticism of the drawings was keen, and

the colour which attracted his attention the most was grey and its shades. The oil painting, No. 72, *Flitting Shadows*, was gazed at by him very intently for some time. So much so, indeed, that he seated himself on a chair, and assuming an aesthetic attitude looked with an intense longing at the dull grey sky. During his walk around the room he made use of the expressions, 'very clever,' 'very pleasing' and 'beautiful.' No. 29, *Kaka-be-kah Falls*, is an oil painting, and in the background is a fall of water a great many feet high, with the waves rushing pell-mell over each other. The water in this picture he characterized as being 'too happy.'

TRIBUTE TO A CANADIAN ARTIST

Oscar Wilde said last night that during the day he had been up to the exhibition of Canadian artists and among the pictures was a landscape of Mr. Watson, a young Canadian, who had never studied in the great schools of Europe, which is full of the highest art and beauty, and Canadians should be proud of such an artist.

5.

["REVIEW OF THE ROYAL ACADEMY SHOW"]

by Archibald Lampman and Duncan Campbell Scott

For nearly 18 months beginning in February 1892, Archibald Lampman (1861-1899) and Duncan Campbell Scott (1862-1947), along with their fellow poet Wilfred Campbell (1858-1918), conducted a weekly column in the Toronto Globe *under the heading "At the Mermaid Inn". The articles are frequently cited because they provide such vivid evidence of cultural values in late Victorian Canada. None of them is more intriguing now than this review, published April 16, 1892, of the annual Royal Canadian Academy of Arts exhibition. In effect, Lampman and Scott critique an entire transitional generation, who were no longer British easel painters but not yet nationalistic landscape artists. The RCA, from which the National Gallery grew, continues to exist and indeed makes occasional promises of a resurgence, but it long ago lost any important role it had in Canadian art. See* Passionate Spirits: A History of the Royal Canadian Academy of Arts, 1880-1980 *by Rebecca Sisler (Toronto: Clarke Irwin, 1980).*

At the first flush it might seem necessary to apologize for what may be considered an act of temerity in venturing to write a notice of the Academy exhibition just closed. If there is any department of criticism that needs special knowledge it is that of the plastic arts, and if our idea in the following sketch had been to point out what was excellent in technique it would have been necessary to accompany our words with a protest. But such was not the idea. It seemed that no task would be more congenial than to set down the impressions which some of the pictures had left upon the minds of two persons whose art is different but whose surroundings and mode of life are the same. And this is what we have tried to do.

31

The position of the painter in a country like our own is one of peculiar difficulty. His art depends more than any other on the culture, the experience of the past, and, in a land like Canada, where we have practically no great pictures available and no eminent resident artist, the young painter finds himself without the means of overcoming the technical difficulties of his profession. To do so he must go abroad; he must seek in the ateliers and in the galleries of Europe for the practical insight which he could never obtain at home. That our exhibitions from year to year show a marked advance in technical skill is due in the main to the fact that our artists often by their own energy and self-denial have sought for knowledge at the source. This has raised the general excellence of the work, and has also had an effect for good upon those native geniuses whose art has often developed an astonishing vigour and individuality under unfavourable conditions. With this last idea in mind one naturally thinks of the pictures of Mr. Homer Watson. Here is an artist who owes less perhaps to influences from without than any of his fellow workmen. But how fine his native manner is, how instinct with energy! He has so thoroughly mastered a certain kind of landscape under definite conditions of atmosphere that he reproduces it without a trace of uncertainty. He speaks from his canvas with something of that authority which is the unfailing indication of genius. In two of the pictures in the present exhibition, which are very characteristic, he reproduces the landscape under the presence of those cool, half-stormy days when the fields are darkened by great shadows and swept by splendid gleams, and he conveys a delightful impression of the reality. How different is the work of Mr. Brownell, whose pictures are characterized by an exquisite skill governing a pure, natural taste. His *Low Tide, N.E.* is perhaps the most satisfactory bit of work in the collection. The delicate clouds part fleecily below the blue, the sandy shore runs into lines of quiet grey, the rocks are yellowish brown, and the sea creeps in with fragile foam from a palish-green distance. The impression is exquisite. His technical perfection is again convincing in *The Step Child*, where the figure has tone pensiveness and the surroundings absolute verisimilitude. Mr. Brymner, another

32

painter who has had the advantage of the schools, produces work in which there is always charm as well as careful sincerity and truth of observation. His *Wreath of Flowers* in the National Gallery is one of the pleasantest pictures which our art has produced, and if none of Mr. Brymner's work in the present collection equals this there are nevertheless three of his contributions which are of very high merit. Conspicuous among them is *In the County of Cork, Ireland*, a painting to which the observer will return again and again with increasing pleasure. Mr. Brymner has treated us to one of the few local and specially national scenes in the gallery, that of *Champ de Mars, Montreal, Winter* ; and his smaller canvas, *Near Killarney, Ireland*, contains a felicitous impression of a cloudy sky and crowded clumps of low trees and bushes. It may be remarked here that Mr. Brymner and Mr. Watson, our two most characteristic landscapists in oils, each possess excellences which, if the power presiding over genius would let them exchange at least in part, would render their work in a still higher degree satisfactory. It would appear that Mr. Watson might spare some of his vigour and wealth of movement to Mr. Brymner, and that Mr. Brymner might transfer to Mr. Watson some of his care and prudence. Unfortunately such loans are impossible or else we would have two perfect painters.

It has seemed to us that, in this exhibition at least, our landscape artists have been most successful, and this statement leads naturally to the mention of Mr. Reid's large canvas, *The Foreclosure of the Mortgage*. This picture, with all its points of excellence and notwithstanding the interest which naturally accompanies a serious and important attempt, hardly succeeds in realizing the painter's motive. The figures in the left foreground— the woman bowed and prostrated by grief and the child at her side looking on with wondering eyes—are done with truth and pathos, and if the painter had exhibited in his completed picture an equal vigour of expression and attitude the result would have been decidedly more impressive. As it is the rest of the figures are detached and fail to produce a satisfactory unity of effect. In bringing into his picture the weakness and misery of the sickroom, the artist has,

has, we think, by overshooting the mark, signally missed the opportunity offered him to represent simply and typically one of the commonest and most significant tragedies of our everyday life. If he had placed before us the figure of a strong man in the full possession of health and strength, beaten down at last in the long struggle with financial difficulties, he would have realized a situation, less painfully pathetic, perhaps, but infinitely more tragic and more imposing.

Mr. Harris's medium-sized canvas in a somewhat similar vein, which he calls *Going Wrong*, is perhaps more successful, although it will not strongly impress those who are familiar with Mr. Harris's finest work. With *Cradled in the Net* Mr. Carl Ahrens makes his first appearance in the Academy. He is to be welcomed and congratulated at the same time. The quiet dreaminess of that sun-flooded corner of the room, where the little child lies in the hammock so sound asleep, leaves us with a perfect sensation of repose and contentment. Miss Bell's *Twilight Reverie* aims at a remarkable effect, and, although not particularly attractive, may be considered one of the most prominent pictures in the gallery. To return to the landscapes again, Mr. Woodcock's *Cabbage Garden* strikes one immediately by its subtle scheme of colour and by its craftsmanship, and, although somewhat affected, it shines by comparison with his other pieces, which appear mannered and conventional. Mr. Raphael, too, has several landscapes which are interesting but unmarked by any individual qualities. Of the portraits, Mr. E. Wyly Grier's *Portrait of a Physician* appears to be the best, although it would have been greatly improved by a warmer background; the present blank wall looks like poverty of invention and leaves the figure unprotected. Mr. Patteson's two portraits and Mr. Forster's *Portrait of My Mother* are good pieces of work. The latter we would rank next to Mr. Grier's, if not with it. Miss Tully's portrait of Mr. Kivas Tully is also noticeable. It fell to the lot of Mary Hester Reid to make a complete success with her *Roses and Still Life*, which is quite indescribably delightful. Here and there about the walls were groups of flowers excellently painted, but this picture was the richest and most natural of them all. The

small canvas of Mr. A. Watson, *A Kitchen Corner in a Humble House*, if faulty from the painter's point of view, nevertheless deserves special mention for a certain pleasant touch of nature which we find to be rare. Turning to the water colours, the conspicuous figure is once more Mr. L. R. O'Brien—conspicuous more by reason of the excellence than the number of his pictures. *Grand Falls on the St John River* and *The Mill Pond at Blair* are, we think, his best exhibits. In the former the beautiful painting of the snow-white, misty cataract with the light upon it is a delicious surprise. Mr. O'Brien's style and method are so well known that any extended observations of his work seem uncalled for. Mr. Manly displays a vigorous touch and much truth of observation. *A Street in Pont Levis* is a very picturesque representation of a sloping street with ancient-looking houses, and *Leafy June A-Summering Comes* is an accurate delineation of a natural bit of river scenery by one who evidently loves the fields. One of the pleasantest pictures of the collection is *Sunshine and Shadow*, by Mr. Fowler, who again displays his characteristic decision of colour and strenuous vigour of touch. Mr. Bell-Smith appears to have been in Paris and to have filched some of the mannerisms of the French watercolourists. His success is rather doubtful although the *Street Scene near Notre Dame* is certainly worthy of careful attention. His *Rocky Mountain Canyon* is decidedly good, although the handling of such subjects of our artists in general is usually an opportunity for complete failure. The Rocky Mountain scenes to which we are being constantly treated are impressive and amateurist, of this we consider most of Mr Matthews's present exhibits to be noticeable examples. His *Pleasant It was When Woods were Green* is somewhat more satisfactory. Mr. Charles Moss has two very pleasant bits of colour inconspicuous in size, but of real distinction. A clever bit of local antiquarian interest is Mr. Watt's *Old Mill at Lachine*, a little picture, pleasant in tone and very truthful; and Mr. Colin Scott's *South Harpswell, Maine*, has some exceedingly attractive features. In looking over these walls covered with interesting and promising pictures, a melancholy and frequent thought returns to us that the perverse fates continue to bestow riches on those who

neither know how to use them for the benefit of the community, nor have the taste to acquire, by a noble employment of them, a rational satisfaction for themselves. We amuse ourselves by making a short list of the smaller paintings, which even if we were only moderately well-off we should assuredly make haste to buy. Most of all we covet: Mr. Watson's *Evening on the Thames*, Mr. Brownell's *Low Tide, N.E.*, Mr. Brymner's *Near Killarney, Ireland*, Mr. O'Brien's *Grand Falls on the St. John River*, Mrs. Reid's *Roses and Still Life*, Mr. Woodcock's *Cabbage Garden*, Mr. Fowler's *Sunshine and Shadow*, and Mr. Manly's *Leafy June A-Summering Comes*.

6.

["A LANDMARK OF CANADIAN ART"]

by J.E.H. MacDonald

When Tom Thomson (1877-1917) drowned in a Northern Ontario lake, Canadian art suffered its greatest untimely loss and gained its most enduring mystery. Thomson scholarship had begun by the middle 1920s, the heyday of the Group of Seven whose work he had anticipated. Both it and the Thomson legend benefitted from the fact that Thomson's colleagues survived him with their testimony. This memoir by the Group member J.E.H. MacDonald (1873-1932) is the first important article on Thomson. It appeared in November 1917, a mere four months after the subject's death, in The Rebel, *a University of Toronto student publication and a precursor of* The Canadian Forum, *with which so many of the Group would be associated.*

A remote and simple Ruskin of ancient China, surveying nature and the Modern Painters of his own Celestial day, wrote as follows: 'With the breath of the Four Seasons in one's breast, one will be able to create on paper. The Five Colours, well applied, enlighten the World.'

Some of our most potent, learned and rebellious Mentors could, doubtless, identify and describe the old Chinese author. They would discover his subtleties of meaning. They would demonstrate from internal evidence that oil painting was not practised in China at such a date. They would talk Dynastics and Chinese Poetry and Sociology, and might draw a comparison between the times when the five precious colours of the old painter were honoured as enlighteners of the world, and the present days of fence advertising and such enlightenment. They might digress into Post-Impressionism, Cubism, Vorticism, Synchromism, lining up as rebels or retrogrades according to their ages and the source of their degrees. But it is possible that they might just miss the fact, that

the Sun shining on the Campus as they talked, is the same as that which brought the garden of our writer into bloom. The breath of the Four Seasons stirs alike in College maples or Chinese acacias. Is there not something wholesome, true, living and immediate in the words flicked and thickened into being by the deft brush of our yellow Ruskin? The dust of time is but a preservative for them. They are fresh and simple as a spray of apple blossom, or the spread of a bird's wing against the gradated sky of the elder art.

In a right Rebellious Geography, East and West do not so much meet as radiate from a common centre. The Yang-Tse-Kiang is a tributary of the St.Lawrence, and both flow from Parnassus through the land of Sweet Living, where the five or more colours still enlighten that folk having a heart ready for enlightenment. The breath of the Four Seasons must ever be our basic inspiration. No China Wall or Dutch dyke, or British privilege hinders the free passage of that living breath. It moves as freely over Halifax as over Hang-Kow. It is made for human lungs, and they must breathe it or the soul will die.

And so, the ice firms and whitens over Kachebagamog, Little Lac Grenier opens a blue eye to the Spring, the wild cherries toss in bloom against the primeval rocks of Georgian Bay, the maples culminate in red and gold, and the year sleeps as the first flakes come steadily down among the spruce and birches of the far woods. The inspiration waits. The eager soul needs merely come and breathe it.

Thus have the seasons passed along the shores and islands of Canoe Lake in Algonquin Park. But the landscape has a new feature there. In the quiet days of late summer, a cairn was raised on the lift of a rocky shore, where it stands rosy-grey against the dark background of spruce. From the end of the lake towards the Smoke Lake Portage, the intent eye can separate it from other rock and bush. The canoe-man passing to or from Joe Lake can readily catch the little cairn shouldering into the sky-line above him. The visitor to Mowat Lodge Hotel may note it a mile or so away over the water, or he may suddenly catch a reflection from the new brass of its inscription plate.

If he should cross the water or make enquiry at hand, he will find that the cairn was erected to the memory of Tom Thomson, a Canadian artist who was drowned in Canoe Lake on July 8th, 1917.

Such a monument is almost unique in Canada. One similar in intention, stands in the burying ground of Fort Mattagami far in the north of Algonquin, commemorating the death of Neil McKechnie, a young artist of promise who was drowned in a rapid there some years ago. They suggest that Canada is becoming aware of the fact that four seasons pass annually over her, breathing inspiration to eternal beauty, as well as life for crops and lumber. They indicate her identity with classical lands. She is making the simple beginnings of tradition. She is raising a human and poetical background for the coming generations. One thinks of Fontainebleau and the memorials in the Forest there to Barbizon masters. Perhaps Canada has already begun her Fontainebleau. Many think, that if this is the beginning she has chosen a worthy name.

Tom Thomson—to give him his name as he preferred it—was a natural painter. He was Canadian born, and without any direct academic training. He certainly knew nothing of Chinese classics but his life in the latter years was a demonstration of the quiet truth of our old author. Born on a farm, he lived the usual squirrel-hunting, apple-eating, cow-chasing, chore-drudging life of the farm boy. An illness in early manhood sent him to the woods, and probably fixed the passion he had for wild Canada. This passion remained with him through years in which he endeavoured to find a formal and conventional level for his life. Among many other things, he even did hard labour for a time in a Business College. Gradually he got into a steady connection with a living art by working at designing for the modern business of Photo-Engraving. He made fine Catalogue covers and pages, or quaint advertisements, and learned that good art may be developed outside of schools and academies by the full expression of an idea in easy conformity to business needs and technical processes. He worked with congenial friends who were cheerful rebels, and

39

made their life as much a joke as possible, but looked seriously to higher things. They sketched and painted in leisure time. They made canoe trips and pictures. They went hunting and brought back sketches instead of deer heads. They cropped up in the art shows and newspaper critics began to speak of them as 'The Algonquin Park School'.

Scribbling habitués of the theatres looked on their work as new vaudeville, and primly found fault with their painting of Nature. There were ribald criticisms and Donnybrook controversies, only kept in check by the law of libel and the timidity of unrebellious editors. Thomson took little part in these things, beyond supplying a goodly share of exasperating art for the critics.

In the latter years he spent most of his time in the woods. Unmarried, and having Thoreau's skill in wanting but little, he was practically independent of the mean recognition given by Canadians to the better efforts of their national artists. He could devote himself freely to the study of the nature that attracted him. He worked as a fire-ranger and guide in Algonquin, and became thoroughly intimate with that region. Leaving Toronto before the break-up in Spring, and not returning to his studio until after the setting-in of Winter, he practically stood waiting on his chosen ground for every inspirational opportunity. This concentration of purpose, and his natural genius and knowledge, and sympathy with his subject are shown in over 300 sketches and pictures left by him. They present the skies, woods, lakes and rapids of the Northland in intimate aspects rarely seen by the casual visitor. And they do this in a simple direct way, obviously inspired by the essential character of the subject. They are particularly remarkable for their strength and intensity of colour, fine colour being undoubtedly the great art heritage of Canadians in their country.

It is not the purpose of this article to discuss the life and work of Tom Thomson, or Canadian art in detail.

One is principally concerned here with the memorial erected to his memory at Canoe Lake. There he had mostly spent several years of the few he had been able to give definitely to art. He had a favourite camping place on the lake and usually made his first

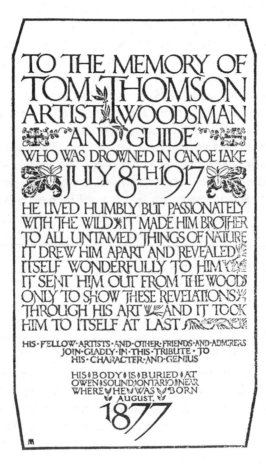

spring visit to the Northland at that point, sketching the melting snows and ice and the changing season's ups and downs from blizzards to cherry blossoms. It was, therefore fitting, that after his tragic death, a number of his fellow artists and friends should get together and decide to place a memorial to him there.

This was done, a brass inscription plate was designed and engraved and set on the south face of a simple truncated pyramidal cairn of boulders, strongly piled and cemented in a commanding position close to an old camp of the artist. There above the rocks that still show the paint-scrapings made by the artist in cleaning the palette after work the simple and fitting memorial stands facing southwards down the long reach of the lake.

There was that in the character of Tom Thomson, which inspired all who knew him with affection. This was shown strongly in the building of the cairn, which was a work of great difficulty on a site so elevated and remote. It would be both interesting and gratifying to be able to record the efforts of the builders in detail. One honours them all, but the generous planning and actual labour of the greater part of the work by Mr. J.W. Beatty, R.C.A., should certainly be mentioned. It was a fine thing, well done, worthy of the generous sincerity that should characterize an art fittingly named Canadian.

The inscription which was written and designed by another friend of Tom Thomson's is reproduced on the preceding page.

One hopes that the long waters of Algonquin Park will bring many a discerning reader to this cairn, and that its wording and purpose will aid him in the interpretation of the Spirit of the Land, which is the aim of travel. One hopes to find it a beacon for Canadian Art, guiding artist and patron alike into the breezy ways where the breath of the Four Seasons blows purely, inspiring both of them to action enlightening the world.

7.

"THE HOT MUSH SCHOOL,
or PETER AND I"

by H.F. Gadsby.

*It is a curious and sorry fact that hostility to the Group of Seven
actually predated the group's formation by a number of years. The
opening salvo against their ideas and inclinations was this highly
controversial article by H.F. Gadsby (1869-1951) in the Toronto*
Daily Star *of December 12, 1913. The absence of artists' names
etc. is due to the fact that publication of such information was
forbidden by the bylaws of the Arts and Letters Club where the
exhibit in question was held. His newspaper's official history,*
J.E. Atkinson of the Star *by Ross Harkness (Toronto: University
of Toronto Press, 1963), refers to Harry (Gad) Gadsby as "one of
the most witty and brilliant writers in Canadian journalism." But
of course the sometime parliamentary reporter and foreign corre-
spondent, though for 20 years beginning in the 1890s a figure to
be reckoned with, was wholly unqualified to write such an assess-
ment, one that is frequently mentioned in the literature but sel-
dom read. His obituary in the* Daily Star *(June 8, 1951) remarks
that he "collected art as a hobby."*

Peter and I belong to the Pierian Club. It includes the arts, the
higher crafts, the crafts that go with them, and everything else for
which one may hold the Nine Muses responsible. Mere Journalists
of the crass Philistine type, we have our troubles with the intellec-
tual movements which ever and anon agitate the members. These
movements are about as welcome to Peter and me as a cold in the
head, which, indeed, they greatly resemble. The painters, in par-
ticular, keep us guessing.

Whenever we see a fresh mass of color on the club walls, with
an accompanying diagram in black and white showing what each

splash costs, if it is not marked down before next Friday, we know that another Exhibition of paintings by a distinguished Centre Forward of the Hot Mush School is afoot and that we must have a care. Peter and I have got in wrong before now by pointing out what we didn't like and why.

In our own sphere of usefulness the Near-Novelists and Electric Seal Poets allow that Peter and I have a certain knack of tickling the mob, though it will never be Real Literature, at least not until we spin the Log Rollers' Section and hand out a little shop to the Other Strivers. However, this is a great honor, and Peter and I feel much flattered, because it was only after they had talked it over a long time that they decided to let Dickens and Shakespeare and Kipling and a few other immortals live on in spite of their obvious faults of style. Such being the case, Peter and I feel that we've simply got to behave or they will take it all back.

The Long Hair of Human Kindness

We get along fairly well too, with the pianists, even the temperamental south-paw fellows who never let their right hand know what their left hand is doing. They credit us with a most human intelligence and do not attempt to deny that we may be charmed by a Chopin waltz without knowing a thing about counterpoint, that we perhaps understand a Beethoven sonata, that we may be able to fathom the sour notes in Strauss's *Salome*, and that we tell the truth when we say we delight in Wagner.

About the only thing they hold out on us is Bach who, they fear, is too mathematical for our untrained minds. But generally speaking they make no dark secret of their art, neither they nor the players on violins, trombones, and other wind and stringed instruments. They do not ask a man to be an orchestra to understand music nor to be able to take high C to enjoy Rudolpho's narrative in *Bohème*. They are good fellows. They let Peter and me in out of the cold. They take our word for it and lift us up among the superfine souls who Appreciate.

44

But with the Painters it's different. By the Painters I mean the younger set, the Advanced Atomizers who spray a tube of paint at a canvas and call it *Sunshine On The Cowshed* or words to that effect. All their pictures look pretty much alike, the net result being more like a gurgle or a gob of porridge than a work of art. But of course Peter's opinion or mine goes for nothing because the younger set will not admit that we know enough to come in out of the wet. They hint that we are colour blind and wonder if having our eyes treated would help any.

There are older artists in the club who agree with Peter and me but the fact that we are constantly seen in the company of painters who can and do draw is considered damning, because the younger painting set does not believe in drawing any more than the Extreme Literary Wing believes in shorthand. The younger set believes in Explosions, Outbursts and Acute Congestions of Pigments, but in drawing. Never! Drawing is bad form. You can always draw when there's nothing else to do - that is to say, when the paint runs out.

The Mission of Big Bill

Big Bill, who paints real pictures himself, has caught the Hot Mush madness to the extent of trying to talk Peter over. He deals with him as he would with a little child. 'What is this picture, Peter?' he asks, pointing to a spasm in yellow and green.

'That,' says Peter, 'Is a Plesiosaurus In a Fit as depicted by an industrious but misguided Japanese who scorns foreground or middle distance.'

'And this one?' says Big Bill, indicating another in sullen reds.

'A Hob Nailed Liver,' says Peter quick as a flash, 'painted from memory by the Elevator Man at the General Hospital.'

'Let's analyze this picture, Peter.' Big Bill is patient with his naughty pupil. 'What do you see here?'

'It looks to me,' says Peter judicially, 'like a Dutch head having a quarrel with a chunk of French nougat, but I suppose it's

called *Moonlight in Jerusalem.* I see a hill, I know it's a hill because it makes a hump in the background. I see people. I know they are people because they have clothes on, but I can't tell whether they are men or women. I see trees. I know they're trees because they're green and fuzzy. I see houses and a road with a horse and cart.

'There you are!' says Big Bill triumphantly: 'You've got it, Peter. The artist tells it in as few words as you do. What more do you want?' 'I want a great deal more,' says Peter with rising anger. 'I want a great deal more before you can put it over me. Why doesn't this man give us a picture instead of colour notes? Would you call it a story if I gave you a stray job or two from my note book? Would you call it a tune if Michael Hambourg went over to the piano there, played a few detached chords, and let it go at that? If you want to know what I think,' and Peter thumped his chair, 'I think that this fellow doesn't sing, but he yells good and plenty. His work's a scream.'

'Oh, Peter,' says Big Bill, 'you don't understand. You lack knowledge, therefore you do not appreciate. You lack imagination, therefore you do not see. To grasp his meaning you must put yourself in the artist's place, see with his eyes, feel with his heart.'

'All right, Bill,' says Peter, 'but how do I do it? Do I hit the pipe or do I squirt the stuff in my arm?'

When Johnson Tries It On

No sooner is the fight drawn with Peter than Johnson approaches to convert me. Johnson has a head of solid ivory. That anybody should be able to steep Johnson in mysticism is a great surprise. I would as soon expect somebody to try to boil a cocoanut with the shell on though I will admit that the cocoanut has a soft spot at the top which might yield to external influences. I have always wondered how Johnson got into the Pierian Club because selling soap is the art he follows for a living. I think it must have

been because he was once a subscriber to the *Illustrated London News*. At any rate he is now a great critic.

'This stuff of Danner's,' says Johnson, evidently remembering somebody else's remarks, 'is to painting what Maeterlinck is to the stage. It is static drama.'

'What I think about that attitudiner Maeterlinck and his silly static drama isn't fit to print.' I say it with heat, because a lecture from Johnson is about the last straw. 'The only thing that happens in a Maeterlinck drama is a knock at the door in the first act, which knock people talk about and run away from for four acts longer and that's the play.'

'Well,' says Johnson, worsted in the argument, 'you're a pretty good knocker yourself, Gadsby. I guess there's no use trying to reach you.'

'Not a bit!' But that crack about knocking: pretty good, wasn't it? I didn't think Johnson had it in him.

Revenge Is Sweet

But Peter and I had our revenge. The other day two of the Younger Set brought an Art Patron to the Pierian Club, and after luncheon they introduced him suddenly to the Hot Mush masterpieces, the idea being to catch him off his guard and put one over on him before he could come up for breath. It was quite evident that he was a comparatively inexperienced Art Patron, and for a man of his money almost timid about expressing an opinion. The captive had a greasy, abject look: he didn't want to make a fool of himself before the company, and he knew as much about art as I do about the civil polity of the inhabitants of Mars. It will always be a pleasure for Peter and me to reflect that we gave him the right cue.

Two of the Hot Mushers had him in charge, each one holding an arm. They trotted him from one corner to the other, "giving him the angle." The angle didn't seem of any particular use to him.

'I guess I'm too far away,' he muttered.

'Take him up close,' said Peter. 'Take him up very close and rub his nose in it. He may be able to tell it that way.'

A gleam of hope shot across the Art Patron's face. An idea had occurred to him.

'See!' he said. 'See how its eyes follow me! Is it a devilfish?'

'No,' said Peter. 'It's supposed to be a barn with one window. But that doesn't make any difference. Even if you don't find the barn you can buy it if you want it. They'll sell it to you.'

'I don't seem to get it,' said the Art Patron, still in doubt.

'Well, for that matter,' said Peter, 'I wouldn't advise you to get it. It's worse than measles.'

'No,' said the Patron, peering at it through his fingers and shading his eyes, 'I can't get it.'

'Of course you can't get it,' I said. 'There's only one way you can get it and that's to have your pores open. No doubt you have come here with your pores shut, and are consequently impenetrable to the higher forms of art.. If you will go away now and return tomorrow, when your pores are not closed to the True and Beautiful—'

But just at this stage the Hot Mushers led him away, and the Art Patron heard no more from us. We have the satisfaction of knowing, however, that that's one Art Patron they didn't sting. He took courage from our words and didn't buy a solitary picture.

8.

"AND STILL THEY COME!"
&
"CANADA AND HER PAINT SLINGERS"

by Hector Charlesworth

The way in which the Group of Seven used the press and were used by it, in a prolonged cycle of abuse and defence, contributed as much to their renown as did prodigious exhibiting by the members. A Bibliography of the Group of Seven *by Dennis Reid (Ottawa: National Gallery of Canada, 1971) is an invaluable guide to the various charges and counter-charges. The most formidable antagonist was Hector Charlesworth (1872-1945), a sophisticated man-about-the-arts and no mere philistine like H.F. Gadsby. Charlesworth already had several other such derisive articles behind him when he published "And Still They Come!" in the December 30, 1922, number of* Saturday Night, *a publication he would edit from 1926 to 1932. His best remembered piece of this sort was "Canada and Her Paint Slingers", which ran in the November 8, 1924, issue. However, the careful reader senses that by this time an element of manipulative play had crept into the pronouncements by the two opposing forces.*

And Still They Come!
Aftermath of a Recent Article on
the National Gallery

Since I published my article on the Canadian National Gallery three weeks ago I have been castigated by spoken word and written phrase to an extent that if I were thin-skinned, I might cry with Henley: "My head is bloody but unbowed." It has been impressed on me emphatically that in writing of Canadian painters it is not only abominable to blame, but abominable to praise. Our musket-

49

eers of the brush will not even accord to a newspaper the right to take pleasure in the works of individual artists.

I was already aware of the danger of praise. A good many years ago I wrote for *Collier's Weekly* an article lauding the general quality of one of the early exhibitions of an organization, now defunct, the New Canadian Art Club. Among those whom I eulogized was a young painter whose personal acquaintance I did not at that time enjoy. A few weeks later I was introduced to him, and he at once assailed me as a menace to the cause of art. I humbly pleaded that I had spoken well of him. "That's just what I am driving at," he said, "What you said about me was all right. But you destroyed the value of it by praising the others." He was entirely sincere,—refreshingly so. This experience was illuminating; and I knew quite well when writing of the National Gallery, I would incur more disfavour by singling out individuals for favour than if I damned the whole band of painters from Alpha to Omega.

A letter to the daily press of Toronto, jointly signed by A.Y. Jackson of the "Group of Seven"; F.F. Gagen, Secretary of the Ontario Society of Artists; and P.H. Robson, of the Toronto Graphic Arts Club, a fairly comprehensive group of delegates for the artistic fraternity denies to me the right to express opinions at all. Since I have been constantly solicited for more than a quarter of a century to attend public and private exhibitions this comes as a sad blow; but I think it is meant to be taken in a Pickwickian sense. Rather more illogical is an editorial in an Ottawa newspaper which accuses me of slap-dash methods and intimates that because I have attained "an enviable position as a critic of music and the drama," it follows, as the night the day, that I do not know anything about pictures. The triply signed manifesto of the Toronto painters boldly proclaims to the world that my standards are those of thirty years ago and that any knowledge I possess is a secret between myself and "le bon Dieu." It describes me as a man who has only the leisure to look at pictures two or three times a year, knows nothing of the great developments of art in the last thirty years in Europe, and has not even time to find out what the artists are striving to do. If the average Canadian painter's interpretation

of Nature were as far from the truth as the three latter statements, then Canadian art would be in a parlous state indeed. As to the relations between "le bon Dieu" and myself, on the subject of Art, all I can say is that they have hitherto been very pleasant and I trust will remain so. Art is one of the rare things in this life that I thank Him for, and His standards date back even longer than thirty years.

<p style="text-align:center">* * *</p>

All this talk about the ignorance of newspaper critics is based on the assumption that the lay public has no right to opinions or intuitions on the subject of Art.

Theirs not to reason why,
Theirs but with awe to sigh,
Theirs to admire and buy.

Letter writers hurl the names of Monet, Cezanne, Whistler, Turner, Courbet and other great men at my head, and seem to assume a parity with them. The use of the name of Courbet as a man persecuted for his art is peculiarly ludicrous, since it was his art alone that saved his life, when he had incurred the penalty of death for atrocious acts of vandalism committed during the Paris Commune. And there have been other misapplications of the names of dead painters to the present controversy which lead me to doubt whether the knowledge of my assailants as to painters ancient and modern is greater than my own. Whistler is always trotted out as an object lesson in artistic controversies; and I fancy it would make that doughtly warrior turn in his grave if he could know that every painter who chances to meet with adverse criticism now imagines that he too is a Whistler.

Whistler was a man as proud of his reputation as a wit, as of his fame as a painter, and was always seeking targets for it. He was also so good an advertiser that he chose targets who would assure his marksmanship of public attention. I doubt if any man ever lived who took more solid an enjoyment out of a row. When at peace he felt himself neglected. What he would say about many

of the pictures in the Canadian National Gallery, I can well imagine; he, with his ever insistent sense of beauty; he, who abhorred hard definitions, and crude colour-masses. Best leave Whistler out of it, my friends.

I can imagine also what Whistler would have thought had he found himself one of a "Group" all painting in exactly the same style and attempting to see things in precisely the same way.

This is what is happening to the younger generation of Canadian landscape painters who call themselves "modernists." There is no analogy between such a system and the so-called "Impressionists" of the 'seventies and 'eighties. Their title, by the way, was an indefinite one of little meaning which they themselves were loath to accept. They fought for liberation from old and dead conventions, especially in the handling of light and shadow, but their strongest impulse was for complete personal expression, so that it would be impossible to confuse Manet with Renoir or Renoir with Manet, or Manet with Pissaro. Their work has lived because of its profound tonal analysis,—and not through the rejection of analysis. They would have been entirely with me in opposing the hardening of Canadian art into one official style. They were for the painter who plowed the lonely furrow.

* * *

After the above lamentable display of my "ignorance" let me tell an anecdote which illustrates how standards of ignorance may differ. This autumn a famous London picture dealer and connoisseur visited Toronto and had a conversation with some of our local modernists. The name of the great English artist, Frank Brangwyn came up. The Canadians emphatically informed him that Brangwyn had been "dead" for twenty years. In other words Brangwyn was a "mossback." The Englishman was rather appalled, and when he told me of the incident it was plain that he thought them ignorant. They are not,—they are good men gone wrong; and where he thought they were displaying ignorance, they thought they were demonstrating their enlightenment. I have even seen young painters get sniffy at the mention of Velasquez. I still main-

tain that he knew something about colour. The standards of thirty odd years ago when the revival of interest in Velasquez reached its climax, with the publication of R.A.L. Stevenson's great monograph, were not so bad.

There is nothing truer than the statement that art cannot stand still. It must move on if it is to survive. But it is equally true that change does not always mean progress. To cut ourselves off from the past is no more an aid to progress than to cut off one's legs is an aid to locomotion. To hold that artists like the Homer Watson of his prime, Carl Ahrens, Archibald Browne and Suzor Coté, who interpret with poetic truth the moods of the older and more pastoral sections of Canada are the less worthy and the less national in spirit because they do not camp out in the late autumn and paint the wilds in a harsh, strident mood is to talk nonsense and very misleading nonsense at that. I know the woods and wilds of Canada as well as most men, and there are many picture lovers like me. My intuitions have been bred in the bone through several generations and matured by long observation; and I am just as well equipped as any man to recognize a true interpretation. That is why I count Tom Thomson's *Northern River* one of Canada's finest national possessions.

Some while back I was talking to a visitor who had seen some characteristic examples of Canadian modernism, and he asked me where they were painted. In Northern Ontario and the Georgian Bay region, I informed him. "Must be a queer country!" he reflected. "Are the rocks all as flat and flabby as that? Don't the clouds ever float? Doesn't the water ever flow? Is there no air in the wilds?"

This is harsh criticism, unjust perhaps to the spirit of those who are striving for an original mode of expression. But the man who made it would merely have scoffed if he had been told that no one was competent to criticise this school of art, except its own creators. On the other hand such criticisms furnish no reason why the works of the modernists should be ostracized as the latter hold the works of others should be.

53

In the final showing all these shouts of "Ignoramus" and "Villifier" against myself and others who dare to look the new art in the face and ask why it should be heralded to the exclusion of other styles of pigmentary expression are merely promulgated to avoid answering my charge that in the National Gallery experimental painters are over-represented and established painters, equally sincere and of truer inspiration, inadequately represented or excluded altogether. It is also an evasion of the suggestion that the Board of Trustees should adopt a buying system that would bring about greater liberty of selection; and less restricted sympathies.

Canada and Her Paint Slingers

There has been a great deal of talk of late in England and elsewhere about "representative Canadian art", especially in connection with a group of Toronto painters who hold that Canada is only truly interpreted through a single narrow and rigid formula of ugliness. Many Canadians of taste and discrimination who went abroad to visit the British Empire Exhibition this past summer, have lately returned and expressions of disgust are to be heard on all sides at the unrepresentative character of what the London critics have been led to believe is "representative" Canadian art. There are some good pictures in the Wembley collection: but the cult of ugliness is so glaringly and insistently exemplified on the walls of the Canadian gallery that canvases of this order overshadow and "kill" pictures of a truly thoughtful and interpretative character.

As has been frequently pointed out in these columns the group, which is trying to force its wares on international attention, do no good to Canada, for they cannot apprehend or put on canvas the beauties even of the subjects they instinctively choose. Many will read with mingled feelings, the following extract from a review of the work of the Toronto blood and thunder school, published in the *Brooklyn Museum Quarterly* of recent issue.

The flavour of Canada to most of us is a mixture of the great Northwest, Quebec and French Canadians, Snow, skis, rapids, canoes and forests primeval. All these contour one's mental image of Canada. And logically, we expect to find some expression of this in her art, forgetful of the fact that stylization, standardization and modernism have done much to eradicate racial qualities in art, and that only painters of the most intense and vital personality can stand up against this leveling process.

The words, "stylization, standardization and modernism", are well chosen to describe the efforts of this school to reduce all Canadian landscape painting to one graceless and depressing formula; but the images they evoke are obviously not those which Canadians accept as true generalizations. The blood and thunder school not only reject the circumstance that Canada in many sections is one of the richest pastoral lands in the world, lovely in its contours as a beautiful woman glowing with exquisite and subtle gradations of tone. Not only do they reject beauty themselves, but they urge that all painters who feel its existence be cast aside and their pictures excluded so far as possible from public galleries as "insincere" and "unrepresentative" from the standpoint of nationality. And the worst of it is they seem to be succeding to some extent in spreading the belief that Canada is a land of ugliness and its art a reflection of a crude and tasteless native intelligence.

9.

"GROUP PORTRAIT"

by A. J. Casson

The last word on the Group of Seven by a participant is this memoir by A.J. Casson (born 1898) which appeared in the March 1986 Saturday Night. *Casson began his professional life as Franklin Carmichael's apprentice in a commercial art firm and was inducted into the Group in 1926. He is now retired from painting. In recent years, police departments have sometimes called upon him to help detect Group of Seven forgeries.*

I always wanted to be an artist. I don't know who I got it from; neither of my parents was artistic, yet even as a child of ten I was drawing. Guelph, where my family lived during the first years of the century, was a bit of a hick town. There was no art gallery, so I had little exposure to painting. Then my family moved to Hamilton, where I attended the Central Technical School. It wasn't that good a school but it gave me a little contact with art. Later, about 1915, my family moved to Toronto, where I was a private student of Harry Britton's. Harry was a terribly sensitive teacher and taught me to use watercolour, a medium I love.

As I entered my late teens I tried to find work as a commercial artist, but things were pretty rough during the First World War and there was almost nothing in that field. Then in 1919 I had a lucky break. I was given a job at Rous and Mann, in those days the cream of commercial art in Toronto.

My boss was Frank Carmichael, the chief designer. He was difficult to get to know—a short fellow with ginger hair, a square body, and long slender fingers. No-one, no matter who he was, could push Frank around. He was a tough little character, and as his assistant I was put through a grilling. I had to be as tough as he

was to take it, but I had enough sense to know he did it for my own good, and I am very grateful for what he did for me.

When Frank was young he had worked for his father, who owned a carriage works in Orillia. Frank was what they called a striper, painting yellow lines on the carriage wheels and fancy decoration on the door. You couldn't use a ruler for that type of work, so Frank had to paint the yellow stripes freehand. I remember the first time I was cutting mats in the studio. Frank saw me use a ruler, and grabbed it from me. "Learn to cut it without that thing!" That's just the way he was, a perfectionist in everything, and I'm glad. I still haven't lost the good habits he taught me. I'll be eighty-eight years old in May and to this day my hand is perfectly steady.

In those days, no holidays were paid for. In my second year at Rous and Mann, Frank came to me and said, "Look, I've arranged for you to go away for a month, and the firm will pay you for two weeks. But I want you to make a least two sketches a day." I didn't know very much about sketching, but I followed his orders; and when I came back I spread the sketches out in his studio. Frank looked them over and was very critical.

The following Friday afternoon he said, "Be at my house tomorrow morning." That was typical of Frank, he didn't ask if you could come, he just told you to be there. The next morning he took me to Holland Marsh, and I sketched as he sat beside me, making comments. He never criticized my actual sketching; it was more my approach that was wrong. He helped me with colour and choice of subject. He was never destructive; though he knocked a lot out of me, he gave me guidance.

A few years before I went to Rous and Mann I had seen a few of Frank Carmichael's paintings in an Ontario Society of Artists exhibition at the Central Reference Library. I saw paintings by A. Y. Jackson and Arthur Lismer. The overall effect was terrifically exciting. With the little knowledge of art I had, I wasn't satisfied with the work that was being done. There were many skilled painters then—Clarence Gagnon, James Wilson Morrice, and Marc-Aurèle de Foy Suzor-Coté for instance—but generally art was in a

57

style that didn't suit this country. Lawren Harris called it "the worn-out European tradition." I instinctively gravitated toward the freer, more colourful work I had seen that day in the library.

The artists who formed the Group of Seven used to sit at the artists' table at the Arts and Letters Club on Elm Street. The critics sat at what we called the "knockers' table." Some of the critics in those days were bitterly opposed to the Group of Seven, especially Hector Charlesworth of *Saturday Night*. There was also a feeling among the critics that the group was meeting every night scheming and thinking up new ways to upset them. It wasn't. There were very few meetings of any sort.

Frank Carmichael would take me over to the artists' table. You might find Barker Fairley there, a critic and great supporter of the group (later known as a painter), or academic artists such as Fred Brigden or George Reid. Frequently you'd find Fred Housser, a reporter for *The Toronto Star*, who wrote the first book about the group, *A Canadian Art Movement*, in 1926. And you might find some members of the group themselves. If you were lucky you'd find all seven.

I always thought the springboard for the group was J.E.H. MacDonald. Jim was outwardly very shy, the oldest, and kind of a father figure too. He was an extremely gentle person. There was only one time I heard him swear. Hector Charlesworth came into the club, just after he'd written a particularly vicious attack against us. Hector had a high-pitched voice. MacDonald heard him across the room, flushed, and said, "That damned rooster!" He had a strong will behind the shyness, and if Jim didn't want to do something, no-one on earth could make him do it.

Long before I became a member of the group, Jim asked me to complete a mural. He'd been commissioned to do it at the Canadian National Exhibition. Jim was never strong, and at that time he really wasn't well, so he asked me to finish the mural for him. I did it on the top floor of the Arts and Letters Club, and when it was done Jim came to take a look. Instead of criticizing it, he said, "Would you mind if I just did one or two things?" The changes to

the mural were slight, but they perked the thing right up. That was Jim MacDonald for you. He didn't want to offend me. I always thought he was one of the finest persons I have ever known.

In some ways he was deeply mystical. He often wrote poems, and he named his son after Henry David Thoreau. Whenever I visited Jim's studio, his son Thoreau would be sitting at his desk, and he'd nod at me shyly. I thought of him as a boy, probably because I was friends with his father, who was twenty-five years older than I was. I always told my wife about "young Thoreau," and a long time later she finally met him. She said to me, "You and your 'young Thoreau' he's only three years younger than you are!"

Jim's close friend was Lawren Harris. Lawren had the fire to communicate with people, so he took Jim MacDonald's ideas and pushed them. Lawren was a handsome man, with a head of white hair and a sharp, crisp manner. He was always impeccably dressed in grey flannel suit, white silk shirt, and black tie. His studio was completely grey, even the upholstery—and tidy! I've never known anyone as tidy as he was.

Lawren was independently wealthy, an heir to the Massey-Harris farm implements business. The rest of us were struggling, and he'd always be doing little things to help us, but he did them in a nice way, never making it awkward. If we were going on a sketching trip, we'd have a meeting at Lawren's house. Lawren would say, "I'll buy the food. One person might as well do it, and later on we'll divide the cost." He'd put off letting us pay him back, till in the end we never paid him for anything. He helped a lot of people in his quiet way.

He was also able to inspire people. He lived on Queen's Park in a Victorian mansion, and gave a lot of parties there. I remember saying to Frank Carmichael that after you'd been at a party at Lawren's you didn't feel like going home to bed, you felt like going home and painting. He had that ability to get you worked up.

Twice I met Emily Carr at those parties. Lawren was awfully encouraging to Emily. She reminded me of my old Irish grandmother, little and stout, with her hair in a bun. Her manner was

crusty. "Mr. Casson," she said, "I've seen your paintings of northern houses, and they look like little wooden boxes."

"Miss Carr," I said, "that's exactly what those houses are—little wooden boxes."

Jim MacDonald and A.Y. Jackson had get-togethers in the Studio Building, not far from Bloor and Yonge, where several of the artists worked. Alec Jackson was a wonderful man, but outwardly rather gruff and blunt. He was an enthusiastic storyteller. One incident in our later years illustrates this perfectly. I'd been given a birthday party by a friend. There must have been fifty or sixty guests. Charlie Comfort, former director of the National Gallery, got up and made a little speech. Then it was Alec's turn. Well, he talked and talked but didn't say a word about me. He talked about the Group of Seven and all sorts of things. After forty-five minutes of holding forth, something seemed to click in his head, and he turned to me suddenly and said, "Oh! Happy Birthday!" He'd gotten so wound up he'd forgotten why he was up there.

There were close friendships within the group—Lawren Harris and Jim MacDonald, Frank Carmichael and myself, for instance—but the Group of Seven was never as tightknit as people think. Some of the relationships were quite casual. That's how it was between me and Frank Johnston (who later changed his name to Franz). I didn't know him well, but he was certainly memorable and very talented—heavy-set, with a pointed beard. He bounced around like a rubber ball. I remember seeing him perform in an Arts and Letters Club revue. He was playing a sculptor, completely uninhibited, throwing props wildly around the stage.

Frank was the only member of the group to make money in those early days. He had a show at Eaton's that was reputed to have sold $10,000 worth of paintings—a staggering amount in the 1920s. He was also the only member of the group who dressed flamboyantly, "like an artist." He'd turn up at an opening night with a smoking jacket of winecoloured velvet, complete with a flowing artist's tie. That kind of outfit made Lawren wince, but it was Frank's business, so no one interfered. If you met other

members of the group, you'd never know they were painters. Lawren, for example, looked like a Bay Street stockbroker in his suits. If someone said to one of us, "You don't *look* like an artist," we'd reply, "What's an artist supposed to look like?"

Fred Varley has been called the gypsy of the group, and it was hard to pin him down. He was very moody—charming one day, nasty the next, and because he had such bohemian ways it was difficult to get to know him. Yet when I was with him I couldn't help but admire him. He was so sensitive to everything. I was walking down Yonge Street with him one winter night, and we happened to pass a furniture store. In the window was a Persian rug. Fred was entranced with it. He went into the store and told the salesgirl, "Deliver that to me tomorrow"—and he didn't give a thought as to how he would pay for it. It was a superb piece of craftsmanship and he wanted it. I remember another cold, blustery night, when Fred and I were again on Yonge Street. He stopped and pointed down a laneway, almost at a loss of words. "Look at that, isn't that...." The view was breathtaking, and if I'd been alone I probably would have passed it.

Sad to say, Fred became a little too much of a bohemian. Drink never afflicted the rest of the group, but Fred went steadily downhill. If Fred had stayed on the straight and narrow, he'd have left a greater bulk of very fine work. As it is he left behind many good things, but his legacy could have been much greater.

Arthur Lismer I knew least. He was an extremely witty man, and used to draw cartoons. He'd carry a little pad in his pocket, or draw on serviettes at the Arts and Letters club. He had a wise-cracking way of speaking; you couldn't always tell if he was serious or joking. Somehow I never felt close to him.

Friendships flourished on sketching trips. Those were marvellous times. Half the joy was in the sketching, and half in discovering landscapes. Whenever we found a clean, sparkling lake, we'd name it jokingly after a friendly critic. When we found a "dead" lake, dried-up and smelly, we'd name it after one of the unfriendly critics.

61

Carmichael took me on weekend outings to the Bradford, Holland Marsh, or Orillia areas. There were far fewer hotels in those days, and some of them were pretty shoddy. We'd take one look at them and pitch a tent. Of course, on the trips to Lake Superior you *had* to rough it, and Jackson, Carmichael, Harris and I had some hilarious times. Once we took a train to Lake Superior and wanted the train to stop at Port Coldwell. It was nothing but a little harbour with some fishing huts. Unfortunately there was a very heavy grade westbound, and if the train stopped it would never get started again. Lawren bribed the conductor to slow down to twenty-five miles an hour at Port Coldwell. We had fifteen pieces of baggage among us, and when the train slowed, I shoved them off. Then the four of us jumped off, landing on gravel. Lawren had arranged for a section man to come along the tracks with a hand-jigger. We loaded our luggage on it, he took it five miles up the track, and we walked behind it.

It was often freezing cold or raining. On one trip it snowed for two weeks straight. It was getting depressing, and suddenly Lawren said, "I forgot! My mother's sending some supplies up." "Look," I said, "I'm the youngest. I'll go get them." I walked five miles down the track to the station. When I got there the "supplies" were some bread, two big cabbages, and two baskets of grapes. I remember how disgusted Alec was, sitting in our tent in the cold that night, eating grapes.

On that trip we were stuck with some pretty awful tobacco. Lawren Harris was a bit of a faddist in some ways. He'd get behind a trend and then drop it. One of those trends was O'Niko tobacco. It had the nicotine taken out. Frank Carmichael rolled his own cigarettes, and smoked them through a cigarette holder. That night was bitterly cold. Frank's fingers were so cold they were almost transparent as he tried to roll that O'Niko. "This isn't tobacco," he said, "it's just old tea leaves."

It was pretty cold in the day as well. We'd be sketching in the wind with our hands bare. Most of us would sit on stools, wrapped up in our various ways. Frank was more resourceful. You couldn't buy a parka in those days, but he made himself

something similar—a coat with a peaked red hood. I have a picture of Frank sketching at Cranberry Lake, looking over the enormous lake, with that little red hat of his. We nicknamed him "Little Red Riding Hood."

Lawren Harris got out of his beautiful clothes and dressed like a tramp on those trips—and loved it. He worked with incredible concentration. If you spoke to him, he didn't answer. He was so focused on his sketching that he didn't hear.

I remember watching him sketch one day. It was a picture of an old farmhouse, and there was a hill that came over to one side. Lawren made the hill go behind the house, instead of just coming up to it, which improved the composition. Another time Lawren watched me working on a sketch that had some white poplars, scorched by fire, in the foreground. He said, "Why don't you knock a couple of those out so your eye can go through?" I had enough sense to listen to him—to all of them. We would sit around in the tent at night, and they'd ask me to bring my sketches out. They never tried outwardly to teach me, but the tips they gave were an enormous help, and little by little they coaxed me and my work along.

The Group exhibited together for the first time in 1920. I was a friend and associate, but not a member. The first break within the group was created in 1926 by the departure of Frank Johnston, who left after the first show to develop his own ideas. He began to paint in a more photographic style, and in my opinion drifted toward a more acceptable style. His work was competent; you couldn't fault it for colour, but somehow it lacked that certain something. However, he continued to be extremely successful, and exhibited at Eaton's until his death in 1949.

His departure reduced the group to six. One afternoon in 1926 my wife Margaret and I attended an afternoon tea given by Lawren Harris. Frank Carmichael and his wife gave us a ride. As we were leaving to go home, our wives walked a little ahead of us. Frank suddenly turned to me and asked, "How would you like to be a member of the group?" I was stunned. "That would be fine, Frank," I replied. "Well, you are one," he told me. "We decided

63

last night." That was all—no fuss. I was made a member and that was that.

In a way, I think I got more fun out of being a member than any of the others. I was never torn to pieces by the critics, because in the early years, when many people were opposed to our style, I was only an associate. In the meantime, I had the group to advise me. I remember once looking at a canvas of mine hanging between a canvas by Harris and one by MacDonald. Looking at my painting alone, I'd thought it was pretty good. But when I saw it between those two other canvases, I thought, "I've got to do a whole lot better!"

About three years after becoming a member, I slowly pulled away from the group. Their influence was too powerful. When I first met them, I had never even painted a canvas. The effect they had on me was profound, and I had to develop a style of my own. For instance, all the group, except Lawren Harris, went up to Georgian Bay to sketch. For a long time I felt that, if I went near the place, I would see it through their eyes. Alec Jackson used to try to persuade me to paint villages with him in Quebec, but I thought, "If I do, I'll just start turning out poor Jacksons." Instead, I began to dig out places of my own, such as the Madawaska valley and the river. I also loved to paint villages. I must have covered nearly every village in Ontario, and I'm glad, because they're pretty much gone now. They've all changed, fallen down, or been destroyed.

In 1932, the group officially disbanded. Jim MacDonald died that year. Lismer was going east; Varley was going west. But the major reason was that we had accomplished our purpose. When I first met the group, no-one was painting in that style, with such a concern for national identity. But after one or two Group of Seven shows, young artists began to paint in the same style; our perception of Canada had finally been accepted.

I'm the last living member of the Group of Seven. Frank Carmichael died in 1945. I'll always remember the last time I saw him. As a young man, Frank had taught himself to play flute and piano. Just before he passed away, he said, "I've given up the

flute and I've bought a bassoon." It was quite a picture—little Frank taking on that great big instrument.

Lawren Harris died in 1970. The last contact we had was in Vancouver. I telephoned and his housekeeper answered. She said Lawren wasn't well and had gone to Victoria for his health. I left my name, and four days later, just as my wife and I were leaving, he called. I'm glad I didn't see him. He was reduced to a quavering old man. He had been such a brisk and vital person, his physical decline would have been sad to see.

In his last years I got very close to Alec Jackson. He was a marvellous, vigorous person until his death in 1974. Once we were painting up at Madawaska. Alec had found a wonderful hill. The top of it was like a graveyard of huge boulders, great big fellows over ten feet high. As usual it was cold as the devil. I had finished my sketch and walked over to Alec. There he was with his little beret on the side of his head, his coat open, singing away at the top of his lungs. I asked him, "Aren't you cold, Alec?" He put his hand out—warm as toast! And Alec was well over eighty then.

Harris, Jackson, Lismer, and Johnston are buried in a graveyard in Kleinburg, Ontario. Recently I went to speak to some children in elementary school. A little boy put up his hand, "Are you going to be buried in Kleinburg, Mr. Casson?" His teacher was horrified, but I laughed. Children never beat around the bush. My answer was yes. I've never believed that a person should fuss and bother about death, but burial in Kleinburg would be fitting. I'll always treasure my days with the group. I never ceased to learn from their examples. The Group of Seven meant the world to me.

10.

"NUDES AND PRUDES"

by Bertram Brooker

That censorship has been an obstacle to the progress of Canadian art is a fact that becomes apparent at irregular intervals, as with the trial of the art dealer Dorothy Cameron in the 1960s or those of the artist Mark Prent in the 1970s, to take some notorious examples. Although published in the Depression, the following survey does not equate censorship imbroglios with the restrictive atmosphere of the 1930s. Rather, it reminds us that they were a component of cultural politics throughout the 1920s, when despite such dangers there was a freer climate for expression and an explosion in Canadian culture not surpassed until the 1960s.

Bertram Brooker (1888-1955), before gradually being paralyzed by a career in advertising, was one of the important pioneers of Canadian abstraction and worked in poetry, fiction, and music, as well as in the visual arts in a variety of media. His article first appeared in Open House, *edited by William Arthur Deacon and Wilfred Reeves (Ottawa: Graphic Publishers, 1931).*

I

There lives in Toronto an artist, a native of France and a frequenter of Paris, who has not been long in Canada. I met him one day in a downtown store. He had come looking for a picture of a horse. After a few minutes chat he was accosted by a clerk, who knew him, and he mentioned his quest. In musical broken English he said:

"I want a picture of a 'orse."

When asked what kind of a horse and for what purpose, he very pleasantly explained:

"Tonight I give lecture to Art Students' League. I want to show that animal is beautiful because every part made for function,

without ornament. In Paris I would show woman, but in Toronto I show a 'orse."

II

There is in Toronto an art gallery conducted by a number of gentlemen who presumably are trustees for the public in matters of art. Here are some items from the history of this gallery:

1. Two or three years ago the gallery invited to be hung on its walls an exhibition of paintings by members of the Société Anonyme, an association of artists living in 22 different countries, including our own Lawren Harris. Miss Dreier, organizer of the exhibition, was present when the show was hung. When she returned to the gallery in the evening for the private opening she found that two paintings had been removed from the walls. One was a nude by Archipenko, and the other a nude by Max Weber.

2. A reproduction of a nude by Giorgione (an old master) was more recently removed from the walls of the print room of the gallery, presumably upon the complaint of some interested party.

3. In the last exhibition of paintings by the Group of Seven there were two canvases by Edwin H. Holgate, the Montreal painter, each of which represented a nude female figure. They were the subject of complaint both in person and by correspondence for as long as a year after the show was taken down. At the annual meeting of the members of the gallery this spring a gentleman appeared for the sole purpose of protesting against the hanging of these nudes.

4. The jury appointed by the Ontario Society of Artists to judge its annual exhibition this spring had 800 pictures to consider. One of these was a canvas of two nudes against a landscape background. The picture was accepted, placed in the gallery for hanging and listed in the catalogue. Before the show could be actually hung a suggestion was made that this picture might offend the Board of Education, under whose auspices hundreds of school children attend the gallery each week. No complaint was laid against the picture, but rather than risk the possibility of complaint

67

the curator of the gallery and the president of the O.S.A. persuaded the jury to withdraw the canvas, as though it had not been accepted. When approached by the Toronto newspapers, who had heard of their action, these two gentlemen sought to avoid publicity by saying that the picture was crowded out for lack of room. Instead of avoiding publicity the conflicting stories of the jury and others concerned only succeeded in getting the incident on the front pages of newspapers, none of which took the trouble to make an issue of Toronto puritanism. Their concern was only with a sensational item of news.

III

A few weeks after the foregoing incident an exhibition of paintings and drawings by John Russell was hung in the art galleries of a Toronto department store. Mr. Russell, a Canadian artist who has lived for a good many years in Paris, had contributed to the Canadian National Exhibition, a couple of years earlier, a nude which had caused a furore in the Toronto press. The puritanical Toronto public flocked to see it.

Another nude (not the same one, as so many people seemed to think) was included by Mr. Russell in the paintings sent to this store. It was hung with two or three other canvases in a tiny room off one of the main galleries, behind a closed door which no one would think of opening unless attention was called to it. The newspapers, of course, quickly apprised the public of the existence of this closeted nude, and when asked by curious visitors the store management made signs in the direction of the closed and inconspicuous door. Not a word of criticism appeared in the Toronto press regarding this bootlegging of the nude.

IV

Related to this attitude of Toronto towards the nude in art is its very similar reaction to sex in literature. This phase of our puritanism was ably commented upon by William Arthur Deacon in his

survey of literature for the *Yearbook of the Arts in Canada, 1928-29*. Since the publication of that volume two more incidents have come to light which are highly symptomatic of the treatment these matters receive at the hands of certain Toronto newspapers. Knowing only too well, apparently, that a puritanical public delights in the discussion of those things which it considers illicit, these papers make a great show of frowning upon anything which smacks of pornography. This policy provides an excuse for reporters and critics to smell out the faintest aroma of irregularity, which they pursue with gusto. (It would be interesting, for example, to count the number of times the words "nudes" and "naked" were used in a column of comment written with evident relish by one Toronto art critic at the time that Mr. Russell's nude was piling up big attendances at the C. N. E. art gallery.)

These Toronto critics are not satisfied to nose out and spice the pages of their newspapers with every possible allusion to sex which they can squeeze out of a book. They must needs drag the personality of the artist into the muck, as well, imputing motives without evidence in order to have a full-course orgy of offensiveness with which to regale their readers.

This happened conspicuously in the case of Mr. Morley Callaghan, a writer who has been fated to receive so much less than justice from the critics of his own country that he may well regard his work as beyond their capacities to appreciate. In a review of his latest novel, *It's Never Over*, a Toronto critic charged Mr. Callaghan with the deliberate policy of using sex themes in his novels in order to increase his sales. It was stated in a way that made it perhaps not quite libellous.

The same critic recently interviewed a writer who had won a prize in a nation-wide novel contest. His first questions were thoroughly in character. Having had no chance to read the novel he began prying at once for sex interest, asking the author if he had "cut loose," and with other queries insinuating that his motive in writing the book might have been the second-hand enjoyment he would derive from describing the sex emotions and acts of his characters.

It is time that artists in Canada raised their voices publicly against this sort of thing. Mr. Deacon did so fearlessly a couple of years ago in regard to literature, and was promptly slapped on the wrist by the *Globe* for doing so. But the painters here have not faced the issue. They had an opportunity to do so this spring when the newspapers were eager to get facts and opinions about the removal of my picture, *Figures in Landscape*, from the O. S. A. show. Possibly some of them might have spoken for publication if so many lies and conflicting opinions had not beclouded the matter as a public issue. These lies, which made it appear that the picture was crowded out of the show because it was not good enough aesthetically to compete with other pictures, prevented me from making a public statement at the time. Had I done so I could easily have been accused of peevishness. I should also most certainly have been accused of trying to get publicity for myself, for I was accused of that in print at the time, although I had not uttered a word for publication. At this distance it is possible to submerge the specific case in the issue it involves.

VI

Nobody pretends, I imagine, that nude paintings or books which deal frankly with sex are dangerous to the morals of grown men and women. The concern of prudes, I take it, is entirely with the younger generation.

It may be further assumed that adults, whose concern with sex becomes more and more a question of cerebral excitement, induced by imaginings and suspicions, in proportion to their declining interest, physically, in the natural and normal sex act itself—it may be assumed, I suggest, that adults grow to fear the effect on young people of what happens in their own minds when they see a nude picture or read a lewd book. In any case, and whatever the reason, the questions of nudity and lewdity become "questions" only because of the young. Which means that prudery can be reduced to an attitude solely concerned with education.

Our educational system is probably wrong at almost every conceivable point, but the point at which it is most flagrantly wrong is where it touches on questions of art.

Boards of education, of course, do not think so. Education in art is in their eyes a trivial and unimportant subject. They think of art as a sort of recreation—something to be indulged in on Friday afternoons when children are fed up with a week's studies—a matter of no practical value, either as a contribution to the student's possible earning power in later years, or to his character as a future citizen. Not until art education is tightened into a commercial course in the technical schools, or concentrates on the making of craftsmen in art schools, is it taken seriously by boards and teachers. At once the emphasis is placed on technical proficiency—that is to say—on craft.

Yet, if art means anything at all besides mere craft—and if it does not there is no need for another word for it—it implies more than the ability to make things—pictures, sculptures or what not. It implies, surely, a development of the capacity to see.

Through ages of evolution our senses have learned to recognize certain signals, largely, in the case of humans, through the eyesight, whereby we escape danger and are attracted to what is good for us. These sense-signals are wholly practical and by themselves lead to no acquaintance with the conception of beauty. This is not the place to go into the basis of aesthetics, but it can be briefly stated that the concept of beauty arises only when an individual is detached from the purely personal urgencies of his own desires and fears. Beauty, in other words, is the product of a view of things which transcends the personal and glimpses the universal. It is a hint of the wholeness of life—a unity to which the individual, concerned only with purely practical problems or self-preservation, is wholly blind.

This larger vision is the essential difference between the artist and the non-artist. Nowadays, of course, after centuries of art, even the non-artist possesses a rudimentary idea of this detached

perception. The legacy of art through the ages has taught him a little how to see, so that now a sky is beautiful for him as well as a mere portent of the weather, and a woman is beautiful as well as being simply the object of animal desire.

The function of the craftsman is to make things. The function of the artist is to see things in new relationships, detached from his own puny affairs and desires, so that they take on the grandeur of symbols—symbols of movements, adjustments and laws that are universal, unattached to any particular time or place, and related only to the boundless and yet unified Being which is the central mystery of life.

The "art" of the craftsman and the "art" of the artist are thus quite distinct, and frequently have nothing to do with each other. Most artists, it is true, become craftsmen in projecting the expression of what they have seen. But most craftsmen do not become artists. They sometimes become good copyists of nature, without sensing any deeper beauty than attracts the eye of tourists.

Yet our educational system completely confuses the two, labels as "Art" the productions of both, and hides its head in the sand when any attempt is made to differentiate between them.

VIII

We are now a long way from nudes and prudes, but we must go still further before returning to the theme of our discussion.

A proper understanding of the real function of art is more necessary today than it has ever been. Now that the orthodox religions are losing their hold, especially on the imaginations of the younger generation, art is more significant than ever before as the only unifying experience that remains to us—the only experience that approximates to the religious in its ability to make us feel *at one* with the universe.

To many, of course, this "at-one-ness" with the universe is not important at all. Even those who complain the loudest about the chaotic condition of modern society do not seem to realize that rules and laws, by means of which they expect to terrorize the

masses into decency, are of little effect unless they have behind them something more than dressed-up authority. People will not dwell together in unity unless they can experience the unity. Our modern emphasis on the rights of the individual, in relation both to God and to man, has destroyed that unity which was once perceived, and which gave man a humble but happy place in nature.

The arrogance of the individual is the source of social chaos, and since religion in its orthodox and systematized forms has lost its power to curb that arrogance (has indeed contributed to it), the power of art is alone left in the world as a unifying influence. From it somehow will surely come the next religion, for the prophets of all religions have themselves been artists essentially, seeing new relationships between man and the universe, new aspects of the unity of Being which alone has power to touch men to finer issues.

Art, then, serving as the inspiration to all kinds of positive conduct (in contrast to the negative spur induced by rules and laws), and considered as a unifying force in modern life, can be seen as an important socially-practical measure, and one which even boards of education may regard, without loss of dignity, as possibly their chiefest care.

IX

Art education, as at present constituted, is simply a tinkering with the child's natural wonder. Any educational system can only succeed in distorting the unity into which a child confidently emerges. The best that any system can do is not to distort it too much. Hence it is of the utmost importance that education in general, and art education in particular, should not be undertaken lightly by Gradgrinds who put faith only in facts, or, on the other hand, by theorists who are likely to warp young minds into twisted, narrow or extreme habits of seeing and doing.

Decisions as to what is to be withheld from a child are fully as important, if not more important, than decisions as to what it should be told or shown. One needs not to have studied modern

73

psychology very deeply to realize that suppressions and inhibitions are dangerous, if not definitely pernicious.

Before either Freud or Dr. Watson was heard of, it was a matter of mere common sense to observe that the over-restrained child usually broke into extravagances later in life.

To withhold knowledge of the human form and its functions, and to discourage appreciation of its beauty at an early age, is to bring up a child with a sneaking curiosity in respect to that unity which of all unities is perhaps the most mysterious and the most important for men and women. It is to implant in his mind the feeling that natural admiration for bodily beauty is sheer animalism, and something to be ashamed of.

Appreciation of the beauties of the nude figure is not altogether due to the impulses of sex, and even if it were— from the standpoint of society which aims at continence and decency—surely it is better to shape such impulses openly into channels of delicacy and open-eyed admiration, than to let them smirkingly fester in secretive foulness of mind.

The tendency today is to tell children in a clean, straightforward, natural way about the functions of sex, so that they do not get their knowledge of it, half-guessed, from the filth they hear whispered in corners. And art is one method of acquainting children with the organs and functions of the body in an atmosphere of candour and beauty.

There is nothing filthy about the mystery of fatherhood and motherhood. He who says so blasphemes not merely against the special God he has been brought up to worship, but against any conceivable scheme of the unity of life that it is possible for men to hold. The vileness associated with sex is purely a man-made matter, and a product of the system of taboos surrounding an act of union which is probably the closest clue we have to the total unity of life.

The division we call sex, which is to be found in all organisms, and is perhaps the principle on which all forms of life are founded—in short, the principle of issuance—may very well be the primary division of Being, the first mysterious step taken by

the primal unity towards multiplicity. As such, it is as fundamental as hunger, and in surrendering ourselves to its age-old attraction we may be nearer to the essential life-unity than we are apart and separate.

That, however, is a speculation that has little bearing on normal conduct in society as at present constituted. It is merely a suggestion of the tremendous significance of sex, and of the possibility of discovering, if we approached it with open eyes, clean mouths and reverent minds, some deeper hint of that wholeness, guessed at and aspired to in the past as the ultimate secret, through knowledge of which we might all be one.

11.

"THE PAINTER AND HIS MODEL"

by Charles Comfort

This defence of modernism in painting by Charles Comfort (born 1900) was published originally in the anthology Open House, *which also contained an essay by E.J. Pratt ridiculing modernism in literature. That modernism should have required such advocates or recognized such detractors as late as 1931 is a loud statement not merely on the importance of social realism in the 1930s but, in a more profound sense, on the painfully slow development of an educated audience for Canada's best work. Comfort was of course a member of the Canadian Group of Painters, and in the early 1960s served as the director of the National Gallery (the only artist ever to hold the post).*

A well known United States journal recently printed the following bewildered criticism of a Picasso abstraction, entitled, *The Painter and his Model*: "In this work we can find no painter, no model, no design, no pattern, no tangibility, no movement, no modelling, no psychological expressiveness, no stimulation of any sense or any taste, and no consistent distortion of anything that might be linked up with something from one's experience in the world of fact and fancy—in short, no suggestion of anything on which one's weary mind can rest in an endeavour to discover what the artist intended to express. We feel that when an artist puts forth something as a work of art, the meaning of which is a profound secret between art and himself, he is taking a liberty with the layman that is to be discouraged."

After all, in the uncertain light of logic and common sense, this is a most plausible criticism. It represents the case of the vast majority of intelligent, practical artists and laymen who naturally distrust the authors of such canvases, and resent the implications

of apparent stupidity which they heap upon themselves when faced with such embarrassing unconventionality. One can actually feel the distress of this unfortunate critic in finding no painter and no model. And as we progress through the other alarming negations of this canvas we can readily see that from this man's point of view his conclusions are completely justified. Is there then, in face of these conclusions, any justification for Picasso's abstractions?

Aesthetes concur generally on the theory that art, like speech, is one means of intercourse between man and man. Tolstoi declares that art is essentially a language, but that, whereas by words a man transmits his thoughts to another, by means of art he transmits his feelings. Here an important difference of opinion creeps in. His critics contend that it is not a transmission of feeling but an expression of feeling that has worth and value. This distinction seems slight, but it is really an important point of departure in art theory. For the rational man the expressionist theory is unsubstantial, chaotic, obscure, and immoral. For the liberal thinker, the transmissionist who of necessity must use obvious symbols, usually realism, limits the means of art expression by the very inadequacy of imitative means.

The view that art is essentially imitation is closely associated with the name of Plato. He refers to poets and painters as imitators, and since mere skill in imitation does not imply any capacity to discern whether what is imitated is good or bad, the artist is regarded by him as an irresponsible and therefore dangerous sort of person in a community where everything is to promote the growth of the citizens in virtue. It would be unfair, however, to infer that Plato was as completely devoid of insight into the nature of art as this statement would appear to indicate. But the very fact that he sees the limitations and danger of purely imitative means is heartening to those who share this sentiment.

In Toronto recently there was extraordinary evidence of the wide popular interest in the purely imitative phase of painting when the amazing work of an eminent Russian court painter was exhibited in a local gallery. People came in legions to see these remarkable three-dimensional illusions of nature. So far-reaching

77

has been the influence of this exhibition as to have markedly affected the work of some of our Canadian painters, not so much I am afraid, from an aesthetic standpoint as for the ready market demand they created. The popular traction value of imitative painting has been completely exploited by, and possibly finds a legitimate use in advertising art and publicity, where the subtleties of specific appeal in pictorial values have been worked out and applied with devastating accuracy. In this field of art endeavour our critic would find "Sense and taste stimulation."

With the creative artist it becomes an imperious need to express felt emotions by direct external forms and signs. The capacity for selecting such forms and signs is a kind of immediate intuition developed and conditioned by experience. This experience may have had its beginnings in childhood, progressed through obsessions with imitative and decorative forms, through periods of mental change and direction into a personal vision. Throughout these stages a process of elimination is taking place. Forms and ideas are discarded as being obsolete or inadequate, others are retained and completed, multiplied, and rendered more precise, till, with a maturing vision these crystallize into personal symbols of highly specialized meaning in which the imitative character is attenuated or lost. Here emerges an expressive art in that it manifests the manner in which the artist apprehends a sensation or sentiment, and gives the measure of what he has felt and of his emotional power. It manifests in artistic form the peculiar interest that man has for man. In it the everyday conception of beauty is at times sacrificed, the vision being concerned with man, his virtues and vices, his accidental and permanent sentiments; there are occasions when it deals with the terrible, the sad, the ugly, the joyous etc.; the truth is not that the beautiful contains art, but that art contains the beautiful.

All this means very little to the rational man. It has no immediate intrinsic value for him. It does not collaborate his common sense idea of the nature and relationship of art and beauty. He is suspicious of forms or sounds that evade or defy the established standards of his better judgement. He doubts the honesty and

sincerity of these apparently juvenile performances. There are charlatans and fakers in the wake of this movement. Confused, distracted and annoyed, he condemns it all and seeks refuge in more obvious and practical value.

The irreconcilably hostile attitude of this mental type towards the creative artist is something that only a psychologist can explain, but it is in no greater danger of arresting the activity of creative effort than expressionism is of destroying the established canons of official art. The fact is that upon these attitudes and the vigour of these attitudes the whole vitality of art depends. The man who is interested enough to "know what he likes" is an important person to the artist. The adherence to and belief in art has its parallel in the denominational variance in religious dogma. This Picasso has an audience, a very large and intelligent audience, but he is not painting for their delight but rather for his own needs. He is expressing that self which is influenced by all past art and also by the vital present, but most of all by his own thoughts and particular culture.

It is not my intention to depreciate or ever underestimate the value of subject-matter or realism as legitimate material for art expression. There are ideas and feelings that can be expressed in no other way. Neither do I wish to champion Picasso particularly among artists. He is simply a convenient example of an approach to expressionism, and the above-quoted comment on his canvas, an interesting and instructive example of rational criticism. I only wish to point out that, contrary to our critic's statement, there is no question of the creative artist taking liberties with the layman. His motives are much more genuine and worthy than that of provoking the indignation of those who do not understand him. I ask no quarter or sympathy for either faction. The only way we have of taking our bearings is to encourage the outspoken candour of those who are interested enough to speak their minds.

12.

"SOMETHING PLUS IN A WORK OF ART"

by Emily Carr

Despite the fact that she published half a dozen volumes of memoirs and reflections, Emily Carr (1871-1945) was less prone to discuss her art than are any number of other painters lacking her gift for words. In this context the two public addresses she is known to have given assume some importance. "Fresh Seeing" (1930), the more often cited of the pair, is likewise the more journalistic. "Something Plus in a Work of Art" (1935) comes closer to discussing her own relationship to the sources of her work. Both speeches were delivered before local audiences in Victoria and were published together in Fresh Seeing: Two Addresses by Emily Carr, *edited by Doris Shadbolt (Toronto: Clarke Irwin, 1972).*

Real Art is real Art. There is no ancient and modern. The difference between the two is not in art itself, but lies in environment, in our point of view, and in the angle from which we see life.

The greatness of an artist's work is measured by the depth and intensity of his feelings and emotions towards it, and towards life, and how much of these he has been able to implant and express in that work.

Perhaps one reason for the great and lasting power of the work of the old masters may have been partly their mode of living. In those days a man did not fritter away so much of his time and strength in running to and fro. His attention too was not rushed from one interest and excitement to another as it is in these days. His life was governed by a few strong simple motives. When he attacked anything like art he did so from the depths of his being, from vast reservoirs of stored vitality and ideas based on funda-

mentals so deeply rooted that they grow and blossom in those canvases still in spite of the time that has passed since their making.

Much of what we call "Modern Art" is, even yet, more "experiment" than "experience." Between the old idea of painting and the new idea of painting, there came a blank stretch, during which much of the meaning and desire for deep earnest expression lay dormant. Something crept in that had not been in the old art, but floated on the surface with a skin-deep sentimental mawkishness. There were still grand and earnest workers scattered among the artists, but into the real idea of art crept the idea of money rather than the idea of expressing. Gradually the standard of pictures was lowered. Men painted from a different motive, to get money, to please patrons rather than to express their art. They told stories in paint. They preached sermons in paint. They flattered people in paint. They reminded them by their pictures of places and things that they had once seen, and people went delightedly tripping back through their memories, not in the least stirred by the art in the pictures, but pleased with their recollections of what they had seen with their own eyes.

This was all very well for those that it satisfied, but it was not art, and there were others who craved the real thing, who wanted to go deeper, whose souls revolted within them at the sham, and wanted something inspiring to push forward into. They wanted the power behind the thing—the weight of the mountain, not the pile of dirt with grass spiking the top.

There was a revolt against all this meaningless softness and emptiness of expression, this superficial representation, and the consequence was the "Modern Movement" in art, which was a brave fierce rebellion. It was experimentation—a burning of bridges by these brave ones—a going back to the beginning, with the belief that the fundamentals which the ancients had used were still available to art, if they rooted up all the clogging sentimentality, and dug right down to the base of things, as the simple, earnest workers had done years before. It was necessary for these pioneers of the Modern Movement to try all kinds of ways and means to get what they were after. They worked with one eye turned

81

way back towards the simplicity and intensity of the primitives, and the other rolled forward towards the expressing of the tumult and stress of modern life. People laughed at them, called them crazy, and refused to acknowledge the sincerity of them or their work. But they stuck, intent on putting the something back into art that had been lost. So they experimented, tried this means and that, gradually weeding out what did not count, and building onto what did. Even the things that were discarded made their contribution. When they were abandoned it was to give place to something better, but the fact of their being abandoned showed growth, healthy growth that is still going on. You have only to go into a room full of pictures painted in the last fifty years by people who have not as yet come under the influence of "Modern Art" to realize what that growth has been. Of course the movement has its empty shouters, the usual rag, tag and bobtail who follow every demonstration because of the noise and excitement, picking up minor and unnecessary details and passing over the essentials, shouting "Modern Art" meaninglessly, and trying to get, without working and wrestling for it, what the man who has thought long and toiled earnestly has got. But the best of the Modern Movement goes serenely on collecting a very mighty following—it continues to come slowly and surely into its own.

Now there are as many ways of seeing things as there are pairs of eyes in the world, and it is a mistake to expect all people to see all things in the same way. Also it is a mistake for anyone to try to copy another's mode of seeing, instead of using his own eyes and finding his own way of looking at things. The more you look, the more is unfolded for your seeing, till bye and bye the fussy little unimportant things disappear, and the bigger meanings like power, weight, movement, et cetera will make themselves felt. To express these, it is necessary, as it is in everything else, that the artist should have some knowledge of the mechanics of painting, know how he can produce what he wishes to express. He must know what to look for. He must know what constitutes a picture. Also he must realize what there is in any special subject to produce in him the desire to express it.

A picture is the presentation of a thought that has come to us, either from something we have seen or something that we have imagined. We want to convey the meaning of what has passed through our mind as a result of coming in contact with that special subject. Our first objective must be, however, to pull it forth into visibility, so that we can see with our own eyes what our minds have grasped. If our minds have not recorded anything definite, we have nothing to give.

If we study our subject carefully, we will discover that there was some particular reason why we selected that subject; we either saw or felt something that appealed to us, that spoke more definitely to us than the rest of our surroundings did. It may have been colour, or line, or movement, or light, or texture. It may have been the combination of all these things. At any rate, all these elements must take their places in our composition, though none of them will be our subject. That will be both hidden in, and disclosed by, these elements. Everything should contribute definitely to it but nothing should overshadow it. The ideal that our picture is built to should transcend all the rest.

Before starting your picture, you first must have a desire, and you must have material; but above all these things, you must form your ideal and build it up. Sometimes the ideal forms itself complete, in a flash, but sometimes you must hunt and hunt, as it were, for a loose end to begin at, then follow it through all its snarls and windings till it comes out the other end of your picture, binding ideas together as it proceeds, until your ideal stands complete before you. The biggest and perhaps the hardest thing in painting is to be true to your ideals.

Suppose six different artists sat before the same subject. Provided they wore blinkers, or did not peep at each other's canvases, but built each according to his own ideal of the subject, carrying it to its fulfillment, it is safe to say that no two of the pictures would be alike—providing, that is,that each had been honest with himself and his ideal.

Undoubtedly it is very helpful to see the work of others, to note what mechanics they have used, what their approach has

been, how they expressed themselves, but the real worker must not be too biased by what another artist does. He must strike out and speak for himself, it his work is to be of any real value to himself or to others.

There are artists who force some strangeness that they do not feel into their work, to make it startling and original, violently different from that of others, but this work is not lasting, because it has no foundation in anything true, and its motive is not sincere.

The painter passes through different stages in his work, where the separate elements in the making of a picture seem to him all-important. These elements troop before him, obtruding themselves and crying, "I am the all-important thing that goes to the making of your picture." We get excited over each phase as it comes along. Form, colour, composition, balance, light and shade, rhythm and many more—these all are important, all have worth, but we must remember that they are only parts; not one of them is strong enough to carry the whole burden, to form the base whereon to build the ideal of our picture. All these things are superstructure; they must not overpower the main issue, but contribute to it.

One of the strongest characteristics of the Modern Movement is the use of design. It is so powerful an element we are almost tempted to think, "Ha! Now we have got to the root of the matter. This design will blend all our elements together. Design will make our picture complete, so that the eye can travel all around the canvas, be satisfied, and come to rest." Very good, that is so, but is that all we want? Are we content to rest in smug satisfaction? To please the eye alone? A thousand times No. We want exhilaration. We want incentive to push further on, we want to make thoughts and longings that will set us wondering, that will make us desirous to explore higher and deeper and wider, to see more, to understand more. Design we admit to be an extremely valuable asset to art, but we cannot stop there, stagnating with satisfied eyes; we must go on, because our souls cry out for more.

In preparing notes for this talk I discovered something that I was unaware of. I should not be giving the talk at all because I am only a worker, and workers should work and talkers should talk,

and both had best stick to their own jobs and avoid getting mixed up. However, perhaps it is good for us to exchange sometimes, so that each may find the difficulties the other is up against. In this case, by making the effort, I discovered that material that was useable for a talk I gave some years ago was not useable for what I wanted to say today. The facts are the same, but I see them from a different angle. Things that seemed to me of vital importance then seem of secondary importance now. Nor can I find the things I want to say in the art books. They do not seem to be in them, but out in the woods and down deep in myself. Emerson says something to the effect: If I say a thing today, it is no reason that I will not say something different tomorrow. If we did not change we would not grow.

I did, however, come across a chapter in a little book called *How to See Modern Pictures*.[1] The chapter was entitled "The Something Plus in a Work of Art," and it seemed to coincide with what I was trying to get at. The author said something like this:

Having considered rather carefully that quality in pictures which is probably the most vital contribution of the Modern Movement in the world of art today—the quality of organization into design—we must now turn to the "something plus," something beyond the literal content of the picture, something that distinguishes the great work of art.

Further on, he stated that this most elusive of all elements in a picture, this "something plus," is born of the artist's attempt to express the force underlying all things. It has to do with life itself: the push of the sap in the spring, heave of muscles, quality of love, quality of protection, and so on.

And again, quoting from another book, he said that one of the most important principles in the art of Japanese painting is called *Sei Do*. It means the transfusion into the work of the *felt nature* of the things to be painted by the artist. Whatever the subject to be translated, whether river, mountain, bird, flower, fish or animal, the artist at the moment of painting it must *feel* its very nature which, by the magic of his art, he transfers into his work to remain

85

forever, affecting all who see it with the same sensations he experienced when executing it. It is by expressing the *felt nature* of the thing, then, that the artist becomes the mouthpiece of the universe of which he is part and reveals it unto man through the "something plus" in the picture, the nature as well as the appearance of the life and forms about him. The old masters of Europe, the Chinese and Japanese, the Greeks, the Byzantines, the Assyrians, the African negroes, the Indians of America, and many others through history, embodied this *felt nature* of the thing in their works of art, and it is when, as in these cases, this divine fire is tempered and controlled by design, that deathless work is born—work that takes its place as part of the universal language of man.

To bring this idea close to home, let us consider for a moment the grand early work of our West Coast British Columbia Indians. Their work has been acclaimed worthy to take its place among the outstanding art of the world. Their sensitiveness to design was magnificent; the originality and power of their art forceful, grand, and built on a solid foundation, being taken from the very core of life itself.

These Indians were a people with an unwritten language. They could neither borrow nor lend ideas through written words. To find means to express, they were obliged to rely on their own five senses, and with these, to draw from nature direct. They saw, heard, smelled, felt, tasted her. Their knowledge of her was by direct contact, not from theory. Their art sprang straight from these sources, first hand. They looked upon animals (through which they mostly expressed their art) as their own kindred. Certain of the animals were more than that: they were their totems and were regarded by them with superstitious reverence and awe. Not being able to write their names, they represented themselves by picturing the particular animal which they claimed for a crest. Every time he pictured this crest the Indian identified himself closer with the creature. To many of the animals they attributed supernatural powers. People who were of the same crest or totem were bound to each other by closer ties than blood, and did not intermarry. A man did not kill or eat the animal of his totem, but did all he could to propit-

iate it. He also believed himself possessed of the special attribute of his totem. If he were an eagle he boasted of strength and fierceness. Ravens were wily, wolves cunning, and so forth. The Indians carved their totems on great cedar poles and stood them in front of their dwelling houses; they painted them on the house fronts and on their canoes. In travelling from one village to another, people were assured of a welcome from those of their own totem. Thus the Indian identified himself so completely with his totem that, when he came to picture it, his felt knowledge of it was complete, and burst from him with intense vigour. He represented what it was in itself and what it stood for to him. He knew its characteristics, its powers and its habits, its bones and structure.

Added to this stored-up knowledge waiting to be expressed was the Indian's love of boasting. Each Chief who raised a pole thrilled with pride, and wanted to prove that he was the greatest chief of his tribe. The actual carver might be a very humble man, but as soon as he tackled the job he was humble no longer. He was not working for personal glory, for money, or for recognition, he was working for the honour and glory of his tribe and for the aggrandizement of his Chief. His heart and soul were in his work; he desired not only to uphold the greatness of his people but to propitiate the totem creature. The biggest things he was capable of feeling he brought to his work and the thing he created came to life—acquired the "something plus".

Once I asked an Indian why the old people disliked so intensely being sketched or photographed, and he replied, "Our old people believe that the spirit of the person becomes enchained in the picture. When they died it would still be held there and could not go free." Perhaps they too were striving to capture the spirit of the totem and hold it there and keep these supernatural beings within close call.

I think, therefore, that we can take it that the Indian's art waxed great in the art of the world because it was produced with intensity. He believed in what he was expressing and he believed in himself. He did not make a surface representation. He did not feel it necessary to join its parts together in consecutive order. He

took the liberty of fitting teeth, claws, fins, ribs, vertebrae, into any corner of his design where they were needed to complete it. He cared nothing for proportion of parts, but he was most particular to give to every creature its own particular significance. The eyes he always exaggerated because the supernatural beings could see everywhere, and see more than we could. A beaver he showed with great front teeth, and cross-hatched tail. Each creature had its own particular things strongly brought out. The Indian's art was full of meaning, his small sensitive hands handled his simple tools with a careful dexterity. He never hurried.

Why cannot Indians of today create the art that their ancestors did? Some of them carve well, but the objective and desire has gone out of their work. The "something plus" is there no longer. The younger generations do not believe in the power of the totem—when they carve it is for money. The greatness of their art has died with their belief in these things. It was inevitable. Great art must have more than fine workmanship behind it.

It is unlikely that any one thing could ever again mean to these people what their art meant to their old, simple, early days. Reading, writing, civilization, modern ways, have broken the concentration on the one great thing that was dammed up inside them, ready at the smallest provocation to burst into expression through their glorious art.

1 *How to See Modern Pictures* by Ralph M. Pearson, 1925.

13.

"CANADIAN AND COLONIAL PAINTING"

by Northrop Frye

Almost since the start of his career in the 1930s, Northrop Frye (born 1912) has maintained a secondary role as a public critic of Canadian culture while fulfilling his primary duties as the author of books such as Fearful Symmetry *and* Anatomy of Criticism, *which have made him one of the most influential of academic critics. In seeking to relate the development of Canadian culture to what he considers essential characteristics of the larger society, he has returned frequently to the painter David Milne and to certain Canadian poets. "Canadian and Colonial Painting" was published originally in* The Canadian Forum *in 1940 and reprinted in* The Bush Garden: Essays on the Canadian Imagination *(Toronto: Anansi, 1971). It is apparently his first attempt to view Canadian painting's emergence from "the garrison mentality," to use his later phrase.*

The countries men live in feed their minds as much as their bodies: the bodily food they provide is absorbed in farms and cities: the mental, in religion and arts. In all communities this process of material and imaginative digestion goes on. Thus a large tract of vacant land may well affect the people living near it as too much cake does a small boy: an unknown but quite possibly horrible Something stares at them in the dark: hide under the bedclothes as long as they will, sooner or later they must stare back. Explorers, tormented by a sense of the unreality of the unseen, are first: pioneers and traders follow. But the land is still not imaginatively absorbed, and moves on to haunt the artist. This is a very real incubus. It glares through the sirens, gorgons, centaurs, griffins, cyclops, pygmies and chimeras of the poems which followed the Greek

colonies: there the historical defeat which left a world of mystery outside the Greek clearing increased the imaginative triumph. In our own day the exploration and settlement has been far more thorough and the artistic achievement proportionately less: the latter is typified in the novels of Conrad which are so often concerned with finding a dreary commonplace at the centre of the unknown. All of which is an elaborate prologue to the fact that I propose to compare Tom Thomson with Horatio Walker, as suggested by a recent showing of them at the Art Gallery of Toronto; still, when in Canadian history the sphinx of the unknown land takes its riddle from Frazer and Mackenzie to Tom Thomson, no one can say that there has been an anti-climax.

Griffins and gorgons have no place in Thomson certainly, but the incubus is there, in the twisted stumps and sprawling rocks, the strident colouring, the scarecrow evergreens. In several pictures one has the feeling of something not quite emerging which is all the more sinister for its concealment. The metamorphic stratum is too old: the mind cannot contemplate the azoic without turning it into the monstrous. But that is of minor importance. What is essential in Thomson is the imaginative instability, the emotional unrest and dissatisfaction one feels about a country which has not been lived in: the tension between the mind and a surrounding not integrated with it. This is the key to both his colour and his design. His underlying "colour harmony" is not a concord but a minor ninth. Sumachs and red maples are conceived, quite correctly, as a *surcharge* of colour: flaming reds and yellows are squeezed straight out of the tube on to an already brilliant background: in softer light ambers and pinks and blue-greens carry on a subdued cats' chorus. This in itself is mere fidelity to the subject, but is not all. Thomson has a marked preference for the transitional over the full season: he likes the delicate pink and green tints on the birches in early spring and the irresolute sifting of the first snow through the spruces; and his autumnal studies are sometimes a Shelleyan hectic decay in high winds and spinning leaves, sometimes a Keatsian opulence and glut. His sense of design, which, of course, is derived from the trail and the canoe, is the exact opposite of the

90

academic "establishing of foreground." He is primarily a painter of linear distance. Snowed-over paths wind endlessly through trees, rivers reach nearly to the horizon before they bend and disappear, rocks sink inch by inch under water, and the longest stretch of mountains dips somewhere and reveals the sky beyond. What is furthest in distance is often nearest in intensity. Or else we peer through a curtain of trees to a pool and an opposite shore. Even when there is no vista a long tree-trunk will lean away from us and the whole picture will be shattered by a straining and pointing diagonal.

This focusing on the farthest distance makes the foreground, of course, a shadowy blur: a foreground tree—even the tree in *West Wind*—may be only a green blob to be looked past, not at. Foreground leaves and flowers, even when carefully painted, are usually thought of as obstructing the vision and the eye comes back to them with a start. Thomson looks on a flat area with a naive Rousseauish stare (see the "decorative panels"). In fact, of all important Canadian painters, only David Milne seems to have a consistent foreground focus, and even he is fond of the obstructive blur.

When the Canadian sphinx brought her riddle of unvisualized land to Thomson it did not occur to him to hide under the bed-clothes, though she did not promise him money, fame, happiness or even self-confidence, and when she was through with him she scattered his bones in the wilderness. Horatio Walker, one of those wise and prudent men from whom the greater knowledges are concealed, felt differently. It was safety and bedclothes for him. He looked round wildly for some spot in Canada that had been thoroughly lived in, that had no ugly riddles and plenty of picturesque cliches. He found it in the Ile d'Orléans. That was a Fortunate Isle with rainbows and full moons instead of stumps and rocks: it had been cosily inhabited for centuries, and suggested relaxed easy-going narratives rather than inhuman landscapes. Pictures here were ready-made. There was Honest Toil with the plough and the quaint Patient Oxen; there were pastoral epigrams of sheep-shearing and farmers trying to gather in hay before the

storm broke; there was the note of Tender Humour supplied by small pigs and heraldic turkeys; there was the Simple Piety which bowed in Childlike Reverence before a roadside *calvaire*. Why, it was as good as Europe, and had novelty besides. And for all Canadians and Americans under the bedclothes who wanted, not new problems of form and outlines, but the predigested picturesque, who preferred dreamy association-responses to detached efforts of organized vision, and who found in a queasy and maudlin nostalgia the deepest appeal of art, Horatio Walker was just the thing. He sold and sold and sold.

14.

"FROM SPRING FEVER TO FANTASY"
&
"FEELING IN PAINTING"

by David Milne

David Milne (1882-1953) wrote fluently about his own painting, and often seemed to assume the stance of a helpful third party or translator, facilitating the understanding of both artist and viewer. More so together than singly, these brief essays show the two strains running through much of his work, the formalism and the emotional or romantic impulse. They also show to what extent Milne, like so many other Canadian painters who came of age artistically in the 1920s, was influenced by the New England transcendentalism of an earlier time. "From Spring Fever to Fantasy" appeared in the April-May 1945 issue of Canadian Art *and "Feeling in Painting" in the May 1948 number of* Here and Now, *a key literary magazine of the postwar period, edited by Paul Arthur, who later edited* Canadian Art.

From Spring Fever to Fantasy

When the first flowers bloom in the bush, I bring some home, put them in water on the table, and look at them. Then I think they would be nice to paint and set about arranging them or, just as often, take them as they happen to be, and set to work. This time there was no arranging. In a cup, near at hand, just before my eyes as I sat looking at them—not clearly seen, out of focus—were some hepatica blossoms, buds and leaves. Beside the cup, but farther away, were hepaticas and dog's tooth violets in a low bowl. Behind these a larger bowl, without flowers. Accepting this as the plan of the picture, I set to work. It didn't take very long and I got quite a "kick" out of the picture.

Why? It was extremely simple and depended largely on arrangement. It could have been done—almost—from a recipe. Get a small boy to throw a handful of white clay on the lower left hand corner, following it with a handful of grey in the same place. He should be able to trace in this with one finger some vague shapes derived from hepatica leaves and flowers and a cup. Then he could do the upper half of the canvas by rubbing his muddy hands lightly over it, leaving only about one-eighth of the picture, in the lower right, to be done. For this you might have someone else who could set down, not too painstakingly, some flower and bowl shapes, and dab on a little pink, yellow and lavender somewhere near where they should go—but not exactly.

That would do it—and leave you confronted with the old mystery that has puzzled most painters many times. Why has the apparently careless and easy picture life and thrill, when the carefully wrought and painfully conscientious canvas may be dull and heavy? Why has the quick, direct sketch power, when the large picture made from it may fall flat?

The answer probably lies in the painter's feeling for his subject, for the colour, shape, texture and arrangement that he sees in it. If this initial impulse—this quickening, bringing to life—is strong, it will carry him through and reveal itself in his picture. Everything he has is concentrated on the rectangle before him. Eager, impatient, driven, he wanders into no side paths, but goes straight for the thing he feels and sees. This intense feeling may not be sustained through the greater complexities and longer time required for the larger picture. Doubts and distractions may creep in. The driving power of feeling may degenerate into duty. And duty, so important in everyday life, is not a painting quality. It isn't good enough. The thing that makes a picture is the thing that makes dynamite—compression.

I suppose each painter has his own ways of launching into the adventures in shape, colour, texture and space that we call painting. I mostly fall into them. A few years ago I was in Toronto for a week without much to do and without the material for picture painting, so I spent some time at the Public Library. There I found

two interesting books. One was about snow crystals, with many photographs; the other dealt with playing cards, the earliest ones, with plates in strong colour and bold free line. I read most of both books and made small pencil drawings of snowflakes and playing card kings and queens and knaves. All right so far, no harm done, no trouble started.

But pencil drawings lying around usually mean attempts at pictures sooner or later. So the snow crystal shapes were the starting point of a picture, *Snow in Bethlehem*. It came easily, logically. Snow crystals are seldom seen in relation to landscape, or in relation to anything except a piece of dark cloth or the pages of a book, so a realistic snow picture was out. But the progression from crystals to winter to Christmas to Bethlehem was easy. I didn't know much about the Bethlehem of today or of New Testament times and made no attempt to find out. I had embarked on a fantasy, where any resemblance to the things of the world around us was little more than coincidental. Houses there would be, and hills, and maybe churches. A newspaper picture of a church in Tallinn gave the idea for the large central structure. Buildings with domes and minarets, summing up my ideas of Eastern architecture, provided a few more churches or houses. I don't know how the little church with the spire got in, perhaps a vague gesture toward the West. The evergreen tree with the fence around it started as a Turkish cemetery, but got simplified until there was nothing left but the tree and the fence. The dark trees? Naturally, Christmas trees. There I had the material for the picture. The colour and arrangement was another matter, and I don't remember now what it developed from or how. Undoubtedly in some way from previous pictures of my own, that had nothing to do with crystals or domes or with Bethlehem. The title, usually the last thing to be thought of, was almost the starting point of this picture.

The numerous drawings of playing card figures from the other book also led to some pictures. They suggested portraits, so I put them in a gallery, framed portraits of kings and queens on the walls and a knave with battle-axe standing guard by a doorway.

That left me with some kings and queens and a lot more knaves on my hands. These found their way into another picture gallery in another picture. This time there were playing card figures posing for a portrait group below framed portraits of their relatives on the wall. That couldn't possibly be considered very realistic, so I pushed the thing all the way over into fantasy by inserting two figures in present-day clothes, call them jokers. I now had a row of figures from one side of the paper to the other, with framed pictures above them. My composition seemed a bit too simple and static, a slow progression from figure to figure and from framed portrait to framed portrait. So I gave the picture a focus by adding a prominent central doorway and bound everything together with an arc of angels at the top. Four angels—two conventional (as I know angel conventions) and two not so conventional, in night-shirts, one with a derby hat. That one has no tradition behind him at all. Call these jokers, too. Colour and line was no problem: the pictures in the book that I started with left no escape from full colour and bold line. The title was *King, Queen and Jokers*. I think I have made it sound too simple, and left no way of explaining why it was under way for three years with numerous changes and repaintings. Anyway the length of time spent on a picture doesn't seem to have much to do with its complexity or quality, or with anything else, so far as I can discover.

Feeling in Painting

Feeling is the power that drives art. There doesn't seem to be a more understandable word for it, though there are others that give something of the idea: aesthetic emotion, quickening, bringing to life. Or call it love; not love of man or woman or home or country or any material thing, but love without an object—intransitive love.

Usually, though not always, the painter's subject stirs some feeling in him before he starts work, some warmth, some exciting interest to get him going. As the work progresses, feeling increases. He is quickened by his own activities.

Each painter develops feeling in his own way, follows his own path. Suppose you are a painter setting out for a day's painting, embarking on an adventure in feeling. The start is slow, your mind is occupied with your own day-to-day affairs and there is room in it for nothing else. Through the fence and along the garden into the neighbour's field, numbed by routine, with little interest in your surroundings. You are scarcely conscious of the frosty air or the crispness of the frozen grass beneath your feet. A squirrel scolds and a blue jay screams, but you pay no attention to these familiar voices. A garter snake basks on the sunny side of a rock. You glance at it idly. On across the pasture, through the scattered maples. As you come to the top of a low hill, the morning train whistles down the valley. You stop, set down your paint box and easel for a minute and watch it pull into the station. A long plume of vapour lies behind it on the still air. You look at it and think, as you have thought before, that this would be a good painting place and subject. But nothing comes of it. Up with your load and on your way. Beside a mill pond you halt again. On the opposite bank are maples in scarlet and yellow, orange poplars tipped with vermilion and the deep purple and green of ash. The trees and their reflections in the still water stir some excitement in you. You try to decide whether the reflections are perfect. Almost! But there is some invisible movement of air that disturbs the water surface and softens the reflected shapes. A slight breeze springs up and they

become less definite, vertical lines are emphasized, horizontals reduced. Nothing is left but wavering bars of colour. Another slight rise in the wind and all are lost. This is not the place; the mirror is too much troubled. The banks of this pond are too low to give protection from the wind. On again!

There is more of purpose now, of search. As you make your way from field to field, you are conscious of trees and ground contours and the changing sky. The escape is almost accomplished, you have a feeling of ease and well-being. Your thoughts, now, are pretty much occupied with things that have to do with painting, particularly with these reflections. You have been giving them some attention recently; you know what to do about them, or at least what to try. You know that to-day's subject will bring a new experience to modify—slightly—your painting methods of yesterday.

At last you come to another pond with another patch of bush mirrored on its still surface. High grassy banks surround it on three sides. Only a strong wind will disturb these reflections: this is the place. You unpack and set up easel and paper stretched on a board. There is no hurry, you hold back rather than press on; quiet, leisurely, observant, with no interest beyond what is in front of you. You decide how much to include and what to omit, how it will do pushed up or down, to right or left. The plan of the picture takes vague shape. You explore some points in your mind, noticing the smallest details you intend to deal with; try to solve some difficulty in arrangement, work out an awkwardness in a major line. Then you take pencil or charcoal and make a few marks on the paper, 'placing' what is to go on it. When you know where things are going, you mark in some way every detail that is to be used. The drawing is not so much a guide to be followed closely in painting as a shorthand reminder, made at leisure, to be used later when work is speeded up and there isn't time to travel back and forth from scene to paper. Anyway, what you put on paper isn't so important as what goes on in your mind. By the time you are through scratching on the paper, most of the picture's problems are solved: problems of shape, texture, colour, arrangement. You will know even how you are going to apply the paint.

Now you get a tin of water from the pool, fix it on the easel and set to work with colour. You work easily, rapidly, without halt or hesitation. The pool and its banks and the bush are gone: everything is on that rectangle of paper. The brush wanders over it, sometimes broadly, sometimes with great application to detail; your attention passes from the part you engaged in at the moment back to what has already been done and forward to what is still only faintly indicated in pencil. On some rare days the painter can do no wrong, things click into place without conscious effort, difficulties melt away, the picture seems to move under its own power. You are carried along by aesthetic feeling.

Not all days are like that, not many; more often feeling fails to develop to an intensity that will carry you through. You may have rushed into your painting too quickly, trying to use duty as a driving force, instead of feeling. Or somewhere along the line of preparation there may have been a failure to solve a preliminary problem or to relate it to the picture as a whole. Anything within the picture—or outside it—that has not a direct bearing on it as a whole, anything that distracts the painter's attention, that slows or divides his progress, that robs him of his singlemindedness, means a weakening of his feeling and his power.

When a check does come, there is a pause to consider the difficulty, a desperate effort to overcome it. If the effort is not successful—and quickly—feeling fails and power is lost like escaping steam; for feeling is not like intelligence, steady-going, even. It never stays at the same intensity. If it isn't increasing, it is decreasing—and sometimes with unbelievable rapidity. When it comes to putting on paint, the artist seems to need a minor miracle: he must be brought to life, quickened, to such an extent that he can work beyond his normal possibilities. That was the purpose of the walk and all the preparations up to the hour or so of actual painting.

15.

"CANADIAN ARMY ART EXHIBITION" & "I LOVE THE ARMY"

During the First World War, the Dominion government, following the lead of Britain, assigned a number of painters, including A.Y. Jackson and Wyndham Lewis, to act as official Canadian war artists. A similar but more ambitious programme was carried out during the Second World War, involving Charles Comfort, Lawren Harris, Jack Shadbolt, Edwin Holgate, Carl Schaefer, and Goodridge Roberts, among others. They were unlike the officer/artists of the Woolwich tradition in that their task was interpretative rather than documentary: there was only one artist per division, a ratio of approximately 1:15,000. This review of their first comprehensive war-art exhibition appeared in the April-May 1944 issue of Canadian Art, *of which Walter Abell (1897-1957) was then editor. Exactly one year later, the magazine published the despatch by Lieut. Molly Lamb (born 1922), who would later marry a fellow war artist, Bruno Bobak.*

Canadian Army Art Exhibition

by Walter Abell

The Canadian Army Art Exhibition, which opened at the National Gallery on March 21 and which will later tour the country, is a stimulating event. From the point of view of the relation between art and society, it constitutes a milestone. Perhaps for the first time in the history of Canada, an official government agency, in this case the Army, has invited a cross-section of the Canadian

people—the enlisted personnel—to draw and paint its reactions to a phase of contemporary life, to enter its work in a national competition, and to exhibit the results at the National Gallery. Such advances toward a national people's culture are among the most heartening by-products of a world at war in the cause of democracy.

Judging by the attendance, the artist may learn one thought-provoking lesson from the exhibition, namely that the public, so often indifferent to art for art's sake, is definitely interested in art which reflects its own activities. On the night of the official opening, the National Gallery was crowded to capacity with representatives of the services, the government, and the general public. The band of the Royal Canadian Ordnance Corps provided music; the Hon. J. L. Ralston, Minister of Defence, and His Excellency, the Governor General, both gave addresses, and the Princess Alice graced the occasion by her presence. Attendance subsequent to the opening has been high. The Army and the society behind it have come to art, at least in part, because art first went to the Army. If similar connections can be built with the social agencies of peace, both official and unofficial, art will never lack communal support.

On the purely artistic plane, the exhibition offers two surprises. It is unexpectedly high in its general level of attainment and unexpectedly modern in its predominant point of view. In this connection one must recall that the pictures exhibited were made by rank and file members of the Army, as a leisure-hour pursuit after military duties. The work of the Army's official war artists, who were selected from professional ranks to give their entire time to painting, is not included in the present exhibition. Yet taken as a whole, the exhibition compares well in quality with the average annual shows of most of the regular Canadian art societies. In addition, many of the entries reveal touches of humour, spontaneity, *insouciance*, which are a relief from the tension of our times and which make art seem a wholesomely casual part of daily living.

The dominance of a relatively modern point of view suggests that the country, or at least the younger art-minded section of the

101

country, is more contemporary in its outlook than we had realized. To be sure the exhibition includes some work of a traditional nature. There is in fact something to please everybody, whether the observer likes his art conventional or experimental, delicate or vigorous, sweet or with a touch of satire. But the preponderance is distinctly "modern" and the judges—A. Y. Jackson, Arthur Lismer, Henri Masson and H. O. McCurry—favoured this modern trend in making their awards. As a result, the more advanced outlook in Canadian art is certain to receive encouragement from the present exhibition.

The prize winners and one of the honourable mentions are reproduced among our illustrations and need not be enumerated here. Five additional honourable mentions were awarded as follows: to Sapper Harry Aslin, R.C.E., for his water colour, *Bridging*; to Gunner Samuel Goodman, R.C.A., for his ink drawing, *The Shoot*; to Private Molly Lamb, C.W.A.C., for her pencil drawing, *Dinner Parade*; to Private Ernest A. Harris, C.M.S.C., for his ink drawing, *Mess Hall*, and to Bombardier Donald Sexton, R.C.A., for his oil painting, *Sessions at the Legion*.

Special credit for the success of the exhibition should go to Sergeant Charles Redfern, attached to the Directorate of Auxiliary Services (Army), who was immediately responsible for organizing the project. Sergeant Redfern is himself a young artist of promise. In organizing the Army show, he of course received nation-wide co-operation, including the advice and facilities of the National Gallery, the help of District Auxiliary Services Officers, and the assistance of preliminary judging committees chosen from the ranks of professional artists within each military district. The exhibition could hardly have been what it is, however, had not the whole undertaking been co-ordinated by a director thoroughly at home in the field of art.

These positive aspects of the Army exhibition need not obscure the fact that there are still problems to be considered in connection with future projects of this kind; problems not so much of intrinsic art quality as of cultural background. In the first place, any exhibition which is predominantly modern is bound to raise

102

difficulties of appreciation. The link between art and the Army brings crowds to the present exhibition, but it does not necessarily enable them to enjoy and appreciate all that they see when they get there. To most people, modern art, whether it relates to the Army or to anything else, is bewildering. The average soldier and the average layman are both surprised to find the awards going to work of a type which, in some cases, they do not understand, while the more traditional and easily comprehensible pictures pass unrecognized by the judges. A good many visitors are thrown back upon the rather comfortless ground of being forced to admit that apparently they "know nothing about art." If art is to solidify its wartime public relations and build them into a permanent sustaining foundation, it must not only produce work of merit, but must find some way of helping the public to understand what it produces. There is here an important, unsolved, educational problem.

Existing cultural conditions being what they are, it is possible that there should be several series of awards in connection with exhibitions like the present one. A jury of artists might continue to select what it considers the best work from the purely artistic standpoint. A jury of military men might make a second series of awards for what *it* considers the best interpretations of military life. A third series, awarded by popular vote, might be given to those pictures which make the greatest appeal to the general public. On such a basis everybody should be happy, since everybody's point of view would receive recognition. The expression and mutual consideration of different points of view is always healthy in a democracy.

A second problem centres around the matter of creative participation. The high standard of the Army exhibition is a result of its having been judged by professional artists according to professional standards. The negative aspect of this otherwise commendable situation is that only those artists whose work approaches professional standards have been accepted for showing. This gives a real opportunity for enlisted personnel who, in peace time, are either artists or serious art students, but it largely eliminates the

work of the soldier who turns to art merely as a hobby. In other words it discourages, or at any rate does not *en*courage the general use of art as a creative recreation. This use of art is an important one. We suggest that it deserves some form of recognition. Possibly future exhibitions might include several sections, ranging from amateur to professional grade. Or perhaps different exhibitions could be held at different times, some to show work of high intrinsic merit, others to stimulate the recreational and moral-building aspects of creative hobbies.

I Love the Army

by Molly Lamb

When I graduated from the Vancouver School of Art two and a half years ago, I joined the Canadian Women's Army Corps and from the very first day I kept a kind of "war diary"— drawings from memory of army life and personal adventures. Along with this rough account, I have had time also to work on a few serious canvases and drawings.

In the winter of 1942, my company was stationed at the Basic Training Centre in Vermilion, Alberta, and every Tuesday we were marched on to the parade square for respirator drill. We wore our respirators at the alert position and because the weather was generally around fifty degrees below zero, we were always thankful to hear the siren scream so that we could push our faces into the piggish looking rubber masks. Most of us made it in the required nine seconds but some poor "Quack" always dropped her mitts and hat and pulled all the parts of the respirator out of the holder in confusion. The corporal in charge would have no patience with her and after the nine seconds she would bawl her command. None of us could hear her muffled voice so we'd all carry out what we thought she meant. Some would forward march, some would right and left wheel, some would stand at ease, some would just wheeze nervously. And every respirator drill day I noticed the pattern of our black boots on the white snow and the unnatural poses of everyone

everyone doing something different...It was really an exciting thing for a painter. So later on, I made a canvas about it.

I was sent to Toronto last April and I lived at Trinity Barracks which is a Depot Company Barracks and therefore full of comings and goings and activity of all kinds. I loved the place and I had time to make several drawings of it.

One day I went to the kitchen and the kind cooks allowed me to do several drawings. And I drew the mess hall also because the combination of relaxed figures and precise tables and chairs was a good subject—and on the walls, by the way, hung the silk screen prints of A. Y. Jackson, Mrs. Haworth and Charles Comfort.

There is endless material in one barracks alone though, one could spend hours at the desk in the main hall, drawing the C.W.A.C.s checking in and out, the new recruits, the fatigue girls in their overalls, the orderly officer....

But almost more stimulating than barracks was the Canadian Army Show where I designed costumes and scenery for the unit shows. One night last autumn, before Number Seven Unit went overseas, we took the Show to Christie Street Hospital. The dressing room there was very small and the girls were forced into a group which I sketched as fast as I could and painted while the colour was still fresh in my mind.

And sometimes on Saturday afternoons during Victory Loan drives, we marched in the parades. Somehow I always managed to get out of the marching, but I went to the parades anyway to see my friends, trying to decide which band to keep in step with. Nevertheless, a parade is always a stirring sight and the C.W.A.C. a stirring part of it. I made a few notes from one of the last Victory Loan marches and painted a canvas in November from them.

The whole structure of army life is agreeable to a painter. All the nuisances of living are done away with because you don't have to cook, you don't have to worry about being poor or sick or being without warm clothes. And everywhere you turn there is something terrific to paint. I love the Army and I'll keep on putting down what I see until the war is over and the C.W.A.C.'s are disbanded.

16.

"CANADIAN NATURE AND ITS PAINTERS"

by Wyndham Lewis

The great English painter, novelist and violent polemicist Wyndham Lewis (1882-1957), an important yet solitary figure in the development of modern art, was technically a Canadian, born aboard ship in the Bay of Fundy. He spent most of the Second World War in bitter exile in Toronto and Windsor, and during that period wrote an essay, "Nature's Place in Canadian Culture," apparently never published, about which he informed a correspondent, "...the main object of my article was to do a personal service to [A.Y.] Jackson." (See The Letters of Wyndham Lewis, *edited by W.K. Rose [Norfolk, Connecticut: New Directions, 1963.]) The following revised version appeared in* The Listener *of August 26, 1946, ostensibly as a book review. It is notable for its misinformation and wrongheadedness: valuable proof of how isolated Canadian art was at the time from intelligent world opinion, and vice versa.*

The Canadian consciousness must always, to a peculiar degree, be implicated with nature, seeing that Canada is first and foremost an agricultural and raw material nation, and, still more important, is everywhere on the frontiers of the wilderness.

The development of the cultural life of Canada will necessarily be conditioned—or so it seems to me—by these facts, however much present-day anti-regionalism there may seek to ignore them. On the other hand its situation on the North American continent also deeply involves it in the Machine Age. The neighbourhood of Chicago and of Detroit is a formidable fact. The culture of this northernmost of the nations of the western hemisphere might develop, consequently, a dual personality. The pull of nature,

however, will probably exceed that of the attraction exercised by the blast-furnace and power-house. Further, the Anglo-Saxon genius has always displayed great affinity with primitive nature. The French Canadian would, after his Latin fashion, continue no doubt to take more interest in man than in primitive nature. The latter is really, in practice if not in theory, and in spite of Rousseau and his school, almost an English monopoly.

An Ossianic pantheism pervades the literature and the life of the Briton: a passionate inclination for the virginity of nature and for the most unruly moods of the elements. Evidences of this can be traced as much in the fondness of Shakespeare for thunder and lightning, as in the appetite of a twentieth-century boy scout for getting lost on quite mild little mountains and practising woodcraft in the home-spinney.

These are the things however that have spelled Empire: that 'violent trading' of the English, as a Frenchman has called it, which eventuated in the North American continent speaking the English tongue: resulted in Hudson Bay, Ellesmere Land, Prince Patrick Island, and other cosy little spots, bearing Anglo-Saxon names, rather than Spanish, French, German, Italian, or Dutch. Such reflections are appropriate in approaching the question of what kind of culture may be produced by the population settled in such close neighbourhood to so overpowering and topheavy a mass of primitiveness as is to be found in Canada, north of the narrow settled belt—from the Bush up to the muskeg and beyond to the icepack.

The question in fact is whether all this unassimilable mass of 'nature' will in the end be left severely alone (just as we seldom turn our eyes up towards interstellar space, and have long ago lost interest in the moon, except for crooning purpose): or whether this proximity of the wilds will continue to influence the descendants of the contemporary Canadian. Surely the latter. That I think is the answer; just as certainly as a people who inhabit a sea coast are conditioned by the neighbouring ocean and its rude habits—the works of their bards being full of splashing and tossing, of ship-wreck and of ships inopportunely becalmed.

107

Now it seems to me that for a person with these tastes, and with these traditions, Canada, artistically, offers extraordinary opportunities, and that these have on the whole been surprisingly neglected. One would have expected for instance Canada to have produced one outstanding poet, inspired by the scene and by the history that is there as native as the folk-song 'Alouette'. This has not occurred.

But pictorially, in a sense, it has. And the Phaidon Press publication, *Canadian Painters*, in its massed photographs, gives one an excellent idea of this flowering—though the effect is perhaps cartographical rather than horticultural. This painting is, in fact, the blazing of a trail and a rough charting—a sometimes crude advertisement of a rich aesthetic vein—rather than a finished achievement of authentic beauty.

In 1920 a movement announced itself in Upper Canada (that is English Canada) under the name of 'The Group of Seven'. This Phaidon volume really celebrates the work of that group. A further volume is announced dealing with work reflecting contemporary European and American influences: for Canada on the whole, it could be said, is busy decanadianizing itself, and firmly shutting the door upon the doctrinal 'regionalism' represented by the seven pioneers of post-war No.1.

The key man in this Canadian regionalist school is Alec Jackson, because without him it is doubtful if it would ever have existed. Tom Thomson, generally regarded as the star-member of the school, died, in mysterious circumstances, up in one of his Northland lakes, in 1917. He was a commercial designer—as all of them were at one time or another, except Harris. In 1913-14 Thomson, then a week-end artist of no particular distinction, became acquainted with Jackson, not long returned from Paris, and a spark was struck. They shared a studio, and by the end of 1914 this contact had transformed Thomson into a remarkable colourist, equipped to get on to his canvas some of the cold vivacious beauty of the spring woods in the Algonquin country. For the rest, his ten years of commercial designing at Grip Limited supplied the formal accessories and the organizing habit.

It would be idle to pretend that the oils, large and very small (mostly the latter), produced by Thomson during a mere three years—1914 to 1917—which is all that is of interest, would set the Thames or the Seine on fire, because they would not. Most gallantly this little group (for the rigours of the social climate were so formidable that only the toughest could survive) pioneered: when the hostility of the press and public held them up, they retreated into commercial design, but always to emerge again as— for the time and place—militant and iconoclastic. Their work was rude: they chopped out their paintings as if they had been chopping wood. They adopted, often, the brutal methods of the bill-board artist to put their country across big and harsh and plain: with all its emptiness and savagery—its trees that crawl along the surface of the frozen earth because they cannot stand erect in the Arctic wind, its shack-hamlets submerged in snow, its Northern Lights, and all the other things you do not meet with anywhere else. Sometimes they painted a beautiful or an original picture. Most of the time they were blazing the way for others: opening up the Canadian scene—for I am sure Jackson did not expect his school to end with the 'Seven'.

The members of this group are dispersed, have 'gone west', have disappeared or died. Only Jackson is left. He had much to do with starting it all: now he stands there alone in Toronto before his easel, in the Studio-building in the Ravine, painting doggedly, the 'grand old man' of Canadian painting.

Canada will always be so infinitely bigger physically than the small nation that lives in it, even if its population is doubled, that this monstrous, empty habitat must continue to dominate it psychologically, and so culturally, as I started by saying. The Northland, as they call it, the 'forty miles of white water', the 'beaver ponds', the virgin beauty of Mississauga, these are what cause us to give Thomson a hearing for his crude song. It is not generally realized how at a relatively short distance north of the cities strung out across Canada in a wavering line the 'bush', the wilderness, begins, with its multitudes of lakes and streams. But Jackson went much farther afield even than Thomson: to Great Bear Lake and to

109

the Polar Sea, and brought back grisly records of what he had seen.

With Alex Jackson I will bring this article to a close, for he interests me the most. He is himself like a bit of nature—and I have explained how it is the nature we see in them, however imperfectly, that gives them their real significance—and the rock is always more important than the man. And with Jackson let me associate Gagnon, as the French and English are conjoined in their native Quebec.

French Canada had in Clarence Gagnon, who died in 1942, a sort of national painter. These two artists are very different, though superficially their canvases have a kind of family look. Both come from the province of Quebec; in the pictures of both there is a lot of snow. There the similarity ends. Whereas Gagnon painted very attractively (mostly in his studio in Paris) an exotic world of brightly-clad peasant-puppets, in their snow-bound hamlet, Jackson paints the same little Quebec hamlet for preference deserted, battened down, all but submerged in the white pest of the Canadian winter. Gagnon's is an innocuous snow, almost as if it were a stylistic device of nature (a very good-natured nature!). But Jackson's is like a white lava to smother and blot out. It is not even white! Often it is a depressing spectral grey, or acidly greenish: not at all like the sparkling blue-and-white of the icing merchants (among whom it would be unfair to count Gagnon).

The village is not where Jackson is most at home. He has painted some excellent villages: but where there are few signs of man is where he really likes to be. Where there is just Jackson and Nature. 'Nature' for Jackson does not mean what it did for Turner, a colossal and sumptuous pipe-dream akin to the Kubla Khan of Coleridge, nor what it was to Van Gogh, a barbaric tapestry, at the heart of which was man and his suffering—his human rhythms branching out, the tormented nervous system of nature responding to man's emotions. In Jackson's case it is nature-the-enemy as known to the explorer.

Yes, it is an affair of Jackson-against-nature and vice-versa. Jackson being what is called a 'fighter' likes this situation. His

110

painting seasons are as it were *campaigning seasons*, rather than the breathless rendezvous of a 'nature-lover' with the object of his cult. It is impossible to associate the notion of pleasure with these grim excursions, or at least nothing sensuous. If anything there is too little that is sensuous; he handles nature roughly. Few have tried to paint the snow. These snowscapes of his fill one with the fascinating ennui of a chapter of the log of a polar-explorer: one of those grand monotonous books where one wonders how many more hundreds of pages must be traversed or trudged through (on seal-meat and pemmican) before one reaches that extraordinary over-rated abstraction the Pole.

There is gaiety sometimes in Jackson, but it is rationed. His vision is as austere as his subject-matter, which is precisely the hard puritanic land in which he always has lived: with no frills, with all its dismal solitary grandeur and bleak beauty, its bad side deliberately selected rather than its chilly relentings. This is a matter of temperament: Jackson is no man to go gathering nuts in May. He has no with to be seduced every Spring when the sap rises—neither he nor nature are often shown in these compromising moods. There is something of Ahab in him; the long white contours of the Laurentian Mountains in mid-winter are his elusive leviathan.

17.

"GLOBAL REFUSAL"
&
"GLOBAL REFUSAL:
TEN YEARS AFTER"

by Paul-Emile Borduas

Refus global *is far and away the most important document in the history of Canadian art and a signal event in the history of Quebec, and so naturally it has tended to dominate the reputation of its author. Borduas (1905-1960) had been apprenticed to the symbolist Ozias Leduc and studied in Paris before joining the faculty of the Ecole du Meuble in Montreal. Through a combination of psychoanalysis and the example of André Breton, he became interested in abstraction and surrealism, and participated in the first group show of Canadian abstract art in April 1946, along with Jean-Paul Riopelle, Marcel Barbeau, Pierre Gauvreau, Fernand Leduc, Jean-Paul Mousseau, and Roger Fauteux. A second show the following year popularised them as* les automatistes. *By that time, the French surrealists had published their June 1947 manifesto, and before removing themselves to Paris, Riopelle and Leduc planted in Borduas the idea of a Quebec manifesto. Further impetus came in the appearance of the* Prisme d'yeux *manifesto issued by Alfred Pellan and his disciples, to whom the automatistes stood in heated opposition, despite what from the establishment's point of view seemed their similar contempt for authority and the traditional social contract.*

Refus global, *which appeared in an edition of 400 copies priced at one dollar each, only about half of which were sold, consisted of the title essay reprinted here, largely the work of Borduas, and a number of supporting documents, with the entire work carrying Borduas's signature and those of 14 younger figures in various disciplines. The scandal that resulted from its appearance in August 1948 was immediate and left no doubt of the document's importance in giving voice to the dissatisfaction so*

112

many felt with the province's regressive politics, stern religiosi-
ty, and constricted cultural life. Indeed it has been called the open-
ing salvo of the Quiet Revolution.

As a result of the uproar, Borduas was dismissed from his
teaching post and in 1952 withdrew into exile, first in the United
States and then, for his final five years, in France.

The following translations of the original manifesto and the
1958 epilogue to it are by François-Marc Gagnon and Dennis
Young as found in Gagnon's edition, Paul-Emile Borduas: Ecrits/
Writings 1942-1958 *(Halifax: Press of the Nova Scotia College*
of Art and Design, 1978). Also of particular interest is Surrealism
and Quebec Literature *by André Bourassa (Toronto: University of*
Toronto Press, 1984).

Global Refusal

Descendants of modest French Canadian families, labourers or
petit-bourgeois, from our arrival on this soil up to the present day
kept French and Catholic by resistance to the conqueror, by an
irrational attachment to the past, by self-indulgence and sentimental
pride and other compulsions.

A colony trapped and abandoned as long ago as 1760[1] between
unscalable walls of fear (the usual refuge of the vanquished)—its
leaders taking off or selling out, as they still do each time they get
the chance.

A little people, huddled to the skirts of a priesthood seen as
sole trustee of faith, knowledge, truth and national wealth,
shielded from the broader evolution of thought as too risky and
dangerous, and educated misguidedly, if without ill intent, in
distortions of the facts of history, when complete ignorance was
impracticable.

A little people, grown from a Jansenist colony, isolated and
cowed; and defenceless against the horde of clerics of France and
Navarre[2]—out to perpetuate in this fear-ridden place (fear-as-the-
beginning-of-wisdom!) the prestige and advantages of a Catholi

113

cism despised in Europe. Heirs of a mechanical papacy, invulnerable to redress, great masters of obscurantism, their institutes of learning still hold sway by exploiting the use of memory, static reason, and pernicious intention.

A little people, that multiplied in generosity of flesh, if not of spirit, in the north of this immense America with its sprightly band of golden-hearted youth and its superficial morality; spellbound by the annihilating prestige of remembered European masterpieces, and disdainful of the authentic creations of its own oppressed.

Our destiny seems harshly fixed.

But, revolutions, foreign wars, disturb the most efficient blockade of the spirit, however disarming.

Some pearls slip through, inevitably.

Political struggles become bitter. Against all prediction, the clergy acts rashly.

Rebellions follow, executions result[3], and impassioned first ruptures occur between the church and some of the faithful.

The breach widens, shrinks, then widens further.

Travel abroad increases. Soon, Paris is the rage. But, too far in time and space, too volatile for our timorous souls, it is often only the occasion for time off to complete a retarded sexual education and to acquire, on the basis of a stay in France, facile authority for improved exploitation of the crowd upon return. For example, the conduct of our doctors, with very few exceptions, is scandalous (after all, those-long-years-of-study-have-to-be-paid-for, whether they have travelled or not!)

Revolutionary works, when by chance they come to hand, seem but the sour grapes of a few eccentrics. The academics acquire prestige from our lack of knowledge.

Exceptionally, among these travels, some produce awakenings. The normally unthinkable is increasingly accepted. Forbidden readings circulate, spreading solace and hope.

Minds are enlightened by discovery of the *poètes maudits*: those who, without being monsters, dared express loud and clear what the unhappiest among us stifle quietly within, in shame and in terror of being overwhelmed. Illumination comes from the example of these men—the first to acknowledge contemporary anxieties, so painful and pathetic—whose insights prove of greater value, in their disturbing precision and freshness, than the interminable litanies chanted in the land of Quebec, or in all the seminaries of the globe together.

The limits of our dreams are broadened.

We are dizzied by the fall of tawdry finery so recently obscuring truth. The shame of hopeless bondage gives place to pride in a freedom obtainable by vigorous struggle.

To hell with the *goupillon* and the *tuque*![4] They have seized back a thousand times what once they gave.

Beyond Christianity, we attain the burning human brotherhood on which they have closed the door.

The reign of hydra-headed fear has ended.

In the wild hope of effacing its memory, I enumerate:

fear of facing prejudice—fear of public opinion—of persecutions—of general disapproval;

fear of being alone, without the God and the society which isolate you anyway;

fear of oneself—of one's brother—of poverty;

fear of the established order—or ridiculous justice;

fear of new relationships;

fear of the superrational;

fear of necessities;

fear of floodgates opening on one's faith in man—on the society of the future; fear of forces able to release transforming love;

blue fear— red fear—white fear; links in our shackles.

From the reign of debilitating fear we pass to that of anguish.

One would have to be of stone to remain indifferent to the grief of deliberately feigned gaiety, of psychological reflexes of the cruellest extravagance: transparent disguises of poignant, present despair (how is it possible not to cry out on reading the news of that horrifying collection of lampshades made of tattoos stripped from unfortunate captives, at the whim of some elegant woman; not to moan at endless accounts of torment in the concentration camps; not to chill to the marrow at descriptions of Spanish prisons, unjustifiable reprisals and cold-blooded revenge?) How can one not quiver before the cruel lucidity of science?

Overwhelming anguish is replaced by nausea.

We are sickened by the apparent inability of man to correct evils, by the uselessness of our endeavours, by the vanity of former hopes.

For centuries, the bountiful gifts of poetic activity have been doomed on the social level: violently rejected by the upper strata of society, or warped irrevocably by them and falsely assimilated.

116

For centuries, splendid revolutions, their hearts high in hope, have been brutally suppressed after a moment of delirious optimism—scarcely noticeable interruptions in our slither to head-long descent:

the French revolutions

the Russian revolution

the Spanish revolution

aborted in international confusion, despite the wishful thinking of so many simple souls around the world.

Death triumphing over life, again.

How can one not be nauseated by the liars, by the forgers, by the makers of the stillborn object, by the tricksters, the obsequious, the opportunistic, the false prophets of humanity, the polluters of springwater, or by rewards obtained for brutal cruelty?

By our own cowardice, impotence, fragility and lack of understanding?

By the disasters of our loves....

By the constant preference for cherished illusion over objective mysteries.

From where do we get the cursed efficiency that we impose upon ourselves, if not from our pursuit of culture made to suit the ends of nations other than our own?

The United States, Russia, England, France, Germany, Italy and Spain: sharp-fanged inheritors of a single decalogue, an identical gospel.

The religion of Christ has dominated the universe. What has been done with it when sisterhoods become exploiting little sisters!

Remove the motivation of competition for raw materials, prestige and authority, and nations might live harmoniously. But grant supremacy to whom you wish, give world control to whom you please, and the same deep-rooted patterns will emerge—although perhaps with different details.

They signify the end of Christian civilization.

The next world war will witness its collapse, by destroying any possibility of international competition.

Its state of decadence will even strike those eyes that are still closed.

Its decomposition, begun in the XIVth century, will nauseate the most insensitive.

Its loathsome exploitation, effective for so many centuries at the cost of life's most precious qualities, will be finally revealed to all its victims: docile slaves, the more eager to defend it as they were made more miserable.

There will be an end to putrefaction.

Christian decadence will have dragged down in succession all the peoples, all the classes it has touched, from first to last, from top to bottom.

It will end in shame at the inverse of its achievements of the XIIIth century.

In the XIIIth century, when the peak of moral evolution had been reached, intuition gave way to reason: gradually, to preserve a supremacy which had once been spontaneous, acts of faith gave

118

place to calculation. Exploitation began in the very bosom of religion through its self-interested use of petrified sentiments and through the rational study of glorious texts.

This exploitation of reason spread to all society's activities, in response to demands for maximum production.

Faith, taking refuge in the heart of the crowd, became its only hope of revenge and ultimate compensation. But there, also, expectations were dulled.

In high places, mathematics succeeded obsolete metaphysical speculation. The spirit of observation succeeded that of transfiguration.

The method hastened some impending progress in limited fields; it encouraged the birth of our versatile machines with their vertiginous speed, it allowed the straight-jacketing of our tumultuous rivers—and decadence seemed amiable and necessary, even if inviting the destruction of the planet. Scientific instruments brought us unanticipated means of investigating and regulating what was too small, too quick, too vibrant, too slow, or too huge for us. Our reason enabled us to over-run the world, but a world in which our harmony was lost.

The rending of psychic from rational faculties is close to paroxysm.

Material progress, reserved for the propertied classes but elsewhere held in check, has allowed political evolution with the guidance of religion (later without it), yet without renewal of our sensibility, our subconscious—without allowing the emotional evolution of the crowd—which alone could have rescued us from the deep Christian rut.

Society, born in faith, will perish by the weapon of reason: *intention*.

119

The inexorable regression of collective moral power to a strictly individual and sentimental level has helped to weave an amazing cloak of abstract knowledge—behind which society hides to devour at ease the fruit of its crimes.

Two world wars have been necessary to bring us to a recognition of this absurd state. The terror of the third will be conclusive. The H hour of total sacrifice is close upon us. Europe's rats already try to build a bridge of frantic escape over the Atlantic.[5] But events will catch up with the greedy, the satiated, the self-indulgent, the appeasers, the blind and the deaf.

They will be put down without mercy.

A new collective hope will be born.

Already it commands the ardour of exceptional lucidities, anonymously bonded by a new faith in the future and the collectivity to come

Magic booty, magically wrested from the unknown, lies at our feet. It has been gathered by the true poets. Its power to transform is measured by the violence shown against it and by its resistance in the end to exploitation. After more than two centuries, de Sade is still not found in bookstores, and Isidore Ducasse, dead for more than a century of revolutions and carnage, remains too virile for flabby contemporary consciences, in spite of the cesspool customs of today.

The items of this treasure reveal themselves, inviolable, to our society. They remain the incorruptible, sensitive legacy for tomorrow. They were ordained spontaneously outside of and in opposition to civilization, and await freedom from its restraints to become active in the social scheme.

Therefore, our duty is simple:

120

To break definitively with all conventions of society and its utilitarian spirit! We refuse to live knowingly at less than our spiritual and physical potential; refuse to close our eyes to the vices and confidence tricks perpetuated in the guise of learning, favour, or gratitude; refuse to be ghettoed in an ivory tower, well-fortified but too easy to ignore; refuse to remain silent—do with us what you will, but you shall hear us; refuse to make a deal with *la gloire* and its attendant honours: stigmata of malice, unawareness or servility; refuse to serve and to be used for such ends, refuse all *intention*, evil weapon of *reason*—down with them, to second place!

Make way for magic! Make way for objective mysteries!
Make way for love!
Make way for necessities!

To this global refusal we contrast full responsibility.

The self-seeking act is fettered to its author; it is stillborn.

The passionate act breaks free, through its very dynamism.

We gladly take on full responsibility for tomorrow. Rational effort, once in its proper place, will be available again to disengage the present from the limbo of the past.

Passions shape the future spontaneously, unpredictably, necessarily.

The past is a contingency of birth, it thus cannot be sacred. We are always quits with it.

It is naïve and misleading to consider the men and things of history through the magnifying glass of fame, which lends them qualities beyond the reach of clever academic monkey tricks, although such qualities come automatically when man obeys the

121

deep necessities of being—when he elects to become a new man in a new age (the definition of any man, of any time).

End the cascade of blows from the past which annihilates both present and future.

It is enough to disengage yesterday from the needs of today. A better tomorrow will be but the unforeseeable consequence of the present.

No need to concern ourselves with it before it comes.

Final Settlement of Accounts

The organized forces of society reproach us for our eagerness to work, our inflated anxieties, our excesses; such things insult their tolerance and gentleness, and their good taste (generous and full of hope and love, merely from habit).

Friends of the present regime suspect us of supporting the "Revolution." Friends of the "Revolution" call us merely rebels, saying we "protest against what now exists but only to transform it not to displace it." As delicately as this is put, we think we understand.

It is a question of class.

We are credited with the naïve intention of wanting to "transform" society by exchanging the men in power with others of the same kind—and of ignoring the friends of the "Revolution!"

But the only distinction between these "friends" and those presently in power is that they belong to different classes—as if a change of class implied a change of civilization, a change of desires, a change of hope!

They would devote themselves at a fixed salary (plus a cost-of-living bonus) to the organizing of the proletariat. So far, so good: the trouble is that, once in power, besides low wages they will foist on the same proletariat always, and always in the same manner, a renewable levy of supplementary charges, without discussion.

We recognize, nevertheless, that they might still be serving history. Salvation will come only after the most excessive exploitation.

And this excess they will achieve.

They will achieve it naturally, with no need of special talents,and the feasting will be lavish. We have refused to participate, already.

Therein lies our "guilty abstention".

For them, the rationally organized spoils (and everything in the affectionate bosom of decadence); for us, the unpredictable passion; for us, the risk of all in global refusal.

(Inevitably each social class will succeed to the government of the people, unable to avoid the path of decadence. And, equally for certain, as history affirms, only a full blossoming of our faculties and a perfect renewal of their emotional sources will extricate us— directing us towards the civilization impatient to be born.)

All of them, those in power, and those who want the power, would pamper us, if we agreed to overlook their crookedness by wilfully restricting our activities.

Integrity depends on pulling down our visors, plugging our ears, lacing our boots and boldly clearing a way through the pack of them, whether of left or right.

123

We prefer being cynical spontaneously, without malice.

Nice people smile at the meagre success of our exhibitions. They are amused to think themselves the first to spot some bargain prices.

If we continue to hold such shows, however, it is not in the naïve hope of making fortunes. We know the wealthy stay away from us. They could not with impunity make contact with incendiaries.

In the past, misunderstanding of exactly that has generated sales.

We believe this text will help dispel misunderstandings for the future.

If our activities increase, it is because we feel the urgent need for union with others.

It is there that success has been gained.

Yesterday, we were alone and indecisive.

Today, a group exists with wide, courageous branches that extend beyond frontiers.

A magnificent duty falls on us: history elects us to preserve the precious treasure it bequeaths.

Real things require relationships repeatedly renewed, or challenged, or put to question: relationships impalpable, exacting and dependent on the vivifying force of action.

Our treasure is poetic resource: the emotional wealth on which the centuries to come will draw. It cannot be passed on unless it is *transformed*, and lacking this it is deformed.

Let those who are inspired by this endeavour join us.

We foresee a future in which man is freed from useless chains, to realize a plenitude of individual gifts, in necessary unpredictability, spontaneity and resplendent anarchy.

Until then, without surrender or rest, in community of feeling with those who thirst for better life, without fear of set-backs, in encouragement or persecution, we shall pursue in joy our overwhelming need for liberation.

Paul-Emile Borduas

Magdeleine Arbour, Marcel Barbeau, Bruno Cormier, Claude Gauvreau, Pierre Gauvreau, Muriel Guilbault, Marcelle Ferron-Hamelin, Fernand Leduc, Thérèse Leduc, Jean-Paul Mousseau, Maurice Perron, Louise Renaud, François Riopelle, Jean-Paul Riopelle, Françoise Sullivan

1. 1760 marked the defeat of the French army by the English invaders of New France and is a traumatic date in the French Canadian mind.

2. The phrase "of France and Navarre" was used in designating the titles of the French monarch, and is used here ironically.

3. Probably the Rebellion of 1837-1838: an abortive attempt at national liberation, still celebrated as the first great moment of Québecois consciousness.

4. The *goupillon* was an instrument used at the beginning of high mass, when the faithful were blessed by the sprinkling on them of holy water, as a reminder of their baptism. Traditionally, the *tuque* was the distinctive hat of the French Canadian habitant. Here, both the holy-water-sprinkler and the *tuque* stand as symbols of the traditional values of French Canada: Catholic faith, ruralism, and narrow nationalism.

5. A reference to the immigration of Nazi sympathizers after World War II.

Global Refusal: Ten Years After

It would be just as well, monsieur, that one stopped flattering the vanity of painters by asking them questions. They take so much pleasure in answering that they will soon run the risk of not painting anymore. Well, let's go, once again:

If the manifesto *Global Refusal* has had an influence on Canadian thinking, this influence should be felt in the improvement of the critical sense in general and in a new orientation for art in particular. Let others be the judge of this. That is one question out of the way.

How can I assert that *art informel*, tachism and plasticism are outgrowths of automatism? What enormous effrontery would be needed to make such a claim by someone with title to fatherhood of the automatist movement. However, more humbly, I know that in Canada automatism precedes these different facets of the same initial liberty. The energetic proclamation of this liberty in *Global Refusal* has given, perhaps, a general impetus to research—even in directions contrary to those proposed in the manifesto.

Do I think that *Global Refusal* has a universal importance? No! Plagues, world wars, our giddy mechanization have this: it is on these that the fate of nations more or less depends. But, tell me, what do you mean by "universal"? (It seems that people speak a lot about it, at home.) Matter, whether animated or not, and also the laws which govern it, can be called universal, and spirit, the thinking modality of matter, is also universal, for sure. As regards the extent of the spirit, that is another problem altogether: God knows how slowly its manifestations may spread (while, even so, losing all poetical value). Notwithstanding the spiritual elements of *Global Refusal*, its worldly impact is nil, in spite of some French, English, Japanese and American echoes. Foreign response has been thoughtlessly to identify the text with the Surrealist line then current, without perceiving its divergent character; and Canadian

criticism has not been more lucid—quite the contrary. And that is about it. A bit later, pretty well everywhere, a similar wave arose, happily disengaged from surrealism. This wave has a universal significance, and the credit for it must go particularly to New York—which owes us nothing, of course. What remains are invisible progressions with unpredictable effects, of which nobody can speak; but of which from time to time the strangest news reaches us.

In full flood, I wrote and signed *Global Refusal* without knowing too much why. Maybe because it was necessary to my inner equilibrium, which required me to change the unbearable forms of a world arbitrarily imposed. Written today, without denying its essential value (which still remains), it would proceed from very different promptings: more impersonal, less naïve, and, I am afraid, even more cruel to breathe. I had faith in young people, in the moral and spiritual evolution of the crowd. My trip to Sicily, among others, would alone have been enough to cure me of such disgusting sentimentality over slaves. Certainly, I still burn with love, to my utmost, for the whole Earth and its inhabitants. But I believe only in a few men. More urgent seems to be to locate in the crowd those burning souls profoundly able to transform the human adventure, instead of relying upon the many without hope.

I hope these few approximations may be of some use to you, monsieur.

Paris, November 11, 1958.

18.

"D'UNE CERTAINE PEINTURE CANADIENNE, JEUNE... OU DE L'AUTOMATISME"

["AUTOMATISM... A NEW CANADIAN PAINTING"]

by Maurice Gagnon

The automatistes *had a profound effect not only on Canadian art but on Canadian art's relation to that of other countries. Maurice Gagnon (fl. 1940s), a prominent art critic of the day, had been one of Borduas's colleagues at the Ecole du Meuble before joining the Université de Montréal, and he very early saw the importance of Borduas's work and vision and of what soon became a movement. The following article, published in French in the Winter 1948 number of* Canadian Art, *is a valuable contemporary insight into the way Canada belatedly gained membership in several broad international currents. The translation is by Christl Verduyn of the French Department at Trent University; the advice of François-Marc Gagnon is also gratefully acknowledged.*

Montreal is—with its bursting activity—the centre of Canadian painting today. Thanks to Morrice, in the past, and to Borduas, Lyman, Pellan and Roberts, as well as to a constellation of young painters who keep producing works of unquestionable quality today, Montreal has truly become a flourishing milieu attracting all the country's artistic life forces.

For the first time in history, the work of these artists is putting us on an equal footing with international developments—no longer in the wake of Europe but in competition with her. This is a new

128

departure and we should rejoice, instead of putting down this vital new work for the benefit of all the dead wood floating about the Canadian waters. There are some people who, out of interest or the wish to come once again to the rescue of this dead wood, do their best to find a place in the sun for the dead wood—always the dead wood and only the dead wood.

Do you think anyone in Europe talks about our dead wood? Not one of these proteges has a reputation beyond his native village and it's not through them that Canada is becoming known abroad—thank God. Moreover, what writers are achieving today and which we rightfully admire, painters like Morrice, Pellan or Borduas accomplished long ago with less flash and fanfare to be sure but in a far superior way, with work of an entirely different scope. Our mistake was not to have taken enough notice of them.

The point is we are an ethnic entity with our own universal values. Amidst these values, one undisputed master, Paul-Emile Borduas, has been influential. His work and lucid theory inspired numerous young artists who received his support, followed his advice, pursued their own experiences and had surprising success. Borduas practised the doctrine he preached: surrealism, and more specifically, that feature of surrealism called automatism. Barbeau, Fautcux, Gauvreau, Leduc, Mousseau, Riopelle all adhered to this type of thinking. After several contacts with the Canadian public, they exhibited in Paris at the Galerie du Luxembourg under the name of Automatism. They drew the attention of France and Europe to themselves and to our country.

What did Europe know of our activity or of what's happened since 1927, when the late Clarence Gagnon mounted an exhibition featuring primarily the Group of Seven and a few Morrices? Nothing. Which is why this very recent exhibition was a revelation to France, as were the Parisian sojourns of Daudelin, Leduc, Mousseau, Riopelle, who received much more notice than their elders, with the exception of Pellan.

What led these young artists to adopt such a difficult mode of expression, almost impossible to attain and to accept because of its

129

higher level of thinking? How did these young painters come to reveal the most intimate, because subconscious, part of themselves —the miracle of art today and the aesthetic event which not only brings them before us but places them at the heart of the most avant garde art today?

Because they are young and like risks, they attempted this 'madness' which is the greatest for artists: self-perfection to the point of complete self possession and then equally total self-expression. This response through their very being is the antithesis of the hypocritical civilization surrounding us, a civilization crushed by materialism and systematic rules...and without poetry. They had the courage to risk absolutely everything for a spiritual voyage which threatened to sink them. I know how many painful efforts lie strewn along the way and how much moral suffering their accomplishments cost. They have one trait in common: honesty, the mark of the true artist. I don't maintain that they all have that indefinable thing one senses and calls quality, but they have a true sense of direction which guides them along the arduous route that almost inevitably leads to the masterpiece. They will vanquish or vanish: only the dead wood hangs on.

Given this pure drive and clear insight, one can understand why this group overreacts and is somewhat distrustful and contemptuous of others. One understands why the group fears corrupting influences and why it is as critical in its judgement of others as it is of itself.

The automatism these artists practise, so often defined by Breton to whom I refer the reader, has nothing to do with being automatons, and falling back on facile and obvious plays on words is not criticism (although some think the more vicious the critic, the better, and the more swamped his opponent). Automatism is not abandoning oneself to all the irrationalities each of us has in us. Here as elsewhere, creating works that hold up requires a powerful formation (in the Thomist sense). Otherwise, the association of form and colour is scarcely more than plastic images (take a look, if you must, at Chicoine's so called "abstractions").

130

I would like it to be clear that it is of no particular interest or advantage to me to defend these young painters any more than it is to condemn those of whom I disapprove. These young people can get along very nicely without my comments; in fact, they could give a d... about them. And I don't blame them a bit (I, for one, know the extent and limits of my criticism).

No other group among us yet has had such cohesion and such diverse personalities. Their activities are based on shared thinking, neighbourly support, and mutual encouragement. In other words—and it is Mr. Robert Davis, the new director of the Art Association who said this in a recent talk—the moral support any artist at any time has needed in order to carry out his work. This group is so self-contained that it has its own playwrights (one recalls Claude Gauvreau's *Bien-être* and J.T.Maecken's *Pièce sans titre*). It even has its own photographer Maurice Perron.

Some claim that putting too much spotlight on these young artists makes them take themselves too seriously. Didn't one of them choose the word 'genius' to describe the work of a painter in the group (the adjective was undoubtedly an exaggeration, but no one took it seriously, proving yet again the group's youthful authenticity). Others think it's doing them a disservice to believe so firmly in their importance. That would be true if only they didn't keep producing new and better work, as in the case of each of these painters.

For this is the story of that rough diamond Mousseau, whose work unfolded from earliest childhood on with the quiet ease of the great artist he is. It's the story of Pierre Gauvreau who evolved through a patient, timely and ever so reassuring reflection. It's the story of the passionate Riopelle, so intense in everything he achieved. None of this would have been possible without profound conviction, youth's fundamental faith which must constantly renew itself, or die.

It is only natural that these young artists should have, in varying numbers, their admirers, followers and critics. But to condemn them simply because they are truly innovative has always seemed to me to be an unacceptably negative attitude.

131

There are three different attitudes toward art, but only one is honest. First is the attitude which opposes everything being produced today. This *a priori* approach—negative and very widespread—corresponds to an infantile stage which mature men should long be over (however, there are more immature men than one generally imagines). Then there's the opposite attitude which blindly accepts everything new—out of snobbery, because it's good to be in vogue. This attitude is hardly better than the first. Finally, there's the attitude of the person who wishes to see, feel, think and understand. Such an individual is moved by beauty and repelled by ugliness. He doesn't treat lightly what has taken the artist so much understanding, love and searching to perfect. Such a person is sincere and if he gets off track—which, we don't deny, can often happen—doesn't he still have a greater chance of getting closer to the truth?

Everyone has the right to take the attitude he chooses just as everyone can think what he pleases. Nevertheless it remains the case that the only possibly enriching attitude is the positive one because it is alive and in tune with work which is done with an open mind and a pure heart.

For those who think that the critic is fooled by these 'farces', that he understands nothing, and is simply paid to write what he writes, are sorely mistaken. No one told me how to write this article, or paid me for it—not even the journal that asked me to do it and whose excellent work I am pleased to encourage by this token of good feeling and respect. Some impromptu critics have taken such pleasure in belittling our work that they've thought the strokes of their pens were slaying the new generation. The reverse is happening. The more they hammered away at them, the more splendidly the artists—rightfully provoked—asserted themselves. The day is dawning when these unjustified attacks are already being answered...

19.

["STATEMENT"]

by Jean-Paul Riopelle

When he signed Refus global *(for which he also supplied the cover art), Jean-Paul Riopelle (born 1923) was simply visiting Montreal from Paris, which he had decided only a short time earlier to make his permanent base. Internationally the best known and probably the most praised contemporary Canadian painter, he was also a signatory of the French surrealist manifesto* Ruptures inaugurales. *He hoped to rediscover the roots of surrealism as an antidote to societal depersonalisation, and worked through a number of technical experiments to arrive at successive styles of abstraction. The search, which is characterized by his own highly gestural brand of abstraction and* tachisme, *is addressed in Canadian terms by this brief statement found in* Riopelle *by Pierre Schneider (Paris: Maeght, 1972).*

Since I'm Canadian, they always talk about the great Canadian forests apropos of my paintings....I am not a painter of virgin forests or infinite prairies...a leaf of a tree, that's enough. It is the whole forest. You have only to see it. My conception is not that of abstracting: is it going *toward* it with a free gesture (I'm not talking about automatism) to try to understand what nature is, departing not from the destruction of nature but rather, toward the world.

20.

"RECENT TRENDS IN MONTREAL PAINTING"

by Paul Dumas

The new confidence of Canadian art in the period beginning 1945 certainly benefitted from the postwar sense of prosperity and conformity in which art could luxuriate and against which it could rebel. And it would not be long before government policy became important in the social equation of art. Yet it was largely through the power of the radical excitement in Montreal that the whole art scene there was reinvigorated. It is too easy to ignore or downplay the overlapping circles of other painters, often older figures who achieved their mature styles during this period and made the Sherbrooke Street galleries exciting places. It is this parallel universe, inhabited not only by Alfred Pellan's rival version of non-objectivist art but also by an entire demography of anglophone figurative painting, that Paul Dumas inventories in this article from Canadian Art, *Winter 1948. Dumas (born 1912) is a Montreal physician and collector and the author of a monograph on John Lyman (who painted a well-known portrait of him).*

A survey of Canadian painting at this time would require the ubiquitous eye of a travelling salesman. The sparseness of Canadian art centres, the heterogeneous values of the official painters who are usually connected with these centres and who may overshadow lesser-known and sounder artists, the frequent inconsistency shown by the painters themselves in the choice of their contributions to travelling exhibitions—painters being, like mothers, often inclined to cherish their most unfavoured offspring—all this makes it impossible for a single critic to give a fair account of Canadian painting as a whole and to appreciate the comparative qualities of the artists. Furthermore, the impetus given to painting in the

province of Quebec during the last few years has been such—
thanks to the amateurs and critics as well as to the painters—that
even for a Montrealer, well informed as he may be, it would be an
arduous task to cover adequately the realm of contemporary paint-
ing in Quebec. The editors of this magazine have foreseen this
difficulty and have therefore invited different contributors to
describe the many aspects of painting in this province.

We shall for our part limit ourselves to the so-called Montreal
painters, especially to those whom we consider most representa-
tive of Canadian painting as it is produced here. We shall perforce
dismiss several who have established themselves in the field of ac-
ademic portraiture or in the production of stereotyped, marketable
landscapes and those also who belong to the Quebec wing of the
Group of Seven. It has been said, and this nowadays remains of-
ten true, that Canadian painting has been on the whole derivative.
Thus we have had imitators of the Italian Baroque (the painters of
the French colonial period in Quebec) and subsequently, followers
of David, of Calame, of Constable, of the German genre painters,
of the Barbizon and nineteenth century Dutch schools, of the
impressionists and of the academicians of Paris and London. The
formation of the Group of Seven was a reaction against this
process of continual imitation; its members aimed at creating
genuine Canadian painting inspired by Canadian themes, mostly
landscapes of the wilderness, as seen by Canadian eyes. The
members of the Group, while opposing the Dutch influence,
repeated the experiment, pursued a few years before in reaction to
impressionism, by the Pennsylvania group of painters led by E.W.
Redfield. It might be interesting to note here the analogical rela-
tionship between these two groups and also the similarity in the
choice and treatment of motives that link together the Seven with
northern European painters of the early twentieth century and par-
ticularly Nicholas Roerich. The Group of Seven, in its efforts, un-
doubtedly helped Canadian painting a great deal, but in the long
run its achievements led to a new formula not less sterilizing than
the European ones.

135

While the Seven were militantly expounding their beliefs through pen and brush, other painters were asserting themselves in Quebec, in as firm if not as loud tones. They were James Wilson Morrice and Ozias Leduc, whom many of our Montreal moderns claim as their forerunners. Though they belong to another era, let us say a few words about these two prominent elders. Some have justified the contention that Morrice was not a truly Canadian painter on the ground that he had lived so many years away from his native country and had indulged so much in exotic themes. To have accepted this narrow-minded regionalist point of view would have deprived Canadian art of its first master in 'living art'. As we have referred to Morrice's self-exile, let us jot down an impression that has struck us for some time: born of Anglo-Canadian stock, Morrice was first attracted in Paris, not so much by French masters as by his fellow North American, James McNeill Whistler, and his own work presents many similarities in mood, colour and pattern with that of two other cosmopolitans of British descent, the Bostonian, Maurice Prendergast, and the Australian, Charles Conder. As far as we know, no comparative study has ever been undertaken of these three painters who, linked together by affinities and blood, came from three distant parts of the English-speaking world to Paris where they became acquainted and influenced each other.

The originality of Morrice and his importance in Canadian art have been underlined by Donald Buchanan and John Lyman in their monographs. Years have elapsed before Morrice gained recognition, but since his death in 1924 and the memorial exhibitions that have been held of his work, his stature has never ceased to grow. He is now considered by Montreal artists as a master, because all his life he strived to be himself, evolving from the Dutch and Whistlerian influences, which he underwent, a personal style that was to bloom gradually and reach the soberness and intensity of expression of his latest works.

Ozias Leduc is at 83 the grand old man of Canadian painting. Still recently he was perched on scaffolds working at mural paintings in churches. Modest, secretive, meditative, he leads an

136

obscure and almost ascetic life far from the cities and the artistic coteries. His work is fastidiously elaborated and not very abundant. It includes still lifes executed with a meticulous brush, yet suffused with a tender poetry that remind us both of Chardin and Harnett, solid portraits filled with a deep psychological insight, lyrical landscapes singing in mellow tunes, and religious compositions that are inspired by a profound faith and an acute sense of liturgical symbolism.

These two artists have set an example for the Montreal group of painters and we have deemed it proper to place their names at the beginning of a study of the latter.[1] Some years before the Group of Seven established itself as a primary force in Canadian art, three painters launched in Montreal the first attack against subservience to foreign influences. They were John Lyman, Randolph Hewton and A.Y. Jackson. They met with a barrage of abuse, the viciousness of which was never equalled afterwards.

Trained in London and Paris, notably with Matisse, attracted for a while towards architecture, John Lyman has shared his life and work, like Morrice, between the old and new worlds. He has been a faithful defender of living art in Montreal and the founder of the Contemporary Art Society. It is astonishing nowadays to see how sedate those pictures, that scandalized the Montreal newspapermen of 1913, appear to us if we compare them with, for instance, certain European works that set the New York press afire when they were exhibited at the famous Armory Show of modern painting in that city, about the same time. More rugged in treatment than his post-war works, these early canvases, nevertheless, contain the essence of his painting, that is, a perfect balance between sensibility and intellect, and a mastery of form through luminous colouring. Dean of the Montreal group, Lyman has passed beyond the period of fiery experiences and attained to the maturity of his talent. His painting never resorts to pure pigment nor distorted forms and for the superficial observer it does not offer the revolutionary impact usually expected from modern pictures. Yet it remains pure painting in a classical sense, that is the

expression of a highly civilized personality through harmonious forms and serene, limpid colours.

Marc-Aurèle Fortin asserts himself as the problem painter of our art. Mostly self-taught, it could be said of him —*mutatis mutandis*—what has been said of Corot, that his prolific output contains gems as well as vacuous, verbose and emphatic compositions. These gems we find mostly among the smaller works and sketches of his middle period. They are almost exclusively landscapes of Montreal and Ste. Rose; they show an intense if naïve feeling for nature and are brushed in a spontaneous and direct way with vibrant colours and rhythms. The harmony of the composition is thus engendered by the ingenuousness of the painter. On the contrary, when his intellect intervenes deliberately in place of his instinct, and he substitutes pompous,decorative patterns, the result is often distressing. At his best, Fortin is strictly an instinctive painter.The first show of Fortin in Montreal[2] after his return from Paris in the mid-twenties caused a stir among the quiet gallery-goers of the time who were not yet used to such boldness in the handling of colour. A similar sensation was repeated when Adrien Hébert exhibited his paintings from France. He had learned from minor French painters, like Jacquemot and Favory, the lesson of Cezanne, but later on turned to a descriptive manner mostly concerned with city and harbour scenes. These two events were steps in the formation of our modern school and should not be overlooked by young painters who are often misled to believe that painting starts from themselves on.

If we advance further into the thirties, we meet Fritz Brandtner, German born and taught, who has brought to this country the styles and mannerisms of the different contemporary German schools. An indefatigable and able craftsman, Brandtner has exerted his remarkable skill in every medium; yet, powerful and striking as his palette may be, he has followed too many paths to attain a truly personal style.

Bercovitch who made a meteoric appearance in the thirties has produced uneven works derived from the expressionist school.

138

Alfred Pellan has associated his name with the resurgence of painting in Montreal. A dynamic and somehow primitive figure with a gift for showmanship, he rallied around him the forces of independent painting on his return to his native country after a fourteen year sojourn in France. Highly temperamental, he has become a sort of lone wolf, but since his appointment as teacher at the Ecole des Beaux-Arts, he has gathered a fervent following of young admirers, among them, his pupil, the much publicized Mimi Parent.

After a Canadian period of formative years—of which two pictures are well known, *Quebec Harbour* and *Basket of Strawberries*—he went to Paris on a provincial government scholarship. At first, he produced solely representational works, mainly austere and monochromatic portraits which remind us of the beautiful heads of Derain and the early Bérard. Later on, influenced by Barque, Juan Gris and Bonnard, he painted a series of still lifes, extremely rich in tones and personal in the arrangements of forms, which mark a peak in his art. Going further, he assimilated other influences, Picasso, Miro, Masson, Klee and Léger, and turned gradually towards non-representative painting, either intermingling so-called abstract patterns in objective painting, or limiting himself to the non-objective vocabulary. Since his return here, after a transitory try at figure painting, he has concentrated on ambitious, semi-abstract compositions, synthetic in conception and in which graphic and plastic elements are sometimes ambiguously interwoven, but that possess, none the less, a sort of savage grandeur. Pellan has undoubtedly proved himself to be a force in Canadian painting. God-gifted, with a skill for line as well as for colour, although he prefers vibrant opposition of pigments to subtle analysis of half-tones, he swallows and blends influences as no one else, but, lacking to a certain extent creative imagination, he has not yet given us that original contribution which we are entitled to expect from him.

Goodridge Roberts is a much different character. Silent and reserved, abstracted from the mundane world by his ever-flowing dreams, more at ease in the bush than in social gatherings, and

furthermore endowed by heredity with a deep love for nature, he has recaptured like no one else the true spirit of our unspoiled wilderness. It has inspired in this taciturn poet an endless and enthusiastic paean. His landscapes are built with a free brush and a very simple scheme of colours without ever resorting to melodramatic effects. Sometimes they convey too well the chaotic beauty of Laurentian scenery, but even then they reflect the moods and feelings of the artist, so intimately tuned with the dreary solitude of our wooded hills.

Roberts has turned out also good portraits, nudes and still lifes. In these he still concentrates more on self-expression than on representation, but his drawing which was apt sometimes to prove a little too frolicsome in his studies of bush scenes, acquires here a keener quality without losing its flexibility. His water colours and satirical sketches are among the best that have been produced in Canada.

Jori Smith-Palardy is one of the most gifted and most natural painters of this country. Utterly temperamental, she works mostly on impulse and has changed her style several times. After having worked in a broad realistic style, she has adopted for some time a kind of incandescent expressionism out of which she is coming now. She is at her best in sketches, summarizing very cleverly movements or forms with a few strokes of colour. This hasty technique is not without danger on larger canvases and should Jori discipline herself to elaborate more she would easily rank among our very best artists as she possesses an innate sense of line and colour. Her recent production marks a notable improvement in this direction.

Paul Borduas's importance is evaluated elsewhere in this number by the well-known art critic Maurice Gagnon. No panoramic study of the Montreal group would be complete, though, without at least a mention of this very personal painter. Less gifted but more imaginative than Pellan, this former pupil of Ozias Leduc and Maurice Denis, has lately derived from his study of the French writers, Lautreamont and André Breton, an esoteric style of paint-

ing through which he tries to introduce us into his dream-world with the help of fluid forms and glowing, precious colours.

It is a tradition at the Ecole des Beaux-Arts of Montreal to oppose Stanley Cosgrove to his colleague Pellan. In fact no two artists are more different from each other and their painting is the exact translation of their individual personalities. Discreet and delicate, Cosgrove seeks after subtleties of hues rather than garish and loud colouring, fineness of texture and design instead of spectacular composition. In the beginning there was an almost feminine and pastel-like quality in the thinness of his impasto. Since his return from studies in Mexico, his art, which at times barely escaped dryness, is gradually broadening and enriching itself.

Louise Gadbois, former pupil of Edwin Holgate, of Jori Smith and of Sylvia Daoust, is better than a good feminine painter. Well known for her portraits and still lifes, though she has also tried her hand at composition and landscapes, she uses preferably subdued tints and "evanescent" forms which confer on her art a distinguished and nostalgic imprint.

Her daughter Denyse, who belongs to the younger set of painters, and who won the first *Grand Prix de Peinture* of the Quebec Government, paints mostly family scenes and still lifes. Her colour register is narrower than her mother's but her sense of form more definite.

Eric Goldberg is the poet of joy in the group. He has built for his own enjoyment and ours an imaginary paradise where gaily coloured forms, haloed with a misty light, gracefully move against a vaporous sky.

Louis Muhlstock on the contrary has his feet firmly on the ground. An expert draughtsman and a sensitive soul, he applies his talent to depict humble subjects, unemployed or old people, labourers, shabby streets, empty rooms, or to outline generous nudes. His drawings have gained him a wide acclaim. His landscapes of the streets or the woods express a genuine love of nature and a strong feeling for form and composition.

141

Philip Surrey has also a deep tenderness for humble beings and things. His studies of city streets at night, or lunch-counters or taverns, as well as his landscapes, are never gloomy or moody. They express a very sympathetic and intelligent comprehension of life together with an unusual acumen for mystery; the forms therein are concise and built with restrained yet evocative colour.

Other names are worthy of mention, all of which cannot be listed here. Canadian painting has lost a refined and talented landscape-painter in the person of Jean Palardy, who now has turned to cinematic art. Henry Eveleigh is a vigorous abstractionist who succeeds as well in poster designs. Jack Beder is a modest painter who translates in simple terms the poetry of countryside and city streets. Allan Harrison has created a melancholy but very plastic world. Jean-Charles Faucher, gifted for satire, knows how to extract beauty out of gray, rainy skies. Marian Scott has fled from her geometric universe to the arcana of cellular morphology. The versatile Agnès Lefort always seeks new achievements while Marguerite Fainmel enjoys herself in the atmosphere of Renoir. Jean Simard, as a painter, has a neat and well-ordered vision and a nice sense of humour, all qualities that pervade his delightful writings.

The most promising names of the younger generation are: Jacques de Tonnancour, a fine draughtsman and self-exacting artist who is struggling at this time with colour; William Armstrong, who has given us a few sumptuous portraits; Eldon Grier, a born colourist; the energetic Charles Daudelin, presently studying in Paris; Julien Hébert, talented for both painting and sculpture, and Pierre Gauvreau, who is dealt with in Maurice Gagnon's article. Let us mention finally a man whose frantic imagination has raised caricature to the level of real art, "le grand" Robert La Palme.

All these painters do not form a school but a group. Most of them have not completely freed themselves from other influences. What links them together, all the same, is a common effort to create original and sincere art by expressing their intimate self and their intuitive conception of life through the medium of line, colour, and form. That this faith in pure art should be shared at the same moment by so many artists is a strikingly new phenomenon

in a country that has been accustomed mainly to derivative and regionalist art. Here lies, in our estimation, the original contribution of the Montreal group of painters to the advancement of Canadian painting.

1. Better acquainted, though we may be, with the activities of our moderns we do not, as is the fashion in some circles, reject scornfully, with the exception of Morrice and Ozias Leduc, all Quebec painters, prior to the contemporary avant-garde schools. We know too well what an ordeal it is for an artist to make a living in this country while remaining faithful to an aesthetic credo. If we place ourselves in the perspective of the era in which they were produced, many works by Suzor-Coté, Henri Julien, Henri Beau, Maurice Cullen and, nearer us, the early works of Robert Pilot, retain an inherent beauty of their own, even as they may have had a revolutionary value in their times. One can find big holes in the merits of these artists' works, but very few artists can boast of having none. It is to be regretted also that other skilled craftsmen, after promising beginnings, have been obliged for material considerations to imprison themselves in popular and repetitious formulas. Let the youngsters pursue their own careers without ever yielding to compromise before judging these men too harshly.

2. At the St. Sulpice Library. It consisted mostly of his famous and flower-like studies of Ste. Rose elm trees.

143

21.

"THE CANADIAN GROUP OF PAINTERS"

by Robert Ayre

The Canadian Group of Painters was formed in 1933 to carry on the Group of Seven's work yet also to supplant it: a response to the fact that the Seven were being relegated to their hard-won place in history. By Spring 1949, when Robert Ayre published this prescient article in Canadian Art, *the new group's formal life already exceeded by three years that of the band it succeeded. This serious and informative popular statement is valuable for the way it measures the widening cracks and, more importantly, for the way it sees regionalism and other forces looming large. Ayre (1900-1979) was one of the last of the important amateur critics, using his position with the Canadian National Railways to subsidize his writings in* Canadian Art, *of which he was once editor, and in the Montreal newspapers.*

To begin with, I had assumed that if you wanted to find out what was happening in Canadian painting, without too much research, you couldn't do better than look at the annual exhibition of the Canadian Group of Painters, which opened this year in Montreal in January and which will go on to other cities. But this obviously puts too much responsibility on the Group. Every year it opens its doors to fifteen or twenty non-members and from these invited guests builds up its membership, which, in the fifteen years of its existence, has grown from twenty-eight to fifty-one. Without lowering its standards, it could not grow much faster. Any attempt to be all-inclusive would result in loss of character: if it spread itself out any thinner, it would cease to be a group; even now, it is full of diverse elements, held together by a common temper or point of view which we might call the unorthodox, the lively, the experi-

144

mental, as opposed to the conservative spirit of the Academy and the unadventurous habits of the popular painters. Of course it could be said that, since nothing really happens in the Academy and in the pot-boiler mills, we must look to the Group. The point is, however, that a great deal of what is going on in Canada today is going on outside the Canadian Group of Painters. Take, for example, the stirrings in Saskatchewan and Alberta; take the "socially conscious" painters in Montreal and Toronto who say (in the words of one of them): "The artist must orientate his painting once again to the joys and despairs of our people and so make art the concern of everyone." The Group may be cognizant of these newcomers, who are essentially Group material, but has not welcomed them yet, because of the technical standards which make it a sort of advanced, unacademic Academy. I have no quarrel with that. In time, painters now groping will be worthy of a place. Meanwhile, the Group is suffering from a more serious deficiency. Quebec is lacking. I can name a dozen nationally known Montreal painters who are exhibiting in the current show, but I am thinking of French Quebec. Its only representative, unless you include Stanley Cosgrove, is Jacques de Tonnancour. Forces like Alfred Pellan and Paul-Emile Borduas, their followers and some of the independents, who are quite up to Group standards, are conspicuous by their absence. The fault is Quebec's rather than the Group's. Borduas, Pellan and others have exhibited in the past, but now they prefer to keep to themselves. I know that when I helped organize an exhibition of Montreal painting a year ago, to be circulated in Western Canada and in the Maritimes, under the auspices of the Federation of Canadian Artists, I couldn't get a peep out of any of them, much less a picture, except from Pierre Gauvreau. It is a pity, because the Group cannot be a truly Canadian Group without them.

The upshot of all this is that you cannot discover what is happening to Canadian painting by looking at the Group show. We shall have to be satisfied with finding out what has been happening to the Group.

The first thing that strikes you is the retreat of the landscape and the advance of the abstract and the semi-abstract (even without the French).

When the Group held its first exhibition in November, 1933, the catalogue stated: "Hitherto it has been a landscape art, typical of all new movements, but here and there figures and portraits have been slowly added to the subject matter, strengthening and occupying the background of landscape. Here also more modern ideas of technique and subject have been brought into the scope of Canadian painting, keeping the art in the van of our forward stride as a nation." The newer elements were represented by the portraits, nudes and other figures contributed by people (some of them long recognized) like Lilias Torrance Newton, Prudence Heward, R.S. Hewton, Edwin Holgate, John Alfsen, Will Ogilvie and Paraskeva Clarke, by the documentaries of Charles Comfort and Yvonne McKague, the folk pieces of André Biéler, Yulia Biriukova, Kathleen Daly and Kathleen Morris; and there were still lifes and flower paintings. (Terms like "documentaries" and "folk pieces" are not very satisfactory, but they indicate roughly what I have in mind.) The only abstractions were Bertram Brooker's. Lawren Harris was still showing landscapes and Gordon Webber was commenting on the life of the working people in portraits. In a show of 118 pictures, more than half were landscapes.

Without all the catalogues to hand, I cannot review the development year by year, but I notice that five or six years after the first show, with Varley in the Arctic and Lismer in Africa, Harris and Webber had gone completely abstract, Marian Scott, an invited contributor, was tending that way and York Wilson was introducing a satirical note. But landscape was holding its own, so much so that Professor Barker Fairley was lamenting the continuing influence of the Group of Seven, out of which the larger Group had sprung, and was calling for some attention to "the urgent human issues".

Humanity was more noticeable three or four years on—in 1942—with painters like the late Pegi Nicol, Henri Masson, Jori Smith, Fred Hagan and Philip Surrey. The challenge of the urgent

human issues of the war was taken up by a few, although not always successfully. George Pepper was trying his hand at drama in *The Naval Club Fire*; Yvonne McKague Housser offered a montage of symbolic figures, guns and soldiers and the farms and mines behind them; Jack Nichols showed *Refugees*. Jack Humphrey, in addition to a portrait and a still life, *Things on a Table*, exhibited a painting of a group of people in a queue. In *Tenants*, Marian Scott painted five men and women on a staircase, but as in *Cement*, an industrial structure, her interest was primarily formal. Rody Kenny Courtice called her canvas *War* but it was a pure abstraction. Harris soared into the ether, Borduas seemed to be delving into the mysteries of growth, Webber to be peering into a microscope. Denyse and Louise Gadbois, with still lifes approaching the abstract, were in that show; and Pellan. Landscapes took up a little less than half the space; some of the canvases were pale reflections of the Seven, but others, notably those of Michael Forster, came from an entirely different experience of Canada.

This statistical examination, this business of counting noses, may not be a very profitable business, but it does help us arrive at the character of Group painting today. I think it is worth noting that the trend is continuing, that this year only about a third of the sixty-three pictures are landscapes and that no more than nine of these are in the tradition of seeing and painting inspired by the original Group of Seven. Only nine out of sixty-three!

These include, of course, A.Y. Jackson and Arthur Lismer. It is interesting to contrast the clearness and hard thrust of Lismer's *Pine Rhythm, Georgian Bay*, with the milder weather and more restrained rhythms of Jackson's *April in the Laurentians* but both are essentially Group of Seven. The compositions *Red Mountain* by W.P. Weston, the *Waterfall, Montebello* by Ethel Seath, and *October, Ottawa Valley* by the late Sarah Robertson, (both as feminine in their way as the outdoor still lifes, *The Pond* by Mabel Lockerby and Miss Seath's *In the Grass*) belong with them; and so do Yvonne McKague Housser's *Cap Chat River* and Anne Savage's *Autumn Fantasy*, though the last named, with its large shapes of falling leaves, puts the emphasis on design for its own sake.

147

Among the other landscapes are found the familiar personal expressions of Goodridge Roberts, Louis Muhlstock and Paraskeva Clarke; Roberts in his own private Eastern Townships, Muhlstock in a forest interior quite unlike Lismer's or Emily Carr's, Mrs. Clarke light-hearted in the city. Without tears but with a sort of healthy curiosity, B. Cogill Haworth reports on the hard life of the people in a hard-bitten land. The lines begin to dissolve. What is landscape and what isn't? Where would you put E.J. Hughes' *Qualicum Beach*? It looks like a primitive but there is something more than ordinarily uncanny about its immobility, something sinister in its colour, and it has the intensity of a nightmare. From the same part of the country come two other experiences of landscape. Bess Harris paints the shore, but she doesn't paint it the same way as Lismer does in *Cape Breton Island Beach*. It isn't because one shore happens to be on the Pacific and the other on the Atlantic. Mrs. Harris is not so much interested in place as she is in formal values, and so I put her among the abstract painters. (If I go on like this, I'll get myself into trouble. I can hear some of the painters telling me that the old Group was always strong on the formal side, and I agree, but it all depends on where you start. There have been, and there still are, dozens of painters who give us pretty transcriptions of the Canadian scene, photographed, as it were, from the country, but they stripped it to its essentials, got under its skin, summarized its elemental forces in symbols: I nearly said slogans. But the point is, they wanted to express the country, or that particular aspect of it that excited them. They were landscape painters. Those who start from the other end, even if they remain fairly close to the landscape, I call abstract.) The third British Columbia experience which is not simply landscape is that of Charles H. Scott in *Salute to Mozart*, a whimsical flirtation with tree shapes that in my opinion has nothing serious to say about music or anything else. In *Laurentian Mood* and *Dark Landscape*, L.A.C. Panton takes us into a romantic, imaginary country, too, but a more satisfactory one. What matters is form and rhythm and the overtones of poetry. Turning away from the inhabitants of the earth, for which he has always had an affection,

148

to the earth itself, André Biéler sees it as pattern in *Landscape in Grey and Yellow* and he goes even further in *Landscape in Red and Grey.*

So much for landscape. Now what about people? There are about a dozen portraits, ranging from the informal sketch to the more substantial academic. The one compelling the most attention is the tremendously vigorous water colour portrait of Carl Schaefer in Air Force uniform by Charles Comfort. I haven't space to mention them all; but I must take note of a change in Henri Masson's work. I don't think he has quite hit his stride yet in the self-portrait and in *Brothers*, which (as Peter Aspell does, too, in his boy) captures some of the gawkiness of youth but, without prejudice to his former work, it is interesting to see a man take a new direction.

Since they have nothing in common except a non-committal title and the fact that they both show groups of nudes, it is really not proper to compare the figure compositions by Will Ogilvie and George Pepper but, if only for the sake of convenience, it is difficult to avoid mentioning them together. Sex has something to do with the difference. The permeating grace and even elegance of Ogilvie's picture would be the wrong key for male figures but apart from that there is a quality in the seeing and painting, a wholeness, that is lacking in the other, which looks contrived and theatrical.

Few of the pictures in the exhibition are drawn from the "social scene". Kathleen Daly paints Indian boys and a young Negro with sympathy; Peter Haworth, in *Political Meeting*, William Winter in *Promenade* and York Wilson in *Conference* bring a little humour; but there is nothing with much bite, as there is nothing deeply moving. Canadians are still shy of those urgent human issues, those joys and despairs of the people. In *New Orleans*, Jack Nichols, on his Guggenheim travels, seems to be far away.

Moving through Isabel McLaughlin's luxuriant *Coleus*, Rody Keny Courtice's greenish mask and leaves, *Memento Mori*, Jack Humphrey's group of objects gathered together on the shore and filtered through a dreamy, melancholy light, Jacques de Tonnancour's collection laid out hard and flat and handsome on a black

149

table, and W. Hawley Yarwood's conventionalized *Pigeons*, we come to the purer abstract. Lawren Harris gives us frail shapes, drifting, dancing, changing, and, while I liked the movement, I didn't like the colour. Bertram Brooker works from truncated trees—so it seemed—in *Suspension* and from the mouths of flower bells in *Chorus*; in circles, discs and spots, Gordon Webber gives us the graph of an idea; Marian Scott shows two of her *Stone* and *Protoplasm* series, the one an intermingling of transparent shapes, the other more solid and, as I thought, better in colour. (In a neighbouring gallery, Mrs. Scott and Mr. Webber, in a stimulating two-man show, presented their recent work in full scope.) Ships—one group in "variable weather" and the other in "classical calm"—were the starting place for B.C. Binning, who linked hulls, spars, flags and ropes into gay designs, not so childlike as they might appear at first glance. In contrast to these which, although firm in their lines, were as insubstantial as reflections in the water, stood Fritz Brandtner's *Studio* and *City from a Night Train*, thick, massive, intense, bursting with life, yet held within the bounds of a rigid scheme.

There you have it. What has been happening to the Group? Not much, some would say. I have never heard so many expressions of dissatisfaction—from serious painters, including Group members and adherents, as well as from innocent laymen who might be expected to be disturbed by the invasion of the abstract. It is indeed an extremely spotty show. I have been listing paintings, for the most part withholding comment; I have mentioned pictures that I do not consider worthy of their painters; I have omitted some that are fine and some that never should have been hung. Quite a few of the original members of the Group did not contribute. It would have been better for some others it they had stayed out. Unquestionably some sent simply out of habit. As Walt Kuhn said: "Painting is a language. If you have nothing in your head or heart, it is better to keep your mouth shut." Had the standards I spoke of at the beginning of this article applied, there would have been a drastic weeding out and it might have been salutary to some of our painters who are simply coasting. I would not go so far, perhaps,

150

as one visitor to the Art Association gallery who said that, on the whole, it was a vulgar show; but I do feel that there is too much rawness in it; that it is not without vitality, imagination and integrity, but that there is not enough subtlety, not enough of real painting quality.

Perhaps it would do the Group—and Canadian painting—good if it skipped a year or two, girded itself together and refrained from appearing before the public until it sincerely felt it could put on a strong show. Meanwhile it might do some missionary work, comb the country for the young painters worth encouraging, make strenuous efforts to dig out others who have been neglected, and sponsor an exhibition that would really give us an idea of what's happening today.

22.

"WHAT IS WRONG
WITH CANADIAN ART?"

by Barker Fairley

In the following CBC radio talk, Barker Fairley (1887-1986) struck a familiar tone in attempting to criticize art criticism for shortcomings all too real but likewise all too common among the different generations. In so doing, he caught the tenor of so many people's instinctive reaction to Canadian culture, with their bedrock feelings of inferiority. Precedent would seem to indicate that the mood is strongest immediately prior to greatest change. Certainly that was the case in 1948 when this was broadcast, to be reprinted in that year's Autumn issue of Canadian Art. *Fairley was the Toronto poet, Goethe authority, and painter, known especially for his portraits, who in 1920 was one of the founders of* The Canadian Forum, *to which he contributed much lively art criticism.*

In attempting to state what is wrong with Canadian art it might be as well to begin at home and say what I think is wrong with the critics, not excluding myself. Canadian art has always suffered from its critics, partly owing to the atmosphere of timidity that pervades every aspect of our intellectual life—whether in art or literature—and partly because our community is too small. The critics are always personally acquainted with the artists they are criticizing, they write rather for them than for the public, with the result that they usually spend more time and energy in seeing that they mention the right names and don't offend their pals than in trying to say something illuminating.

As I hinted a moment ago, it is the same in the literary field where there has always been far too much mothering and coddling in my opinion and far too little insistence on aims and standards. I

would be prepared to argue that literary and artistic criticism in Canada has never helped our art and literature much and that it has more often hurt it. To take the most conspicuous case of all, at the one time in the history of Canadian art when the thing took shape and did something that we can put a name to—I mean the Group of Seven movement—the critics almost to a man were uncomprehending or hostile or even offensive. The only help they gave was the help that enemies give by putting their opponents on their mettle and making them fight harder. And you can't call that criticism. There was at that time not more than a bare handful of individuals in the length and breadth of Canada who saw the value of the movement and were ready to say so in public. I recall with pride that I was one of that small number. If the main body of critics had had their way there would have been no Group of Seven movement at all and Canadian art would have been that much further behind in its development...

What the Group did for the development of Canadian art was to set landscape painting free. Before their time the landscape painter in Canada was tied for the most part to sober imitation; after that time he could do as he liked, not copying the forms of rock, tree and cloud slavishly, but using the resources of shape and colour creatively to reproduce the spirit of what was before him. As the fruits of this liberation we now have a body of landscape painting—Group of Seven and post Group of Seven—which warms the hearts of thousands of Canadians and gives them the right sort of national pride.

This was so excellent an achievement that it seems a shame to find fault with it, yet, if I may make a confession, I have for years wanted to find fault with it, not for its performance, which remains, but for its influence, which continues. If I never said it before, it is because I too was timid and unwilling to argue with my friends. It doesn't take courage to say it now. No sooner had the Group done its main work—say twenty years ago—than the feeling spread abroad that there was no more work to do, that the battle was won, and that we had now entered into our artistic heritage. In consequence of this, Canadian art, after taking a great

153

leap forward, came almost to a dead stop and has never to this day recovered the momentum it had then. Like a man, who having jumped across the rapids, is so astonished to find that he has landed dry on the other side, say in a clump of juniper, that he does not dare to move out of this uncomfortable position.

What was needed then, and is still needed now, is to set the whole subject-matter of art free and not just the landscape part of it. It is the human subject, the human face, the human figure, whether alone or in groups or in crowds, in town and country, in war and peace, in life and death, that is the real and central subject of art, as it is of poetry. What is it that prevents the Canadian artist from moving boldly into this central field and treating the human subject with the imagination that he enjoys in doing skies and forests? Whatever the answer—and I will attempt one before I finish—it is certain that this freedom has never been really won. We cannot yet warm our hearts with Canadian figure painting as we can with landscapes.

I suspect that deep down the Group of Seven themselves knew the force of what I am saying, but didn't see their way clear to act on it. Some of them tried introducing figures into their big landscapes, but the number of such canvases cannot be more than about half a dozen. The characteristic work of the Group is as empty of humanity as an extinct volcano. And this, whether they wished it or not, has had a powerful and far from beneficial effect on those who came after. It is still true of Canadian art today, as it was true then, that our artists, taken as a whole, have landscape painting on one plane and figure painting on another and cannot easily merge them. It isn't that the two don't go together, because we know from experience that they do. It is simply that when confronted with a face or a figure the Canadian artist loses half his freedom and is unable to adventure, as an artist should.

This is not a purely Canadian problem. It merely comes out strongly in Canada because of the unpopulated North, which explains, and to some extent justifies, what has happened in Canadian painting. Artists in every country are faced with the confining tradition of naturalism which the nineteenth century built

up and which they now have to throw off. For some reason the throwing off has proved easier in the non-human field—in subjects without people in them—than it has in the human. It is not for nothing that one of the greatest of twentieth century artists, Picasso, has spent a lifetime rounding this difficult corner, analysing and re-analysing the human figure pictorially in a gigantic series of experiments till in late years he found the new way of expressing it that satisfied his need. And, to prove how right he was in his main endeavour, when he did satisfy his need he did more than that and satisfied ours too. I mean that he not only expressed his own feelings but also those of modern civilization. Needless to say, I am thinking chiefly of the great Guernica cartoon in which he imaginatively recorded the bombing of a Spanish town in the Spanish war in 1937...

In Picasso's *Guernica* the world crisis is recorded as nowhere else in art or literature and the picture owes its success technically to a freedom in the drawing of human beings, their hands, their feet, their faces, that puts our timidities to shame. Please don't think, any of you, that I am suggesting to Canadian artists that they should directly imitate Picasso at this point. They couldn't if they tried and they are too sensible to try. But what they or rather we—artists and public together—can learn from such work is that there are new ways of expressing humanity pictorially and that there must be Canadian ways as well as Spanish or French.

If you would like a less foreign example consider the sculptor Henry Moore, a Yorkshireman this time, who has also taken extreme liberties with the human form and to my mind justified them. In an age of crisis like ours there has to be a sense of re-birth and of beginning again as well as a sense of destruction, and it is this sense of re-birth that Henry Moore gives, carving figures, often large figures, in stone and wood which usually express, or approach the expression, of the female form, minimising the head and magnifying the body, and not only working over the surface of it, but hollowing it and excavating it and making the inside live, and in the end bringing out what I can only describe as a sense of

155

maternity, as if the very rocks were giving birth and the world of man coming again out of chaos.

Here, then, we have two great modern artists, a painter and a sculptor, a Spaniard and an Englishman, reaching their highest achievements by taking extreme liberties at the very point at which Canadian artists are afraid to take liberties—with the human form.

Now I have often heard it said that you can do what you like with rocks and trees but you must leave the human form alone. In other words, you can be free and imaginative in the use of shape and colour when depicting outer nature, but that when you depict humanity you have to toe the line and be as academic as you can. It is the prevalence of this belief, spoken or unspoken, among Canadian artists and art-goers and art colleges that holds Canadian art back, and it is a belief that I am ready to challenge. First, because, if it continues, it will be the death of art in this field. Artists will turn aside from the figure and choose subjects that set them free as artists. This is why nine times out of ten they prefer landscape or abstract subjects today. And, second, because it is out of line with the modern direction, as evidenced not only by Picasso and Henry Moore, but by Rouault and Matisse and the Mexican Orozco, all of whom boldly stylize or simplify or, as we say, distort their figures, as men have done from the beginning of civilization until this realistic tyranny descended upon us.

The nearest we come in Canadian art to this ancient tradition is in the Indian totem poles which so attracted Emily Carr. One wonders whether she had it in her to create in this sense and give us gigantic figures of her own, instead of just making documentaries of those she saw. Possibly. But like a good Canadian she concentrated more and more on trees and skies and sent all the people home. But think what some artistic descendant of Emily Carr, some Canadian Orozco, may do with Indian legend on a big scale some day. Or imagine a great mural painting on the Paul Bunyan theme. Surely you don't want that done naturalistically. It will have to be done in some other way.

Well, there's my argument. Canadian art is stagnating. People are losing interest in it. The poets and novelists in the country are

156

beginning to outdistance the painters and sculptors who used to be in the lead. What can they do to gather speed again? Or rather what can we, the public, do to help and direct them? Because remember, they in the long run are more dependent on us than we on them. They express us to ourselves. Perhaps the trouble is that we, all of us, not just the artists, are not sufficiently interested in humanity to develop a great human art. The whole community is involved in such a question. Everyone who cares for the arts should be thinking about it.

23.

"A HERITAGE IN DECAY—
THE TOTEM ART OF THE HAIDAS"

by Wilson Duff

There has long been a connection between Canadian art and anthropology, and in the 1950s, with Emily Carr a decade gone, new attention was paid the iconography that had inspired her so often and so memorably. The primary student and conservator of traditional West Coast native art was Wilson Duff (1925-1976). While associated with the British Columbia Provincial Museum from 1950 to 1965 he saved many of the last remaining Haida totem poles. Later, while at the University of British Columbia, he published works such as Arts of the Raven: Masterworks by the Northwest Coast Indians *(Vancouver: Vancouver Art Gallery, 1967) and* Images Stone: B.C. *(Saanichton: Hancock House, 1975). The early progress report that follows appeared in* Canadian Art, Winter 1954.

If the Haida Indians of the Queen Charlotte Islands of British Columbia had carved their totemic monuments in stone, a great Canadian art would have been assured the permanence it deserves. But they chose to carve in wood, and wood carving exposed to the storms and rains of the Pacific Coast is not a lasting medium, so that today we have come perilously close to losing all but the most meagre samples of this important native sculpture.

Recognition of the art of the Indians of the North Pacific Coast, of which totem poles are but the largest and most striking examples, has been late in coming. But in recent years it has come, with a rush. There have been several books, by R.B. Inverarity, R.T. Davis, Erna Gunther and Marius Barbeau. There have been major exhibitions, in Montreal, Brooklyn, Colorado Springs and Seattle. These have emphasized that our native sculptors produced

one of the world's great primitive art forms. Furthermore, it is not only as *objets d'art* in museums that the art of the totem is appreciated; the totem pole as a distinctive emblem has come to be used liberally to flavour the developing regionalism of Canada's West Coast. Totem trade-marks are now used on theatres, on buses, on license plates. British Columbia is fast becoming "Totemland".

The vision an outsider has in his mind of the West Coast is usually one of colourful native villages or of city parks crowded with a wealth of totem poles. But this is far from the true picture. The great numbers of carvings which existed seventy years ago have dwindled away; most of those which remain are fast decaying.

There is little doubt that the characteristic social features of Haida culture are of long standing, and that its characteristic art forms, including some types of totem poles, were developed and nurtured over many centuries of life on the coast. But there is also little doubt that the coming of the fur traders provided the natives with new ways of getting rich, and stimulated those social forces which found expression in art. The availability of better tools brought technical improvements, with the result that in the trading period Haida art reached its amazing climax. By the late eighteen eighties there stood in some fifteen villages more than three hundred and fifty of the largest and finest totem poles ever carved. But smallpox also came with the traders, and alcohol, and these brought wholesale death and demoralization to the Haidas. The nineties saw the remnants of the tribe come together in two villages, Skidegate and Masset. The other sites with their houses and forests of totem poles were left deserted. The nineties also brought missionaries, and in a misdirected zeal to reject heathenism the Haida chopped down and burned a large number of their totems. Perhaps eighty met destruction this way. The remainder, mostly in the abandoned villages, were left to the slower destructive forces of weathering and boring by insects and parasites. A small number of these, perhaps forty, have since been removed from the villages, mainly to new sites in city parks, where their continuing decay

159

is masked by coats of bright paint. Only about a dozen have found promise of permanent preservation in museums.

The writer spent a month on the Queen Charlotte Islands last summer in an attempt to find out whether or not any of the former carvings had survived in a sound enough condition to be salvaged. Extended visits were paid to several of the places made so familiar by Emily Carr in her paintings and writings, namely Cumshewa, Skedans, Tanoo, and Skidegate.

Skedans is typical of the old villages; there the general impression is one of devastation, dampness and ruin. The beams and timbers of the great houses have collapsed. They lie askew on the ground, moss-covered and rotting. The totem poles have fared only slightly better. Nearly all of the tall, hollow-backed frontal poles of the houses have fallen and are shattered, but several of the stubbier mortuary columns still stand more or less upright on their rotting bases. The carvings which are in open clearings are weathered almost beyond recognition. But most of Skedans has been overrun by the encroaching spruce forest, which hides the ruins and provides some shelter from the elements. On many poles spruce seedlings have taken root and grown, and their expanding roots, like wedges in slow motion, have split apart the decaying cedar poles. All of nature's forces here combine to make soil out of wood.

Only in the most sheltered spots, have the poles remained sound and strong and the carving deep and clear. A few complete examples, a few salvageable sections, these are all that remain fit for recovery. These are magnificent remnants. In these weird surroundings the strength and strange beauty of Haida sculpture breathes life into a scene of ruin.

One is appalled that so many of the carvings have been allowed to rot away. About a dozen complete poles and sections of many more can be rescued from the villages. Not sound enough for display outdoors, they, however, would make a fine showing in museums. Used as models, copies for display in parks could be carved from them.

A sensible start in this direction has recently been made by the Provincial Museum in Victoria. It has a three-year programme to give Victoria in its Thunderbird Park the most permanent and representative outdoor display of totem art in existence. Skilled Kwakiutl Indian carvers are making exact copies of the finest old poles in several tribal styles; the originals are thus released for permanent indoor storage and display. In addition, they have produced in the centre of the park an authentic Kwakiutl house complete with carved house-posts, adzed beams and timbers and painted house-front, with a large heraldic pole standing beside the front door. The native carvers, working in a special workshop in the park, are in themselves an educational attraction for both tourists and students. Their best craftsman is Mungo Martin, of the Fort Rupert Kwakiutl tribe, whose carvings in Victoria and Vancouver now assure him a prominent place among Canadian artists for generations to come.

The Museum's programme, however, is of limited scope; by itself it cannot accomplish the larger tasks of salvage and preservation required. But it can provide that nucleus of skills, knowledge, and facilities which is essential if a more major programme is to be successfully launched. Interested groups are now at work promoting such development. It is to be hoped that they will be successful.

24.

"IN SEARCH OF CONTEMPORARY ESKIMO ART"

by James Houston

The native art of the Canadian Arctic has intrigued anthropological critics as far apart in time and style as Edward Sapir and Edmund Carpenter, but it was left to James Houston (born 1921), a Toronto artist and writer, to create a place for it in the Canadian art world. He discovered Inuit sculpture while doing administrative work at West Baffin in the late 1940s and enjoys most of the recognition for creating a public taste for it in the south. It was likewise Houston who introduced printmaking techniques to the Inuit. In turn, he has borrowed from their oral traditions for a series of illustrated books for children. This article from Canadian Art, *Spring 1952, is representative of his tireless efforts at that time.*

A splendid art of stone and ivory carving and delicate line engraving, equal to or excelling any native art on its continent, is found among the Eskimos of Canada's eastern Arctic. That these two Eskimo cultural groups, the coastal or seal people and the inland or caribou people, should be so creative is not surprising for they have always shown great ability in all the crafts they undertake.

Their slim kayaks are said to be the most perfectly devised water-craft in the world. Their clothing, made of caribou skins, is well tailored, and unsurpassed for warmth and comfort by any we have yet developed. The seal-oil lamp, the harpoon and fish spear are unique designs perfectly suited to the Eskimo's requirements.

Because the natural resources of the Arctic north of the tree-line are extremely limited by the climate, these people dwelling on the tundra and along the rocky coast line of Hudson Bay and

162

Baffin Island have been forced to use every inventive power and technical skill they possess in order to remain alive.

As the Eskimo's entire life is motivated by a quest for food, and animal fat for heat, in his creative work we see art through the eyes of a hunter. He keenly portrays the other hunters, the animals and objects around him. His expert dissection of game gives him a fine anatomical knowledge of the animals he lives on, and this readily shows in his well proportioned carvings. We also see in his work a reflection of his playfulness and good humour—a quality rarely found in our Indian arts.

The surge of civilization that swept the continent in the past century stamped out many Indian ritualistic tribal arts, and later replaced them with a meaningless souvenir trade. But their geographic remoteness protected the Eskimos, who were by-passed, and the link between past and present in their art is as yet unbroken.

When we ask an Eskimo if he carves art objects (*sinourak*), he replies: "Certainly". In a land where people, whose lives are governed by the hunt, live in small groups of two or three families, everyone must be able to do everything: make a pair of boots; shape a harpoon; braid a dog-whip; build a kayak; fashion a knife; sing a song; and, of course, create a pleasing object of art.

Kopeekolik, an Eskimo from Povungnetuk, once brought me a splendidly carved stone walrus, the best I had ever seen. I wanted to know if he would make me another one. He looked at me for a moment and then asked, "Why?" He said, "I have carved a perfect likeness of a walrus. Why would you want me to make another one?" As far as he was concerned he had proved his craftsmanship as a walrus carver and that was the end of it. I then suggested that I had never seen him carve a caribou; he was at once excited by this idea and immediately left to select the stone.

The Eskimo practice of carving is thousands of years old. In the past, and to some extent in the present, the carvings were made as miniature likenesses to bring good fortune in hunting, to be placed in the graves of the dead, to be worn or used as protective amulets, and to serve as toys or games.

163

The Eskimo still uses his primitive methods in carving. A bow drill is employed to make holes. The ivory mouth-piece steadies the revolving drill shaft while the carver holds the object in his free hand. He attains the carving's smooth shape with a rough stone and stone dust, and its polish by submerging it in seal oil. Later he rubs it to a fine finish with his hands.

Files are now used, but when these are not available, the Eskimo readily returns to the old ways.

The complete adoption of our methods will probably not improve the art of the Eskimos, as their simple tools force them to study the raw materials and best utilize their natural shape. Infinite care and patience are shown. Like the Chinese, they keep their small objects wrapped away, instead of on constant display, until they are passed to a guest for inspection. For this reason, we find all the parts (such as the pads of bears' paws) carefully carved in detail.

The Eskimo never has wasted his energies on warfare, and the climate demands that he spend a considerable amount of his time inside his home. Thus, he has had the opportunity to perfect his art.

Of course, I had no knowledge of this when I first visited the Arctic in 1948. But my thoughts were filled with the north, and I had long had a desire to draw the Eskimo in his true surroundings. I boarded a train in August which took me as far as the rails would carry me—to Moosonee on the southern tip of James Bay. There I had the outrageous good luck to be offered a plane trip to Port Harrison and Povungnetuk on the east coast of Hudson Bay.

I had the best time imaginable. The Eskimo carver is inspired with the coming of each new season, and by the migration of game. In some subtle way it is thought good luck to carve the animal one is about to hunt. You can feel the excitement of the search for walrus, of the seal hunt, of the coming of the geese, of the salmon run in the rivers, by looking at the carvings as they come in. One month there will be an abundance of geese, the next month of walrus, and so on. The fatness or the leanness or the agility of the animal is in each instance depicted with the concentra-

164

tion of a carver whose whole mind is focussed on his future food supply. There is no copying of one another in this work.

A month later I returned south with my drawings; but more important I had some splendid carvings in stone, made by the Eskimos.

The Canadian Handicrafts Guild suggested that I might make a test purchase for them the following summer. The object was to find out whether the Eskimos on the east coast of the Bay could produce carvings in quantity and of a quality that would be saleable.

Once the Eskimos fully understood that we wanted to trade cartridges, tea and so forth, for all their work, they went at this new industry excitedly. They were paid by means of a system of chits through the facilities of the Hudson's Bay Company, and soon the allotment of money was used up.

When a sale of the Eskimo work was held that fall in Montreal it was advertised by the Guild to last a week; but to our delight, everything was sold out in three days!

The Department of Resources and Development became interested in the project, and asked the Guild to extend its search for such material even further north. They stressed the need for work in areas that were depressed because of a scarcity of game and offered the Guild a small grant to cover my salary and travelling expenses.

Five trips have been made thus far. Points on the east and west coasts of Hudson Bay have been visited. Hudson's Bay Company post managers are continuing to purchase Eskimo handicrafts at those places where I have spent some time on behalf of the Guild.

Over twenty thousand pieces have been brought out, and sold by the Guild to the Canadian public. The supply has not begun to meet the demand.

We are aware of the many pitfalls in the mass production of this type of art. The Guild does not wish greatly to increase the volume, or in any way change the methods Eskimos now use in their carving. We are aware of the Eskimos' proud sense of individualism, and employ the method of purchasing all of their art—

165

paying larger sums for the better work. We are also much interested in children's work and encourage them by purchasing everything they make, even though we are sometimes only able to offer them a very small price. This has proved fruitful; for in some cases children of fifteen years, after a few months of practice, turn out work that compares favourably with the adult art. The good carver is rarely the good hunter in any Eskimo group. The purchase of carvings, therefore, often improves and stimulates whole families—and gives them a new standing in their community.

It is perhaps an interesting insight into Eskimo character that the truly gifted carver, when he brings a piece to trade, will greatly malign his art. He will say that he is a worthless carver, and that nothing should be traded for his work. When the slip is given in trade, he will put it away carelessly in his parka. Yet not one has ever been lost. And if the price paid is good, he will most certainly have another carving when you next see him.

The work of Eskimo women is an important part of this development. They produce objects of rare design and beauty, utilizing all their skill in needlework and in the blending of furs. In its own way, this work of Eskimo women is unsurpassed in Canada.

In this first step into industry, we find the Canadian Eskimo clever and energetic. He is delighted with the opportunity to improve his living (and to avoid the necessity of Government relief) through the creation of art. Over seventy-five per cent of those in any of the groups we have yet met take an active part in producing saleable work. Certainly this is Canada's liveliest art group.

Their recent work has been shown this year at the Royal Ontario Museum and at the National Gallery of Canada. It is our greatest hope that in the future names like Munameek, Akeeaktashook, Kopeekolok, Tikketuk, Tunkgeelik, Oshweetuk, and those of many other fine carvers, will be well known to all Canadians.

25.

"ABSTRACTS AT HOME"

by William Ronald

In the late 1940s and early 1950s, abstract expressionism faced much the same sort of ridicule that had greeted the red maple symbolism of Tom Thomson and the Group of Seven two decades earlier. In fact, the shouts of derision were louder than before since the chorus was an international one. One cannot help be affected, then, by this brief report by William Ronald (born 1926) in the Winter 1954 Canadian Art. *It describes an attempt to win some small acceptance from the non-prehensile middle class by exhibiting in a Toronto department store. It was successful only to the extent that it led Ronald and others to form Painters Eleven, repeat the battles, and finally win. When this was written, Ronald was commuting to New York, the epicentre of abstract expressionism, and would soon move there for a period of years, like a number of other important English Canadian painters of the day. His relative position in Toronto at that time may be deduced from an editor's note appended to the article, informing readers that Ronald "first attracted general attention in 1952 when he was one of four Canadian artists to receive the Hallmark Art Awards, which are given annually by that United States firm to the winners of an international contest for contemporary designs for Christmas cards."*

During a panel discussion last year in the Art Gallery of Toronto, entitled "Why Should We Buy Canadian Paintings?", George Robertson, as a writer and critic, put forward the suggestion that more should be done to encourage large department stores to sell original Canadian paintings by novel merchandising methods. As I recall, this idea had a rather cool reception. I, however, thought that here was a chance to find a better way of bringing non-objective and abstract art to the attention of the public. A group of us, including Ray Mead and myself who were doing such work in

167

Toronto had previously tried to have it commercially displayed through normal methods but had failed. So, following the panel discussion, I approached the Robert Simpson Company Limited in Toronto and discovered that they were interested. As a result, in October 1953, this firm sponsored an exhibition of abstract and non-objective paintings, under the title "Abstracts at Home". Included was the work of Jack Bush, Oscar Cahén, Tom Hodgson, Alexandra Luke, Ray Mead, Kazuo Nakamura and myself.

The aim was to persuade the general public that this form of contemporary expression in painting was as much at home within surroundings of everyday living as in an art gallery. To illustrate this, paintings by each of the seven artists were used as the central themes in seven actual rooms which were decorated in both traditional and contemporary settings. Also on view in each room was a photograph of the painter and a short quotation by him regarding his work. The department store then ran a full page advertisement in a newspaper, complete with reproductions of each room setting. The advantages of a promotion of this nature are great, both for the artist and for the store itself, and it is certainly an idea which should be encouraged in other Canadian cities.

A successful aftermath of this showing was the bringing together of the original seven participants and four other artists of like aims, who have now arranged to hold a large exhibition of their own in a commercial art gallery. The additional painters are Walter Yarwood, J.W.G. Macdonald, Hortense Gordon and Harold Town. This exhibition, entitled "Painters Eleven", is to be held at the Roberts Art Gallery in Toronto in the middle of February, 1954, and there is a tentative plan to send it afterwards to Ottawa and Montreal.

26.

["INTERVIEW RE: AUTOGRAPHIC PRINTS"]

by Harold Town

This piece of unusually bald exposition from the Summer 1956
Canadian Art *provides evidence of creeping public sophistication
about abstraction, and casts some light on the unique career of
Harold Town (born 1924). Described in an editor's note as "a
painter of distinction..many of our readers may not be familiar
with," he was in fact already the most celebrated, most prodigious
and least typical Canadian artist of his group and generation,
famous (in a Canadian context) the same way Whistler had been
famous: for almost athletic versatility and usually controversial
public stands. His autographic prints, though not a significant
part of his career, had brought him important notice in a 1954
exhibition; when this interview took place, they were scheduled
to be shown at the XXVIII Venice Biennale.*

"The most engrossing and exasperating problem in painting,"
[Town] explains, "is the multitudinous opportunity it offers for
direct creative improvisation in each and every manipulation of the
surface of the picture at any time during its creation." He adds that,
whether the artist clearly understands what he wants in his finished
painting or has only a dim intuition of this, he always must con-
sciously or subconsciously reassess what he is doing while he is
working on the picture surface.

"This being so," Town hence reasons, "the original creative
purpose becomes as laminated as the surface of the picture, convo-
luting further the already intricate empathy of hand, eye, spirit and
will, and bringing into being the time factor, which means memory

of what was on the surface of a picture, what is on the surface, and what was and is intended to be the picture."

This machinery of metamorphosis can involve the painter in a tortuous struggle.

"How then," asks Town, "can one accomplish the miracle that most creative artists at one time or another instinctively seek?...the sudden complete magical revelation in which supreme order and the distilled chaos of experience are united in a whole larger than the sum of its parts? I have been able," he concludes, "partly to realize the magic in print-making.

"Here what work one has done", he explains, "is a thing in itself with a time of its own, and what is created is not really evident as a veritable whole until the paper is removed from the stone, screen or plate; then, like magic the conception of hours, days or minutes past is complete. The result may be hideous or fine but, no matter which, the suspense and drama cannot be removed."

Print-making has thus, in a sense, become a separate world of creation to him. This extends even to place and time. He does not do his prints in the studio where he paints. Instead he walks from Wellesley Street in Toronto to a building about a mile distant, near the gate of Victoria College on St. Mary Street where he has a second workshop.

A wealth of original experiment has gone into the techniques he has developed in his basement printing room. The variety of means he employs is, at times, extraordinary. In some of the prints, the ordinary lithographic process is transformed by the addition of personal elements. "These," he writes, "incorporate both hand pressure and mechanical aids (combs, burlap, thread, wire, etc.)," together with the use of "stencils, templates, screen resists (rubber cement or wax), adulterated inks and collage..."

"All my prints are based upon actual experience, childhood memories, or historical recreations. They can never be rightly called non-objective, a term which to me is meaningless.

"I try also to delineate psychological experience within given situations. I have been greatly influenced by Japanese prints and

170

films, and by colour films generally, such as *Henry V.* Some prints have their origins in my ambivalent reactions to paintings.

"One such example is *Centaur Entering a School of Barbizon Forest.* The origin of this came from my dislike of a picture by Borguereau but then I discovered the essentially comic nature of this same picture, and so I went on to create in my print an abstract parody of a centaur 'tippy toe-ing' into a forest which had somehow become all 'robber-and-sprite' green like a Courbet, whose work I admire."

27.

"PAINTERS ELEVEN 1957"

by Paul Duval

Like earlier congregations of Canadian artists, Painters Eleven was formed for the specific purpose of pushing back the limits of public acceptance—in this case, of abstract expressionism. Its members throve on the give-and-take of combat but no clear victory resulted, only their steady usurpation of the mainstream, a process that altered the character of both attackers and defenders. Continuing the established pattern, the group finally disbanded (in 1960) long after its members had become important as individuals and redundant as a body. The art critic Paul Duval (born 1926) tells the story in this catalogue note from the show "Painters Eleven 1957" held that year at the Park Gallery in Toronto, by which time acceptance was at hand and death, defection and perhaps flagging interest were already taking their toll. The original group consisted of Jack Bush, Oscar Cahén, Hortense Gordon, Thomas Hodgson, Alexandra Luke, J.W.G. Macdonald, Ray Mead, Kazuo Nakamura, William Ronald, Harold Town, and Walter Yarwood: for its time a surprisingly diverse list in terms of ethnicity, gender, and approach, though the first two qualities were not much remarked on and the third downplayed by the sheer power of their coming together.

Duval is the author of books such as High Realism in Canada *(Toronto: Clarke Irwin, 1974) and* Ken Danby *(Toronto: Irwin, 1982).*

Painters 11 is not an art movement. It issues no manifesto. It is not a crusade to save art from anybody or anything.

The 11 painters who originally formed it were brought together by the practical desire to find a common exhibition platform. They shared similar sympathies about painting.

172

The formation of Painters 11 stimulated its members to discussion and heightened creative activity. Its exhibitions have focussed attention on abstract painting done in the Toronto region.

Painters 11 provoked high critical praise during its New York showing of April, 1956. It has since been invited to send several exhibitions abroad. Its individual members have won many major national and international awards.

Within the few years since its formation, Painters 11 has performed a service for Canadian art far beyond its numbers.

In the war of sound (not sight) that surrounds painting today, we hear of a vast and conclusive return to nature, as if nature were a bomb shelter to be used in time of plastic trouble. We are nature, and it is all around us; there is no escape, and those who wish to go back have nowhere to go.

What might seem novel here in Ontario is an accepted fact everywhere else. Painting is now a universal language; what in us is provincial will provide the colour and accent; the grammar, however, is a part of the world.

During the year 1953 an idea was being discussed by several small groups of Toronto painters. One night after a publicity photograph had been taken for a display of the work of seven modern artists in room settings at a Toronto department store, one of the painters suggested calling a meeting to explore the possibilities of this idea. The eleven painters contacted were Jack Bush, Oscar Cahén, Hortense M. Gordon, Tom Hodgson, Alexandra Luke, Jock Macdonald, Ray Mead, William Ronald, Harold Town, Walter Yarwood; the first meeting was held at Alexandra Luke's lakeside studio near Oshawa.

The idea was this; the eleven painters had been exhibiting for years with local and national art societies whose exhibitions were always and perhaps properly so, a cross section of current art expressions, from the academic to the modern. The possibility of an exhibition comprising only work in the abstract and non-objective idiom was discussed. Everyone proved enthusiastic. It had of

173

course happened in many other countries, but never before in Ontario. It was agreed that Bush, who had exhibited at the Roberts Gallery in 1952, should approach the Wildridges of that Gallery with the idea of showing the work of the eleven painters as a group. The Wildridges agreed, and the first show opened on February 12, 1954. Each artist was represented by three unjuried paintings. At the end of a two-week period, Roberts Gallery reported that more people had attended this exhibition than any other in the gallery's history. The local art world stirred but sales were few, and the critics only mildly interested.

After this Toronto exhibition, the show travelled to Ottawa, where it was shown at the Robertson Gallery in March. An Ottawa art critic said that the work was of little consequence, and the artists had no knowledge of the concepts of modern art.

In the year 1955, a second show was held, again at the Roberts Gallery in Toronto; this was in February, and in March it was shown at Adelaide House in Oshawa. Later, arrangements were made through Clare Bice in London, Ont., to have a Painters Eleven exhibition travel the Western Ontario Gallery circuit. Paintings were gathered in the fall of 1955, and shown in London, St. Catharines, Windsor, Hamilton, and Oshawa. In February 1956, they came to Hart House in Toronto for what was considered to be one of the finest exhibitions of contemporary art ever seen in this city. Simultaneously, an exhibition of small paintings was held at the Roberts Gallery. The critics, artists and the public were almost silent. Despite this general indifference, there has been and continues to be a hard core of fervent supporters.

In April 1956, Painters Eleven were invited to exhibit as guest artists from Canada at the Annual Exhibition of the American Abstract Artists held at the Riverside Museum in New York City. The show opened on a snowy Sunday afternoon, April 8th; it was an exciting event for the small Canadian contingent attending, and the New York critics were decidedly receptive and much more appreciative of the unique qualities of the Canadian paintings than the Canadian press had ever been. New York opinion suggested

174

that the Canadian painting was as distinctive as work by members of the American Abstract Artists.

Following the successful New York Exhibition, a show was held in September 1956 at the Arts & Letters Club, Toronto.

On the afternoon of November 26th, Oscar Cahén was killed in a motor accident. This was a great personal loss to Painters Eleven, and a tragic blow to all interested in Canadian art; Oscar was just 40 years old, an artist of tremendous ability, admired, respected, and with great work ahead of him.

No gallery being available in the 1956-57 season for a group exhibition, the eleven made strong individual contributions in the annual exhibitions of the Canadian Group of Painters, the O.S.A., the Water Colour Society, and the 2nd Canadian Biennial at Ottawa. Nakamura, Town, and Hodgson had striking one-man exhibitions at the new Gallery of Contemporary Art, Yarwood and Mead at the Greenwich Gallery, Ronald his first one-man show in New York at the Kootz Gallery, and Hortense Gordon a retrospective exhibition in Hamilton, Ontario.

Due to commitments in New York, William Ronald has resigned as a member of Painters Eleven.

The current exhibition of recent work by Painters Eleven at the new Park Gallery in Toronto includes some of the last painting by the late Oscar Cahén.

28.

["ANNOUNCEMENT RE: THE GREENWICH GALLERY"]

by Avrom Isaacs

Av Isaacs (born 1926) was the most important art dealer of the generation that found itself artistically in the 1950s. The flyer announcing his first show, in 1956, reveals his commercial acumen; three of the five disparate painters—Snow, Ronald and Coughtry—built major and enduring reputations. More importantly, the text points up his key role in helping to create a discriminating constituency for contemporary Canadian art at a time when most commercial galleries depended for their trade on European chocolate box painting, with perhaps a few Canadian artists whom time and changing taste had rendered benign. Yet in a necessary link with tradition, his gallery was also a framing shop (where William Kurelek was employed). The original Greenwich Gallery was located in the Gerrard Street village of Toronto; the name was changed to Isaacs Gallery when the business moved to Bloor and Yonge in 1959. Other artists long associated with it include Dennis Burton, Gordon Rayner, Joyce Wieland, and Robert Markle. In 1987, the gallery moved again, to the Queen Street district, this time following a trend it had no hand in establishing. Isaacs also played a part in the popularization of Eskimo art as proprietor of the Innuit [sic] Gallery.

GRAHAM COUGHTRY - born - St. Lambert, Que. - 1931. Studied at Montreal School of Art and Design, and Ontario College of Art. Worked in Spain and France on Eaton travelling Scholarship. Has exhibited frequently in Canada as well as in Paris and Madrid.

WILLIAM RONALD - born - Stratford, Ont. - 1926. Studied at Ontario College of Art. Currently living in New York City after

working with Hans Hoffman on a C.A.H.A. scholarship. Has exhibited with major Canadian Societies and has paintings in the permanent collections of the Toronto Art Gallery and the National Gallery.

GERALD SCOTT - born - St. John, N.B. Studied at Ontario College of Art. Has exhibited with major Canadian Societies and recently held a one-man show at Hart House. His portraits hang in many private collections.

MICHAEL SNOW - born - Toronto, Ont. - 1928. Studied at Ontario College of Art. Travelled extensively in Europe pursuing his dual avocations of painter-musician. Has exhibited with most major Canadian Societies as well as in Paris and Brussells.

ROBERT VARVARANDRE - born - Lyons, France - 1922. Studied at l'Ecole des Beaux Arts, Lyons and in Birmingham, England. Recently held a successful one-man show in Havana, Cuba.

In choosing this exhibition to mark the opening of the Greenwich Gallery I have endeavoured to present a visual statement of the Gallery's aims for the future. While these five young painters represent diverse directions in painting, their work suggests, I believe, a common standard of artistic integrity and it is my earnest intention to adopt this standard and grow with it as it grows, rather than trying to adjust to any mythical "level of public taste." I hope to make the level which is evident here attractive and easily accessible to the public by making it possible for people to buy paintings by contemporary Canadian painters on a time payment basis and by featuring low priced Canadian and European graphic art. Arrangements are also being made to exchange exhibitions with galleries in other countries and this, along with a planned programme of discussion evenings and similar events, should help to make the Greenwich Gallery one of the centres of artistic activity in Canada. This opening exhibition conveys some of the excitement and optimism I and the painters involved feel toward these prospects. I also make the best frames in town.

29.

"A GARDEN FOR THE EYE: THE PAINTINGS OF JACK BUSH"

by Hilton Kramer

The towering international reputation he enjoyed in the latter part of his career has tended to obscure the fact that Jack Bush (1909-1977) represented a large slice of the chronology of Canadian art. He was a member of both the Canadian Group of Painters and of Painters Eleven. Similarly, and despite the unifying fact of his masterful colouration, he moved in a great arc from a figurative style, one that acknowledged illustration, to that for which he is best known: the hard-edged abstraction of his final years. Along the way he acquired several important international boosters, including Clement Greenberg. This posthumous tribute by Hilton Kramer appeared in the December 1980-January 1981 number of artscanada. *Kramer (born 1928) was the art critic of the* New York Times *from 1955 to 1961 and since 1982 has been the editor of* New Criterion.

"It is only after years of preparation that the young artist should touch colour—not colour as description, that is, but as a means of personal expression. Then he can hope that all the images, even the very symbols which he uses, will be the reflection of his love for things, a reflection in which he may have confidence if he has been able to carry out his education with purity, and without lying to himself. Then he will employ colour with discernment. He will place it in accordance with a natural, unformulated and completely concealed design that will spring directly from his feelings..."

Henri Matisse, 1948.

178

In the Jack Bush retrospective seen in London, England, this fall, there was one painting—*Snowball with Peony and Iris* (1960)—that was unlike any other in the exhibition. Even its title, alerting us to the concrete "subject" that inspired it, differed from the titles of most other paintings in the show. *Snowball* is brushy and "informal" in the manner of lyrical abstraction. It is freer in its colour, simpler in design, and lighter in feeling than the Abstract Expressionist paintings the artist produced earlier on. Its luminous, sunny shimmer clearly owes something to an experience of the flowers identified in its title, yet what Matisse meant by "colour as description," while not totally rejected, doesn't exactly govern what we see on the canvas, either. One is left with the sense of a vivid reminiscence of colour spontaneously distilled and transmuted into its purely pictorial equivalents. One is left, too, with a sense of the artist's "love for things."

Snowball, though a very appealing picture, was neither the strongest nor the best of the paintings included in this exhibition, yet for this writer it proved to be an important one. It confirmed something that was vaguely apparent but only dimly understood in earlier encounters with Bush's paintings. Reviewing the Bush exhibition at the Museum of Fine Arts in Boston in 1972, I wrote that he had "carried the development of colour-field painting into a very personal realm of expression that is in some ways closer to Matisse himself than to some of the Americans who have obviously acted as an influence." I then observed that Bush had "taken a style that was often in danger of degenerating into an impersonal technical exercise and realigned it with the specifications of experience" (The *New York Times*, February 27, 1972). At the same, however, I had no idea of what the "specifications of experience" in Bush's work might be. The importance of *Snowball* was that it now provided an essential clue.

Would it be merely fanciful to suggest that there was something about the pastoral setting of the London exhibition that reinforced the implications of this clue? The show was originally organized by Duncan Macmillan for the University of Edinburgh's Talbot Rice Art Centre at the time of the Edinburgh Festival (August

179

15-September 13). It then moved to the Serpentine Gallery in London's Kensington Gardens (October 11-November 16), which was where I saw it in October. The Serpentine has often proved to be a difficult space for a painting exhibition. The building is essentially a small pavilion isolated in the open verdant acres of a London park. Its rooms are awkwardly divided, and on bright days they are flooded with natural light. It isn't every painter whose work can withstand the light from within or the vistas that beckon from without. Yet Bush's paintings took complete possession of this setting, quite as if they were intended for it. Which suggests to me that he was, in a sense, a pastoral painter whose "love for things" expressed in his work must often have had something to do with gardens and flowers.

Dr. Macmillan is, I believe, the first writer on Bush's late work to explore its debt to nature in this respect. In his essay for the catalogue of the exhibition, he tells us that *Snowball* belongs to a group of abstract flower pictures that Bush never exhibited. "In them," he writes, Bush "displayed for the first time, and far more vividly than in the other pictures of the time, the sense of colour that became the most famous feature of his work." And he goes on to spell out the exact relation that obtained between this sense of colour and the observation of nature. "The pictures are taken so directly from nature," he writes, "that it is clear that the colour is the colour of the flowers." He then supports this observation with some essential biographical information. "He continued, too, to look to nature for his colour," Dr. Macmillan writes. "Alex Cameron, his assistant during the last five years of his life, describes how he would bring leaves and flowers to the studio. Mabel Bush, his widow, in a conversation with the author, looking out at the garden of their home in Toronto, said quite simply, 'that was what he painted.'" Dr. Macmillan concludes that "reference to the natural world remained a vital part of his work and is often very near the surface," and suggests that it is "the continuing link between his early and his late work."

It risks vulgarity, perhaps, to suggest that abstract painting at this level may contain some concealed or transmuted reminiscence

of nature. The philistine mind is, after all, always on the hunt for thematic revelations of this sort, and more often than not they prove to be aesthetically irrelevant even where some evidence for them can be found to exist. Yet in Bush's case, at least in the paintings that Dr. Macmillan selected for this exhibition, what I take to be the "garden" motif is so persistent that, once glimpsed, it can hardly be ignored. Nor can I see that it in any way diminishes the purely abstract element in Bush's painting to acknowledge its subliminal attachment—if subliminal it was—to a concrete realm of observed experience. It simply adds another level of meaning to the abstract element that remains, undeniably, the dominant element in the art of Bush's maturity, and not a level easily dismissed from any final reckoning.

Clearly the turn towards colour-field abstraction that Bush succeeded in realizing and building upon in his art from 1960 onward released something fundamental in his sensibility as a painter. This is not something that the experience of nature, no matter how dearly prized, is ever sufficient in itself to secure for an artist as acutely conscious of pictorial traditions as Bush was. It was in the American painters of the colour-field school that Bush found the impetus he needed to achieve that release. The example of Kenneth Noland is said to have been particularly important to this process. From the look of the painting called *Soar* (1961), I have the impression that Motherwell may also, though with a less permanent effect perhaps, have remained a factor. Dr. Macmillan speaks of Motherwell's influence earlier on, in the late fifties, when Bush was still working in a more or less Abstract Expressionist manner. He cites *Mute Beginnings* (1958) as an example, and the reproduction of this painting in the catalogue certainly suggests a debt to Motherwell's *Spanish Elegy* series. (Unfortunately, *Mute Beginnings* and two earlier paintings from the 1950s were omitted from the London exhibition, though they were shown at Edinburgh.) There is a lot of Matisse in *Soar*; but it looks to me like Matisse filtered through Motherwell. Matisse was central to Bush's whole later development, of course, but it was through his absorption in American painting that he got the Matisse he needed. Once he was

181

launched on his new course, however, Bush displayed a quite remarkable wisdom and independence. Did his position as a Canadian—closely attentive to American developments, yet the cultural offspring of a very different history and milieu—contribute something important to this? My impression is that it did, that it gave him a certain inner margin in which to develop on his own terms. I think his age and experience contributed something important, too. Bush was in his fifties when he had his first one-man show in New York in 1962. The work that he produced in the 15 years that followed—the work that he will be remembered for—has all the power, the compression and intensity, of a "late" style. It is not the work of a young artist testing his first discoveries. There is nothing tentative or second-hand in it. It summons great reserves of strength that are now focused with an uncanny clarity.

To our attempts to understand exactly how Bush achieved this late style Dr. Macmillan has made another important contribution by exhibiting—for the first time, I believe—some of the small studio drawings that from 1963 onward appear to have formed the basis for much of the painting. These drawings are often remarkably complete, in their fusion of colour and form—complete, that is, in the way they make colour the basis of form. The division of the canvas into zones of colour can be seen to be pretty thoroughly worked out in them. It is in the drawings that we glimpse the intuitive, improvisational aspect of Bush's colour decisions in the painting, and it is one of the miracles of the painting that it succeeds so well in retaining the freshness of an idea already so completely realized on paper. Something else results from the drawings, too. Dr. Macmillan suggests that "the brilliance of ink on paper influenced the colour of his oil paint," and this appears to be true—true even in the last paintings where transparency is eschewed in favour of a return to a brushy surface and a thickened texture.

In the radically delimited idiom of colour abstraction, every mark on the canvas acquires a heightened significance, of course. So does every change in texture—every shift in the weight of what impinges on the eye. The tendency of large areas of colour to

"float," so to speak—to detach themselves from the surfaces containing them—and declare their independence of the support they are meant to articulate, is likewise heightened in this idiom. In colour abstraction, our experience of every detail in the execution is thus greatly magnified, rather as it is in a colour slide of a painting of any style or period that is projected upon a large screen. (It would be interesting, as a matter of fact, to explore sometime the parallel developments of colour-field painting and the increased use of these colour-slide projections in the classroom. Surely it means something that they coincide so exactly.) Projecting a colour slide on a large screen, with everything this entails in the intensification of light and scale, in effect turns every painting into a colour-field experience.

Bush appears to have prepared his paintings for this sort of intensified scrutiny very carefully in the drawings, which, in effect, functioned for him like "slides" that were "projected" onto the canvas. Perhaps this accounts for the degree of finish we find in the paintings. They do not strike us as having evolved from "discoveries" made on the canvas. Again, I think it was Bush's age and experience that counted for something in this process. We are never left feeling that he has exploited a lucky accident. The control is just about total. This was to be expected, perhaps, in the ladder-image paintings—*Tall Spread* (1966), say, and *Floating Banner* (1968) in which the total "field" is locked into a structure that the slightest hesitation or overemphasis would very likely ruin. (It is worth remarking that Bush never resorted to using masking tape in such pictures—a common practice in colour-field painting at the time. Every edge and seam has a hand-drawn feeling that contributes something important to our experience of the total image.) But the same degree of control is there in the paintings that follow the caesura caused by the heart attack that occurred in 1969—paintings that Dr. Macmillan describes as consisting of "high-coloured, flatly painted shapes against deeper-toned, broken grounds." In these paintings—from *Irish Rock No.2* (1969) right through to *Sharp Flats* (1976) and the other wonderful pictures from that year before he died—the image

183

recedes slightly from the edge of the support, and this, combined with the increased density of the ground painting, has the effect of "lifting" the image off the canvas and floating it into a space where it meets the descent of those "high-coloured, flatly painted shapes" described by Dr. Macmillan. (Is there, perhaps, a reminiscence of Matisse's *L'escargot,* the big 1953 gouache découpée in the Tate Gallery, in the form and movement of these shapes in *Sharp Flats* and certain other works in the 1976 series? Seeing the Matisse again a day after the Bush exhibition gave me the feeling that Bush had studied this work very carefully.) This last series of paintings constitutes, in any case, Bush's finest work. There is some thing eerie in the spectacle of all this strength gathering force on the eve of the artist's death, quite as if he were transferring his vitality to the canvas and leaving nothing left over for his life. There was a year near the end of Milton Avery's life when we could see the same thing occurring; he, too, painted his best pictures that year. Perhaps this is part of what we mean when we speak of "late" art. There are fine painters who never achieved it—Picasso was one who didn't—but Bush achieved it triumphantly.

He was certainly one of the best painters of the last 20 years, and this exhibition showed him at full strength. Part of his genius, I think, lay in his ability to keep his painting so closely in touch with his experience. Dr. Macmillan gives us many examples of how he accomplished this, the constant renewal of his imagery based on "his love for things" in the observable world. For myself, it is the image of the garden that remains central to the end. It is sometimes there in almost literal terms, as we can see in *June Garden* (1974), but it is always there in one way or another. It was the home of his pictorial imagination, and from it emerged each of these late paintings that address us as a garden for the eye.

30.

["THE PROBLEMS OF PAINTERS
AND GALLERIES"]

The Massey Commission

*The Royal Commission on National Development in the Arts,
Letters and Sciences, convened in 1949 under Vincent Massey and
popularly known as the Massey Commission, was the most
extensive study of Canadian culture ever undertaken. The fact that
the government acted on a number of its important recommenda-
tions makes it unusual. What makes it extraordinary are some of
the tangible results, such as the creation, in 1957, of the Canada
Council. There is much to be said for the frequently expressed
view that the commission's report, which was tabled in 1951,
heralded a new and exciting age of Canadian culture, one which
lasted at least until the late 1960s. At the very least the report
signalled that henceforth the federal government would fulfill a
major function in the arts, as patron and also warden. These two
excerpts from the report discuss measures to alleviate some of the
pressures on painters and curators.*

PROBLEMS OF THE CANADIAN PAINTER

12. ...The Canadian painter faces very serious problems. Painting
in Canada is not yet fully accepted as a necessary part of the gener-
al culture of the country, to the detriment both of the painters and
of other Canadians. Canadian painting does not receive sufficient
recognition from either official or private sources. The result is that
in spite of the great enthusiasm of the painters and of important
groups of amateurs, they are still somewhat isolated from the rest
of the population. Art galleries, as we have said, do all they can to

bridge the gulf, but they have not sufficient means to allow them to encourage Canadian painting by regular purchases of Canadian pictures. The result is that, although there is Canadian painting of very high quality, the Canadian public needs more Canadian painters and more Canadian paintings. The Royal Canadian Academy of the Arts, for example, spoke to us of "the quantity production which we so badly need in this country of quality work."

13. ...Yet our small group of Canadian painters in more ways than one makes a notable contribution to the cultural life of our country. We heard of an art centre founded partly through the generosity of Canadian painters who helped to raise the necessary funds through the gift of their paintings. Our painters, as they themselves have told us, constantly lend their work without fee to exhibitions of all kinds, although they not infrequently receive it back in a somewhat damaged state. We heard from the Northern Ontario Art Association of the generosity with which painters of wide reputation helped to organize beginners' courses in the fine arts without any remuneration to themselves. We had a similar expression of appreciation from the West Vancouver Sketch Club. We cannot but admire the restraint and discretion with which Canadian painters have spoken of their material problems and of their needs.

14. We have also noticed their strong sense of the freedom and integrity of the artist. The brief of the Federation of Canadian Artists states:

> "The arts must not be dominated, regimented or exploited to serve special or narrow ends; they are an unfolding and evolving expression of the inner consciousness of the individual or society.....The arts can be stimulated, encouraged, fostered, assisted, and they may have new horizons opened to them, with nothing but advantage. But if their natural development is interfered with, no matter what the immediate results may be, the final consequences will be destructive both to the arts and to the power that has undertaken to dictate to them."

186

Speaking further on the question of an organization for the co-ordination of the arts, the representative of this Federation said: "...This organization, however it is set up, must avoid impinging upon the freedom and independence of the artists. The artist must not be left in the position of being subject to direction as to the nature of his work."

This does not mean that our painters wish to work in isolation or that they hold themselves aloof from society. They have, on the contrary, expressed both their national and their international interests. They are conscious, as we have suggested, of the importance of making painting a force in Canadian society. The Royal Canadian Academy of the Arts pointed out that the Academy wanted to be regarded as a working organization, existing to serve the public rather than the particular group which it represented. Canadian painters insist at once on their liberty and on their necessary function in society. They are, however, no narrow nationalists. The Canadian Group of Painters urged an increase in invitations to painters abroad to hold exhibitions in Canada.

15. At the same time, Canadian painters, as we have shown, feel that they could serve their country better if there was in Canada a more general recognition of the worth and dignity of the artist; and, in particular, if there were more opportunities for the artist to live by his art without resorting to other pursuits. Asked by the Commission whether economic conditions were favourable to the practice of art, Mr. Pellan replied, "We are compelled to perform certain types of work which are irrelevant to our interests as artists; we are quite unable to live from our art alone." A young amateur from Chicoutimi, that part of the province of Quebec where so many Canadian painters, abstractionists and naturalists alike, go frequently for inspiration, was more outspoken: "Just as much as workmen, artists have the right to eat, to live in a house, and even to sleep without too much worry. There should not be men who have the right to live and others who have the duty to die of starvation. To continue the suffering of a great company of talented artists under the absurd pretext that the work of an artist is not productive is part of the coarseness which dishonours a nation."

187

16. The Federation of Canadian Artists urged that to provide the artist with the means of a livelihood was for the nation a good investment from every point of view: "The cultivation of the arts is not a luxury but an essential prerequisite to the development of a stable national culture; and for this reason justifies the expenditure of very considerable effort and money. Just as language is necessary to the development of reason, so is the more fundamental language of the arts essential to the development of the basic emotional and imaginative nature that underlies reason and dominates action. Without an adequate development of this submerged seven-eighths of man's nature, any society that he creates must lack inner integrity, self-reliance, cohesion, and awareness of itself as an entity;..."

17. We have received with interest a number of suggestions on the means of making possible for our painters a greater degree of material independence and, as a consequence, greater liberty of action, and more time for creative work. Various associations interested in the arts, such as the Northern Ontario Art Association, the Canadian Federation of Home and School and the Canadian Arts Council, suggested that established painters be given bursaries or awards which would permit them to devote, for longer or shorter periods, their entire time to their art. The Federation of Canadian Artists even recommended a title for these bursaries or awards: "Dominion of Canada Art Scholarships". These would be in Canada the equivalent of the pensions which certain other countries grant to their poets and to their artists.

18. This same Association adds to the first proposal for grants a series of recommendations for the initiation of a national scheme in the arts similar to the War Artists Project of the United States. This project, which would be supported by the state, would inspire our painters to produce works of which the best would be included in the collections of the National Gallery. Other works more purely pictorial or descriptive in nature would form the nucleus of collections intended to depict certain areas or certain aspects of Canadian life; for example, a series of such paintings would be commissioned to decorate our public buildings at home

and our diplomatic missions abroad. Finally, through the co-operation of an appropriate agency, the sale of works of art of all kinds to important Canadian institutions, whether public or private, would be encouraged. The Federation of Canadian Artists includes also in its proposal the commissioning of representative works of art, demonstrating different techniques and varying achievements in Canadian painting, intended for sale to local museums. An important part of this ambitious project, which has also been recommended by the Calgary Allied Arts Centre, is that in addition to providing our best painters with rewarding commissions, it would create currents of curiosity about Canadian painting which are as necessary to the vitality of art as the circulation of the blood is to the life of the body.

19. Although such schemes as have been suggested are desirable and necessary for the encouragement of Canadian painting, the Canadian Arts Council reminds us that what the artist really wants and needs is an increase in regular purchases and commissions. In Canada, it is very difficult for an artist to live by these means. The National Gallery is the most important institution to make a regular practice of purchasing Canadian works of art; it was suggested to us that the average sum of $32,000 which the Gallery has been able to devote to its entire annual purchases during the last ten years is far from adequate and that the proportion which can be devoted to the acquisition of Canadian paintings is quite insufficient. Voluntary societies are in agreement in recommending purchases on a much more generous scale. They urge also, however, the importance of organizing throughout the country more numerous and representative exhibitions of painting in order to educate the public taste. In the long run, these exhibitions, by making people everywhere more interested in and familiar with Canadian painting, would encourage private purchases. These exhibitions would therefore not only educate the Canadian public but would help to support the artist.

20. That the education of the Canadian public is a matter of first importance has been stated to this Commission on numerous occasions. The Director of the National Gallery did good service to

the cause of painting in Canada by pointing out that exhibitions held in Canada do not produce such satisfactory results as exhibitions of Canadian painting held abroad. Canadian painting has been exhibited in England, France, South Africa, Australia, the United States, Italy, and Belgium. These exhibitions not only brought to the artist an increased prestige, but also gave him an opportunity to sell abroad certain of his works; art exhibitions which are held in Canada do not produce the same happy results. The Société Canadienne d'Enseignement Post-Scolaire recommended that exhibitions abroad should be increased but that at the same time everything should be done to obtain greater practical results from exhibitions of painting in Canada.

21. A number of other suggestions have been made to us for increasing the interest of the Canadian public in Canadian art. For example, the Vancouver Art Gallery and the Northern Ontario Art Association believe that a campaign to increase the circulation of *Canadian Art*, of which there are now published six thousand copies, would arouse a helpful interest in Canadian painting. Other associations propose that the government assist financially the publication of articles on Canadian art and of albums of Canadian painting. The reproduction of paintings in the National Gallery has also inspired proposals which would give help to our painters. The Saskatchewan Arts Board states that reproduction of Canadian works should be exhibited in our schools so that Canadian art would become a daily reality for the pupils. At present, unfortunately, the public appreciation is so limited that the Art Gallery of Toronto, having begun the experiment of publishing each year a large-scale reproduction of the work of one Canadian painter, was forced to discontinue the venture for want of public interest and financial support. We recall, however, that the Sculptors' Society of Canada, commenting on "piratical" activities which extend even to federal agencies, maintained that artists should receive a commission on all reproductions.

22. Another suggestion that was made to us for the assistance, or rather for the proper support of painters, was the payment of a fee to artists who lend their paintings for exhibitions. As

190

we have mentioned, they now lend their work without charge and often receive back after a considerable interval a damaged painting which they might have been able to sell privately. In the United States it may happen that all paintings exhibited in an official exhibition are purchased by the sponsors, but more commonly there is an agreement that a certain proportion of them will be thus acquired. It was proposed to us that some such practice should be followed in Canada.

23. We have already mentioned a number of other suggestions for increasing in Canada an understanding and appreciation of the work of Canadian painters. It is generally agreed that the educational work of the National Gallery could be extended; and that more might be done through the C.B.C. and the National Film Board to stimulate public interest which has already responded warmly to efforts made in the past.

24. Canadian painting, through its honesty and its artistic value, has become above all the other arts the great means of giving expression to the Canadian spirit. Canadian painting has become one of the elements of our national unity, and it has the particular advantage of being able to express its message unimpeded by the barriers imposed by differences of language. But in order to perform his civilizing function, both within and without our country, the Canadian painter must receive appropriate encouragement. The problem facing Canadians is to find a practical means of giving to the painter a place in our national life as important as the place which he himself in his art gives to the moral and material aspects of our way of living.

GALLERIES

The National Gallery

1. Of all the Federal Institutions dealt with in this section the National Gallery has perhaps the most universal appeal, and has certainly achieved the widest contacts with the Canadian public. Some seventy briefs discussed its work, many of them in considerable detail. There was much appreciation and helpful criticism which will be noticed later. We were particularly interested in the wide variety of purposes represented by the groups which came before us to discuss the services and the problems of the Gallery.

2. The National Gallery has been in temporary quarters for seventy years. It was founded in 1880 by the Marquess of Lorne, who selected the pictures which were then lodged with the Department of Public Works. In 1907 an Advisory Arts Council was appointed, first, to administer grants to the National Gallery and second, to advise the Minister of Public Works on purchases of or expenditures on any works of art, including monuments in Ottawa and elsewhere. In 1910 the pictures were moved to the east wing of the Victoria Memorial Museum building where they still are. The Gallery was incorporated by an Act of Parliament in 1913, under the control of a Board of Trustees. The Board was entrusted with the development and management of the National Gallery, and with the cultivation of Canadian interest in the fine arts.

3. The various functions of the Gallery have been described to us in some detail in the National Gallery brief. The National Gallery, we are informed, should not in any sense play a paternal role in relation to other institutions but should advise upon, stimulate and co-ordinate art activities in Canada which the Gallery believes are the better for being the result of local initiative. The relations between the National Gallery and art societies in Canada have been, we are told, most cordial and co-operative.

4. The first charge of the National Gallery is, as the brief states, the development and care of the national collections. The

Gallery's collection of Canadian art is the most complete in existence, and the European collections, although not fully representative, are regarded as important by well-informed authorities in Canada and from abroad. Requests for the loan of important individual paintings in the collection for exhibitions in other countries are received from time to time. Each request is considered on its merits, in accordance with the importance of the occasion, the prestige and equipment of the receiving institution and the conditions of transportation. Such loans enhance the international recognition of the importance of the National Gallery collection, and the treasures of the Gallery become more widely known and studied by experts. Loans from the European collections in the National Gallery have been made to American and to British galleries. In 1949, a request was received for a Botticelli to be sent to a special exhibition in Florence.

5. The second important service of the Gallery is the arrangement of loans and exhibitions from abroad, or from its own holdings which are sent to galleries throughout the country. During the past twenty-five years exhibitions have been brought to Canada from some twenty other countries including Britain, France, the United States, Australia, Germany, Poland, and Sweden. In addition, the Gallery sponsors exhibitions of Canadian painting which have increased in number from 31 in 1928-29 to 200 in 1947-48. These may be arranged by the chartered art societies, such as the Royal Canadian Academy of the Arts, the Canadian Group of Painters or the Canadian Society of Painters in Water Colour. The Gallery has arranged from time to time retrospective exhibitions of the work of Canadian artists, notably those of Morrice, of Emily Carr and of Pegi Nicol.

6. There are, however, two major limiting factors, apart from the cost, in the extension of loan exhibitions. One is the absence in other Canadian cities of fireproof buildings in which to hang the pictures, and the other is the want of experienced staff in local galleries to take care of unpacking, display and repacking. There are only about six local art galleries in the country completely satisfactory in these respects.

7. Another very important function of the Gallery is its general extension work. In 1922 the present Director, on tour in Western Canada, discovered the need for reproductions of Canadian pictures. A year or two later a series of reproductions in large and in postcard sizes was begun. These were sent out to schools with lesson leaflets prepared by an expert in art education. This educational programme was carried further with the development of radio which made possible broadcasts from the Gallery over the national network. The National Gallery has also taken an active part in the production of films dealing with the work of Canadian artists. It has encouraged lecturers from abroad to come to Canada. The officials of the National Gallery consider that broadcasts and films on art undertaken at national expense are a legitimate and essential part of the Gallery's responsibilities. The production of large silk-screen prints of Canadian paintings was undertaken by the Gallery during the war. These reproductions have been displayed throughout Canada and in many places abroad. We were interested in a suggestion from British Columbia that they should be purchased for display in rural post offices in order to bring Canadian paintings to Canadians everywhere.

8. The National Gallery also undertakes to send exhibitions of Canadian art abroad. This work began in 1924 when the Gallery was put in charge of the Canadian Section of Fine Arts at the British Empire Exhibition in London. The event created great interest in Canadian art and has been followed by a series of Canadian exhibitions in various parts of the world for which the Gallery has been responsible. These include the first continental exhibition of Canadian art in Paris in 1927, and later exhibitions in the Argentine, South Africa, Australia and New Zealand. The series culminated before the recent war with the "Century of Canadian Art" at the Tate Gallery in London in 1938. Since the war there have been other important exhibitions including the recent large and representative one in Washington.

9. The National Gallery states that it can only with difficulty carry on even its present services unless certain immediate needs are met. First of all, it asks that its present anomalous position in

relation to the Department of Public Works be clarified and that it be established as a separate branch of government under a Board of Trustees, with a status similar to that of the Public Archives. It is further suggested that the general advisory functions of the former Advisory Arts Council be revived and re-assigned to the Board of Trustees of the National Gallery. It is considered important that some competent authority be responsible for advising the Government on such art matters as are properly a matter of public interest.

10. The second need, according to the brief, is a new building. The present building is inconveniently situated, ill-arranged and badly lighted; it lacks proper facilities for the staff; it is overcrowded, and the temporary partitions together with the highly inflammable materials used in the basement workshops form a serious fire hazard. The very large collection of historical paintings of the First and Second World Wars is, for the most part, still in storage. The new Gallery should have adequate space for the display of pictures, prints and drawings, sculpture and loan exhibitions, a reference section, a library and proper office accommodation and an air conditioning plant. A photographic studio and a laboratory for the inspection and repair of works of art are also necessary. The present laboratory, which is completely inadequate, undertakes to serve all the public galleries in Canada.

11. A greatly increased staff is also needed immediately since the amount and the variety of work at present is quite beyond the power of the Director and his three professional assistants. The following statistics give a comparison between the present staff of the National Gallery and the staffs of certain American galleries which, although they may have larger collections, obviously have not comparable national responsibilities:

Staff Members

Philadelphia Museum of Art	46
Cleveland Museum of Art	45
Museum of Fine Arts, Boston	43
Worcester Art Museum	33
Art Institute of Chicago	32
Toledo Museum of Art	26
National Gallery of Canada	4

It was suggested to us that the staff of the National Gallery should be at least doubled immediately.

12. For the extension of the staff and for the purchases of works of art an increased appropriation is urgently needed. Another comparison with the annual budgets of American galleries shows how modest is the amount spent by Canada's National Gallery:

	Purchase Fund	Total Expenditure
Boston Museum of Fine Arts	$317,498	$955,963
Toledo Museum of Art	328,447	656,894
Cleveland Museum of Art	157,305	493,754
Philadelphia Museum of Art	Not published	798,094
National Gallery of Canada		
(average for 10 years)	32,000	90,000
(appropriation 1950-1)	75,000	260,770

In the ten years before 1950 the National Gallery cost the country less than one cent per head of the population per annum. The figure in the United Kingdom and in the United States would be at least three or four times this amount.

13. We received interesting information on the Industrial Design Section of the National Gallery, a recent venture which has received much support and encouragement. In a number of west-

196

ern countries there have been conscious and concerted efforts by government departments and agencies, manufacturers and others for the improvement of industrial design. The well-known Swedish experiment was described to us as well as more recent developments in Great Britain and the United States.

14. In Canada, there are few industrial designers and only since the recent war has there been official recognition of the importance of Canadian industrial design. In 1946, the Department of Reconstruction and the National Research Council co-operated with the National Gallery and the National Film Board in putting on an exhibition which might provoke interest in the matter. The exhibition was arranged, was shown at the convention of the Canadian Manufacturers' Association and later toured the country.

15. As a result of the interest aroused among manufacturers and others, a small office was established in 1947 under the supervision of the National Gallery to investigate problems of industrial design, to establish a record of all original Canadian work, and to answer the numerous requests for information. In the following year, partly because of American exchange difficulties and the resulting demand for parts and products designed and made in Canada, there was established an Advisory Committee of some thirty manufacturers, designers and representatives of universities which meets several times a year to advise the Industrial Design Section, to co-ordinate efforts for the improvement of industrial design, to develop public interest through exhibitions, and to provide training for those engaged in design through the granting of scholarships.

16. The great need of the Industrial Design Section at present is for more space for its activities and for exhibition purposes. We understand that arrangements are being made to meet this need. We have been reminded more than once of the importance of good industrial design as a means of raising the level of public taste. In the United States, as in our own country, art galleries have assumed much responsibility in this work of general education.

17. We have dealt with the work of the National Gallery in general terms because, as the preceding pages have shown, much

of its important work goes on outside the building, and far from Ottawa. It was mentioned earlier that the original function of this national institution was to encourage Canadian interest in the fine arts. It operates therefore not only in Ottawa but throughout the country, and to see its work as a whole one must leave the capital and visit the local galleries in the provinces.

Local Galleries

18. The local art gallery in Canada, although confronted with serious and sometimes baffling problems, presents on the whole a cheering picture. Just as the National Gallery is the federal institution in which voluntary societies take the most interest, so the local gallery in many places receives the warmest support. There are a number of reasons for this. Painting is one of the arts in which Canadians have acquired some reputation even beyond the borders of the country, and there is within Canada a wide and growing enthusiasm for amateur painting. Moreover, local galleries have been fortunate in maintaining a connection with and securing services from the national institution, as well as in co-operative efforts among themselves. A reading of the briefs and evidence reveals no undue complacency but an intelligent and critical evaluation of what they have been able to do for themselves and of what the National Gallery may do for them.

19. We have heard from nine galleries in all, including all but one of the "Grade A" galleries in Canada, so called since they have reasonably fireproof buildings and are recognized by the National Gallery as suitable and safe for valuable exhibitions. We have also learned of nine other regular exhibition centres, and of nine painting and sketch groups which hold exhibitions as or when they can. We have thus learned of the plans and problems of a great variety of institutions from the large metropolitan gallery to the local sketch group holding its annual amateur exhibition in the basement of the fire hall.

20. It is, however, scarcely necessary to mention that there is no gallery in Canada to compare with the wealthy and established

198

institutions to be found in the United States and abroad. All galleries in Canada regard themselves as poor; but with their limited resources they try to carry on all usual functions of such institutions and to make the most of what they have. Collections are developed with care and economy. Poor galleries, we were told, cannot afford to buy in the fashionable market, but must secure what is good at a time when it is not dear. There was much interest in problems of arrangement and display to meet the needs both of the public and of students. Small and flexible permanent displays with special facilities for students are recommended by the Art Gallery of Toronto.

21. Much attention was given to travelling exhibitions which naturally are of special interest to small galleries. All those from which we heard receive exhibitions from various sources; through the National Gallery, or directly from abroad, and from different parts of Canada. Local exhibitions, professional and amateur, especially the latter, are of course available to all galleries, large and small. Some larger galleries, although they may depend exclusively on local support, devote much time and effort to organizing regular series of exhibitions in smaller galleries in their areas. The Art Gallery of Toronto offers a number of circulating exhibitions every year to various institutions. These are composed mainly of photographic panels or reproductions, with a few originals. For the past seven years, the London Art Museum has operated a regular circuit in nine cities of western Ontario; sometimes speakers accompany the exhibitions. Other cities have asked to be admitted to this circuit and have had to be refused; but occasional exhibitions have gone much farther afield, even to Prince Edward Island. The Gallery would like to increase this service, at present offering about 100 showings a year, if its resources permitted.

22. Art circuits may also be arranged co-operatively by all the galleries in a certain region. In Western Canada three "Grade A" galleries participate with eleven smaller galleries to form the Western Canada Art Circuit, created in 1944 to facilitate the exchange and circulation of exhibitions among its members. Exhibitions are selected and a schedule is drawn up at an annual conference. A

nominal charge to each centre for every exhibition has recently been established, but most of the work must be done, with difficulty, by voluntary effort and in the "spare time" of the Director, who is also Director of the Calgary Allied Arts Centre. These services stimulate and nourish the small and isolated centres. Were it not for the Western Canada Art Circuit, we were told, there would not be more than four or five galleries in Western Canada.

23. It is in the arrangement of travelling exhibitions that the local gallery and the National Gallery have their most intimate contacts and most fruitful co-operation. Although local galleries are not exclusively dependent on the National Gallery for their exhibitions, they do draw on its resources to a considerable degree. On the other hand, without the premises of the local gallery and the services of those responsible for them, the National Gallery would be unable to perform what is, as we have seen, one of its chief functions, the sending out of travelling exhibitions throughout the country for the benefit of the Canadian people as a whole. We found everywhere in Canada the warmest appreciation of the exhibitions of the National Gallery. These expressions of appreciation were accompanied by helpful and constructive suggestions.

24. On the subject of travelling exhibitions, forty groups in all parts of the country discussed their problems and their needs. It must be remembered that exhibitions, important to all galleries, are essential to the smaller ones, which depend on them for most of their interest and support. We received numerous statements that the National Gallery should send out more exhibitions and, if possible, exhibitions of higher quality. A better representation of Canadian painting in particular was urged. Local galleries also described to us the difficulties under which they often must work. Lack of adequate permanent premises, lack of facilities for unpacking the pictures received for exhibition purposes, and want of even sufficient experienced help have meant that local arrangements must often be made at the cost of much sacrifice of time and effort on the part of busy people.

25. The officials of the National Gallery were clearly well aware of these problems. The Gallery fully shares the view of local

institutions that it exists to serve the nation and not the capital city alone. As we have said, the Gallery for many years has maintained a generous and even ambitious policy of travelling exhibitions, and has regarded this activity as a major responsibility. A substantial proportion of its expenditure, apart from purchases of works of art, is directly related to extension services to other parts of Canada.

26. Since it is responsible for the pictures belonging to the nation, the Gallery, as was pointed out, must ensure that these are not exposed to undue risks through lack of careful handling and unnecessary hazards in the premises where they are shown. As we have already mentioned, the Gallery suffers from shortage of space and from insufficient staff. These factors have limited the expansion of the Gallery's services. Our attention was drawn by local institutions to the importance of personal contact between themselves and the National Gallery; they suggested the appointment of regional directors in their areas to serve as links between themselves and the Gallery. We understand that this could be achieved by an increase in the Gallery's staff, which would make possible closer personal contact between the Gallery and the local institutions, to the advantage of the important common task in which they are co-operating.

27. We believe that the organizations which have appeared to discuss this matter would wish us to state once more that their criticisms were not intended to convey any lack of appreciation of the exhibitions received. The following quotation from the Royal Canadian Academy of the Arts would, we think, find general acceptance:

"The Academy wishes to compliment the Trustees of the National Gallery, their director and his assistants, on their able and imaginative administration. It is well known that they have carried out their programme under most confining circumstances, without a home of their own, and without adequate facilities of any kind. With the most meagre subsistence allowance, they have attempted to cope with the

201

growing cultural needs of a modern state. Though Canada now ranks third among the trading nations of the world, we find its National Gallery still operating on a budget more appropriate to an earlier age and in a manner incommensurate with its national responsibility."

28. An activity of local galleries which they consider important and in which they would welcome help and co-operation from the National Gallery is the provision of regular instruction in art for children and for others of all ages and, in general, the encouragement of amateur efforts of all kinds. As a rule, the task of the gallery is not so much to arouse interest as to meet an insistent demand. We were particularly interested to learn of generous grants made by the Carnegie Corporation of New York to galleries in Montreal, Toronto, Winnipeg, Vancouver and to the National Gallery of Canada, for developing educational programmes in art museums. The funds from the Corporation are now exhausted, but as far as possible the work is continued with local support. In particular, the Montreal Museum of Fine Arts maintains a regular School of Art and Design, offering a three-year course, and serving in various ways nearly 500 students. This is, of course, a special project, but is not unrepresentative of the responsibility felt by art galleries in general for the education of the public. Less formal education is carried on in a variety of ways through loans and loan exhibitions to schools and other institutions, special gallery lectures, picture rentals and other devices.

29. Many suggestions were made about ways in which the National Gallery could help this educational work. There was a general expression of opinion that exhibitions should be accompanied by experienced lecturers. The request for lecturers with exhibitions or simply with coloured slides came from ten groups in various parts of the country. If it were found impracticable to send out lecturers, appropriate publications were suggested. A number of organizations mentioned with enthusiasm the successful magazine *Canadian Art*, a National Gallery publication begun in 1942. Other educational services requested were more and better repro-

ductions, a more popular magazine of art, more publicity for existing art library facilities, a union catalogue of all public and private collections in Canada available for lending, a photographic and film collection of Gallery holdings from which prints might be distributed, a loan system of coloured slides with descriptive lectures for schools, and a series of radio broadcasts of high quality. The brief of the Art Gallery of Toronto discusses in some detail the functions of a gallery in relation to lecture tours, extension lectures, broadcasts and so forth.

30. The nation-wide problem of securing and retaining a trained staff was discussed thoroughly. This problem closely affects both the everyday work of the local gallery and its relations with the National Gallery. Several interesting ideas were presented; for example, that the facilities of the National Gallery, in co-operation with other large galleries, be more completely organized for the training of curators. The possibility of scholarships for travel abroad was also discussed. The urgent need of small communities for persons with at least some training was repeatedly brought to our attention and the suggestion made that the National Gallery offer short courses for the immediate use of community leaders, some of whom might ultimately wish to become professionals. Finally, the request was made that the National Gallery arrange an annual convention for directors and curators with a view to their mutual instruction and inspiration.

31. One other important question received attention from a number of groups: the relation of the Gallery to the contemporary artist. It was pointed out that Canadian artists depend much more on public and less on private galleries than do their fellow artists in the United States. Increased purchases by the National Gallery of contemporary Canadian art would provide one remedy. Annual artists' shows nationally sponsored with financial awards were also proposed, and exhibitions of the successful pictures throughout Canada after their display in the Gallery. The Federation of Canadian Artists would like a National Gallery committee to promote the sale of Canadian pictures. Two organizations suggested rental fees for pictures, a practice which, as we remarked elsewhere, is

followed in Great Britain. Finally, on the assumption that the former functions of the Advisory Arts Council would be resumed by the Board of Trustees of the National Gallery, two national groups of artists suggested the appropriation of one per cent of the cost of all federal buildings for sculpture and murals.

32. A final problem discussed by many local art groups must be mentioned because it proposes an important change in Gallery policy on which there is definite disagreement. Certain groups suggest that the Gallery, to be truly national, should be decentralized. Some eight organizations and individuals advocate branch or affiliated galleries throughout the country with (some suggest) at least one in every province. The exact relations which these should have with the central gallery are not always made clear. One group seems to imply that these branches should be owned by the Federal Government. Another suggests that an assistant to the curator be supplied by the Federal Government. Most seem to have in mind a gallery, supported by local funds, receiving national pictures on permanent loan. It was submitted that this would encourage cities and towns throughout the country to raise their standards of building and of curatorship.

33. To this plan one group was definitely opposed, objecting to any dispersal of the national collection. Others, without going so far as to suggest branch galleries, suggested semi-permanent loans on a generous scale, or alternatively, the practice of having an important part of the Gallery collection on tour constantly, spending perhaps a year at a time in each "Grade A" gallery.

34. In general, it is probably true to say that most organizations would be satisfied if arrangements could be made to finance a more extensive exhibition policy. Five national organizations of widely different interests, (only one of them even indirectly connected with the fine arts) advocated nation-wide exhibitions, if necessary, at the nation's expense. There were many detailed suggestions for increasing the number of National Gallery exhibitions, and for means by which they might go to smaller places. The importance of offering small collections for places of limited exhibition space was emphasized by one group with a small but

fireproof hall. There was also some discussion of the needs of rural areas, and it was suggested that they might be served by exhibitions of reproductions and of photographs, perhaps through the co-operation of such rural organizations as the Canadian Federation of Agriculture and the Women's Institutes of Canada or *Les Cercles des Fermières*.

35. In all our dealings with local galleries we were much impressed by the enthusiasm with which they were operating, under very difficult conditions, and by their determination to increase and develop their activities. Many of their comments on the National Gallery clearly indicated both their conviction that this important national institution could do much to help them and their determination to exploit its resources to the full. The many helpful suggestions and criticisms offered are evidence of the keen interest which has been developed in painting and the related arts through the joint efforts of the National and the local galleries.

31.

"WHY OTTAWA IS AFRAID OF ART"

by Sandra Gwyn

The federal government's entry into the arts, with the creation of a new cultural bureaucracy, could not help but make this New Jerusalem of culture a sometimes chaotic place, even before the provinces began to follow Ottawa's example. The seasoned political journalist Sandra Gwyn (born 1936) caught the essential dilemma, not to say paradox, of government arts policy in this article from the May-June 1962 issue of Canadian Art. *Her argument centres on architecture and design but the subtext has much broader implications.*

"Children keep climbing all over the birds," said the guards. "How can we stop them?"

The guards were commissionaires at Gander airport, and the birds were *Welcoming Birds*, a metal sculpture by Art Price, commissioned by the Department of Transport for the new terminal. The problem bounced back to a senior official in Ottawa. His answer? "It has always been Mr. Price's intention that the birds be ridden on."

There is a useful analogy between the guards' attitude towards the birds—they're Art, to be looked at, not to be climbed on —and the government's uneasy attitude towards the arts in general: they're a Good Thing, we have to support them, but we musn't get too involved. In short, the arts are an irreverent frill on the government's plain cloth.

It has become fashionable for after-dinner speakers discussing Our Cultural Heritage to say that "patronage by government has replaced patronage by the nobility," but they almost never add that there is a good deal of difference between aristocratic and democratic aid to the arts. We accept democracy; we must accept some of its limitations:

1. Government patronage is of its nature assistance by committee rather than from man to man. Nobles and princes were interested in the personal growth and development of the artists they supported. Government is more interested in the finished product, in showing the public its money's worth. During the "conception" period of any cultural venture, government wants a minimum of trouble, of arguments between cultural organizations; of fights between the artist and the public. On the other hand, when cultural efforts meet with obvious success, when the National Film Board takes a top prize at an international film festival, when the CBC harvests its regular crop of Ohio State Awards, when Eskimo prints become known throughout the world, the government of the day is only too eager to step in and take the credit.

2. Government involvement with the arts is subject to public and to political pressures, as the perennial troubles of the CBC before successive Commons' committees go to prove. These pressures tend to result in an inevitable timidity and restraint. "In an overwhelming sense of insecurity and fear," one critic says, "the right thing gets done for the wrong reason or in the wrong way." In 1956, for example, a few members of the St. Laurent Cabinet persuaded their reluctant colleagues to use death duties from the estate of Sir James Dunn to establish the Canada Council, a measure which would almost certainly have been turned down had it been an election issue. Saving Sir James' unwitting largess, the council might not have been set up at all.

3. Government patronage of the arts is subject to the hazards, better the haphazards, of politics. The National Gallery is a totally unrelated adjunct of the Department of Citizenship and Immigration. Other cultural agencies, like the National Museums (Northern Affairs) and the CBC (National Revenue) are scattered among departments with which they have nothing in common. Ministers, whose reputations depend on the way in which they handle their portfolios, can rarely give the special agencies any more than minimum attention.

207

The wonder is that government has produced anything at all, let alone the CBC, the National Film Board, the National Gallery, Eskimo prints and paintings in terminals. The answer seems to lie in people, not in policies. The right man in the right place has usually been able to get his way in spite of a large measure of indifference and ignorance. Where such men have been absent, the effect of their absence has been obvious. So much for the background. What is the record?

In the first place, it is all relatively new. It is only about a generation ago that the arts began creeping in through the back door of the government's house. Many Canadians are still trying to throw them out, as witness Hansard when the Film Board or the National Gallery are being discussed. But, once in, the arts have proven to have more staying power than, as lilies of the field, they are usually given credit for.

There are broadly two ways in which government supports the arts. The first and obvious method is through a number of agencies whose sole function is the development and encouragement of the arts in one form or another. These are: the National Gallery, the CBC, the National Film Board and the Canada Council. The annual reports of these bodies set out their aims and objectives, how they operate and how much money is spent. The second method is more nebulous. It is achieved through departments whose main functions are more pragmatic; through the departments responsible for federal construction (Public Works and Transport), our image abroad (External Affairs) and with the development of industry for the original Canadians (Northern Affairs and Indian Affairs). On the fringe are Trade and Commerce (responsible for the Exhibition Commission and the National Design Council); the Post Office (responsible for stamp design) and the Queen's Printer (responsible for government publications).

The dichotomy of the government's involvement with the arts in nowhere better illustrated than in the Department of External Affairs. It is in the cultural field for a practical reason: to present a good image of Canada to the world. In some respects this goal is being achieved, in others it falls somewhat short of the mark.

208

There are no cultural attachés as such. Instead, regular foreign service officers are seconded for the job. There is a small cultural section, which acts mainly as a middleman between cultural organizations at home and the embassies abroad. An official explained: "Our responsibility is to keep Canadians informed of opportunities to show their work abroad."

The department is also involved in a creative sort of patronage through its four-year-old paintings-for-embassies programme. The aim is to let other nations see the flourishing art movement which exists in Canada. Efforts are being concentrated on ambassadors' residences—where most official entertaining is done rather than on chanceries. The paintings are chosen by a five-man committee, made up of representatives from the department and from the National Gallery. Each of Canada's 64 missions has at least one or two paintings or graphics. In some larger posts, the collection is substantial. In Washington, for example, there are works by John Fox, Marthe Rakine, David Milne, Jack Humphrey, Robert Pilot, Moe Reinblatt, Jean-Paul Riopelle and A.Y. Jackson. Care is taken to send paintings to the most effective places. Eskimo prints, for example, are considered particularly suitable for Scandinavia and for Mexico, countries which have their own strong tradition of primitive art.

The picture-buying programme, thanks to the work of a few interested career officials, has maintained a consistently high and imaginative level. The same cannot be said, unfortunately, of the program for the interior decoration of our embassies which in its way is equally important as a salesman for Canada. Despite a staff of five qualified interior decorators, most embassy residences are dull to the point of complete anonymity. Although the department insists on "high quality" and although it "buys Canadian" whenever possible, it has until recently made little attempt to use the work of recognized Canadian furniture, product or fabric designers.

On the other hand, External Affairs is beginning to give Canadian architects a chance to show their work abroad. Until now, the department built very few of its own embassies; instead the practice was to buy or rent existing buildings. But architects have

209

recently been chosen to design three new embassies: in Ankara (Robert Fairfield), in Brasilia (Thompson, Berwick and Pratt) and New Delhi (Peter Thornton). The selection was made by an Advisory Committee made up of members of the Royal Architectural Institute of Canada and of the department.

As far as federal architecture is concerned, it's a clear case of the good guys (Transport) showing up the bad guys (Public Works). An Ottawa civil servant told me: "I met a friend from New York at the airport the other day. While we were waiting for his luggage, he walked around, admired everything from the Archambault screen to the lighting fixtures and lobby clock. Then, as we drove into town, we passed the Trade and Commerce-Veterans Affairs building. My friend said 'Good Lord what's that—a penitentiary?' 'No,' I had to tell him, 'That's where I work.'" Why this startling difference between the performances of these two departments? Both are subject to strict regulations and to the scrutiny of Treasury Board. Yet our airports, put up by the Department of Transport, are handsome, elegantly furnished buildings while Public Works, responsible for all other federal structures puts up what have been called "buildings for future generations to go quietly mad with."

The easy answer, and one given semi-officially by Public Works, is that airports are showplaces for Canada and are used by the entire Canadian public. Federal office buildings are for civil servants to work in and, as one Public Works official said bluntly, "the public won't stand for civil servants to work in expensive buildings." (This statement is of limited accuracy since all government buildings are intended to serve the public and some, like the Post Offices, the Immigration buildings and offices of the Employment Service are for the almost exclusive use of the public).

An architect, who has been involved with the design of public buildings, put it another way. "The public really has no idea of true building costs. You could say a building cost $8,000,000 or $20,000,000 and no one would know which was the valid figure. But Public Works is convinced that the public can recognize an

210

expensive building when it sees one and so any frills are cut off and buff brick spread all over the place, inside as well as outside."

Expense as an excuse for our frankly appalling public buildings has perhaps some validity, although federal office buildings in downtown Ottawa, built in the monumental traditional (as opposed to the strictly utilitarian complexes on the edge of the city) certainly look expensive. But there is a deeper reason. It can best be found through a factual survey of the record of each department in the various aspects of public building:

ARCHITECTURE

In 1952, the Massey Commission suggested, although it did not specifically recommend that "all important buildings should be designed in open competition. Such a procedure would help to avoid the mediocrity which so easily besets government architecture and would provide at once an example to private enterprise and to the architectural consciousness of the public." But this has never been adopted, although the government made one curtsey to the commission when, some years ago, it sponsored a contest for the design of a new National Gallery. The winning design was widely acclaimed. But the project was shelved and the gallery is housed instead in a badly proportioned box which will sometime in the future become an office building. The official reason for not holding architectural competitions is that it would be administratively impossible. The National Capital Commission must approve all federal buildings in Ottawa and it would not be feasible for the commission to rule on a dozen or more designs for the same building. "But," an architect points out, "the NCC should be able to state in advance the general requirements for a building." Perhaps a more valid reason lies in the fact that architectural contracts, unlike those for actual construction, are not awarded by open tender but by private invitation. The opportunity for patronage exists. It is reported that the current practice is for departments to prepare a short list of acceptable firms from which the Cabinet selects a suitable candidate.

Although the Department of Transport and the Department of Public Works work from the same set of rules, there is a striking difference in the way these rules are applied. At the Department of Transport, Chief Architect W.A. Ramsay and his staff have some voice in recommending architects for airport commissions and make every effort to encourage their consulting architects to conceive an imaginative design and hold to it. Public Works, on the other hand, often presents its consultants with completed plans, to be then realized by them in three dimensions.

A Cabinet Minister who doesn't like the look and proposed location of a projected building can delay its erection indefinitely. Agricultural Minister Alvin Hamilton, for example reportedly put off the start of a new Department of Agriculture for more than a year because (a) he didn't like the site (b) he thought the plans included too much glass. The Ottawa Journal reported on January 5, 1961: "Agriculture Minister Hamilton has won his case...his new $6,000,000 departmental headquarters will not be built on Observatory Hill on the farm and will not be in the ultra-modern architectural style of gleaming glass and stainless steel...instead of large expanses of glass which Mr. Hamilton had termed 'Hothouse Architecture,' brick or stone with much smaller windows will be used....given the freedom to design his own building, Mr. Hamilton thought he might draft something after the style of the Centre Block or the Confederation Building."

INTERIOR DESIGN

The Department of Transport, alone among government departments, recognizes the existence of interior design. Most government buildings, even on their public floors, are prime examples of what design is not. "Institution green" is the predominant colour. Good old golden oak desks and chairs have ben supplied to the same Public Works specifications for generations. But the interiors of airports, designed for harder wear in a year than the average office building gets in a lifetime, have managed to prove that functional isn't a synonym for drab. The Department of Transport is proud to have encouraged designers to design and manufacture

first quality public seating for its airports. Some of the seating it has promoted, designed by Robin Bush and Walter Nugent, has subsequently had spectacular commercial success.

A key man in the Department's design program is Stan White, a young staff architect-designer. He has had an influence in the interior of all the new terminals and he has done well. Aside from the actual and extremely happy choice of furniture and fittings is the evidence that interior design has been considered an integral part of a building's design, not a frill tacked on later to hide the brickwork.

PAINTING AND SCULPTURE

The Department of Transport is due for yet more plaudits, for it is involved in an ambitious fine arts program. Like many government manoeuvres, it began by chance. Around the time that the airport building program was about to start, W. A. Ramsey, Chief Architect, attended a lecture by Alan Jarvis, then Director of the National Gallery. Jarvis reminded the assembled architects that sculpture and painting must be accepted as an integral part of all public buildings. Ramsey was impressed. He passed the idea on to his Deputy Minister, John Baldwin, and the programme was born in time for painting and sculpture to be included in Gander, the first airport to be completed. Mr. Jarvis acted as consultant for this first venture. He suggested a limited competition for a mural be held. Accordingly, five artists, Kenneth Lochhead, Takao Tanabe, York Wilson, Alfred Pellan and Jean Dallaire were invited to submit, for a $500 fee, finished sketches and a sample panel. No subject was set, but contestants were asked not to include aircraft forms in their proposals for the simple reason that these would date badly. Lochhead's sketch for *Flight and its Allegories* won the competition. It was also decided that a piece of sculpture should be included and Art Price was commissioned for the *Welcoming Birds*.

The next terminal to be completed was at Ottawa. Louis Archambault was commissioned to design an exterior screen. His creation of massive metal forms in cast aluminum was an

213

immediate success. But some critics are less happy with Archambault's free-standing *Symbol of Flight* which stands in a reflecting pool. The original design in 2" thick aluminum leaves was found to be structurally impractical, unfortunately, for the piece would have had the unusual property of acting as a thermo-couple, changing its shape with changes in temperature.

The Department is self-confident enough about its work that it is not afraid to admit a mistake. A spokesman told me "At the Regina terminal we were unsuccessful in encouraging the artist to capture the essence of the whooping crane. The realism which resulted, in cast aluminum, is more of an ornithological display, appreciated by bird-fanciers everywhere."

Montreal's Dorval terminal, in terms of public use, is the most important new terminal. It is also the most handsomely appointed building put up to date. Richly textured tiles, hand-glazed by Claude Vermette, form entire, shimmering walls. Some of the fine art in Montreal is found in the reception suite for official guests of Canada. It includes a wood sculpture from the studio of Armand Vaillancourt, paintings by Jean-Paul Lemieux and John Robinson, a metal sculpture by Gord Smith and a magnificent tapestry by Micheline Beauchemin. Native arts are represented by a sealskin tapestry from Port Burwell, stone carvings, and an exquisite model of an Eskimo kayak. The terminal's nursery boasts a broad assortment of toys recommended by the Canadian Toy-Testing Council, a fanciful mobile by James McElheron and sealskin dolls made by the Eskimo of Port Harrison.

Most of these items were bought from commercial galleries. So also was a David Partridge abstract, *Midnight Sun*, which hangs on the mezzanine of the Ottawa terminal. "If the Department wished to," I was told, "It could enter into the art dealer business at a profit. We've been offered more for the Partridge than we paid for it."

An active fine art committee has been formed to advise the Minister of Transport on the commissioning of works for new terminals in Toronto, Winnipeg, Edmonton and Vancouver. Though the personnel varies from city to city, the Director of the

National Gallery and the Chairman of the National Design Council attend each meeting. The fine art plans for these have not yet been released, but clearly the department, led by its consulting architects, John B. Parkin Associates, is going all out at Malton. "It will be a gasser," promises Stan White.

There has been no rigid pattern for the programme. Limited competitions will probably be held for murals at Winnipeg and Edmonton, painting and sculpture will be commissioned for all the terminals and pieces will be bought from commercial galleries for the reception suites. Treasury Board has agreed that one half of one percent of the construction costs may be used for the purchase of fine art. For a $20,000,000 building, this formula produces $100,000.

In any discussion of the fine arts programme, department officials are quick to give credit for the realization of an idea to Deputy Minister Baldwin.

The Transport Department is concerned only with airports. The Department of Public Works builds just about everything else. And here the story is just about reversed. Use of a fine-tooth comb reveals a few examples: a sad little fountain within the Mackenzie Building in Toronto, four murals in the heroic tradition, done by veterans, in Ottawa's DVA building, a mural depicting a covered wagon in Winnipeg, and a bas relief of a letter carrier in the Vancouver post office. The Department claims that "we have asked for a fine arts allocation, but been turned down." But one wonders how hard this department tried when another was able to succeed with exactly the same request.

FOR THE FUTURE

The Ottawa building programme is about half complete. Six major structures are due to be started this year. Less than a dozen others remain. Will these be any better? There are a few hopeful signs.

1. Public Works is becoming increasingly sensitive about the brutally severe criticism it has aroused among architects, journalists and, unkindest cut of all, among the public it strives to please. Officials now admit that its immediate postwar buildings, like the

215

Tunney's Pasture complex, are bad. It feels that the recently completed Confederation Heights development is an improvement, although one architect describes it as "less bad."

2. Several additional architects, who will improve liaison between the department and the consulting architects, have recently been appointed.

3. Plans for the new Northern Affairs building include some fine art from the north. Original stone blocks used for printmaking at Cape Dorset will be set into a wall in the building's foyer. An Inukshuk—a figure used to denote an Eskimo landmark—will stand in front of the building.

4. The firm of John B. Parkin Associates has recently been asked to make an intensive study of the Union Station site in downtown Ottawa. (The station is shortly to be relocated in the suburbs.)

5. The National Capital Commission is discovering its responsibilities. Since 1948, the N.C.C. and its predecessor, the Federal District Commission, has had the right of approval for the location, architecture and general nature of proposed federal works in the Ottawa area. But, until now, the NCC has concerned itself very little with architectural criticism and has concentrated on the less controversial field of building parks and parkways. Recently, however, a number of new appointments have been made and indications are that plans for government buildings will be subject to much more rigid scrutiny.

In the end, the difference between the records of the Department of Public Works and the Department of Transport lies not so much in their formal policies as it does in individuals. At Public Works, there has been no one to match the vision of John Baldwin and his associates. This department seems to pay more attention to its duties as the nation's construction engineer than to its responsibilities as the nation's master builder. Buildings it considers only structures to house civil servants. No one has had enough strength or conviction to shout: "Stop, we've got to do better that this. We're building for posterity." In effect, federal buildings are a massive monument to a man who wasn't there.

32.

"SURVEY OF THE WORK OF 24 YOUNG CANADIAN ARTISTS"

by Robert Fulford

This census from the January-February 1961 Canadian Art is fascinating in retrospect partly because it supports the contemporary assumption that there was indeed a new generation abroad in the land, who coalesced despite geographical and ideological differences and perhaps even because of artistic ones. Robert Fulford (born 1932) had been a critic and observer of many of these artists since the mid-to-late 1950s, in the Toronto Star and other publications, and is particularly associated with the early careers of Michael Snow and Harold Town. He has been the editor of Saturday Night since 1968.

The big, dark hole in the centre of **Edmund Alleyn's** *No Horizon* seems intended to suggest that the searching hand of a curious spectator has reached out impatiently toward the picture plane and ripped the canvas open, only to find ... nothing. The surface— bumpy, irritating, purposely challenging—covers, as it turns out, only another surface. As so many critics have noticed, the single most significant tendency in the art of the last two decades has been towards painting in which the paint and canvas themselves are the artist's subject; painting, in other words, that is 'about' painting. And surely we will never find a better example than *No Horizon,* in which the painter seems almost to satirize the whole idea of painting as a mysterious, arcane expression, full of secret meanings and deep implications. Yet at the same time this bitter parody fulfils itself as it fits into Edmund Alleyn's peculiarly bleak but engaging art. Two paintings in the artist's collection in Paris (which unfortunately I have been able to see only in black and

and white photographs) suggest, even in their titles, the intransigence of his personal vision: *Monologue* is a study of loneliness, and *Border* suggests not so much the border of a country as the very frontier of existence.

In his recent oil paintings, Alleyn rarely allows himself a step beyond this self-limited expression; nor does he show anything like the exuberance or humour of his work in other media. But *The Lover,* a 1958 sepia wash, is lyrical as well as tragic. The soft, interlocking shapes suggest that he has at least noticed the more sensuous work of Paul-Emile Borduas, and the spatial relationships, changing constantly as one's eye 'reads' the picture, seem to lead us in and out of a subtle and enormously complicated affair. In this he reflects the cubist influence that played so large a part in his work only a few years ago: the painting with which he won the $1,500 grand prize of the Concours Artistique of the Province of Quebec in 1955, *On the Sands,* is most definitely a late-cubist work, with its overlapping shapes and subtle handling of space. Since then Alleyn has apparently been influenced most by the Paris painter, the late Nicolas de Staël, whose rich, thick surfaces have especially appealed to Alleyn's temperament.

In Canada, particularly English-speaking Canada, Alleyn has not yet received the extensive exhibition he deserves; but he has had little difficulty finding wall space in Europe. In 1958 he had one-man shows in Paris and Basle, and was represented in several Paris group exhibitions. Alleyn was born in Quebec in 1931, and studied there at the Ecole des Beaux-Arts under Jean-Paul Lemieux. He has lived in Paris since 1955.

Among all the abstract painters of eastern Canada there is none who comes closer to maintaining the Canadian landscape tradition than **Suzanne Bergeron.** Perhaps you can only with difficulty imagine Tom Thomson being pleased with her work—she is, after all, an artist of the 1950s, and abstraction, the period style, dominates her work. But in her colour, and her sense of rhythm, and her obvious engagement with the subject of landscape, Miss

218

Bergeron suggests nothing so much as a Group of Seven painter who has suddenly been transported into the world of abstract art She has that same intense dedication to nature, coupled with an almost savage desire to convey in paint the ferocity of the Canadian outdoors. A typical Bergeron consists of a white background with bold strokes in greys and browns in the foreground. They are often slashed across the canvas, like wounds made by a whip, and they tend to bunch together, creating a confusion of images close to the surface. Another recurring theme is an abstraction of an underbrush: irregular parabolas, their lines swooping up towards the top of the painting, done in hasty, spontaneous strokes. In landscapes like these, and in her other work, Miss Bergeron rightly lets her brush and her knife carry her where they will, and if it is true that she sometimes ends by describing chaos it is also true that she sometimes produces a solid, nearly perfect abstraction of natural forms.

"This artist is a painter of clean, clear and frosty below-zero atmosphere," according to Dorothy Pfeiffer, the critic of *The Gazette* in Montreal. And we have to agree that Miss Bergeron seems attracted almost exclusively to the barren time of year, when nature reduces itself to essentials. In her paintings (and this can be said of few abstractionists) we can almost hear the crunch of the snow, almost see the painter's breath condensing in the air. In those of her drawings which I have been able to see, she turns away from the landscape and fixes on the human form, but here she arrives at an even more severe way of looking at the world. One 1955 drawing, a nude, shows us a bleak, twisted and impoverished figure, angular and sullen, offering no hope of warmth, no relief from the terror of being human. Here, and in her other drawings, she abandons the wild slashings of the paintings in favour of a soft, subdued technique. Nevertheless, her drawings seem only to magnify the narrowness that is the least attractive quality of her paintings.

Miss Bergeron was born at Causapscal, in the Gaspé Peninsula, in 1930. She studied with Jean-Paul Lemieux at the Ecole des Beaux-Arts in Quebec, and, more recently, in Paris. She lives now at Valleyfield and exhibits in Montreal at the Galerie Agnes Lefort.

219

The paintings and drawings of **Bruno Bobak** show clear evidence of a strange mingling of cultures. Bobak was born in Poland in 1923. He was brought to Canada while still a child, and he studied in Toronto, mainly at Central Technical School. During the Second World War he served as a Canadian Army artist, and while working in Britain he met (and later married) another war artist, Molly Lamb. In the middle forties they moved to Vancouver, and since then they have been an important part of the British Columbia art scene. But Bobak's work does not, as we might expect, show a mixture of East European and Canadian influences. It shows, rather, an unlikely meeting of Oriental and English art—a reconciliation of some of the most important characteristics of Japanese flower painting and *art nouveau*. In recent years Canada has had few artists of importance who were not born in Canada—the myth of the immigrant bringing cultural riches is still largely a myth—and perhaps this is why Bobak, whose cosmopolitanism permits him to use any influence that appeals to him, is such an unusual figure in Canadian art. His painting is eclectic, certainly: we never know whether the next work will lean more towards the tangled wiriness of *art nouveau* or the slim splendour of Japanese painting. But he manages so often to pull these disparate elements together into a work of art that is entirely unified and personal that complaints about eclecticism shrink to insignificance.

Bobak's work shows two major directions. The first, exemplified by a drawing like the one that appeared on the cover of the spring, 1959, *Canadian Art*, is toward light, delicate paintings of flowers, often primroses, which seem to hang gracefully in space, attached to nothing. The other is towards the intense analysis of trees, rocks, flowers. *Ashcroft Scene,* which was painted for the *Maclean's* collection of B.C. art in 1958, emphasizes the veins in the hills of the desert near Kamloops; in Bobak's hands they seem to fall into an abstract pattern. Over the years, Bobak has moved closer and closer to his subjects and has tended more and more to explore the designs he discovers in the ordinary structure of plants or rocks. In this concern with the abstraction of nature (as opposed, say, to non-objective art or art based on the human form)

220

he remains close to the modern B.C. tradition. Bobak's work is in most major public collections in Canada, and a few in the United States. His work can be seen, aside from group shows, at the Galerie Agnes Lefort in Montreal, the Roberts Gallery in Toronto, and the New Design Gallery in Vancouver.

Molly Lamb-Bobak is the kind of painter who, in the 1950s chose a new suburban subdivision as a theme for a series of pictures. Her greatest concern, as a painter, is with the human being and his environment, in her own time and place. Man, and the works of man, interest her far more than, say, trees and rocks—or abstract shapes. We can see this interest emerging as early as 1943, in the drawings she produced as a war artist with the Canadian Women's Army Corps. They show the CWACs dressing, dancing, lining up for meals, working in the kitchen; together the drawings seem to be an attempt to make a human experience out of something that was generally dehumanizing. As drawings, they are less than successful. They lack almost everything except a point of view; but they have that in abundance. And it is this same point of view, this same attempt to find a human scale, that has pervaded Mrs. Bobak's art in the years since then, as she has worked towards her present position as a mature, sensitive artist.

This humanistic point of view has broadened, in recent years, to include also an engaging sense of humour; and it has deepened, to, so that there is now a great sense of sympathy implied in her depiction of human beings. These qualities are combined, along with the abstract values that absorb her, in *Lelant Pub No. 1*, which she painted during the year she and Bruno Bobak spent in Britain. In this the glasses and bottles of the pub are picked out in swirling *art nouveau* calligraphy, and the balance of the picture suggests an absorption in formal, abstract values. But the pubkeeper himself, with his comically intense posture, is a figure of human sympathy. This same human sympathy, perhaps once removed, invests a pencil drawing like *St. Ives* with its special dignity. Here no human figures appear, but we sense in this

221

beautifully composed drawing a feeling of satisfaction with the works of man. This same feeling appears often in Mrs. Bobak's modest, comfortable paintings of ships and harbours. These last are perhaps her favourite subjects, but almost anything in the world seems able to engage her imagination; she recently made the transition from B.C. subdivision to Cornwall village without any noticeable difficulty.

Mrs. Bobak was born in Vancouver in 1922, the daughter of H. Mortimer Lamb, who is well known both as a leading patron of art and as an amateur artist of distinction. She studied with Jack Shadbolt at the Vancouver School of Art and then entered the CWAC at the age of twenty. She has taught extensively at the Vancouver School of Art and elsewhere. Her work can be seen at the New Design Gallery in Vancouver.

Perhaps the work of the three other women artists in this collection could have come from the studios of men; but it would be impossible to imagine that a man produced the paintings and drawings of **Ghitta Caiserman.** A unique, sturdy womanliness fills her pictures and helps to give them their own special quality. This is evident not only in some of the subjects—pregnant women, the recurring theme of growth, the relationship of mother to child—but also in the almost maternal compassion with which she paints them. In this unabashed assertion of her sex, Miss Caiserman is unique among Canadian painters. But she is unique in another way, too, for she draws on a tradition which is forgotten by almost all Canadian artists of importance—the tradition of social realism, particularly as it has been maintained in the United States by Ben Shahn. The condition of man (and woman), not the paint itself, is the major theme of her work. In recent years she has brought this closer to the personal level, so that her subjects are seen at close range, rather than in general and sentimental terms. Lenore Crawford of *The London Free Press* has pointed out that Miss Caiserman's attitude to her human subjects is "abstract...rather than specific. They are members of the human race

222

rather than individuals; their large, solid-pupil eyes are expressionless." This is a fault, no doubt: one does not express the possibilities of mankind by tacitly suggesting that men are all expressionless ciphers; but is seems to me that this is less obvious in Miss Caiserman's work than it was once. If she has any major fault, it is in painting too much (or perhaps exhibiting too much). Often her small pictures are stunningly inconsequential, dismayingly repetitious.

Sometimes Miss Caiserman gets closest to the life she wants to depict by eliminating human subjects entirely: *The Bed*, a 1958 oil, uses the folds of rumpled bed-clothes in an excellent composition, soft and rather lovely, yet never denies the implied sensuality of the subject or eliminates entirely the idea of squalor. Here, as in all of her best pictures, Miss Caiserman feels the subject with a complicated intensity. She has managed to show this same intensity, rather surprisingly, in some of her recent ink drawings, which seem to combine the influences of Shahn and Marc Chagall. Miss Caiserman shares some of the Jewish childhood images that illuminate Chagall's best work, and sense of fantasy. Perhaps we can hope that in the future some of these ideas will turn up in her oil paintings.

Miss Caiserman was born in Montreal in 1923, and she studied in New York at the Parsons School of Design and the Art Students League. She is now represented in all major public collections in Canada, and her work is shown at the Waddington Galleries in Montreal and the Upstairs Gallery in Toronto.

The most typical example of **Alex Colville's** art, and the one in which he most convincingly demonstrates his importance, is the picture called *Hound in Field*, which he painted in 1958. It shows us a dog, caught and held in a moment of time, as it turns while running across a field. The animal seems almost ready to fall out of the picture; yet it remains there, locked in an elaborate spatial arrangement which can engross us again and again. The critic Robert Ayre has referred to the way Colville holds his subjects in an

"intensely revealing trance;" and, indeed, it is this trance which most distinguishes his art. It teeters always on the brink of surrealism, yet never involves the Freudian symbols of that style. It threatens at any moment to turn to sentimentality, yet only rarely does this happen. About every Colville picture there is a sense of mystery which can never be properly defined or explained. But a work like *Child Skipping* (in which, it seems to me, the child who has left the ground so gaily will never return—will, in fact, remain suspended at exactly that height, forever) suggests what Colville is up to: he wants us to *see* the ordinary things around us with greater clarity and comprehension. When he arranges the exhibits and judges at a cattle show into a classically perfect (and quite breathtaking) spatial pattern, it is because he wants us to note every outline, every muscle, every neglected ounce of beauty. The aura of mystery draws us into Colville's pictures, and there we find ordinary, everyday life.

Colville works, of course, to the most time-honoured definition of art: that it imposes its own order on the disorder of the world. Just about every other painter mentioned in this issue would be pleased to be called "spontaneous", but for Colville (I imagine) there would be few words more insulting. There is nothing immediate about his work. The casein tempera and oil panels (often on masonite) which emerge from his studio all show the results of months of careful work. To many visitors to art galleries, and indeed also to many painters, it is astonishing to find a young artist today who takes care to brush in every hair, every blade of grass, every wave. Yet it is this careful piling up of detail upon detail which builds the tension and mystery that Colville seeks.

Colville was born in Toronto in 1920, but he spent part of his childhood in Nova Scotia and has lived in the Maritimes ever since; since 1946 he has been a teacher at Mount Allison University in Sackville, New Brunswick. He has had one-man shows in New York and Toronto, and his paintings now hang in most of the public collections in Canada.

If the ability to handle paint poetically and meaningfully is the first test of an artist of the 1950s, then **Graham Coughtry** is one of our finest artists. There have been few Canadian painters in any period who have shown such a deep love of paint and such a wide grasp of its possibilities. Among the best Coughtry paintings, to my eye, are those thick, warm interiors of 1957 and 1958, in which he conveyed superbly the visual equivalent of the feeling, or touch, of the materials that attracted him—cloth, wood, flesh. Those rich, glowing canvases, with their softly combined reds and blues, translated the message of impressionism into the language of mid-century North America. In them we saw the spirit of the painter who has most influenced Coughtry, Pierre Bonnard, combined with the fresh, quick, perceptive attitude of Coughtry himself. With these pictures, Coughtry created his own style and his world-in-paint, and thus came to maturity as an abstract artist. Later, he abandoned the interior as a subject—apparently it had yielded all he expected it to yield, for the present—and in a 1959 one-man show he exhibited a series of what he called "portraits." These were not portraits in any usual sense—that is, they did not describe individual faces—but rather impressions of the ideas of the portrait: the *idea* of confrontation between painter and subject. Again, the surfaces were lush, varied and altogether admirable; but the subject-matter itself was so thin that it seemed to me to render the paintings sterile—at least by comparison with his earlier work.

Graham Coughtry was born in 1931 at St. Lambert, Quebec. He studied at the Montreal Museum of Fine Arts and at the Ontario College of Art, and in 1953 he went to Europe on the college's Eaton Travelling Scholarship. His year in Spain and France (and particularly that part of it in which he studied Bonnard) turned him away from the late social realist painting that had preoccupied him till then. It caused him to concentrate on developing his natural talent for handling paint. His first one-man show, at the Isaacs Gallery in Toronto in 1956, brought this talent before the public in a tentative but promising form: the pictures, all in light, sun-filled colours, had at the time a bleached, somewhat empty look; but, not

225

too surprisingly, those same pictures today have come to look better and better.

Until the summer of 1959, when he resigned, Coughtry was employed in the graphic design department of CBC television. His imaginative, emotional drawings, somewhat influenced by Ben Shahn, were among the most compelling features of Canadian television, and the prizes he won for them at the Art Directors Club of Toronto shows established Coughtry as one of the leading graphic artists in Canada.

When confronting the work of painters like **Pierre Gendron**, I have the feeling that they are generously intent on extending to the spectator the absolute freedom that has been won by the artists of the twentieth century. Never before, surely, has the visitor to an art gallery been so free to decide for himself what a picture contains. A painting like Gendron's *Composition, 1958,* suggests that the artist has attempted to provide building blocks from which the viewer can construct a picture of his own. In this composition of rectangles there are no sharp edges; the rectangles softly overlap one another. They eye is allowed to enter the picture, roam around, and collect the images for itself. There is something here of Jean-Paul Riopelle's famous 'allover design,' but there is also a suggestion of surrealism, perhaps the late surrealism of Joan Miró. The same echoes of Miró appear, much more obviously, in one of Gendron's etchings. In black and white, the wildly assorted shapes, unhinged, dance and leap, gathering towards the centre in a cluster of confusion. In another 1958 etching, *Nature Morte,* Gendron seems to stand somewhere between cubism and non-objective art: he reminds us emphatically of the cubists' spatial variety (here again, the eye can wander in and out, unimpeded) but the objects on the table seem to be flying off in a dozen different directions at once; and, as each does so, it seems to be changing shape under some unthinkable violent pressure.

Etchings seem to fit easily into the body of Gendron's work, and this makes him a most exceptional Canadian artist indeed.

226

Most Canadians skilled in print-making are known for just that—their skill in print-making, not their importance as artists. Most of the artists of the present generation have avoided etching and lithography, partly for economic reasons (after all, if a painter cannot sell more than a few oil paintings or watercolours, how can he hope to sell an edition of twenty-five etchings?) but partly also because abstract painting seems to demand the kind of freedom that only oil painting—and, to a lesser extent, watercolour—can provide. Thus the effort of a fluid, sensitive abstract artist like Gendron to move over into etching while retaining his basic approach is an important one; he has not yet shown that the ideas is entirely successful, but the early attempts are encouraging.

Pierre Gendron was born in 1934 in Montreal. He studied at the Ecole de Beaux-Arts (under Jacques de Tonnancour and Albert Dumouchel, among others). Recently he studied print-making in Paris, under a Province of Quebec scholarship.

Few current painters, in Canada or elsewhere, approach non-objective art as a severe discipline, to be practised in terms of steady contemplation, cautious experimentation, and strict adherence to a set of formal standards. **Robert Hedrick**, of Toronto, is one of them, and as much as anything else it is his programme of discipline in action that makes him one of the most fascinating Canadian artists of the present. Hedrick attacks a single aspect of his art at a time, reflects on it, refines it, and perfects it within narrow limits. Only then does he look for a new experiment, to test himself again. His first appearance in a one-man exhibition, four years ago at the now-defunct Gallery of Contemporary Art in Toronto, showed him working cautiously and yet inventively with *collages* in muted colour. In his next show he offered a series of simplified, stripped-down abstracts, the colours carefully graduated and the picture plane divided by simple horizontal lines echoing the landscapes on which the pictures were based. Last April, in his third exhibition, he brought forth a series of ten all-over-design non-objective paintings, most of them about six feet

by four feet. At first glance they suggested a departure from the prudence of his earlier painting; but closer observation revealed that for all their exuberance they were executed with consistent discipline. Hedrick carried the same thrusting stroke and the same colour combinations insistently across the canvas, in time with a confident inner rhythm. The result was a series of absorbing, cross-hatched designs, each of them built solidly and honestly.

Hedrick, who is thirty years old, was born in Windsor, studied commercial art in technical high school at London, and later worked as a commercial artist. In Mexico he has studied with James Pinto and Rico Lebrun, the latter association giving him a deep, permanent interest in the discipline of drawing. This has resulted in a series of exquisite flower drawings, which have more recently grown into some of the most beautiful abstract drawings on the Canadian scene. Hedrick, like the late Paul-Emile Borduas and a few other painters, indicates in both his paintings and his drawings that non-objective art can provide a fruitful approach for a painter whose most serious interests are tied to extreme sensitivity and severely worked-out structure.

Tom Hodgson is among the hardest of Canadian painters to appreciate. Even at this late date he can still shock us with his florid, romantic canvases. He lacks just those attributes which tend to make an immediate, favourable impression for an abstract painter—William Ronald's power, for instance, or Harold Town's delicate command of detail. A Hodgson canvas seems to storm over us, filling our eyes with its swarms of apparently unrelated images. It is not until long after our first glimpse of the work that its organization and structure become apparent. At first it appears to be a jumble of squiggles and smears, arrows and parabolas. But when we examine it more closely and allow the painting to assert itself we begin to see the way in which one image leads into another, and also the way in which each of the several levels is securely anchored in space. And while examining it, and others by Hodgson, we begin to see that the strange colours—purple,

228

purplish red, dull green—are not only the result of a rather eccentric colour sense but also are the result of Hodgson's desire to break away from all traditional usage and create new worlds of space and light. From the paintings themselves we gather that Hodgson's attempt to chop for himself a new path through the jungles of modern art is undertaken not in a spirit of slow, contemplative construction but in something much closer to a wild frenzy: the big shapes swing wildly across the canvas, the little ones are haphazard squiggles. The result of this, in a one-man show by Hodgson, is a lack of consistency. He tends to exhibit his mistakes as well as his triumphs, and it has always seemed to me that the single, selected Hodgson, isolated in a large group show, points up his talents far better than an uneven one-man show of twenty or thirty pictures. In his water colours, Hodgson comes much closer to a confident, mature statement. Here he is perhaps less restless, less audacious; but as compensation the colours are clearer, the shapes better defined, the central feeling more directly projected.

Hodgson was born in Toronto in 1924. He graduated from the Ontario College of Art in 1946 and that year began to exhibit with the Ontario Society of Artists. Since then he has appeared in all the major Canadian exhibitions, and won several prizes. In 1953 he was a founder, with ten other painters, of Painters Eleven, a Toronto group of abstract artists which has enormously influenced the appreciation of contemporary painting in English-speaking Canada. One of the members of Painters Eleven, until his death in 1956, was Oscar Cahén, the Danish-born artist who had a greater influence on Hodgson than any other painter.

"I am concerned," the Vancouver painter **Donald Jarvis** has written, "with developing a form which will convincingly express a basic feeling toward the time and place in which I find myself." Jarvis is now in his middle thirties, and it is interesting, as well as helpful, to look back over the ways in which he has attempted to find this basic stance. In 1949, he painted *Man Lighting a Cigar*

ette, a stylized picture which reflected the peculiar distortion of the social realist painters of the 1930s. At this time (his pictures suggest) he was looking around himself, at the human beings within range, in the hope of finding a suitable form. In the next few years, his pictures of people became more and more stylized; in 1951, *Procession* showed a crowd of people rendered into almost totally abstract shapes. But eventually he came (as, it seems, all British Columbia painters must come) to the landscape. In recent years his pictures have had titles like *On the Shore* and *Beach Fire*. He has turned to the coast forests and beaches, the forms of trees, stumps, and driftwood, as well as aspects of the city and its people. He concentrates, as he says, on "the passage of the seasons; the relation between the sea and the land; between nature and man-made forces; the processes of life."As he has pointed out, the main problem now is to pull all these various threads together into original and authentic images. In a painting like *Forest* he comes close to success. This picture suggests a burning forest, or perhaps an action painter's mental image of a forest, in which the artist can experience the depth and bewildering variety of nature and render them coherent on canvas. This is the kind of rich, elaborate painting, full of the artist's own personality but also full of the B.C. outdoors, which has so distinguished West Coast painting in recent years. But none of this has come easily; and a glance at Jarvis's recent sketch-books indicates that his next step, when it comes, will be carefully planned. One of the 1959 sketches I saw recently showed that Jarvis was focussing his attention on formal values. He was working with interlocking shapes, finding his way through a series of complex relationships. But the fury and dash with which he handled them indicated that this was not just an academic exercise and that soon these shapes would be finding their way onto canvas, as an integral part of Donald Jarvis's expression of his own time and place.

Jarvis was born in Vancouver in 1923. He studied at the Vancouver School of Art, and on graduation in 1948 won an Emily Carr Scholarship which permitted him to study with Hans

Hofmann in New York. His paintings are in several major collections, and can be seen in Vancouver at the New Design Gallery.

The most eloquent indication of **Anne Kahane's** solid, mature talent is her ability to mold warring influences and impulses into a single confident style. Miss Kahane is a Montreal sculptor, thirty-six years old, born in Vienna but brought to this country at the age of two. She works mainly in wood, either from the single block or by construction; sometimes she colours her material—occasionally with an enamel-like white that gives them, at first glance, a porcelain appearance; more often, she uses a dull, flat blue. The first impression given by a small group of her figures is one of eclecticism: here we find the influence of medieval (and perhaps early Quebec) folk carving; here we notice hints of the blockier sort of modern sculpture bearing on her; here we see a face that seems to have been borrowed from the art of caricature; here we discover a lingering trace of social realism. Yet a careful study of fifteen or twenty Kahanes produces just the opposite reaction: the sculptor has seized on all of these elements and doggedly converted them to her own use, as a unified and personal means of communication for her own forceful personality.

Her careful, tentative drawings—which have occasionally been exhibited alongside the sculpture—have a withdrawn, alienated feeling: they refuse to offer up their message easily. But her sculpture, superficially similar, is in essence quite different—it makes its point bluntly, even when the point involves compassion. In a minor work like the 1959 *Sleeping Child* she offers, quite directly, a very lovable and very modest expression of an adult's thoughts on contemplating a child at rest. This piece suggests the outlines of much of her work: it is abstract in the literal sense of abstracting from the scene the essence of emotion.

In a work like the 1957 *Delegation*, the point is more mysterious and therefore more intriguing. Here a clutter of heads,

231

bunched together, peer intently at us, demanding that we read into their expressions our own message, of contempt or admiration. In *Follow the Leader*, however, she is much more explicit. The four figures walk doggedly in single file, their gazes fixed vacantly on nothing. We do not narrow the piece's range unfairly when we realize that it is the sculptor's comment on mob culture and mob politics. Miss Kahane's work is frequently exhibited at the Isaacs Gallery in Toronto and the Galerie Agnes Lefort in Montreal, and has won sculpture prizes offered by the Winnipeg Show and the Montreal spring exhibit. Uniquely, for a Canadian sculptor of her generation, she has not gone without appreciation outside this country. Aside from Canadian sponsored appearances abroad (like those at Brussels and Venice in 1958) Miss Kahane's work has won the British Unknown Political Prisoner competition (1953) and has been shown at the Pittsburgh International. Her sculpture is owned by the public galleries at Ottawa, Toronto, Quebec, and Winnipeg.

The branch of surrealism that achieves its greatest delight in the unlikely juxtaposition of strikingly dissimilar objects and ideas—"Beautiful as the chance encounter of a sewing machine and an umbrella on an operating table," as one apologist put it— finds one of its few Canadian champions in **Kenneth Lochhead,** the thirty-four-year-old director of the School of Art at Regina College. In the work of Lochhead, Canadian images and the images of modern western life (as seen in Canada) find their way into the half-magic, half-comic world of surrealism, and the result is never less than fascinating. *Bonspiel* (1954) is perhaps an extreme example of Lochhead's habit of adapting surrealism to the Canadian scene, but for that reason it illustrates his approach most vividly. There are the faces—egg-shaped, with their blank gaping eye-holes—which remind us so quickly of European surrealism, but they are attached to the bodies of curlers! They stand solemnly, brooms at the ready, as the match goes on, and for a moment it

seems the juxtaposition is only a joke. What saves it from this is the way Lochhead has placed his figures so securely in the endless prairie space, making their solemnity and their sport into a kind of stolid defiance of the vastness around them. He follows the same theme in his 1953 *The Dignitary,* which is now part of the National Gallery collection: here the blank, faceless, characterless crowd waits in sullen silence for the approach of the great man, but here, too, Lochhead brings a kind of terror to his work. The painting sets out in slow stages to recast our notions about human relations, and ends by leaving us with a chilling vision of the huddled life on the treeless prairies.

Lochhead's best-known work, his twelve by seventy foot mural for Gander Airport in Newfoundland (for which he won a national competition) sounds in the officialese description like the grandiloquent mixture of abstraction and high-flown allusion which characterizes most Canadian mural work: "Two trumpet swans represent the introduction to flight; a man juggling apples represents air traffic co-ordination; a central figure symbolizes man co-ordinating flight...."And so on. Yet the reality is something different: a crowded, hectic, no-holds-barred collection of large and small men (both half-realistic and surrealistic), birds, huge women, roaring seas, small distracted children, and stylized trees. Sometimes the visual jokes are fairly obvious: airplanes imitate birds, so Lochhead makes birds imitate airplanes, to the point of developing metallic bodies, complete with rivets. Yet the total effect is altogether engrossing: it's the sort of mural that could easily make you miss your plane.

Lochhead was born in Ottawa, and studied commercial art in high school there. Later he studied at the Pennsylvania Academy of Fine Arts, at Queen's University, and at the Barnes Foundation in Merion, Pennsylvania. Recently he spent a year of study and work in Rome.

233

Kazuo Nakamura's art is marked by a degree of versatility which is rare in the art of Canada or any other country. To watch his work carefully as it emerges from his studio over half a dozen years is a baffling experience. The usual marks of growth and development, beloved of critics, are absent; in their place is a sideways movement from one style to another and then to another and then back again to the first. In any one year of Nakamura's work you can find lush, romantic landscapes; abstract paintings in which a group of sticks seem to have been dropped into water and allowed to float towards the bottom; 'string paintings' in which Nakamura achieves a remarkable serenity in combination with a thrusting display of imagination; tight, linear drawings of bridges and cityscapes; and vast panoramas of enormous cubes, placed in the middle of what seems to be a vast prairie. A retrospective exhibition of Nakamura's work—and I do not doubt that we will be seeing just such an exhibition in thirty or so years—will be fascinating experience.

In the course of an interview four years ago, Nakamura told me, "I think there's a sort of fundamental universal pattern in all art and nature," and he went on to explain that he hoped—by studying everything from the landscapes around him to the shapes revealed in a microscopic photograph of human tissue—to isolate such a pattern and put it to work in his painting. There is no doubt that much of his work shows this tendency, and in particular his string paintings (which seemed to me at first altogether boring and then, as more of them appeared, infinitely absorbing) benefit greatly from such an approach. But the desire to search for such patterns seems, on the evidence of his art, to be contrary to a romantic impulse which constantly reasserts itself. Nakamura's art can never settle easily into a system. In a painting like the 1954 *Inner View* the groping for pattern can be discerned, but alongside it there is a sense of mystery which I find much more attractive and which probably holds more possibilities for the future. So far, Nakamura has never been impelled to test or demonstrate his ability as a draftsman—his drawings, for all their ingenuity, have an

extremely narrow technical range—and perhaps it is this that his art most seriously lacks.

Nakamura was born in Vancouver thirty-four years ago. He was a charter member of the Toronto group, Painters Eleven, which did so much to introduce abstract painting to Toronto in the nineteen-fifties; he has been represented in almost a dozen foreign exhibitions of Canadian art, and he has had five one-man exhibitions in Toronto in the last seven years.

Jack Nichols has managed to avoid all the major tendencies —from Group of Seven style landscape art to action painting— which have dominated Canadian art in his time. He is almost alone among Canadians in his basic direction, which is towards the depiction of individual human beings in their immediate environment. "This interest is instinctive as well as being organic," he has said, and it "appears to have a firm and maybe permanent hold on me." [Catalogue, Stratford Festival Art Exhibition, 1959] It is no surprise, then, to learn that one of Nichols' early teachers was Fred Varley, the only one of the Group of Seven who has shown a persistent interest in human beings as subjects; and it is even less surprising when we notice—as we must, immediately—that Nichols' strongest influence is Picasso, who above all other modern painters has embodied this impulse. But the tone and the mood of Nichols' paintings *are* surprising. From the work with which he first achieved prominence—the war art executed with the Royal Canadian Navy—to the most recent prints and drawings, we can discern an even, though developing, mood. It is one of grim contemplation. Nichols' work rarely celebrates human beings, and on those rare occasions when it does, the celebration is inevitably accompanied by melancholy. More often, Nichols regards his subjects with a solemn, sympathetic eye, which occasionally leads him into sentimentality—as in his 1956 mural for the Salvation Army building in Toronto.

235

His early drawings of men at war—a typical one shows sea-men wrestling in a kind of agony with a hosepipe, the muscles in their bodies matched by the snaking hose—are comparatively literal. Later, the lines soften, the figures are rendered in hazy outline, and the artist's attitude to the subject is reflected in his technique. Nichols' drawings in the last decade have been mature and sensitive without ever being strikingly original; and his watercolour-and-chalk paintings have, for all their spontaneity, seemed finished and complete. But the most impressive achievement of his career is the series of black and white lithographs, first exhibited in 1958, which were the product of two years of research and work in Paris. They show a mastery of the technique of lithography which is unmatched in this country, and they demonstrate also a vision which is broader than Nichols has shown in any previous work.

Nichols, who was born in Montreal in 1921, lives now in Toronto. He had his first one-man exhibition at the Picture Loan Society in 1941, and he has exhibited individually at that small, distinguished gallery six times since then. His work has also been shown widely across Canada, in Europe, and in the United States. It is now in all of our major collections.

More than any other artist of his generation, **Claude Picher** has been able to read into the Canadian landscape a meaning that transcends nationalism and approaches universal significance. For Picher, a thirty-three-year-old Quebec City painter, the physical reality of Canada is never a bold challenge or a shining promise or an invitation to elegance: it is a threat. He takes the images—the jagged pine, the enormous tree-studded field of snow, the brutal rocks at the water's edge—which have become so familiar, so comforting; and he boldly converts them to his own private use. He charges the Canadian landscape with a highly personal importance and presents it to us as a forbidding, menacing, terrifying force. In their austere black and white, his paintings show us a landscape full of death, and as they sound this note again and

236

again they impress themselves upon us, and lodge in our memories. His is one of the most intransigent sensibilities in Canadian painting, and one of the hardest to avoid.

With the exception of a few minor exercises in relatively pleasant landscape painting—which in the context of Picher's work seem positively frivolous—all of his recent pictures maintain this mood. In his 1958 *Snow Geese Are Leaving* he shows us a furious, turbulent sky on the brink of winter, and leaves us with a new, chilling awareness of nature. In his 1959 *The Cold Night* he catches the blue-black mystery of an icy twilight. And he carries the same sombre intensity into his recent explorations in painting dead birds and fallen, murdered trees.

Picher has come to these jagged, violent landscapes in the last few years, after a decade of free-wheeling experimentation. In Quebec he has studied at the Ecole des Beaux-Arts (under Jean-Paul Lemieux) and has added to this studies in New York at the New School, and in Paris at the Ecole National Supérieure and the Ecole du Louvre. In recent years, as a director of exhibitions for the Musée de la Province and, later as a liaison officer for the National Gallery, he has come to know Canadian painting probably better than any other artist of his age; possibly this is what gives him the air of having lived through most of current and past Canadian art and then emerged at the other end, free to be his own man. In the late 1940s he produced occasionally a curious kind of decorative abstraction, and in the 1950s he brought a highly patterned approach to his work. Now he appears to have settled, not comfortably but certainly with confidence, into a semi-realistic style which offers one of the best hopes we have for the continuation in Canada of serious landscape painting which is free of nostalgia and rhetorical gesture but filled with a valuable, life-giving sense of the world around us.

In Canadian art it is impossible to avoid coming to terms with the painting of **Jean-Paul Riopelle**. More than any other Canadian, living or dead, he has impressed his artistic personality on the world outside Canada. He has, of course, left Canada to do it: he has worked in Paris since 1947, though he has maintained his close connections with this country. But in historical terms he has done much more than this: he has exemplified, more perfectly than any other painter in the world, the dominant tendencies of post-1945 art. In his work, the artist's thoughts are submerged in favour of the act of painting itself, and the physical fact of the paint is allowed to dominate the canvas. The paint is applied in what appear to be little rows, by the palette knife. It is scraped onto the canvas, then gouged and scored, leaving what looks like a tray of brilliantly coloured jewels. The result is an allover pattern, which has no time-sense, no broad rhythm, no structure—only a single overwhelming texture. Scores of other artists, from Warsaw to Los Angeles, have produced paintings which this description would fit fairly accurately, but none has done so with such consistency and with such pure devotion to the single method of action painting. In recent years a large part of abstract painting has seemed to abandon the concept of the single, independent work of art which is valuable in its own right; in place of this concept we have paintings which are pieces hacked off the artist's personality, sent to us bit by bit over the years. Again, Riopelle has exemplified this concept in its purest form: almost all of his paintings, from around 1952 to the late 1950s, can, in our imagination, be extended above or below the canvas or to either side; or for that matter they can, almost, be chopped into pieces, without changing their basic nature to any significant degree.

Riopelle's approach has produced some brilliant and memorable canvases, and certainly he has carved out a vision of paint-as-reality which must be taken into account in any survey of recent art. But the approach has also led to repetition, mediocrity, and eventually the dulling of the image he established with his earliest mature work. In the last two years, perhaps sensing that he has pushed his allover manner to the limits of usefulness, Riopelle has

238

seriously modified it. Some of his recent canvases are dominated by large central colour areas formed into solid abstract shapes. The palette-knife scrapes are still there, and it is still possible to identify the paintings as Riopelles at a distance of ten yards, but there is a slow shift toward more disciplined and thoughtful painting which can be discerned in any one of twenty or so canvases produced since 1958. They now have a machine-made air less often, and more often they show the evidence of contemplation. Riopelle, enormously talented, is still only thirty-seven; the next few years should be among the most interesting in his career.

"He has required," wrote the New York critic Parker Tyler, "only two years of his present sum of thirty-one to live in New York and clairvoyantly appropriate its milieu of paint." [Greenwich Gallery, Toronto, November, 1957] Three years ago, Tyler's judgement was appropriate; since then it has grown steadily less relevant, as **William Ronald** has gradually liberated himself from the overpowering influence of New York action painting. In his 1957 *Zoroaster,* a canvas five feet by six feet, we can see one of the last examples of almost pure action painting in his work: the big, slashed-out wound in the centre; the long swooping parabolic line; the thick, creamy buildup of paint—all of these are, or were, among the dominant trademarks of New York art, and Ronald learned how to handle them superbly. He had come to New York in 1955, after establishing a modest reputation in Toronto. His education at the Ontario College of Art had been studded with controversy (he was a natural rebel from the beginning) but he had been lucky enough to study there with J.W.G. Macdonald, whom he now calls his most important teacher. He had been a member of Painters Eleven (he resigned three years ago) and had won several scholarships. But his arrival in New York, at the age of twenty-nine, was the beginning of the crucial years of his career. In a sense he had to work his way through

New York painting—which he had admired enormously from a distance—before he could find a personal way to face the canvas. In his 1958 paintings, like *White Three*, we can see him solving this problem: he combines the techniques of action painting with an acid colour sense, a firm and developing structure, and a sense of mystery which is lacking from so much of even the best action painting. In more recent work these tendencies have been emphasized, and in the last two one-man shows I saw (at the Kootz Gallery in the autumn of 1959 and at the Laing Galleries, Toronto, in the winter of 1960) he showed a series of compelling and monumental paintings. In the latter exhibition he also demonstrated that he has not lost but instead has developed his ability (extremely rare among non-objective painters) to produce small pictures, both watercolours and oil sketches, which embody all the personality and ingenuity of his larger works.

Ronald, who was born in Stratford, Ontario, has represented Canada at both the Brussels Fair and the São Paulo Bienal, and he is one of two Canadian painters of his generation—Riopelle is the other—who have achieved some reputation outside of this country. His exhibitions at the Kootz have established him on the New York scene and his paintings are now in the collections of the Museum of Modern Art, the Brooklyn Museum, and the Guggenheim Museum, among others. In 1959, when Frank Lloyd Wright's new Guggenheim building opened on Fifth Avenue with an Inaugural Selection from the permanent collection, those Canadians who attended had the distinct pleasure of discovering that the youngest painter honoured by inclusion on this occasion was William Ronald.

Gordon Smith has been called by the Vancouver critic, Anthony Emery "an abstract-figurative-expressionist"[*Canadian Art*, Autumn, 1956]; the term itself, though perhaps offered half as a joke, indicates the difficulty that critics face when they approach a painter like Smith. He is abstract because he calls on the techniques developed in recent abstract art. He is figurative because of-

ten he leans heavily on the images offered by the British Columbia landscape around him. He is an expressionist because in many of his paintings he borrows the surface techniques of expressionist painting. But even this only begins to suggest the influences that have played on Smith in the last twenty years, and which he has resolved so successfully in the best of his painting. One of the strongest influences, and one that never escapes from his work, is that of the Bay Group of California painters, whose ideas were injected into Smith's paintings during his 1951 visit to California. His work has the buoyancy and sometimes the delirious handling of light which we associate with the best California art. Like the best of British Columbia painting it also has a very intense and intimate relationship with the B.C. landscape. "Gordon Smith paints nature at one remove," Emery has suggested: "he faces the landscape, but views with the inward eye." But it seems to me that he is successful in direct proportion to the use he makes of the inward eye and in inverse proportion to the extent that he imbeds some images derived from the landscape in his pictures. Certainly nature fills and enriches his best work—the earth colours surround us as soon as we enter any Smith exhibit—but he has been most convincing when he has abandoned the conventions of semi-realistic landscape and allowed his talent for free, spontaneous calligraphy to assert itself. A painting like *Pruned Trees*, in which he brings together a series of natural forms in a dense, allover pattern of lines and planes, is typical of Smith at his best. This same basic approach been carried over into his sculpture—notably in the abstract architectural sculpture for the Vancouver Civic Theatre. Smith was born in England and came to Canada as an adolescent. He is an assistant professor at the University of British Columbia. His paintings hang in all of our major museums, and his national stature has been recognized by two major prizes: the National Gallery Biennial Award 1956, and a Baxter Award, at the Art Gallery of Toronto, in 1959.

241

To work out at the edge of art, charting new regions of sensibility, takes a special kind of disposition: confident, searching, restless, never quite pleased. This is **Michael Snow's** personality, as we can watch it grow and develop in his art. In the spring of 1959, when he was asked to submit a small group of paintings for a Four Canadians show at the Art Gallery of Toronto, Snow in a typically audacious move—decided, at the age of thirty, to stage what amounted to a midget retrospective exhibition. The paintings he submitted covered the five years or so of his maturity. They demonstrated an unusually high level of achievement, but they showed something more: Snow had, on at least four different occasions, mastered a style that was unique. He had found, for instance, in 1957 a completely personal approach to action painting; and in 1956 he had worked out, in a picture that looked like a gentle explosion, a very individual kind of impressionistic abstraction. On either of these paintings, and on at least two others in the same show, many a painter could have built a career. But Snow's paintings are complete in themselves. He makes each a challenge and an achievement, and, better than anyone else in Canada, he avoids the current tendency to repeat a theme endlessly and to offer, in each painting, just one more chip off the artist's personality.

It is one of Snow's many charms that he is resolutely unCanadian. He stands completely outside what R.H. Hubbard has accurately defined as the Canadian tradition:"that peculiar combination of directness, sober restraint, honest expression, and decorative intent that has made Canadian art what it is."[R.H. Hubbard, *An Anthology of Canadian Art*, Oxford, Toronto, 1960] Snow's art, on the contrary, is frequently indirect: he is given to sly comic effects, absurd juxtapositions, ironic asides. His art rarely shows sober restraint: it jumps and crackles electrically, and in its intense searching for extremes it seems to attempt to encompass all human emotion, all radical opinion, all visual possibility. It is honest, certainly, but it shows nothing that could be called decorative intent.

At first glance much of Snow's work seems absurdly simple, but he turns out to be one of the few Canadian painters who reward long contemplation. His 1958 *To Orangeville*, which seems

242

to me to sum up many of the tendencies he showed in earlier pictures, is forthright enough in its layout: six small squares march across the middle; a large rectangle dominates the top; a smaller one is placed at the bottom. Yet the picture moves with spontaneous vigour, in sharp, jerky, irregular rhythms. Snow's influences—among them modern jazz (he is a professional pianist as well as a painter), film animation, and several senior members of the New York school—have never been resolved with more skill and finality. But even this doesn't define Snow's talent: to do that you must consider his beautifully funny pen drawings, his often effective sculpture, and his rich, sensuous nudes. Snow studied at the Ontario College of Art and then in Europe; now he lives in Toronto and exhibits regularly at the Isaacs Gallery.

A cursory examination of major association exhibitions in the east or perhaps even a careful examination—would have yielded the conclusion that there exists, between Ontario and British Columbia, something close to an artistic wasteland. It was therefore a large surprise, and an altogether pleasant one, when **Ronald Spickett** of Calgary was awarded one of the three $1,000 Baxter Awards in Toronto in 1959, the year those prizes were first given. And it was even more surprising that the painting with which he won was, easily, the most impressive of the three prize-winners. The fact that we had had no chance to observe Spickett's progress towards this point, and that he thus emerged full-blown from the West, only testifies to the still shaky and erratic nature of inter-regional communications in Canadian art.

Spickett has come very gradually to the kind of abstract painting which won the Baxter Award and which he has subsequently exhibited in greater quantity not only in Toronto but across the country. He was born thirty-four years ago in Regina, and he has worked as a display artist, as an editorial cartoonist on the Regina *Leader-Post*, and since 1957 as a teacher at the Provincial Institute of Technology and Art in Calgary. His first serious art studies

243

were at the Institute shortly after his naval service in the Second World War, but in the middle-fifties he also studied for a year at the Instituto Allende at San Miguel, Mexico (a school which, having provided tuition for at least a dozen Canadians, will surely someday find a place of importance in any history of Canadian art). In Mexico, and for some time after, he concerned himself primarily with interpretation of the human figure. "If my paintings retained the image or illusion of form longer than seemed contemporary," he has said, "it is only because I have found it necessary to experiment, grasp, accumulate ideas and methods, in order to unravel and release them."[Spickett/Caiserman. *National Gallery Catalogue*, 1960] As a result, he has concentrated on non-objective painting only in the last few years.

What is surprising, in the light of his history and his statement, is that in most cases these accumulated forms and ideas have failed to make any appearance in his actual paintings. His best work can be placed securely within the tradition of Jackson Pollock—allover design, sometimes a delicate tracery of lines, no discernible images or traditional structure. In a sense, he has borrowed Pollock's insights and tamed them. Whether he can find ways to use them more broadly for his own purposes is a question still unanswered, but there is no doubt that already he has used them with skill and grace.

Like several other Canadian painters of Japanese descent, **Takao Tanabe** of Vancouver does not bother to deny his link, however obscure or complex it may be, with Japanese visual culture. Instead, he seems to exult in it, and though he had not been to Japan until a Canada Council grant took him there last year, his painting has all along reflected a Japanese influence. In a work like the 1959 *Forest at Top Loft*, he demonstrates a kind of soft, sensuous calligraphy which is a mixture of Japanese discipline and action-painting freedom. All of his work, or almost all of it, has the quick grace and the extreme reticence which this picture illustrates. Tanabe works, so far, in an extremely narrow range of colour and

form: for several years most of his paintings offered us small, gentle shapes dancing lightly on a creamy white background. In a one-man exhibition (he has had at least one in every major city in Canada, and two each in Toronto and Ottawa) this leads to a kind of dreariness: after a while the paintings tend to run together in the viewer's mind; Tanabe is one of the few good abstract painters who suffer rather than benefit when a score or so of his pictures are brought together. But individually, as he intends them to be seen, Tanabe's paintings make their own firm, memorable impression.

His abstract landscapes, unlike most of those which emerge from the studios of B.C. painters, are connected to no particular time or place. He refers to his general subject as an "interior land,"and gives his paintings such titles as *Tacygraphic Fragment from My Interior Land*. The forms themselves he has picked up in B.C., on the prairies, in his two-year tour of Europe (particularly in Denmark).

Tanabe was born at Prince Rupert thirty-four years ago, the son of a fisherman. With his family, he was "evacuated" by the government to Slocan, B.C., and eventually reached Winnipeg before the end of the war. He has studied formally at the Winnipeg School of Art and the Brooklyn Museum Art School, and briefly with Hans Hofmann, the Banff School, the University of Manitoba, and the Central School in London.

No Canadian artist, of the current or any other generation, has made such a deep impression, in so many media, as **Harold Town**. A note on his art can easily become a catalogue of enthusiasms: for the big, swooping shapes in the best of his oil paintings; for the rich inventiveness of his *collages*; for the brilliance and tension and clarity of his "single autographic prints," the form which he invented for his own purposes; and for the virtuosity of his drawings. But even a list like this omits Town's accomplishment as a mural artist—the spectacularly virile and imaginative

abstract wall painting, ten feet by thirty-seven feet, which he executed for the observation tower of Ontario Hydro's power dam at Cornwall in 1958.

Town's various approaches to these forms differ in so many ways that it is tempting to regard him as an artist without any central purpose or direction. But a long exposure to his work of all kinds leads me to a different conclusion. The same images and ideas, drastically altered but still recognizable, turn up again and again: the great swooping shape of the 1959 drawing, *The 72 1/2 lb. Departure* has been seen several times before, notably in the Hydro mural, and the ambitious, interlacing, level-on-level construction of his 1957-58 *collage, The Deposition of Yang-Kuei-Fei* appears frequently in both his prints and his paintings. After several years of watching Town's successes and failures (the latter occur most often in his smaller paintings and in the more derivative of his drawings) the close observer begins to sense his basic direction. Town is reaching for a heroic gesture, for a noble form. Like Picasso (who is by far his major influence, particularly in the drawings) Town plunders art history for inspiration, using classical forms and ancient iconography to prod his own imagination. In many instances—most importantly, I think, in his *collages*—he reaches, through a combination of virtuosity and inspiration, the nobility of form that he seeks. The statement these works make is, after a time, both obvious and enriching: they stand against reticence and modesty, and in favour of large, heaven-storming deeds.

Without leaving Canada, Town has achieved the beginnings of a reputation abroad: he has won prizes at international exhibitions in Switzerland, Brazil, and Yugoslavia, as well as in half-a-dozen Canadian exhibitions. In Canada his place is the art of the present is secure: his work hangs in all of our important public collections, and most of the private ones.

By the end of 1958, **Tony Urquhart** of Niagara Falls, Ontario, had been exhibiting regularly for less than two years and had not yet reached his twenty-fifth birthday. Yet he had already: 1) won the first prize for an oil painting at the Western New York annual exhibition at the Albright Gallery, Buffalo; 2) won the Canada Council purchase prize at the Vancouver Art Gallery; 3) been admitted to the Pittsburgh International; 4) been included in the five painters representing Canada at the Guggenheim International exhibition in New York; 5) had two one-man exhibitions in Toronto and found his way into several of the country's best private collections. His appearance on the Canadian art scene—he began to exhibit in 1956, even before he graduated from the Albright Art School—was as sudden as it was exhilarating. His was obviously an unusual, natural talent; his draftsmanship was confident and unexpectedly mature, his colour sense was admirable, and his imagination showed signs of flowering brilliantly at any moment. But collectors, critics and ordinary gallerygoers may, on the basis of this promise, have expected rather too much development immediately—certainly we tend often to expect, even demand, a steady, consistent growth which is more mythical than real and which has rarely if ever occurred in the life of an actual painter. In any case, Urquhart's paintings began to seem inadequate to his promise. To me they appeared, especially in early 1960, to be cluttered and rather thoughtless; sometimes his oil paintings, as well as his drawings, looked not so much like finished works of art as tentative sketches for something larger and more important. Still, even in his most careless canvases we can never miss the signs of genuine talent, and his interpretations of landscape maintain a constant gaiety which is entirely welcome in Canadian art. His drawings, which range from lively calligraphic scrawls to graceful leaf drawings, are charged always with a personal sense of rightness and well-being.

247

33.

"CAN TORONTO OVERTAKE
MONTREAL
AS AN ART CENTRE?"

by Hugo McPherson

Government's new role in the arts equation often seemed to stir up old parochialism and provoke regional discord even as it encouraged new activity nationwide. In this November 1958 Canadian Art *essay, Hugo McPherson (born 1921), an academic and journalist as well as one-time chairman of the National Film Board, writes hopefully of Toronto's rise, viewed against the diminishing echoes of the* automatistes *and other Montreal groups. He bases his argument on such considerations as the number of artists each city could attract, the extent of the comparative infrastructure, and the influence of language in giving them access to larger audiences: some of the concerns which would be taken into account in the coming debates over regionalism, which McPherson's piece so clearly anticipates.*

There was a day, not too long ago, when many Torontonians felt comfortably sure that their city led the nation in the field of fine art. Today, although the city's cup of talent still appears to be brimming over, it is clear that Montreal has become the country's leading art centre, while Vancouver has produced a group of challenging skill and originality. Since the heyday of the Group of Seven, in fact, Toronto's prestige has steadily declined. For example, only three Toronto artists (two of them living away from the city) are among the 23 who represented Canada at the Brussels World's Fair. And this year the annual exhibition of the Ontario

Society of Artists (its eighty-sixth) achieved such a finished banality that even painters cried out.

Yet despite the repressive hand of an Academy that is self-satisfied, and a widespread public hostility towards the bulk of post-impressionist painting, an uninhibited crowd of young people now tug rudely at the stays of tradition and threaten to strip Ontario's school-teacherish old muse down to the measurements of a leggy chorus-girl. So definite is the change, in fact, that Toronto now leads the nation in the birth-rate of new galleries. It is time, then, without mincing words, to re-examine Toronto's position in the arena of Canadian art. It is beginning to promise the artist new stimulation and rewards, but at the same time it presents him with a number of problems that are cruelly piercing.

I cannot consider this change without first exposing a paradox in Toronto's history as an art centre: the Group of Seven was at once a triumph for Canadian painting and a calamity for Ontario artists. It was a triumph because it gave the nation an art that was distinctly *Canadian*. Canada wanted a national art just as it had wanted (twenty years earlier) a Canadian literature; and the Group of Seven gave the nation a handsome record of its landscape, just as Carman, Lampman and Sir Charles G.D. Roberts had given it a poetry on the same subject. There is no point in quibbling about the appropriateness of such work; before 1930 Canadian nature was the most arresting subject that confronted the native sensibility, and it was absolutely inevitable that artists should interpret this subject first. But by the same token the Group of Seven was a calamity, not because of its paintings (many of which we venerate) but because its work confirmed the English-Canadian audience in its provincial Victorian view that art is inspiring and ornamental and divorced from the "practical" world of affairs. Thus, when revolutions in politics and in science were forcing European artists to re-examine both their subject-matter and the very materials of their art, the English-Canadian audience clung fondly to a style of painting which had passed its peak by 1930, even in Canada.

For the Group of Seven we have nothing but admiration. But to have treated them as an *ideal* rather than as a landmark on the

road is a calamity, for their many imitators have never surpassed them; and younger painters, finally aware of the inadequacy of this tradition in relation to the contemporary scene, have had a long struggle to find buyers. The Toronto public, almost totally uninitiated in twentieth-century art outside of Ontario, has bitterly resisted the idea that art should be provocative and challenging—a living experience. The last exhibition of the Ontario Society of Artists, a demonstration of accomplished technique with nothing at all to *say*, is surely final proof that the old well has gone dry and no new spring has yet been recognized officially as the foundation that may quench a growing city's thirst.

I do not mean to suggest that Montreal has always been an oasis for artists while Toronto has wandered in the waste land. On the contrary I would argue that (if we except the achievement of James Wilson Morrice) Toronto flowered first in modern painting, for the Group of Seven, although an offshoot of French impressionism, established a subject and a manner. Montreal, representing a culture that was at once close to the French tradition and long since acquainted with the Canadian landscape, did not *need* a Group of Seven. Morrice was the first to demonstrate the links between Canadian and modern European painting, but the real rebellion in French-Canadian art came long *after* impressionism; this rebellion was instructed by the pattern of change in French painting, and its dynamic was not Canadian nature but the artist's need to find his place in a traditional society now menaced by the juggernaut of industrial capitalism. As a result, Montreal has provided in recent years a most exciting atmosphere for the artist. It has been a city full of the riches of Europe and the tensions of a society in the throes of change. This atmosphere has given Canada the turbulent expression of Borduas, Riopelle, Dumouchel, Bellefleur and Mousseau, and the statements of such non-French talents as Marian Scott, Anne Kahane and Ghitta Caiserman. In a word, the Montreal artist seems intent above all on finding out "where he is" in a challenging world; the Toronto painter (if he has not been basking in the sun of the Group of Seven) has been trying to escape the knowledge that he is in Toronto.

250

In a moment I shall consider some positive signs that Toronto's drought is slackening, but first another major problem commands our attention. It is a curious fact that Ontario painters (and I think particularly of those who are well known) fail to develop their gifts progressively. They evolve until they find a theme or themes, and until they have perfected a style. Then, having achieved a trade mark and a market, they become merchants rather than artists. They imitate themselves endlessly to the point that even their admirers begin to say apologetically: "It's fine style, but he hasn't tackled a new problem in fifteen years." Now painters, like poets and musicians, enjoy producing works "in their best vein," and of course these variations on a theme give them the financial return that they deserve. But the genuinely creative artist cannot stand still; he must move on to new things or stagnate. Certainly the twentieth-century French masters have never become dull, and Montreal's artists (Pellan, Tonnancour, Kahane, Dumouchel, to name a few) have continually attacked new problems, often at great risk to their personal prestige. Why, then, do Toronto's artists, after an initial success, begin to mark time?

Three answers present themselves insistently. First, since Toronto has become more and more a commercial and industrial mushroom in the last decades, painters have had many chances to do commercial work or to teach. And in either category the emphasis is on a recognized style rather than experimentation. Certainly the Ontario College of Art itself places skills above originality; and even the few magazines that risk such "daring" artists as Tom Hodgson and Harold Town want a trade-marked style. Second, a sizable number of painters have aimed very simply at giving the Toronto audience what it wants. Their attitude may be purely cynical, or they may honestly think, as their public does, that the decorations which they produce are serious art. Whatever the case, it *pays* them to stand still. Third, and certainly this is the most important point, Toronto painters have felt no real stimulus from outside until very recently. Until this year, for example, the new Quebec painters have rarely been seen in commercial galleries, and the leading painters of the American movement have been

251

glimpsed only sketchily in such institutions as the Art Gallery of Toronto.

But even as I state them, these three answers almost explode in my face, for the Toronto scene is crackling with portents of change. I can do no more than describe them in turn.

To begin with, that "old" Toronto, the city that wrinkled its nice Helen Hokinson face in bewilderment at the whisper of abstraction, is having a blood transfusion. Once it was the living centre of solid Ontario, but now one in five of its citizens is a New Canadian, as compared with a national average of one in fifteen. German, French, Italian and "British" echo along the streets and a U.N. babel of names (Shadbolt, Motherwell, Marini, Sutherland, Buffet, Pollock, Riopelle and Town) rise above the standard gallery comment of: "I don't know anything about art, but I know what I like." The character of the gallery-going audience, in short, is changing; the standards which it is learning to apply have nothing to do with patriotism or with the cult of Canadian nature. This audience takes an exuberant interest in new art, and it is anxious to *buy*.

Inevitably, the taste of a substantial part of this developing public is uncertain; they don't know what to buy because they have seen little more than the toes and tail of modern painting. As a result they buy out a showing of lithographs by a recognized master, Chagall, even though the prices are as much as double the going price in Paris; and they gobble up trivia by recognized painters while young and promising talents barely cover the costs of exhibition. But public interest, paralleling the boom in American painting, does exist, and the range of new exhibition space has met this demand. The Greenwich Gallery, for example, has held distinguished exhibitions by Montreal's Anne Kahane and Niagara Falls' Tony Urquhart, alternating with such impressive Toronto talents as William Ronald, Michael Snow, Graham Coughtry and Mashel Teitelbaum. The two-year-old Gallery of Contemporary Art has presented a half-dozen good painters including Town, Hodgson, Nakamura and Hedrick, and from the rest of the continent it imports works by Jean Marin, Rico Lebrun and the ancient

252

sculptors of Tarasco. The same gallery has shown work by the Quebec painters, Borduas, Bellefleur, Riopelle and Mousseau, while the Laing Galleries have adopted Jacques de Tonnancour and the Roberts Gallery has put on a generous group exhibition of Quebec painters and sculptors. In tune with this ferment, and with its well-established tradition, Douglas Duncan's Picture Loan Society alternates brand-new painters with such nationally known figures as Joe Plaskett and Scottie Wilson. Meanwhile in "village" garrets and refurbished drawing-rooms, isolated groups of painters and art students are announcing themselves to the world, while the fashionable new Park Gallery presents the Helena Rubenstein collection of Canadian painting and a show of Painters Eleven. The Eglinton Gallery, speaking principally for France, imports prints and drawings from Europe. Even large corporations, such as Imperial Oil, have begun regular "house" exhibitions for their personnel and clients. The Toronto public, in short, is being exposed to a quantity and variety of art that is unprecedented in any Canadian city. This, surely is a fundamental step away from the chauvinistic tendency to accept only one style and one period. Toronto, I believe, has broken its provincial shell, and in the course of time should become a lively centre for contemporary art.

If I could say that this increase in exhibition space was paralleled by a growth of stimulating art criticism, I would be very happy, but that development is lacking. And worst, I learn that persons sent to review exhibitions accost the exhibitors with: "Well, if you won't tell me what the show *means* I won't be able to write a story." Critics who might be expected to mould opinion, are apparently reluctant to tread on tender toes. As a result, only the CBC's reporter, Robert Fulford, has had anything useful to say.

But whether criticism is available or not, there is no mistaking the spirit of a group of the city's younger artists. The most significant development on the Toronto scene is undoubtedly this: younger painters (whether consciously or unconsciously) are more and more finding their inspiration and their moorings in the dynamic American school of abstract expressionism. One, William

Ronald, is already well established in New York. Another told me recently: "The Quebec painters are fine, but their abstractionism is soft. The American painters, people like Pollock, have a good gutty feeling. They're *with it.*" This comment, borrowing from the idiom of progressive jazz, is not merely giddy enthusiasm. It means that Toronto's newest talents find the Quebec group lyrical and romantic by contrast with the two-fisted energy and directness of American abstract expressionism. The central intention of these new artists is related to the impulse that has produced the jazz and poetry of the "beat generation," but it is more interesting. It strives above all (without recourse to drugs or motor cycles) to *connect,* to lay bare the very heart of an experience. Thus while Alfred Pellan examines the mysterious figure of *woman* in a canvas that blends myth and psychological symbols in a studied mosaic pattern, Graham Coughtry attempts to get at the essential nature of figures in nocturnal repose; or Kazuo Nakamura evokes the viewless stresses of a bridge by dipping the edge of a card in ink and printing a delicate mesh of lines. In the same way, while Riopelle moves towards tapestry effects of great splendour and richness, Tom Hodgson develops a series of green forms in *Painting Full Grown* to suggest directly the exciting process of growth. In even more impressive terms, Michael Snow's canvas, *Descending*, defines his perception of "the table" as a central fact in man's experience. This expression emerges from a long series of paintings of domestic furnishings; and it strips the concept down to the very core of its meaning. In another vein, Harold Town's *The Dixon Passing Muggs Island* records the *interior* excitement, the artist's flashing comprehension of a boat rounding the point of an island in Lake Ontario.

There can be no doubt that such expression operates within highly restricted limits. Indeed the viewer must often depend upon the title of a work for the spark that detonates its full meaning. (The same is true, of course, in representational painting where a simple title such as *Delilah* establishes a frame for the viewer's appreciation.) But it is inaccurate to argue, as the speaker at the Toronto opening of the Society of Graphic Arts argued last May,

that the abstract painters now flourishing in Toronto produce "identical," meaningless canvases devoid of human experience. Nothing is more characteristically human, surely, than the struggle to communicate an experience in its most direct, vivid form, not merely the exterior features as the camera does, but to communicate them *existentially*—to give the living reality. Such work is *intense* with meaning; one wonders if its detractors forget Andrea del Sarto's bleak perception that that though he could draw faultlessly his work was sterile as compared with the struggle revealed in Michelangelo's works. Certainly the engaged vitality of these painters, as they explore the very fundamentals of their materials and their experience, is infinitely more interesting than an art which goes on monotonously copying achievements that are a quarter-century old.

Thus, with its growing audience, its new galleries and its energetic new group of painters, Toronto shows promising signs not of overtaking Montreal as an art centre but of finding a vigorous life of its own. Undoubtedly its enlarging orbit will come more and more in stimulating contact with Montreal, but its pole-star will be New York, just as Montreal's pole-star is Paris. To say that the new era is beyond its infancy would be a wild exaggeration. It would be truer to say that the birth announcements have just now been painted, and the reluctant godparents—the artists' societies and the Academy—still pretend that the unwanted infant does not really belong in the family. But these institutionalized groups, so often cast as aging tyrants, will not be responsible if the new movement fails to develop. The real ferment of change must come from painters and their audience. Toronto has still not reached the point, for example, when a sculptor will beg a condemned tree from the City Works Department, as Roussell did in Montreal, and convert it into a sculpture where it stands. Toronto University students do not band together (as students from McGill and the Université de Montréal did last January) to exhibit a collection of the major contemporary painters of the United States. Ontario students, to be blunt, come to university armed with the assurance that contemporary art is largely nonsense.

Moreover, Ontario artists as a group lack a lively interest in each other's work and the kind of camaraderie that led Montreal artists, both the best and the worst, to hold a huge non-jury exhibition in a third-floor storeroom next door to the local burlesque house. That took place in 1953, and crowds climbed the rickety stairs to see the exhibit.

Ontario's climate, by contrast, has been more favourable to the erection of solid brick suburbias and monuments to its own past than to garrets and creative experiments of the mind. Indeed it will never duplicate the culture of Montreal, with its deeply-rooted classical tradition. The hope, therefore, is that Toronto, with its provincial history reaching an end, will produce an art expressive of its new identity and its new awareness of the international community. From the ashes of the past may arise a phoenix; for the moment, the funeral pyre is no more than well aflame.

34.

"THERE ARE NO UNIVERSAL LANDSCAPES"

by George Woodcock

The libertarian perspective of George Woodcock (born 1912), the Vancouver critic and man of letters, gave his role in the regionalism debates of the 1960s and 1970s an unusual forensic edge. His contention that regionalism is the true nationalism and flourishes best without reference to government was a recurring theme in his writings on cultural politics, including this article published in the October 1978 issue of artscanada, *a journal to which he often contributed. Woodcock's many books include several of relevance to the visual arts in Canada, such as* Ivan Eyre *(Toronto: Fitzhenry & Whiteside, 1981) and, with Toni Onley,* The Walls of India *(Toronto: Lester & Orpen Dennys, 1985).*

In discussing regionalism and the land in Canadian art and literature I am in no direct way concerned with the political analogues, for though the political conformation of Canada is a reflection of the geography and history that have also shaped its arts, and though provinces may share boundaries with regions, provinces are artificial creations while regions are natural realities. It is in regions that landscape combines with history to create traditions, as the Québecois and the Basques, the Welsh and the Flemings, all so demonstratively affirm. And, if Marshall McLuhan was correct in suggesting that artists anticipate what society will become, the growing regionalist consciousness of Canadian artists and poets is of obvious importance to our vision of the future of this country as well as to the history of its arts.

Regionalism is not a very old concept in relation to Canadian art or literature, which had first to be defined in colonial and then

257

national terms before a thorough understanding of the land as scape made a regional definition possible. However, a great deal that has passed for nationalist in post-Confederation Canadian arts is in fact regionalist.

The Group of Seven, for example, undoubtedly saw themselves in protonationalist terms. In the foreword to the catalogue of their fist joint show in 1920, Lawren Harris extended a welcome on their behalf to "any form of art expression that sincerely interprets the spirit of a nation's growth," and J.E.H. MacDonald said his own paintings and those of the Group in general, "Their nationality is unmistakable." Yet one immediately detects analogical rather than logical relationships being established.

Art can never be truly national any more than it can be truly cosmopolitan, and here—about the time the apologists of the Group of Seven were talking of art and the nation—Homer Watson came nearer the truth when he noted down some thoughts that seemed to reflect the philosophy behind his own intensely regional landscape painting.

> There is at the bottom of each artistic conscience a love for the land of [one's] birth. It is said art knows no country but belongs to the world. This may be true of pictures, but great artists are no more cosmopolitan than great writers, and no immortal work has been done which has not as one of its promptings for its creation a feeling its creator had of having roots in his native land and being a product of its soil.[1]

Of course, a love of the land may be adoptive and many Canadian artists have nobly interpreted regions where they were born: Malcolm Lowry sensitively evokes in "The Forest Path to the Spring" the coastal inlets of British Columbia where he had *found* a true home, and the transient British officer Thomas Davies in his pre-Victorian watercolours distilled an essence of the landscapes of Laurentian Canada.

An artistic interpretation of the land is inevitably localized; there are no universal landscapes, and landscape painting is in fact the genre least likely to submit to cosmopolitan homogenization.

By this token, the Group of Seven were among Canada's most regionalist painters. Regionalism, of course, does not necessarily produce landscape art. The Coast Indians and the Melanesians are regional artists in the sense that their styles and techniques were developed in small geographical areas; their art is linked with the cult of the ancestors which in turn is linked with possession of the land and intercourse with its tutelary spirits. Yet the land as such is never imaged in the arts of these peoples, who live in and from it rather than standing aside to observe and hence to dominate it as we do. They render their particular and concrete experience of the land animistically through beings who, taking animal or near-animal form, inhabit and embody landscapes.

We do not accept such animist mediation, and so, encountering the land, we draw our *mana* directly from its forms, its colours, the atmosphere that tones it. Hence landscape is our most direct presentation of regional awareness. It is not accidental that romantic pantheism was linked with a strong awareness of landscape, as happened poetically in Wordsworth and visually in Turner; if there is anything to which modern man seeks to place himself in totemic relationship, it is the land. But the land is still inhabited, if no longer by spirits; its creatures, vegetable, animal and human, enter into the subject matter of regional art.

The region does not merely provide the artist with models. Tradition, language, history, terrain: all impinge on the regional consciousness, making it more distinctive, inclining it to seek its artistic promptings locally. It is not accidental, for example, though difficult to explain with logical precision, that modern Canadian High Realism in landscape painting has flourished especially among Atlantic Provinces painters.

There are dangerous temptations attached to this kind of localization; much regional painting and writing, particularly fiction, becomes deeply involved in genre, in the creation of local colour, and while genre and local colour are quite compatible with impressive artistic achievement, as in Joseph Légaré's dramatic early nineteenth-century paintings of cities afflicted by plagues and fires, they can lead to the kind of obsession with the picturesque that

259

marred so much painting of Quebec life, not only among outsiders like Cornelius Krieghoff, who exploited the quaintness, but among Québecois like Clarence Gagnon and Aurèle de Foy Suzor-Coté, who as landscape painters helped to revolutionize Canadian painting by introducing an impressionist style that at last took advantage of the clear Quebec winter light, but who almost invariably sentimentalized the human element.

Whether they came from France, Britain or the American colonies, early immigrants brought with them the pioneer mentality that blights the arts by seeking to duplicate an old world culture in an alien setting, and in the process ignores the nature of the new environment, which is usually wilderness and therefore hostile and terrifying—"this anomalous land," as Hugh MacLennan called it, "this sprawling waste of timber and rock where the only living sounds were the footfalls of animals or the fantastic laughter of a loon, this empty tract of primordial silences and winds and erosions and shifting colours."[2]

The first painters in Canada were priests like Friar Luc who showed in conventional French landscapes the Indians they hoped to convert, and the first poems were Marc Lescarbot's laments at being left in an alien wilderness at Port Royal and the witty Jacobean verses Robert Hayman wrote in Newfoundland to amuse Ben Jonson and other London wits.

The Aire in Newfound-land is wholesome, good;
The Fire, as sweet as any made of wood;
The Waters, very rich, both salt and fresh;
The Earth more rich, you know it is no lesse.
Where all are good, *Fire, Water, Earth,* and *Aire,*
What man made of these foure would not live there?[3]

That is the poetry of conceit, not of landscape, and such the poetry of both Canadas, French and English, remained long into the nineteenth century as the poets sought to escape their settings by describing them in imagery appropriate to European cultivated landscapes.

Landscape painting and drawing emerged from the colonial period before a true poetry of the terrain. The pre-modernist painter tended to work from a model in nature to a much greater extent than the poet, who can produce literature out of literature for a much longer period than the painter can produce painting out of painting. Moreover there were utilitarian impulses that hastened an awareness among early Canadian artists, who were largely amateur and therefore unacademic, of the visual realities of their new world.

Before photography, armies depended on topographical artists to provide representations of the terrain, and British officers were often trained in topographical drawing by professional painters. Moreover, the great government-supported naval explorations of the late eighteenth and early nineteenth centuries needed illustrations for the voyage narratives that were then a form of literature, and so they were often accompanied by artists, either professional, like John Webber who reached the Pacific coast with Cook in 1778, or amateur, like Sir George Back whose sketches done on the Franklin expedition of 1825 first introduced a European audience to the desolate landscapes of the Canadian north. Such artists gained by experience an understanding of regional landscapes that was functional in purpose, but which often, as with Thomas Davies or with William Hind illustrating his brother's narrative of exploration in Labrador, led to aesthetically interesting pictorial results.

In a similar way a utilitarian but sensitive landscape prose developed long before landscape poetry, in early exploration narratives like Samuel Hearne's *Journey to the Northern Ocean* (1795), which presents the look and feeling of the Barren Lands with an immediate authenticity not rivaled for generations.

When poetry did begin to show a real sensitivity to the Canadian landscape it was largely through the work of men who had followed the explorers into the regional remotenesses of Canada: men like Charles Mair who had travelled the unploughed prairie which he wrote of as,

Voiceless and calm, save when tempestuous wind
Rolled the rank herbage into billows vast,
And rushing tides which never found a shore....[4]

and Duncan Campbell Scott whose work as an Indian agent took
him far into the northern wilderness. Scott was one of the Confed-
eration poets who in the 1880s broke away from colonial literary
attitudes. He and his fellows visualized landscape authentically for
the first time and found the images and verbal forms that rendered
its nature with poetic truth. Charles G.D. Roberts in New Brun-
swick, Archibald Lampman in the Ottawa Valley, and Scott in
northern Ontario wrote the first genuine regional poetry in Canada.
Scott's "En Route," with its sharp and almost imagist clarity is an
excellent example of this kind of landscape verse.

The train has stopped for no apparent reason
In the wilds;
A frozen lake is level and fretted over
With rippled wind lines;
The sun is burning in the South; the season
Is winter trembling at a touch of spring.
A little hill with birches and a ring
Of cedars—all so still, so pure with snow—
It seems a tiny landscape in the moon.
Long wisps of shadow from the naked birches
Lie on the white in lines of cobweb-grey;
From the cedar roots the snow has shrunk away,
One almost hears it tinkle as it thaws.
Traces there are of wild things in the snow—
Partridges at play, tracks of the foxes' paws
That broke a path to sun them in the trees.....[5]

The great Canadian landscape poems of the 1930s and 1940s,
like Earle Birney's "David," A.J.M. Smith's "The Lonely Land"
and Douglas LePan's "The Canoe-trip" are all foreshadowed in
Scott's seminal work, his luminous transformation of observation
into image.

Scott and Roberts were transitional poets in the sense that to render Canadian landscapes truthfully they had to liberate themselves from traditionally romantic verse forms. Similarly, to become true regionalists Canadian painters had to free themselves from the servitude of academic studio painting. Paul Kane, working long before the *plein air* revolution, was a significant transitional example.

Kane travelled west in the mid-1840s, the first professional Canadian painter to visit the Prairies and the Pacific Coast. His journal—*Wanderings of An Artist*—is a fine document of life in the Old West. He also took back to Toronto 500 oil and watercolour sketches of the western landscape and its inhabitants which provided the material for many years of studio work; he never returned to the West.

What is striking about Kane's work is the disparity between the two sets of circumstances in which he was working and their effects on his painting. On the road he sketched visual notes in poor light and in circumstances that demanded haste. In his studio in the comfortable world of colonial Canada he sought to make monumental canvases in the current European style, with the grandiose mannerism appropriate to the cliché of the noble savage into which he turned the Indians whom he had once drawn in settings with such vivid directness. He became a ponderous, derivative painter whose pristine insights had been processed into conventional paintings instead of being transmuted, as in another age they might have been, into original art.

When we look back at the notations of those insights we recognize Kane's lost potentialities. He did two paintings of the same high valley in the Selkirks. The finished work is the oil painting *Boat Encampment* (ca.1847) in which a fairly authentic-looking camp in the foreground is surrounded by towering grandiose mountains and darkly romantic forests. In the water colour sketch of the same scene the mountains do not overpower the landscape but belong to it so intimately that their white slopes echo the white slopes of the foreground tent, and the whole view—sombre in the oil—is bathed with the clear sunlight of high altitudes. One senses

263

immediately how fresh and vivid Kane's perceptions of the original scene must have been, and one also realizes that he had a power of understanding and rendering a landscape's intrinsic patterns which he put aside when making paintings for the market. What Kane produced in the region with which we associate him was far better than what he produced in eastern Canada's late Victorian art centres. He became a landscapist manqué because he allowed a true regional insight to be overwhelmed by a deadening cosmopolitanism.

The liberation into true regional perception among Canadian artists after Paul Kane could doubtless be illustrated by considering the careers of quite a number of painters whose working lives extended from the late Victorian era into the twentieth century. In the examples I choose—Homer Watson, J.E.H. MacDonald and Emily Carr—I am probably guided most of all by a sense that I can understand their progressions in terms of my own response to Canadian regional landscapes.

Watson's career covered an unusually long span; he was represented in the first exhibition of the Royal Canadian Academy in 1880, and he was still painting in the 1930s. I see him as preeminently the painter of settled agricultural Ontario after the great forests had been felled by the Upper Canadian pioneers a generation or more earlier. The painting of his in that first Academy show which the Marquis of Lorne bought for Queen Victoria was in fact a meditation on that pioneer period in a style we might today call romantic realism; *The Pioneer Mill* (1879) is an elaborately detailed and rather sombre study of an already decaying building against a background of cliffs, surging water and exuberant woods and projects a nostalgia for a lost age surprising to see so early in Canadian painting. Essentially, despite the brooding grandiosity of a few studies of valleys and cloud-weathered hills, Watson was painter of flat country where isolated clumps of trees preserved in farmlands provided verticality and the infinitely receding horizon of a cleared terrain created a sense of almost stereoscopic three-dimensionality. Oscar Wilde, who discovered Watson early in his career and fulsomely patronized him, once introduced the Canadi-

264

an painter to Whistler as "Barbizon without ever having seen Barbizon," and here I think he was far nearer the mark than in his more celebrated definition of Watson as "the Canadian Constable." For though he had his imitative moments when he indeed painted pseudo-Constables, Watson moved in his best work towards a free yet true rendering of landscapes observed directly and immediately recorded. There is a steady progression in painterly recognition of a landscape's pictorial elements from the mimetic verisimilitude of *After the Rain* (1883), with its soft reflections in flooded furrows and the poetic notation of a flock of doves coming up over the tops of the elms, to the awesomely simple directness of a small painting from 20 years later, *The Sand Pit* (1903).

This is the evocation of a stripped land left to the elements. The ochreous plane, narrowing to nothing as it merges into the dark suggestions of far-off woods that no longer tower in the vision. It is the immense and stormy sky, with great dark rain curtains sweeping down diagonally from the left, and the deep gouge of the sandpit, buff shading into the darkest umber where the shadows on the right balance the heaviest squall clouds on the left, that give the painting its immense vertical movement. In the shadows of the pit, fitfully highlighted, the dark dim forms of horses stand like patient statues awaiting the storm. It is a moving vision of man's ability to change the surface of the earth and yet to be unsheltered before the great forces of nature, but also, with its darkly luminous projection of summer stormlight, enhanced by the dense yet obviously rapid application of the paint, it shows how Watson responded to the peculiarly opaque and humid atmosphere during the hot months in Ontario between the lakes.

The Group of Seven moved into northern country where the lakes, though numerous, were small, and, grand though the storms might be, the air was clearer and the sharp boreal light gave a special vibrance to the translucent greens of springs and the vivid leaf colours of autumn. What the Group and its friends, especially J.E.H. MacDonald and Tom Thomson, did was to find in a European style of high artifice the elements through which they could give a true pictorial expression to the Shield country. The link

265

between the Seven and *art nouveau*, with which they were familiar from their commercial work, is usually dismissed as a matter of early influence quickly shed when they began to work *en plein air*. This I believe a false interpretation, especially in the case of Mac-Donald. The MacDonald painting I use as an example, *The Elements, Georgian Bay* (1916), seems at first sight far distant from the almost perverse unnaturalness we often associate with *art nouveau* in its European manifestation. What has this powerful evocation of natural grandeur to do with the decadent designs of Aubrey Beardsley? No more than that each artist discovered in *art nouveau* elements that liberated him from conventional forms to attempt a new pictorial statement. The elements MacDonald found appropriate to his painting of the Shield country were: the use of clear and brilliant colours, arbitrary if necessary, to give a landscape pictorial meaning; the inclination to stylize natural forms, particularly trees, to echo the larger forms of a landscape; the tendency to outline heavily, which emphasized aspects of the landscape normally lost in the sweep of vision. I suspect none of these elements taken from *art nouveau* would have helped if MacDonald and his fellows had been faced by the massive forms of the Rockies or the wide sweeping expanses of the Prairies. But the broken country of the Shield, with its worn and convoluted rock outcrops, its small lakes and low hills, its gnarled trees growing in poor soil and its incredible seasonal colourings seen through a marvelously clear light, was waiting for such a manner of painting.

In *The Elements, Georgian Bay*, the intense and immediate perception of a regional landscape is rendered in a way that shows all the pictorial features I have described, and does so in an especially impressive way because the vast pile of cloud casting its shadow over the men in the middle foreground gives the painting an illusive sombreness. In fact, in its areas of Tiepolo blue sky and azure-purple flashes of water, in the luminosity of the more distant clouds modulating from buff-white to madder behind the dense dark purple-grey of the approaching squall, in the vermilion flash of the fire and the darker red of the men's clothing beside it, in the mineral touches of blue and mauve and rose that liven the red-

266

brown of the rocks, the painting shows a daring vibrance of colour, while the stylized pines, twisted permanently in the same direction as the storm, presage its drive, and the rock shapes are emphasized by darkness of outline as much as by light and shadow. It is an almost perfect adaptation of a highly self-conscious art style to the rendering of a wilderness landscape.

Emily Carr is certainly one of the greatest Canadian landscape painters. One can trace copiously in her journals and letters the progression by which she advanced towards an understanding of her special British Columbian landscape, which was not the great mountain ranges but the Pacific rain forests and the shorelines below them. Carr went through the stages of self-discovery familiar among regionally oriented artists. Despairing of learning her craft in provincial Victoria, she toured the recognized art centres of her time, San Francisco and London, Paris and Cornwall and Brittany. She returned with a recognition that in Europe she had not learned how to solve the problems created by "our clear Canadian atmosphere and great space" or by the sheer vastness of the landscape's natural features.

Back in British Columbia, Carr turned to painting Indian subjects, her version of the genre paintings of other regionalists; these scenes of villagers and totem poles would hardly be valued if she had not come, through long periods of inactivity and tentative searching, to the discovery—in some ways an animistic discovery that stemmed from her long preoccupation with Indian life and art—of the rain forest as an almost literal presence and an inspiring one. Paradoxically, she solved the problem of space by entering the enclosed density of the forest and then by breaking out.

Anyone who has lived in British Columbia will recognize the dual pictorial truth of Carr's work, its darkness and its light. In a painting like *Old Time Coast Village* (ca.1928) the poles and the longhouses are stylized shapes of light above a luminous curve of beach, but all is trapped and overshadowed by the dense green darkness of the surrounding forest, its trees stylized into cowled and terrifying presences. The Indians feared the rain forest, which their imagination populated with menacing spirits, and in *Old Time*

267

Coast Village locality and fear are darkly combined in a compelling and strangely visceral nightmare.

But the rain forest of British Columbia soars its 200 feet of trunks and branches at some seasons into a world of light that is often curiously metallic in tone in contrast to the dense vegetable darkness of the forest floor—golden light in autumn, silver in spring, steel in high summer when the woods can burn. And in a painting like *Loggers' Culls* (1935), which I have always seen as complementary to *Old Time Coast Village*, man has opened the darkness, and in a bare wide alley between denser remnants of forest, five scattered and spindly trees, arboreal bottle-whisks, strain up into a turbulent vortex of brightness that is the sky.

In paintings like these the impersonal actuality of the landscape is transmuted into a vision that is entirely personal, into a glowing mindscape in which the formal harmonies long maturing in Emily Carr's very mystical mind were at last externalized. Observation and experience, personal perception and the traditional vision of the native people, came together to make Emily Carr's work a superb achievement in landscape art; none of these components can be dissociated from her passionate regionalism.

Emily Carr's was not an isolated achievement. Her regionalism and her power of transmuting the elements of landscape were inherited by West Coast artists, so that painters like Gordon Smith and John Korner whom one does not immediately think of as landscapists in fact incorporate important elements of the seacoast environment into their paintings. The most striking example perhaps is Jack Shadbolt, whose work involves a deep penetration into many aspects of the British Columbian environment, cultural as well as geographical, and an enrichment of imagery through West Coast Indian art forms, bird and plant forms, through the awareness of looming mountainous masses and the influence of the coastal light with its everchanging tonalities. In great triptychs like *The Way In* owned by The Canada Council Art Bank, Shadbolt exemplified that landscape can perhaps be most inspiring when the painter gives up an intent of being in the strict representational sense, a landscapist.

1. Ms. note quoted in J. Russell Harper, *Painting in Canada: A History* (Toronto: University of Toronto Press, 1966) p. 216.

2. Hugh MacLellan, *Barometer Rising* (Toronto: New Canadian Library, 1958) p. 79

3. Robert Hayman, *Quodlibets* (London, 1628)

4. *The Book of Canadian Poetry*, ed. A.J.M. Smith (Toronto: W.J. Gage, 1957) p. 126.

5. Quoted in *Wilderness Canada*, ed. Borden Spears (Toronto: Clarke Irwin, 1970) p.87

35.

"PAINTING AND SCULPTURE IN PRAIRIE CANADA"

by Clement Greenberg

In his long heyday beginning in the late 1940s, Clement Greenberg (born 1909) was the pre-eminent critic of American (and American influenced) abstraction, and a tastemaker of considerable power. His famous, almost iconic, book Art and Culture: Critical Essays *appeared in 1961. In this widely discussed survey undertaken for* Canadian Art *magazine (March-April 1963) he is surprised, reassured and at times even gratified by the extent to which the art he so long espoused was flourishing in the Prairie provinces. The University of Chicago Press is currently publishing* Clement Greenberg: The Collected Essays and Criticism *in a projected four volumes, edited by the Canadian art historian John O'Brian.*

When *Canadian Art* asked me to do a report on the situation of painting and sculpture in Manitoba, Saskatchewan, and Alberta I was a bit taken aback. Didn't they know about that situation in Ottawa? Was that how difficult communication was between prairie Canada and the rest of the country? Northern Ontario and the Canadian Rockies were, apparently, great isolating factors. But then I remembered how little we in New York knew about the situation of American art outside New York, and that the reason was not geographical but simply the assumption that that situation was not worth finding out about. On the basis of this assumption one hardly bothered to read the "letters" in the New York art magazines reporting on the art scene "out of town." The case, I concluded, must be more or less analogous in Canada. Montreal and Toronto as leading centres of art, with Ottawa as a headquarters if not a centre, and Vancouver in the role of San Francisco, took it for

granted that prairie art was nothing but provincial—and were all the readier to do so because they themselves felt in a provincial relation, art-wise, to Paris and New York. For this reason I saw prairie art in Canada as being wrapped in double obscurity.

My visit to western Canada this past summer (which started off, importantly for me, with two weeks at the Emma Lake Summer Art School of the University of Saskatchewan at Regina) modified this view. It might have been the correct one a year or so ago, but since then eastern Canada had become aware at least of art in Regina. This, I surmised, was what had actually prompted *Canadian Art* to think of this survey, and then ask me to do it (when it learned that I was going to be in western Canada anyhow). Eastern Canada did want to hear more about what was going on with art in prairie Canada, and the isolation of the latter was indeed beginning to be penetrated. And it was for good reason: much better reason than we in New York would have for penetrating the isolation, say, of art in Los Angeles.

ABSTRACT PAINTING

Regina

The vitality of art in Regina does constitute an unusual phenomenon. It may involve, immediately, only a small group of artists, but five such fired-up artists would amount to a lot in New York, let alone a city of 125,000. I am tempted to attribute it all, ultimately, to the spirit of the province itself—especially since Saskatoon has begun to show a similar vitality in art. Saskatchewan could be considered, I suppose, the remotest or most isolated of the provinces of western Canada that border on the United States. Manitoba has Minnesota directly below it, while British Columbia has next to it the Pacific Ocean and the American Northwest, in whose proximity Alberta seems to share; but Saskatchewan has only North Dakota and Montana to the south. What makes Saskatchewan unique, however, in my experience is not its isolation as such, but that its inhabitants seem to face up so squarely to the

fact of it. That this is not an eccentric impression on my part is confirmed by what an English artist named Robert Dalby, who has lived for a good while in the north of the province, told me about Saskatoon, which he thought a remarkable place because of its awareness of how much, in its remoteness and newness, it needed the rest of the world. I found this state of mind pretty much present elsewhere in Saskatchewan. Unlike Podunk or San Francisco, the place does not waste its mental energy in conjuring up illusions of itself as a rival to New York or London; it frankly acknowledges that it is in a provincial situation. If it is true that looking an obstacle straight in the eye is the first step in overcoming it. This may explain why I found both Regina and Saskatoon far less provincial in atmosphere than I had expected.

The specialness of art in Regina consists most of all in a state of mind, of awareness, and of ambition on the part of five abstract painters who live there, and whose activity is centred around the Norman Mackenzie Art Gallery, of which one of them is the director. (The gallery is attached to the Regina campus of the University of Saskatchewan.) Not that the specialness does not consist in achievement too—particularly in seven or eight pictures that Arthur McKay did in the winter and spring of 1962. But it is even more because of McKay's spirit, and the spirit of his colleagues, that I find something wonderful going on in Regina art.

That spirit expressed itself in what the Germans would call a fateful way when Ronald Bloore, Roy Kiyooka and Arthur McKay proposed that the painter, Barnett Newman, be invited to come from New York to conduct the 1959 session of the Emma Lake workshop. (Emma Lake is near Prince Albert National Park.) They had discovered Newman in the reproductions accompanying an article in *Art News* by E.C. Goossen (the first article ever devoted to Newman in any magazine), and what they could make out of his startlingly simplified art from black and white photographs convinced them, apparently, that it offered the kind of challenge they were looking for. Newman came to Emma Lake without bringing any of his paintings along, and he did no painting while he was there, but according to all reports his personality and his

272

ideas had a galvanizing effect on the artists who attended his "seminar." The new seriousness with which some among them began to take themselves as artists after Newman's visit became a main factor in the creation of the informal group of painters now known as the "Regina Five."

They are Ronald Bloore originally from Ontario and the present director of the Norman Mackenzie Art Gallery, Ted Godwin, Kenneth Lochhead, Arthur McKay, and Douglas Morton. (Lochhead was away on a Canada Council grant at the time of Newman's visit, but felt its after-effects. Kiyooka has in the meantime moved to Vancouver.) Every one of these painters is more or less what I call a "big attack" artist, by which I mean an artist of large and obvious ambition, with an aggressive and up-to-date style, and with a seriousness about himself that makes itself known in his work as much as in his demeanour. Though not the only "big attack" artists in prairie Canada, the Regina Five form the only concentration of them in that region, and this, as much as anything makes Regina the art centre it is.

There is relatively little of Newman's direct influence to be seen in their work aside from a tendency to clean-edged drawing and open design, and maybe something in Bloore's use of white on white. Kenneth Peters, who is in his early twenties and not a member of the Five, is the only painter I saw in Saskatchewan who had taken something integral from Newman—his linearism, namely, and his warm dark colour—but Peters still has his own way of handling paint itself. He would rate in New York as a "far out" artist and there is already something more confidently individual in his art than in that of one or two of the Five themselves, but a wariness of artists who break through before reaching thirty makes me hesitate in commending him.

I think it can be said without offending any one that Bloore is the "leader" of the Regina Five; and certainly he was the most formed and distinctive artist of the group before the advent of McKay's new painting. This does not mean that I like what he does. It's a little sour and at the same time too elegant in its impasted whites; and there is also a somewhat trite relation between his

273

regular, geometrized configurations and the shape itself of the picture; here he could have learned a lot more than he did from Newman. All the same, Bloore remains very much an individual and remaining that, he may yet force me to eat my words. And even if that does not happen, the School of Regina will remain in debt to him for his leadership, which brought in a certain influence that kept certain other, more noxious influences out. This, too, I think, was a most important factor in the formation of the Regina Five. By introducing Borduas's direction, Bloore warded off that of New York abstract painting in the fifties, with its mannered brush swipes and smears and spatters, and its deceptively hackneyed scaffoldings of light and dark. The influence of this New York manner has been one of the most blighting, as well as most infectious, that I know of in modern art. Borduas's influence may carry some Paris "pastry" with it, which can be just as bad as New York "lather," but Borduas's integrity seems somehow to have communicated itself to his influence, at least in Regina, and prevented it from having too deleterious an effect there. With one or two exceptions, the other "big attack" painters I came across in prairie Canada were victims of the New York influence, and the difference between what they were doing and what the Five were doing made clear how great was the service Bloore-Borduas had performed for Regina art. (Ironically, Borduas himself derived from New York, but from the New York of Pollock, not of de Kooning, insofar as his art won its first distinction by Gallicizing Pollock's ideas. And it is really Pollock, as polished and interpreted by Borduas's palette knife, that is at the bottom of the "all-over" pictures that both Godwin and McKay were doing up until a year or so ago.)

The Bloore-Borduas influence in Regina has been, as it now turns out, of positive as well as negative benefit. Through it Arthur McKay has been able to realize himself. In the already mentioned seven or eight pictures that he painted before last summer, McKay converted Bloore-Borduas knifehandling into something altogether his own, and did with it some of the best as well as most ambitious painting I have seen anywhere in Canada since I came on the

later work of Jack Bush three years ago in Toronto. Working in a lower key than any abstract artist in Regina other than Peters, McKay sets rounded squares, blunted ovals, or trued discs, sometimes solid, sometimes open, but always pale, against very dark grounds that are infused with luminous blues, or greens. Where McKay's originality declares itself as much as anywhere is in the curiously spacious way in which his central motifs are related to the shape of the support. (Bloore could have learned something from him too in this respect.) This is no merely technical matter, but has a lot to do, in McKay's case, as in Mathieu's, Fautrier's, and even Clyfford Still's, with a new specification of pictorial feeling; it marks a break from the cubist "box" as we still see it in Soulages, de Kooning, Riopelle, Guston, and many others, and embodies a new response to experience. These new pictures of McKay's would be as new in Paris or New York as they are in Regina.

The turn Kenneth Lochhead's painting took in the summer of 1962 towards colour and concentricity should make him the next among the Five to be reckoned with importantly. Emerging from under the influence of Bloore-Borduas monochrome, he has broken through to pure flat colour stated in shapes that approach "geometry" without really touching it. This new direction relates to nothing else in contemporary Canadian painting, for which reason Lochhead's latest pictures are perhaps a more surprising apparition even than McKay's. It remains to be seen whether this accomplished and versatile artist will pursue his new vision of colour with the required tenacity, and, above all, nerve.

Ted Godwin, too, is in transition, and he too seems to be on the point of breaking out of the hitherto accepted channels of abstract art. The ideas that appear in his recent oils remind me at most of things glimpsed in East European or Levantine contemporary art—I mean the art of abstract or semi-abstract painters from those regions who work within the West European tradition of easel painting. But to say this is to be less than just to the originality of Godwin's new conceptions. Right now his problem is to realize these conceptions pictorially; they are still more a matter of illustra-

275

tion than of painting in the full sense; they still rely too much on allusions to the third dimension, which is not necessarily wrong, but in his case causes the picture rectangle and the picture surface to jam up and flow over. Here Godwin reminds me strongly of the paintings of Arshile Gorky in the period (1943-44) when the latter was trying to accommodate ideas derived from the early Kandinsky and Matta to a space shallower than theirs. Gorky had already found the solution, in the openness and looseness of crayon drawings done from landscape subjects a year earlier, and all he had to do in the end was bring his oils closer to these. It strikes me as being more than a mere coincidence, in view of certain vague resemblances to Gorky that I find in his latest oils, that Godwin should have, as I think, his own solution pre-figured in the very successful openness of the gouaches and water colours he did at about the same time.

Douglas Morton, the remaining member of the Five, offers the case of an artist whose sheer facility stands in the way of self-discovery. Morton can do anything with paint, but he has scattered himself in too many directions so far; he has not yet arrived at what he, and only he, can do and has to do. Though several of the paintings of his that I saw in Regina attained a high level of success—particularly the one most lately acquired by the Norman Mackenzie Art Gallery—I would still consider him a largely unknown quantity in terms of realization. But that a real capacity is there I do not doubt.

Saskatoon

The only unmistakably "big attack" painter I found in Saskatoon was Otto Donald Rogers, whose vision manifests both breadth and depth but is kept from fulfilment by too great an infusion of the New York manner of the 1950s. His art does not present the most extreme case of the "Tenth Street touch" that I chanced on in prairie Canada, but it is one of the most regrettable of such cases precisely because with Rogers that touch belies a fullness of inspiration rather than covering a want of it. Which is

276

not to say that some of his pictures are not brought off; they are. Some of them belong with the very best abstract art I saw in western Canada; yet their viscous paint and dragged brushstrokes, with all that these connote of fashion and convention, keep them from being more than very good local art.

There are several other abstract painters in Saskatoon in whose favour I may be prejudiced because I was with them at Emma Lake last summer. Henry Bonli and William Perehudoff do not yet have the attitude of "big attack" artists, but the stripped-down kind of painting they have both begun to do strikes a less provincial note than Rogers' kind, and it depends only on their steadfastness and nerve whether they become artists of more than local importance. If they do, a lot of fresh air will have been let into Canadian abstract art by the "Saskatoon School."

Among other things that attested to the surprisingly high general level of art in Saskatoon were the small and modest, but original and complete paintings, in a Klee-ish vein, of Wilbur Lepp, a very young artist whom I likewise met at Emma Lake. On the other hand, the two or three pictures each I saw by Louis Frischolz and Stan Day in Saskatoon struck me as unresolved, though they were definitely not routine. Nor were the promising but incomplete quasi-geometric paintings of Joan Rankin of Moose Jaw routine— she was another abstract artist I met at Emma Lake, where almost everybody to my surprise, turned out to be a "pro". And I mean a "pro" in the fullest sense.

Edmonton

Abstract art in Edmonton, which was the first place I visited in Alberta, was more provincial than in Saskatchewan. Art in Edmonton has the benefit of a municipally supported art centre whose collection is not to be sniffed at, and whose director, John Macgillivray, is active as well as informed. And Edmonton also has an artists' co-operative, the Focus Gallery. But the art being produced there seemed to me to lack the élan of art in Saskatchewan; nor did I get as vivid a sense of a coherent artists' community. Maybe this was because Edmonton is in such a rapid state of expansion. It

reminded me curiously of New York. Even more curiously, its abstract art showed the highest frequency of New York influence that I found in prairie Canada.

The pictures of Ethel Christensen and Les Graff were not only soaked in Tenth Street mannerisms, they were also brash and aggressive in a Tenth Street way. This is no verdict on the potentialities of these two artists, but it does reflect very much on their taste. In Douglas Haynes's touched-up prints I was even more surprised to see the lay-out of Adolf Gottlieb's "Burst" paintings unabashedly present (though Gottlieb is the antipodes of Tenth Street). This lay-out was handled, all the same, with a certain felicity, so that I had to conclude that Haynes had added something of his own to the idea by reducing it in size.

One of the better abstract painters of Edmonton was Jean Richards, in one of whose pictures I was again surprised to detect Gottlieb's influence, though assimilated and almost hidden in an "imaginary landscape" that was quite unlike the "imaginary landscapes" Gottlieb himself did ten years ago. Another work that showed real feeling was C.R. Kaufman's semi-figurative painting, where something was germinating under a manner that seemed both familiar and uncertain. Still another abstract artist of interest was Detta B. Lange, who did silkscreen prints in a semi-abstract, stylizedly "primitive" manner; Miss Lange presented one of those comparatively rare cases of an artist whose work benefited from increasing abstractness.

The most professional and accomplished of all the abstract painters whose work I saw in Edmonton was John B. Taylor, whose example (not style) may be responsible for the fact that most of the abstract art there stays close enough to nature to be called semi-figurative. The fault I found with him lay, however, precisely in his professionalism: in fact that his art was so completely and seamlessly encased in a rather familiar manner derived from Klee, prismatic cubism, and what I call "Northwest Indian" abstraction. And I felt (I hope Mr. Taylor will excuse my presumption in saying so) that he could have put his high talent to better use in more forthrightly representational art.

Calgary

Calgary, too struck me as being more of an American than Canadian place, but the situation of its art and of its artists was quite different from that in Edmonton. Its artists' community is of longer standing, and has many more members—more members, apparently, than any other artists' community in prairie Canada. It also has a first-rate commercial gallery in the Canadian Art Galleries, as well as a very active and commodious art centre under the expert directorship of Archibald Key. Nevertheless, the general impression made by the abstract art I saw there was one of timidity and irresolution—there was certainly nothing in it to match the aggressiveness I saw in Edmonton.

I could, however, recognize one unmistakably "big attack" painter in Calgary besides Stanley McCrea (who lives in Lethbridge and brought his work to Calgary for me to see). That was Ronald Spickett. The fact that his art had a French and Franco-Oriental cast spoke for the case of abstract painting in general in Calgary, which showed surprisingly little American influence of the Tenth Street variety. I had already seen five or six large paintings by Spickett in Edmonton, where they were about to be hung in the Art Gallery, and one of them, barely reminiscent of Mathieu, with a sparse linear motif on an empty but pregnant ground of saffron (or something like saffron) remained, and remains, in my mind as the boldest abstract painting I saw in prairie Canada, and the best and most ambitious I saw outside Regina. But nothing else of Spickett's that I saw could be compared with it; everything else was too much involved in silken and gilded graces; his smaller paintings were all brought off, but too well brought off. In other words, he had failed to recognize his "message" when it came.

Stanley McCrea of Lethbridge is far more immersed in New York mannerisms than Rogers of Saskatoon is, but his plight is a similar one. Like Rogers, McCrea has something to say, but it is almost completely muffled under a paint surface that is as inexpressive as it is agitated. Forceful configurations that have nothing intrinsic to do with trowelled paint or poured soup barely manage

279

to make themselves seen. Nonetheless, McCrea is a painter to watch.

I saw the work of more than twenty other abstract or quasi-abstract painters in Calgary. Most of it was thoroughly competent, none of it gave me anything like a real surprise. A small lithograph-and-metal print by Deli Sacilotto that had a nice and—for once—American kind of openness, was the best single abstract picture that I saw at the Calgary Allied Arts Council, but even this was a little on the tasteful side, and set the key for the less enterprising tastefulness of most other things present, in which every vein of polite cubism current since 1930 was represented (and also what I took for the strong influence of Seattle). On the whole I found the water colours, gouaches, drawings, and prints superior to the oils, three-quarters of which were done by the same hands. Among the best both in oil and in water colour was Marion Nicoll, who revealed the helpful influence of Will Barnet (the first of the New York artists to come, in the summer of 1958, to Emma Lake). There was a nice oil by Illingworth Kerr, who was further represented by a perhaps over-tasteful Klee-like sand drawing. Other oils that, for all their circumspection, caught my eye were by Brownridge, Wood, Palmer, Mitchell, and Lindoe. Frank Palmer was perhaps the most finished painter I saw in Calgary, aside from McCrea and Spickett and Maxwell Bates, but he demonstrated far more strength in his representational pictures. I would say the same of Bates, whose oil was far too European-stylish, even though his half-abstract water colour was eloquent. A batik wall hanging by Clifford Robinson betrayed some distinction, as did a water colour by Velma Foster, another artist in whom I thought I discerned Barnet's influence, and a water colour by Joseph Tillman. Exceptionally, Janet Middleton's colour lithograph showed her to be better in an abstract than in a representational vein.

Among the abstract pictures that I thought were betrayed by their timidity and mere tastefulness were those of Patton, Perrott, Motton, Whillier, Blodgett, Ungstad, Angliss, and Snow (another who showed to better advantage when working from nature). Kenneth Sturdee's tondo and the very competent but Gorky-

infected painting of Mihalcheon was about all I saw in Calgary that approached New York flashiness. Iain Baxter's painted screens may come even closer to the Paris-*cum*-Pollock kind of flamboyance, but I hesitate to say, since I know them only from black and white photographs.

Winnipeg

Abstract art in Winnipeg revealed a little less timidity than it did in Calgary, but maybe even greater irresolution. I had been told that Winnipeg was pretty much dominated by tendencies emanating from the art departments of the Midwestern universities to the south, but I was still surprised to see how much in its painting reflected the present stagnation of abstract art in the Midwest. (Winnipeg has a thriving art centre, directed by Ferdinand Eckhardt, but it seemed to have proportionately fewer active artists than any other place in prairie Canada, even though its ratio of wholly professional artists seemed larger.)

The only painter who looked aggressively up-to-date in the impromptu showing Dr. Eckhardt put on for my benefit at the art centre was W. Leathers', in whose picture I recognized the Chicago abstract manner of the 1950s: a combination of Gorky, Matta, and Joan Mitchell; but there were enough Tenth Street notes in Leathers' painting to justify calling it New York stuff with a Chicago accent. Anthony Tascona, the local "whiz" and ostensibly a "big attack" artist, came out of an earlier Chicago, the Chicago of the late forties, when what I call "Whitney Annual abstraction" flourished widely in the United States: a composite kind of thing, of "free" shapes and Picassoid and Miró-esque loops and curves (Seong Moy's style was the epitome of it) in shallow illusionist space. This standardized manner was not consistently present in the seven or eight recent paintings of Tascona's that I saw, but it was there enough to give them a rather old-fashioned and provincial look. Not that I object to the old-fashioned in itself; what I found objectionable in Tascona's art was its failure to say anything, its lack of content.

281

The small abstract paintings in mixed media on paper of Robert Bruce verged on preciousness, but did try to get something said by dint of their painterly colour, and even his landscape straight out of late Picasso had some personal feeling in it. The colour of Bruce Head too, in a pair of oils otherwise bogged down in the tasteful lights and darks of juicy paint, was strong enough to make me feel he was one of the more promising abstract painters of Winnipeg. Frank Mikuska, to judge from his "ink graphics," was trapped in an eclectic, catch-all, painterly conventionality like and unlike Bruce's and Head's that, coming out of both New York and Paris, was hard to label but easy to recognize. The conventionality of James Willer's half-abstract landscape was easier to define: decorative prismatic cubism, but pleasant at that. George Swinton's quasi-abstract drawings were better, but their thinness gave far from an accurate measure of the capacities of this artist.

Of all the abstract artists whose work I came on in Winnipeg, Donald Reichert was the one who seemed to have the most possibilities. Almost everything I saw in a show of his at a commercial place, the Grant Gallery, was involved in the effort to say something. The main trouble was that it all went off in too many different directions no one of which seemed exactly the right one for this artist. It will be interesting to see whether Reichert will be able to find the right one without leaving Winnipeg.

An unusually adept painter whose work I saw at the Winnipeg Art Gallery was Jack Markell, who perhaps should not yet be classed as abstract. His earlier pictures derived from the Boston school of Jewish expressionism—Jack Levine's and Aaronson's—and were no better and no worse than their prototypes. A later picture, which was more abstract, did not make Markell seem any the less of a virtuoso. And, in fact, I found Winnipeg abstract art too much occupied in general with *cuisine* and mechanics and virtuosity.

LANDSCAPE PAINTING

Winnipeg

On the whole I found abstract art in prairie Canada faring no better than it has, lately, in Chicago or Montreal or Los Angeles, or Brussels or Munich. The going styles in Paris and New York are reflected in Calgary, say, after a greater lapse of time perhaps, but the consequences in terms of actual quality are not much different. What I myself notice is that the fashions of abstract and quasi-abstract art do more to stifle personality than the fashions of academic representational art ever did. Far be it from me to call for a return to nature. Art goes where it goes, heedless of calls, pleas, or commands. Still, straightforward representational painting seems to me to suffer far less nowadays from the repetition of stereotypes and clichés. With the artist who works directly from nature, personal feeling about his subject will often break through whatever stereotyped effect he may be striving for and put enough of itself in the result to make it minimally interesting. With the artist who works without the direct help of a subject in nature, personal feeling has to insist on itself much more strongly in order to make itself evident, and often the artist has to summon up his courage in a more conscious way in order to let the expression of his feeling take him away from over-studied effects. This may be part of the reason why the challenge to major originality is largely confined nowadays to abstract art, but it is also the reason why— given that most artists, like most people, lack the courage to be consciously and effectively themselves—a much greater proportion of abstract than of representational art remains hopelessly derivative and boring. If the very best art of our time is abstract, so is the very worst, and most of the very worst. In other words, quality, even if it is only minor quality, is far more frequent even today from nature than it is in any other kind of painting and sculpture.

It is not so surprising therefore to find that what makes a visit to Canadian art, in the present as well as the past, most generally rewarding is its landscape painting. It had not been Riopelle (an

283

empty artist, at least in oil) or even Borduas (who can be overrated) who awoke my interest in Canadian art in the first place, but Goodridge Roberts, with a landscape that I came across at the Carnegie International of 1955. Since then I have gotten to know and relish the Group of Seven, Morrice, Cullen, Emily Carr, Milne, Lemieux, Tonnancour, Humphrey, Cosgrove, and quite a few other Canadian landscape painters. Landscape painting is where Canadian art continues, I feel (allowing for Borduas, Bush, MacKay), to make its most distinctive contribution. Even the landscapes of Varley, who devotes more attention to the figure and portrait, seem to me to surpass by far the rest of his work (two or three landscapes of his that I came on in the permanent collection of the Calgary Art Centre struck me as being among the very best things I have ever seen in Canadian art). Nothing in Canadian landscape painting contributes to the "mainstream," exactly; nothing in it amounts, that is, to major art. But this hardly dilutes my pleasure in its freshness and authenticity, or makes it less valuable. Least of all does it justify condescension. In praising it I make no allowances whatsoever.

One could speculate that the distinctiveness of Canadian landscape painting is owed to the character of its favourite terrain, the pre-Cambrian shield country. I myself feel that the northernness at least of this country has something to do with the hallucinatory note I find in many Canadian landscape paintings—a note that gives an unmistakably Canadian feeling to even the *handling* of landscapes done by an artist so recently out of England as Robert Dalby, who lives on Lac La Ronge in north-central Saskatchewan.

But I also feel that the distinctiveness of Canadian landscape painting in this century comes in part from the assimilation of fauvism-*cum*-impressionism to Anglo-Saxon temperaments and northern subjects. The liberated colour and brushwork of this fusion of modernist French styles has proved particularly congenial to American painters too—painters like Marin, Hartley, Avery, and Arnold Friedman. It is as though any other approach to the wild or half-wild northern landscape would have been, for these Americans as well as for their Canadian counterparts, too stately

284

and formal. And by and large, the transplantation of French modernism to this side of the Atlantic has produced better landscape art than the transplantation of anything previous, including Constable and the Barbizon School.

The tale of landscape painting, both in Canada and the United States, is far from told. I would hazard that more good landscape painting is still being turned out today in both countries than painting of any other kind.

This certainly proved true in prairie Canada, where landscape painting everywhere but in Saskatchewan rescued situations I would otherwise have had to report as discouraging. Reversing the direction of my tour, I start this part of my report with Winnipeg, where George Swinton's northern landscape in pinks, oranges, and reds, with overtones of Varley, in the permanent collection of the Winnipeg Art Gallery Association made a tremendous impression on me. If Swinton has other pictures of this quality to show, then he should be rated as one of the luminaries of North American art.

Kevin Clark's filmy, Passmore-like landscape was successful but in a much more tenuous way. Another good representational picture I saw in Winnipeg was Ivan Eyre's Bonnard-influenced interior with figure, which was much stronger than his pencil and crayon essays in Beckmann-ish expressionism. But after Swinton's landscape, I took pleasure in, above all, Barbara Cook's large academic water colour of a river with houses, the truth of which was felt in every unpretentious and straightforward square inch of its handling. Among the other "modest" representational painters whose things I liked at the Art Gallery Association in Winnipeg were Pauline Boutal, Victor Friesen, and Denise Chivers. (And I would have liked their pictures anywhere: in New York, Paris, or London. I bother to say this lest some reader think I'm being patronizing towards Winnipeg.)

285

Calgary

My discovery among landscape painters in Calgary was W.L. Stevenson, whose style does not suffer by its closeness to Goodridge Roberts'. I had the good fortune to see a show of Stevenson's at the Focus Gallery in Edmonton, and can't understand why he is not known all over Canada. I also saw a retrospective show of Maxwell Bates' work on the eve of its hanging at the Canadian Art Galleries in Calgary, and thought that the landscapes were consistently the best among his paintings, although a French street scene in grays and blues out of Marquet gave the clearest indication of what this artist could do at his best, and I was disappointed not to see more pictures like it in this show. Among others things I saw at the Canadian Art Galleries were an excellent landscape by Frank Palmer, of whose work in this vein I would have liked to see more, and a good street scene by William Welch.

A view of shacks in grays, whites, and tans by Heinz Foedisch, in the show put on at the Calgary Allied Art Council for my benefit, struck me as being the best oil painting, abstract or other, in the whole show—as though to refute everything I've said above, for it was only vaguely Canadian in subject, and hardly at all so in its slightly "expressionist" realism. Foedisch's largely pencilled water colour was, also, for me the best of all the water colours in the show. Foedisch is, obviously, not a "big" artist but on the basis of the evidence at the Calgary Allied Art Council, he is a very true and gifted one, and I wondered where he came from, with his German name, and why he too was not better known.

Among other landscapes or near-landscapes that I liked in Calgary were a Hartleyan oil by W.F. Irwin, a rather pretty one by Annora Brown, a pleasant if somewhat amateurish one by H.G. Hunt, a tight water colour by H. Earle, and two other water colours by John Snow and E. Carleton respectively; the latter also showed a very successful oil, but my notes do not indicate what its subject was. All they say is: "Maybe the best colour in the lot."

Nothing in the figure or portrait paintings and drawings I saw in Calgary impressed me markedly, but I did notice the potentiali-

ties revealed if not realized in several pictures in different mediums by Ursula Zandmer. Her three-quarter-length drawing of a girl showed, by its superiority to Mrs. Zandmer's other works, that sentimentality was her trouble—which, as was to be expected, was least restrained in her oil painting.

Edmonton

Edmonton, too, had its share of good representational painting, with landscapes again in the lead. Douglas Barry showed two landscapes that were successful, and one of which, though it may have owed something of its emphasis to Goodridge Roberts, exhibited unusual temperament. Murray MacDonald's water colour landscape was a perfect work within its limits, while his diving view of three boats was another picture that betrayed unusual temperament, and despite the fact that it was less self-evidently realized than his landscape, it may have been the best painting I saw by an Edmonton artist at the Art Gallery. Mary Parris' landscape fantasy showed originality of feeling, whereas Barbara Roe Hicklin's two landscapes, one in oil and the other in water colour, succeeded in a more familiar and straightforward manner. The straightforwardness of Margaret Chappelle's landscapes was even more felicitous and poetic; she too is a superior representational painter (though I may be prejudiced in her favour by the fact that I met her at Emma Lake). J.P. Nourry (Mrs. Douglas Barry) is a semi-figurative artist of competence, but the one picture of hers that I saw told me very little else. The more forthrightly representational work of Thelma Manaray was definitely stronger than that of hers which was more abstract, and would have benefited, I felt, by coming even close to nature.

H.G. Glyde's village scene in oil was shot through with "Canadian" feeling—though the artist, I was told, was English-born; its thorough professionalism did not compensate, however, for a certain lack of accent or modulation. Violet Owen's figure paintings were more than accomplished, which is no small thing in figure painting today, but needed more of an individual approach

to their subjects, as I felt. Were Miss Owen to solve the problem she proposed herself in her seated figure of a woman, and get real anecdotal interest as well as an explicitly abstract harmony from the result, she would be doing something that seems beyond the capacities of most painters of this day.

Saskatoon

Saskatoon was the only place in prairie Canada where I saw the prairie itself really tackled as a subject for landscape. Elsewhere, for the most part, I saw the "bush" being painted, or parkland, or hills, or bodies of water. In Saskatoon, however, the prairie seemed to enter into almost everything (and for an Easterner like me the prairie was a far stranger sight than the "bush" which you can see in Maine and Quebec too). The problem was how to master the prairie's lack of feature, and the most usual solution was to find a town on it, or a clump of trees, or a conspicuous slope.

One could see the prairie in a very good small landscape by Otto Donald Rogers, and as Andrew Hudson has suggested, it might also be glimpsed in the new openness of Henry Bonli's and William Perehudoff's abstract paintings (though I am not one to dwell much on the jumping-off places in nature of abstract art). Suffice it to say that Perehudoff's "real" landscapes, which were done earlier, were more than nice.

Among the outspokenly representational painters of merit in Saskatoon was Reta Cowley, who renders the villages and towns of central Saskatchewan with delicacy and fresh feeling. She demonstrates that one can learn from Cezanne and Klee how to make nature more, not less, vivid in pictorial art. Nonie Mulcaster's landscapes show a penchant for a wilder nature and the germs of a temperament of force, a temperament that might demand a less gentle way of being asserted. The neatness and prettiness of R.N. Hurley's water colours of prairie farms and towns have, I gather, made them popular in almost a commercial way, but that should not be held against them; they are as genuine and affecting as they

288

are modest. Nicholas Seminoff's landscapes, like Perehudoff's, had a happy sturdiness to them; that is, they were less "optical" and more "plastic" than those of Cowley, Mulcaster, and Hurley—which did not make them *necessarily* better, as good as they were. Margaret Turel's landscapes were both sensitive and firm, as well as displaying a curiously deep sophistication, which was borne out by the "intimism" of her still lifes and interiors; she has to watch out, however, for the sentimentality with which she tends to treat the human figure.

Mrs. Turel was not the only foreign-born artist who had something to do with the sustaining of the surprisingly high general level of painting in Saskatoon. There was also Andrew Hudson, a year out of England, who is a completely accomplished representational artist, at home in all *genres*. Then there was the Austrian-born Ernest Lindner, whose sharp-focused, high-keyed literalism, as displayed in water colours of astonishing skill, struck a note entirely different from anything else I had come across in prairie Canada except for the tiny engraved landscapes of the late H.F. Bergman, another foreign-born artist, who lived in Winnipeg. Lindner's close-up vision of the forest interior and its tangle is all his own, and includes high colour as well as tight drawing and modelling; but it has had to be aerated and loosened and opened up in order to declare itself rightly. I had the good fortune to see this happen under my very eyes at Emma Lake this past August.

The handicap of art in Saskatoon is a diffidence and modesty I find characteristic of Anglo-Canadian art as a whole. Diffidence is better, as I find out increasingly, than brashness; it tends to guarantee honesty. But there comes a point where its disadvantages outweigh its advantages. For one thing, it entails the reluctance to take oneself seriously enough as an artist. For another, where nerve and pretention can falsify the truth diffidence can diminish it. Dorothy Knowles (Mrs. William Perehudoff) is not the only artist in Saskatoon who suffers from diffidence, but the whole problem of it seems lately to have come to a head for her. Aside, possibly, from George Swinton, she was the only landscape painter I came across in prairie Canada whose work tended towards the monu-

289

mental in an authentic way. The Group of Seven failed with the large landscape, as it seems to me, because their feeling for colour was one whose intensity demanded concentration in space as well as time, and could not be maintained adequately over a large canvas or in one that had to be executed in more than one or two "sittings." Miss Knowles, however, does have a colour gift of the size required, and that gift has the benefit, moreover, of being informed by the experience of abstract art. For her the question is whether she has the nerve, not to take further advantage of the "liberties" offered by modernish art, but to come closer to nature and literalness...

Regina

It would be a shame if the prominence of abstract art in Regina hid from view another woman painter, Mollie Lawrence, whose Chinese-tinged, largely abstract landscape fantasies, off-printed from oil paintings, deserve a much wider public. These prints say something, albeit in a subdued way, that has not been said anywhere else. Another woman painter of Regina who contributes to the high level of art in Saskatchewan is Margaret Messer; her straightforwardly representational paintings ring true—truer than her abstract ones. F.J. Miller, on the other hand, is a painter whose development appears to be carrying him inexorably—which is the only way to be carried—towards the abstractness he has hitherto disdained. I felt that Miller has hardly begun to make his most serious move, as complete an artist as he is—and even though his murals in the new Regina courthouse, and in a new Catholic church in the same city, exhibit a better command of the pictorial resources of the mosaic medium than any yet shown, as far as I know, by any artist, avant-garde or academic, who has had a chance to work at it in the United States.

SCULPTURE

French Canada has a tradition of folk sculpture, but somehow one doesn't expect to find much in the way of sculpture in Canada at large. This may be a prejudice on my part that comes from the American experience. We had, relatively, a lot of sculptors in the nineteenth century, but none of them came to much (though two or three of them are not utterly negligible in their however abject neo-classical way). But even today, with American painting in the ascendant, we have very few sculptors of really large quality, despite all the ballyhoo to the contrary. After David Smith, after Seymour Lipton, after the somewhat over-rated Calder, who is there?

Indeed, I did not come across many sculptors on my tour of prairie Canada. But among the few I did come on, not only did the work of most of them prove to be very much worth looking at, but a piece done by one of them—to which I shall return below—gave me perhaps the biggest moment I had anywhere outside Regina.

In Winnipeg—to start there again—the Ukrainian-born Leo Mol turned out be a good and sensitive modeller of figures and heads who proved, once again, that academic sculpture still has some life left in it. Richard Williams' welded construction-sculpture showed, in contrast, all the liabilities that afflict the new "open" sculpture of modernism; there was no denying Williams' ability and taste—only that taste was outmoded in the wrong way, and the ability was put to the service of the "biomorphic" and orna-mental cliches that have become current in abstract sculpture since the 1940s.

Unavoidable difficulties prevented my seeing any sculpture in Edmonton, but I was told the name of one sculptor there, Millott. The nearest thing to sculpture that I saw in Regina were the in-cised-wood bas-reliefs of Helmut Becker, which were pleasant enough, but seemed to me to belong more to pictorial art. Calgary, having as it did more artists than any other place in prairie Canada (or having at least more artists in evidence), turned out to be a dif-ferent story. Katie von der Ohe revealed herself to be one of those

291

rarest of all artists in North America, a good abstract sculptor, doing tight and beautifully sensed little monoliths in terra cotta; surprisingly, the one representational work of hers I saw was weak. But that was amply compensated for by the more than half life-size nude figure of a girl done in terra cotta by one of Miss von der Ohe's pupils, Jane Gerrish, which was as haunting in its sentiment as it was simple and direct in its slightly stylized handling. Of Roy Leadbeater's abstract sculpture in "found object" wood, the best I can say is that it had something at work in it which showed this artist to be still in the process of searching—which is perhaps more than can be said of most of the other abstract artists whose works I saw in Calgary.

I discovered Saskatoon to have the best as well as the most advanced public sculpture I've seen on this side of the Atlantic, even though it consisted of only two pieces. There was Robert Murray's fountain sculpture on the plaza in front of the new city hall, an open construction in welded metal that was both powerful and elegant in the distance it kept from the geometrical. Murray was one of the artists inspired by contact with Barnett Newman at Emma Lake in 1959; formerly a painter, he now works in New York where he has abandoned welding for the time being for modelling in bronze. If anything he does in the latter medium in the near future matches the quality of his fountain in Saskatoon he will have established himself as one of the stronger abstract sculptors of this continent.

The second piece of public sculpture for which Saskatoon should be notable is Eli Bornstein's open and "drawn" geometrical construction in stainless steel directly in front of the Teachers Union Building. The over-all conception of this work, which must be almost three times the height of a man, is magnificent, and the artist responsible for it stands or falls as a major artist and nothing else. It is true that the piece is marred, and from certain angles of vision even destroyed, by the excessive busyness of the small steel "cards" that articulate its interior space, but its over-all conception survives, and it was that that I carried away with me and really retain, not the fussiness of the "cards". Bornstein, I learned, was an

292

American from Wisconsin who teaches art at the University of Saskatchewan in Saskatoon. I was also told that he is an adherent of Charles Biederman's ideas, according to which the only truly fruitful way left open today to painting and sculpture is strictly geometric abstract construction-sculpture either in the round or in bas-relief. I saw one of Bornstein's coloured bas-relief constructions in the hall of one of the university buildings, and though I was dissatisfied with it, felt that it too revealed a major hand and a major ambition. Whether he should be considered a Canadian artist, I don't know, but Bornstein is, or should be, a very important artist. It would be unfortunate, however, if the power of his art gave added weight to his programme for art. I don't happen to think that the ideas that programme involves are beside the point or crazy; I once knew Charles Biederman, and I respect his imagination if not his art (Bornstein's is far more inspired), but it would be dreadful if his ideas gained the least bit of legislative force outside the minds of artists who, like Bornstein, seem to find them congenial to start with.

So much for contemporary art in prairie Canada as seen by this outsider. I know that my report is incomplete, and I am aware that it may seem distorted by favouritism towards Saskatchewan. I honestly don't feel that it is distorted in this respect, but I hope that those who disagree and those better acquainted, in part or whole, with the ground I have tried to cover will not hesitate to make themselves heard from.

36.

"CANADIAN SCULPTORS
AT EXPO"

by Barry Lord

*In art as in other areas, Expo 67 helped to create, and certainly
helped to create awareness of, a new wave of national confidence.
Among the focal points was the "Painting in Canada" exhibit at
the Canadian pavilion, curated by Barry Lord (born 1939). In this
review from the May 1967 artscanada, of which he was then
editor, Lord analyses Expo as a forum for Canadian sculpture. He
does so from the nationalist viewpoint that was the most conspi-
cuous and productive feature of Canadian cultural politics during
that period.*

Next to the architects and exhibition designers, the sculptors of
Canada were the artists who might have profited most from Expo
67. Commissions of major pieces—for the Canadian pavilion, the
various provincial pavilions, the theme pavilions and especially for
the Expo site itself—undoubtedly make this fair the largest single
opportunity ever offered to Canadian sculptors. It is sad to observe
that as a group they have failed to meet this challenge, and even sad-
der to reflect that in general they were simply not prepared for it.

The patron has not been stinting. A dozen or more large pieces
can be seen on a tour of the Canadian pavilion, and it is refreshing
to see that smaller pavilions like that of the Atlantic provinces have
remembered the place of the arts in their presentations. (The pavi-
lion of the western provinces appears to be an execrable exception
in this as in virtually every other respect). The Ontario pavilion
organized a competition for its sculpture, and the various theme-
pavilion labyrinths promise to have works hidden away inside.
But the major source is the Canadian Corporation for the World

Exhibition itself, which has spent, according to sculpture project organizer W. Arnold Phillips, approximately one million dollars on sculpture, pools and fountains by Canadian artists.

The commissions have of course been distributed inequitably, and in many cases lesser artists have enjoyed very large sums while others have had to make do with relatively small allowances. Gerald Gladstone, our most over-rated sculptor, has for example three large commissions, while Robert Murray, our greatest talent in this field, received only one contract for an amount which, with luck, will just cover his costs of fabrication. Indeed, it would be well to remember that we have not suddenly created a nation of wealthy sculptors. Most of the artists involved have spent their commissions on construction and emplacement, in order to ensure that they are represented by what they consider important pieces.

The selection of sculptors has also not been completely successful. Calgary's Katie von der Ohe and Montreal's Hugh Leroy appear to be missing, for instance. With the exception of the Canadian pavilion's *Fusion des Arts*, where they are involved in a co-operative kinetic project, the "hard-edge" Montreal sculptors (the group which the National Gallery is now circulating in an exhibition aptly entitled *Montreal Construction*) is not prominent. The absence of Les Levine, whose engrossing maquette was juried out of the Ontario pavilion's competition, is most regrettable. Emphasis in the collection is on the tortured metal and worked surfaces associated with the abstract expressionist sculpture of the 1950s. Nevertheless, it must be said that the works as a group reflect the constipated condition of sculpture in Canada today.

Relations between the piece and its environment have in many cases been worked out with considerable care and imagination. Michael Snow's *Walking Woman* in the Ontario pavilion for example will most effectively draw the strolling visitor into the exhibition structure. Expo's sculpture organizer Phillips is a landscape architect (from the U.S. by the way), and has co-ordinated closely with the sculptors on details of siting and position; in many cases he has responded to the sculptors' ideas by altering his landscape surround. Perhaps the most successful integration was achieved in

the administrative headquarters of Expo itself, where the sculptured concrete walls by Ted Bieler in the foyer function at once as both textured components of the building fabric and as individual works of art; they are perhaps one of the happiest examples in Canada of fruitful collaboration between artist and architect.

This kind of co-operation was attempted in the Canadian pavilion also, but with much less success. Gord Smith's 110' wall for example is simply a flimsy, cluttering obstruction of mindlessly altered planes between the splendid mass of the *Katimavik*, itself a most impressive "primary form" architecture-sculpture, and that curious exhibition structure, the "tree" of the people of Canada. Sorel Etrog's *Flight* does take a handsome presence in correct scale with the art gallery, and Elza Mayhew has contributed a sensitive low *Meditation Piece* which responds very well to the high, enclosed sanctuary it was commissioned for. But beside Etrog is a screen by Armand Vaillancourt, another meaningless interruption of what might have been a most dynamic vista. The architects and exhibition designers have perhaps done their job too well, so that the buildings and displays minimize the effect of much of the indifferent sculpture.

A recurring problem is that of scale. Eskimo carvers, whose best work is related to the dimensions of the human hand, have been allowed to cover the walls of the Canadian pavilion's restaurant with large murals depicting the life of an entire village; the results, while vastly superior to the wretched excess of Madeleine Arbour's colour and texture (and live birds in cages) splashed over the cafeteria, confirm the suspicion that these sensitive artists are not at home in the exhibitionist atmosphere of the fair. Scattered around the site are contributions by Walter Yarwood, Suzanne Guité, Charles Daudelin and others which are similarly out of scale; many probably appeared much better in maquette than in final execution. David Partridge's nail sculpture is a fussy tower which might have been half as high, or even not at all.

There are a few important works. In addition to her *Meditation Piece* for the Canadian pavilion's sanctuary (a work which is marred by her over-prominent signature and date), Elza Mayhew

has distinguished herself in *Concordia*, an 8' high cast bronze totem which is one of her best to date. The surface has been intelligently organized and expressively incised, without becoming too busy as it often does in her weaker pieces. Robert Murray's 16' painted aluminum *Dyad* is another incisive stage in his analysis of relationship between two elements in one piece; it is a more complex statement of the formal values explored in his *To*, which is in the collection of the Art Gallery of Ontario. Françoise Sullivan, also working in enamelled metal, presents an interesting, discrete statement of altered plane and connected form achieving a jaunty continuity in space.

But lamentably, most of the Canadian sculpture at Expo can be characterized by pieces like Jordi Bonet's battered columns in the Place des Nations—more of those fragmented figures jammed between pillars or enclosed in prison-bar cages which used to fill international sculpture exhibitions only a few years ago—and Yves Trudeau's figure-in-the-scorched-metal monster, this time compounded by mechanical "kinetic" motion. How, one may ask, given the state of Canadian sculpture today, could it have been otherwise? The planners of Expo set out, in organizer Phillips' phrase, to make of the fair site "a showcase of Canadian sculpture;" unhappily, they appear to have succeeded only too accurately in registering the present retarded state of that art in our country today.

It will be interesting to see what becomes of the Canadian sculpture at Expo. No decisions have yet been made, and while Phillips has proposed that the pieces be kept on the site to form the nucleus of a great sculpture garden, others have suggested that the works be distributed to museums and other public institutions across the nation. It is unlikely that there will be too many bids from collectors outside Canada.

We may look forward to the major exhibitions of Canadian sculpture now being organized for Toronto's City Hall and Vancouver's Queen Elizabeth Playhouse, both to open this summer; we will then be able to conclude the extent to which Expo's sculpture is dismally representative of what is actually happening.

And if, as I suspect, it does register correctly the low index of this art in Canada today, we may then ask ourselves why this should be so. The answer is not far to seek: there is a complete lack of the most rudimentary conditions for a sculptor's continued existence in this country, ranging from the relative indifference of many architects and builders through the non-existence of adequate casting or fabrication facilities to the virtual absence of teachers. The few sculptors we do raise must go outside Canada for education, construction and (except in 1967) for commissions. The superficial assistance to sculptors which Expo and the Centennial have provided should not obscure these underlying problems, which will persist after the party's over. While we're celebrating, we might consider how we propose to meet them tomorrow.

37.

"CANADIAN ART IN THE SIXTIES"

by David Silcox

In this stylish essay from Canadian Art, *January 1966, David Silcox (born 1937) sums up the achievement of the generation that had come to fruition in the previous decade. Looked at now it is not only a thoughtful summary of their position but a revealing measurement of just how much the art world was soon to change. For he was writing on the eve of artist-run galleries, conceptual art, feminist art...of new stars, new places, new movements, and new media. Silcox has been a key arts administrator with the Metropolitan Toronto government and the federal Department of Communications and is now Ontario's Deputy Minister of Citizenship and Culture. He is author with Harold Town of* Tom Thomson: The Silence and the Storm *(Toronto: McClelland & Stewart, 1977).*

Decades and half-decades are perverse measure of trends in art and they are treacherous when they tempt us to write contemporary history. But if we compare today with the Fifties, disregarding what they have in common, and give consideration only to what is peculiar to the Sixties—new developments, new mutations, new directions—then we will have the means to make a useful if provisional analysis.

The Sixties have so far been kind to artistic enterprise in this country. The climate of acceptance has become more comfortable and, with department-store promotion, might even become debilitating. Private buying, while as yet not magnanimous enough to put the artist beyond the dreams of avarice, has been sufficient to spawn a number of new commercial galleries across the land. Official assistance to artists and to public art galleries has increased markedly, while corporate purchases and public commissions have

hearteningly entered a new era. There have been increases in both imports and exports, and the avowed aim of the Painters Eleven, who banded together in Toronto in the Fifties to launch the international idiom in Canada, has been largely realized. The evidence for that is in the greater number of international exhibitions that are now coming to Canada in both public and commercial galleries, and in the obvious fact that our artists, however unobtrusively, have thrown their hats into the international ring.

If the language of Canadian art is a sort of pictorial Esperanto with a Canadian accent, and I take that as read, it is primarily because New York has become the new art centre of the world, and its proximity has had a crucial effect on Canadian art, artists and public. Admittedly the Canadian artist is still on the periphery, but he has become less peripheral. It is now not unusual to see our painters mentioned in international art periodicals, their work shown in international exhibitions or bought for foreign institutional and private collections. During the past year, for example, Guido Molinari and Claude Tousignant were in the Museum of Modern Art exhibition *The Responsive Eye*, Yves Gaucher in the *Art Today* eye-opener in Buffalo, and Kenneth Lochhead, Arthur McKay and Jack Bush in Clement Greenberg's *Post-Painterly Abstraction* exhibition.

The influence of New York, however, has had varying effects on different parts of Canada, and to the minds of some, not all of it good. But as Hugo McPherson shrewdly observed a few issues back (*Canadian Art*, No. 95, January/February 1965), "Until a community develops the prestige to *lead*, it must in some degree adjust to the prevailing [western] idiom, or remain content to be proudly independent but relatively unimportant." The outbursts of activity in Regina and Montreal during the Sixties are the result of a direct confrontation with New York, though the very enthusiasm of them smacks a little of adolescent idolatry. The results have been immensely stimulating and productive, however, and may later develop a flavour that is both *à la mode* and Canadian. In Toronto, where the liaison with New York has been longer (the Painters Eleven showed there in 1956), it has been more fruitful.

300

More of New York has been shown in Toronto than in any other Canadian centre, and the Art Gallery of Toronto has the most important collection of contemporary U.S. art in Canada. Toronto's idiom, as influenced by New York, may be less dramatic than that of Regina and Montreal, but because there have been time and talent to evolve a distinct variation, it is perhaps more honest, more mature, and certainly more self-assured. So even if Canadian art is "international," it is not necessarily true that by nibbling at the international pie we will get a definitive idea of what art in Canada tastes like.

The trend from the late Fifties to the present has been a gradual one leading from density towards spaciousness, from the tumultuous towards the neat, from the bountiful to the economical, from the personal to the impersonal, from the emotional blot to the intellectual diagram. Whether you look at the work of a constructivist, a geometrician or an expressionist, the scales are at present weighted by formalism. The words that describe Canadian art today are elegant, smooth, refined and restrained. While these may not describe all that has happened or explain the emergence of new forms of expression, they seem to characterize the most important work done in the Sixties in every style and to differentiate it from the Fifties.

In Canada this transition is exemplified best in the works of Harold Town. He, more than any other painter in Canada, always works in and of his time and place. He is a touchstone, the national seismograph, for the development of art in the country as a whole. In 1958 he painted the handsome and dynamic mural for the Ontario Hydro station in Cornwall. This work was a valediction to the Fifties. It summarized painting activity of the post-war years and, as far as Canada was concerned, it was the greatest achievement in the abstract expressionist idiom. From there Town edged away from the packed and strident style of this mural towards a style which gave ever greater emphasis to sharp contours, to precision of line and to tidy details. In short, he moved from paintings, largely abrasive and rude and full of animal vigour and muscular bravado, to works full of rich elegance, sophisticated

301

simplicity and intellectual grace (*The Great Seal* and *Tyranny of the Corner* series). His recent concern with optical problems is not new, but is rooted in several years of development and comes as a natural outgrowth of it.

Once we note the character of Town's evolution, we see it everywhere. Graham Coughtry's progress is easier to follow— from the violent, jagged slashes across the *Reclining Figure* of 1957, through the early, thickly-worked *Two Figure Series* (1962-3) to the *Two Figure Series XXII* of late 1964, in which the two figures are compressed into one simple form, flat on the canvas, and basically in three colours. The personalized handling of the paint, demonstrated with such virtuosity in his early works, is here drastically reduced and subordinated to the form.

Or look at Ronald Bloore's work *Le Forêt méchanique* of the late Fifties and compare it with *Painting No. 6* from his 1965 show in Toronto. The former is dense, sombre and complicated; the latter precisely incised, open and commodious. The same progress towards simplification is evident in the work of Lochhead, McKay and Morton, other Regina artists.

In Montreal no less striking and no less characteristic a change has taken place. Yves Gaucher's work in the late Fifties and early Sixties was full of textural and painterly qualities, even in his prints. His recent prints and paintings are sparse and geometric, unequivocal in colour values and, again, simplified to such a terse intellectual proposition that some people are a little chilled by the transformation. As works of art they are as good or better that his earlier ones, though it is unnecessary to make value judgements to prove the point. Guido Molinari had begun in the mid-Fifties to discard the excessively personal gestural style of the Borduas-Riopelle legacy in order to conduct his campaign for flatness, and simple, pure colour. (While Borduas is a crucial figure in Canadian art history, he might be shocked to discover so many of his Quebec fraternity still wallowing about blindly in the gluey wake of *tachisme*.)

In Vancouver, Toni Onley has moved past his preoccupation with over-all patterning (his early collages) and now works with

one or two forms floating in ample space between the borders of the canvas. Roy Kiyooka, the only Vancouverite who has gone whole-heartedly "New York," has abandoned his earlier concern for texture and asymmetry for flat, impersonal and geometric compositions. Even Jack Shadbolt, always welcoming the new, has opened up his lyrical and florid landscapes to make way for broad, waving stripes in banner colours.

This general shift in style emerges as a major characteristic of the Sixties, even though there is still considerable vacillation and hesitancy. The causes for it may be both within or outside painting itself. It may simply be a reaction to action painting which had many adherents in Canada, especially in the related but insular *tachiste-automatiste* movement in Quebec. This might partly explain the pull towards New York where the reaction was first evident. Again, it is possible to read it entirely in terms of the imposition of new techniques, materials and paints which suggest new possibilities of form and style. Pure, thin acrylic paint, for instance, seems to demand expansion (in forms, not size), and the mixing and scumbling of oils is certainly an obstacle to the purity of visual sensation that is so avidly pursued now. It is also arguable that concepts change first and make artists inquisitive about new methods and devices, though it is probably a combination of both. What are the social causes? Have the black threat of the bomb and the tension of the cold war eased or become familiar enough to permit a relaxation of intensity? Is the diet we now want one of easier, simpler forms and gayer colours? One wonders that the anxious, spiky, tense forms of sculpture a decade ago (Chadwick, Butler, Vaillancourt) should be filed down to the smooth, colourful, toy-like works of today (Dalwood, Caro, Comtois). Has the role of the artist shifted too? And has his work now a slightly different place in society?

The transition is probably a complex of these and other factors too numerous and difficult to sort out. So I shall change the subject with another general observation about the Canadian artist in the Sixties as inferred through his work: that there is a conscientious attempt by the artist to deal only with an object, or with what

303

is on the canvas, and not to involve his own personality, not to indicate his own reaction to his work. If I may revert to an eighteenth century literary example of what I mean: when Boswell wrote his *Life of Johnson* he divulged as much about himself as he did about Johnson because he told us as much about his processes and practices of gathering information as he did about what it was for. So it was with Canadian painters a decade ago. Today they are more concerned with the *product* of their work and less to show the *process* they used to arrive at it. The techniques, while still visible, are increasingly directed to an end and considered less as ends in themselves. In the expressionist art of the Fifties we could marvel at a mighty stroke across the canvas and imagine the artist's heroic arm still hovering phantom-like at the end of it. We looked on it as an event, a performance, a process. Today we find it difficult to see the artist's ghost still at work. In fact, we can't see it at all. Perhaps that is why so much of today's art appears so effortless, easy and simple, even though we are aware that it must have been very difficult to create.

In some cases this de-personalizing of forms and this creeping expansiveness of space has led to emptiness. Indeed, I have heard it argued that that is *all* it has led to and that one doesn't even get one's money's worth in paint anymore. This is mistaking a cooler, lower-keyed approach for one that is bland or feebly constructed (the case for all second-rate art). The best of Canadian art today has taken the power and energy which makes a work aesthetically viable and put it inside, interiorized it. As in the design and function of aeroplanes, outward simplicity is the first rule: no more protruding cockpits or big blades beating the air in a display of power; no more thick paint or violent palette knife strokes. Town's knowledge of the forms of industrial machinery "fuels" (his telling word) his pictorial forms from within. Drenters' forms are related to outward forms of rockets and towers, the totems of our day. Gladstone's work professes to deal with space-age themes, but his forms more often remind me of the clumsy circle of cooling fins from the bi-plane era. Bloore, on the other hand, in his best works, captures the same sort of tension that there is between the

304

wing and the suspended, yet thrusting, engine of a DC-8—a static relationship suggestive of great potential energy. If at first glance the works of many Canadian artists of today seem cold, impersonal and excessively intellectual, that doesn't necessarily mean that they are less vital or aesthetically less powerful than the art they have developed from. Is the reason for their coolness that attention has been transferred from the inner to the outer world, from the studio to the social milieu and the physical environment?

Before we try to come to any conclusions about that, we should look briefly at three other aspects of Canadian art in the Sixties which seem significant: the relationship with mass media, the place of sculpture and the renewed emphasis on the figurative.

When we think how dependent we are on tape recorders, phonographs, photographs, movies and television, all of which are means of reproduction, it should not come as a surprise that art has been influenced by these ways of seeing and knowing. Reproductions, whether film, photo or sound recording, are now accepted as "the real thing." A taxi driver once told me that he didn't realize what a street he drove on every day looked like until he had seen a picture of it. Nearly all popular music has to be processed through an amplifier before it is acceptable. Television and film have revitalized interest in visual "images" (messages without words) and will probably displace painting and sculpture as the most effective way of reflecting society to itself and to posterity. But painting and sculpture are themselves being revitalized by using the media for their own propogation. They have already been profoundly influenced in their form, style and content by the possibilities of printing and electronic methods. Perhaps they are on the threshold of becoming mass media themselves and there are hints in the work of U.S. artists Andy Warhol and Robert Rauschenberg to suggest this. In Canada, the work of Snow, Wieland, Levine, Gorman and Rayner has already set some direction for exploration along this line.

Time sequences have become an integral part of the content and/or effect of works that are motorized, blown by the wind (mobiles) or, more recently, computer-programed. The early media

305

influence was largely shown by the repetition of motifs or images (such as Duchamp's *Nude Descending a Staircase*) which suggested motion or gave the illusion of it, but in a relatively unrefined way (as far as the media were concerned). Snow's *Walking Woman* often appears in sequences reminiscent of a film strip, or in positive or negative forms, or as seen through distorting lenses as illustrated by *Five Girl-Panels*, both references to cinematic technology. Rayner's *Nursepap* could not have been created without considerable knowledge of film processes. It is significant that these artists, and many more, have been making films, and that others use cameras to collect ideas. If our vision is so much conditioned by seeing or apprehending objects and experiences through the eye of a camera, then is this recent concentration on cinematic techniques not an indication that the artist is concerning himself with the way we do see, and is thereby able to present his ideas more forcibly to our attention?

Town has for some years been dealing with another mass medium: the city and its network of streets and expressways. In some of his recent works repeated motifs of a circle of varying sizes provides the background (or the landscape) for optically brilliant lines. Some paintings may be read as contour maps; others as aerialscapes slashed by superhighways; but in either case the whole has been given an aesthetic force which rises above the too often drab abstractions that one sees from an aeroplane. If one of these paintings hung among the maps and plans in every city-planning department across the country it might prove to be truly inspirational.

The characteristics of painting in the Sixties may also be used to describe the character of that ever more closely related art, sculpture. Robert Murray, now living and working in New York, has produced works recently which are simple, strong and sophisticated. He is one of our great sculptors if, indeed, we may still claim him. Robert Hedrick's work, while quite unlike Murray's, has shown over the years the same tendency to move from the complicated and organic towards an expression which is both more linear and more quiescent. Irving Burman's new drawings

for sculptural projects foreshadow a new landscape sculpture which has developed from his work for the Montreal Sculpture Symposium. The colourful configurations by Ulysse Comtois and the cast aluminum constructions by Walter Yarwood give a fresh and vigorous boost to sculpture in a domestic scale and setting. But Michael Snow's *Walking Woman* constructions have, perhaps more than other works, suggested that the painter-sculptor is newly concerned with the spacial environs of the city. That the *Walking Woman* could look so much at home at Queen and Yonge Streets in downtown Toronto indicates the potential that sculpture has, not merely in decorating our cities, but in exposing and commenting on both our physical environment and our view of ourselves in it.

It is rather late in the twentieth century for sculpture to find the significant place in Canadian art that it finally seems to have found. But the Group of Seven gave little attention to sculpture or print-making and both these forms of expression have only begun to develop healthily since the early Fifties. When artists like Town, Snow, Comtois, Riopelle and Hedrick divide their time between painting and sculpting, and when so many like Richard Turner, Yosef Drenters, Elza Mayhew and Anne Kahane give their full time to sculpture, something significant is bound to be produced; witness the recent summer exhibitions sponsored by the National Gallery and the Montreal Sculpture Symposium. And when the businessmen of the city take the initiative, as they have in Montreal, to commission work to beautify historic sites, and when the government itself is more generous about the sculpture that adorns public buildings (the airports), then one must admit that the forecast is for sunshine.

The figurative seems to have received a fresh impetus in the Sixties. The "return" of a recognizable image or object (I don't think it ever "went away") reinforces the observation that the artist is attempting to be more concrete and also more detached from his work. The impersonal quality, rather than removing the artist from society, has actually brought him closer to it than he has been since the formalism of the Twenties (Le Corbusier, Ozenfant, the

307

Bauhaus, etc.). Much of the art of today emphasizes affinities with the early part of the century and brings with it a moral attitude of direct concern and involvement in public matters which the artist of ten years ago did not seem compelled to express. The pop artist is an extreme example of this concern with "things" and public attitudes and though both artists and critics have suggested that he is indifferent to the message of his work, his very selection is a commitment and a stand. As I suggested above, the emphasis on the product takes art away from the personal shadows of experience and immediacy and puts it instead closer to the spotlight of statement and axiom, closer to something that can be rationally apprehended and therefore capable of greater didactic import. This didacticism is now being tentatively approached in Canadian art, and it is a trend which I hope will continue to develop strongly.

It can be seen primarily in the works of Town and Snow. Snow has been using his *Walking Woman* to ask some very profound questions about the nature of art and about the nature of society. And clearly, many of the variations of this ubiquitous dame investigate aspects of both the physical and social environment, of the relation of art to them and of our relation to them. Whether any or all housewives and secretaries ever see her as portraits of themselves is beside the point. She is going to change the environment they live in because she has defined some of the problems which architects and engineers will have to solve: the scale and *décor* of our streets, buildings, subways and parks. If a gingerbread man looks most natural in a gingerbread world, then the *Walking Woman* serves to bring attention to the inhuman surroundings we make for ourselves in our cities. Town's *Enigmas* which he began early last year embody a moral attitude on a very high level, for they are first of all good drawings. They are saturated with social satire and comment which anyone, no matter how visually illiterate, can read. Their intention is not to address an introverted clique, but to speak in a national voice about national concerns.

Throughout this article I have been conscious of using a few artists as examples over and over again. There is a generation, that

of the Painters Eleven, which has become the most creatively powerful in the country. Their preeminence, however, has not obscured but rather encouraged younger artists like John Meredith, Richard Lacroix, Gerry McAdam and Claude Breeze. What new developments, new mutations and new directions both younger and older artists may yet take in the Sixties is something for the Seventies to discover.

38.

"A SHORT HISTORY OF PERFORMANCE ART AS IT INFLUENCED OR FAILED TO INFLUENCE MY WORK"

by Gathie Falk

There are relatively few external documents that give access to the performance art that was nurtured in alternate spaces and through association with other disciplines; there are certainly few more approachable than this statement by Gathie Falk (born 1928), the Manitoba-born painter who throughout the 1970s progressed towards performance art and multimedia works generally. It appeared in artscanada, *April 1981.*

When I was introduced to performance art in 1968 I had just settled into a career of making sculptures. I was making sculptures of men's coats folded like shirts and standing up like portraits; I put 69 ceramic grapefruit all over a gallery floor; and I placed a ceramic roasting chicken into a pink-flocked birdcage.

My introduction to performance art was made by Deborah Hay, a New York artist whose roots were with Merce Cunningham's contemporary dance, and who in 1968 was doing performances with artists like Rauschenberg. To my gratified surprise she gave my work as an incipient performance artist a great big stamp of approval. Since this discipline was a new one to me I needed this approval. I also got a big wad of satisfaction from the fact that this new work was closely related to my sculpture and that, paradoxically, I had learned an entirely new language without much bother.

310

From my perspective, to make a performance piece is to put together, or choreograph, or compose a work of art that has a beginning, an end, and a middle, with preferably, but not necessarily, a climax or several climaxes. Sometimes a piece works in a linear way with one event following another (*A Bird is Known by His Feathers Alone*, 1972); sometimes the choreography is worked out like a fugue in music, with one event beginning close upon the heels of another, and a third event intertwining with the first two. The analogy of music is apt. One of my works, *Red Angel* (1972), is like a rondo, with theme A followed by theme B, followed by theme A.

The events, or themes, I like to use are, guess what, activities of ordinary everyday living: eating an egg, reading a book, washing clothes, putting on makeup, cutting hair, together with slightly exotic events such as shining someone's shoes while he is walking backwards singing an operatic aria, sewing cabbage leaves together, smashing eggs with a ruler as in playing croquet, making a painting out of lipstick, powder, and perfume, measuring and graphing my cat's tail as it is projected on different gallery walls, moving a hundred oranges across a floor with a prone body while a hundred cocktail glasses are moved in the opposite direction by another prone body, sawing popsicles in half and using them as weapons of assault and defence, along with plastic flowers in the back pocket.

To some spectators it seemed that all this effort was made with a view to toppling the usual order of things or that the aim was outrageousness. Not so. The activities I used belonged together in that mysterious way that all things in every strong work of art belong together, with neither too much nor too little of anything. I was not fighting the battles of the Dada artists; in fact, I wasn't fighting any battles: just doing, creating, with different material, the things I also made with more traditional materials.

This new material was people, used not in the conscious way of dance nor the narrative way of theatre, but in a way that only a visual artist would find natural.

311

Making a performance piece, for me, also meant trying not to bore people to death. A lot of tolerance, concentration, "a new way of looking," as Steve Paxton called it, is required from the audience of performance art. The least the artist can do is not intentionally bore this hardworking audience.

People who undoubtedly influenced my work in the sixties were visiting artists from New York, Deborah Hay, Steve Paxton, and Yvonne Rainer. The work of each of these people was definitely related to a new careful examination and perception of the natural movements that people reiterate in their daily activities. Each deferred also to slightly idiosyncratic interpretations of those movements: for instance, Deborah Hay's filling a corner with people, which looks a bit mad but is related to filling an elevator with people.

While these artists had something in common they were also very different from each other. Yvonne Rainer leaned towards dance, while Hay's and Paxton's works encompassed a wider range of analogy, much of their material being verbal. Hay gave you a punch in the stomach quite often, while Paxton's work flowed more gently to a conclusion without a climax.

There was other work piped in: the piano-axer, chicken-killer, pigs' blood-thrower. My work was not much affected by this artist since I'm the kind of person who feels that a good stripper can be more effective in the way she/he removes a glove than how she/he takes off everything.

Another person who affected my work was my friend, Tom Graff, who does exotic, baroque, long, complicated performance works. To the uninitiated they sometimes look like musical reviews with a lot of unexplainable visual stuff. These people don't know that Graff is using entertainment itself as a subject for his work, bashing it around till it comes out a different shape but with some pieces still recognizably there.

Graff's work made me think about using songs and dances in my work. In *Red Angel* I used *Row, Row, Row Your Boat*; I used *Drink To Me Only With Thine Eyes* in a piece called *Drink to Me Only* (1972); *Low Clouds* (1972) had a dance-like movement of

312

clouds. I also began making sculptures intended chiefly to be used as props. And I wrote some music to the lyrics, *Name, Age, Sex, Racial Origin* for a piece called *Chorus* (1972). This work took me well into the seventies.

Simultaneous with my first strong sculpture and performance experience, influential critics were telling us that art no longer hung on walls, that Concept art was the only way to go, and that if we wanted to look at something it must be documentation of said Concept art, or, a few years later there was the new thing called performance art or video art. Both the new performance art and video art were closely related to Conceptual art. Instead of inviting people of divergent talent to participate it dictated a narrow dogma of restraint and minimalism.

The result of this cultural revolution was that painters kept on painting, sculptors kept on doing what they do, and some of us flamboyant Performance artists went our own naughty ways.

Now that Performance art has gained a firm place of respectability in the art world I hope that there will be room for all kinds of individuality, for, if it keeps on being bound by rules and formulas, we will soon see it on the shelf of London Drugs packaged in a squeezable tube.

As for me, why did I stop doing Performance art about four years ago? Well, when you get older you get tired of lugging around heavy boxes, looking in vain for a round dishpan in a major Canadian city, and teaching a new crew to crow.

39.

"WOMEN AND VIDEO"

by Carol Zemel

Video art has often proceeded from attitudes achieved in conceptual and performance art and has been at the leading edge of technical experimentation and the general rediscovery of narrative. This article by Carol Zemel (born 1943), a Canadian art historian now teaching at the State University of New York at Buffalo, is one of the earliest important Canadian documents on video. It appeared in artscanada *in October 1973, a year before the Art Gallery of Ontario organized "Videoscape", the first major exhibition of Canadian video, and just as acceptance of the feminist sensibility in Canadian art was becoming general.*

For a historian of modern art, video at the Toronto portion of the *international festival of women and film 1896-1973* reflected the widely ranging forms of art encompassed by this new medium. It was an opportunity not only to encounter a new aesthetic, but also to consider it within its unique social and political context. And while the quality of the works presented was uneven, they did explore several avenues of video expression.

Video as an art form is still recent enough that for the general, or even the regular art and filmviewing audience, it requires a reorientation in approach. A TV generation has learned to be passively entertained by the phosphorescent screen. Relaxing at home, they idly flick channels, turning in or out. The image is beamed from an intense screen of light, and with its small, furniture-scaled presence, allows even the most hypnotized viewer the choice of periodically looking away. To confront this visual format as art is difficult and confusing.

For most of us, looking at art involves a ritualized stance before what are often huge paintings or sculpture, or passive absorption in the larger-than-life energies of theater and film. These spectator contexts do not apply to video art. An attempt to watch a videotape—no matter what its visual style—for more than 15 minutes with the intensity of concentration required for looking at Seurat or Pollock, following the narrative drama of film or the live action of theater and dance, will ultimately prove exhausting; the mind and eye cannot take the subliminally flickering intensity, and one begins to resent the video screen as a lightbeamed intruder boring into the brain. Happily, most video artists know this, and advise limiting concentrated watching to 45 minute stretches.

There is confusion in the assumption that the order of information the viewer will confront—artistic, social, political, etc.—is similar to that offered by the other arts. The opposite is true. If every art form or medium uniquely explores and assembles human experience, video's organization of experience and information is tied to its immediacy and intimate, human scale. Though similar in many respects—such as in its transitoriness—to film and theater arts, video is able to convey an intimacy of gesture, drama and form often ignored by other media. Previously unnoticed, uninflected aspects of visual information can be collected, immediately examined, manipulated, and explored. In the banal context of broadcast TV, this factor perhaps explains the minute scale of emotionalized, dramatic "action" in daily soap operas, as well as the close psychological focus of better television drama. *Video*, however, does not strive for filmic climax or dramatic narrative sequence. It seeks to instantaneously picture uninterrupted, even awkward sequences of subtly unconscious movements, to record the raw accident or unrefined crudity of closely scrutinized behaviour .

Like so many contemporary movements in the arts, video too is in some ways a camp divided. On the one hand are social and political radicals who see the medium's technological facility and directness embodying a truly democratic art, one way to bring the means of communication to the people. On the other hand are the

video artists. Within these broad divisions there is of course a range of activity, and the several video categories—as in any field—spill over and overlap their aesthetic fences. Still, socio-political video vs. artistic video can effectively serve as an introductory structure for the multiplicity of current *genres*.

Much of the work presented at the festival was socio-political or documentary in style and intent. Video is a potentially powerful medium for social change. As a communicative tool whose documentary and playback capacities can enliven recorded data, there seems little doubt that for schools, social and psychological study programs, as well as social and political documentarists, video affords a relatively inexpensive, easily handled, and direct medium for exploration.

New York video artist Wendy Clarke offered a workshop at the festival that allowed a glimpse of the medium as a penetrating psychological tool. Ten participants were instructed never to look at each other directly, but to communicate only through the video monitor. Much of the activity involved self-exploration, as each person talked about her face, watching as she did so; drew, watching the drawing hand in the monitor; and involved a small group in the creation of a brief videotaped skit. It was an effective way to see oneself and others, and the images were unsettling in their reality. Videospace is not a comforting, conventional mirror, but an instantly visualized reality. One was both detached from self and wary at the same time, and with this heightened self-awareness, continued to feel, act, communicate, and create, while the camera projected its "objective," egoless reflection.

Much of the socio-political video presented in Toronto referred to a feminist sensibility and consciousness. Here too political attitudes and consciousness-raising styles varied. Frieda Forman produced a taped interview of English suffragette Nell Hall Humperson, who carried explosives, and endured prison fasts in the women's struggle for the vote. Humperson, who emigrated to Canada, appeared at the festival and relished telling tales of her revolutionary past, but saw no reason then or now to continue the struggle for women's liberation once suffrage was achieved.

316

The Montreal Cable Stations presented what seemed to be an endless series of tapes on feminist issues. The series ran last year on the cable station, but received no audience response—understandable in view of the dull, clinical attitudes that pervaded the tapes. The programs pretended to probe female culture and awareness, but their psycho-sociological professionalism—an uptight social-worker reporting that "girls were not encouraged to explore their bodies," rather than a direct recounting of her own body explorations—evoked a smugly platitudinous atmosphere. Feminist consciousness was effectively abstracted and reduced to tedium.

In contrast, San Francisco's Femedia produced *Clik*, a grab-bag tape that included cartoons of sexist job situations, "Dear Miss Maggie"—a feminist counsellor speaking on masturbation, and a video recording of a feminist poetry reading. The most effective segment, "As Women See It," was a spoof of a gangster film, with tough fedora-wearing, gun-toting women kidnapping and liberating women and girls from their laundromats and dolls. The caricatured gangster roles drew attention to sex role stereotypes, and though somewhat technically insufficient and heavily ideological in content, the satire was both humorous and thought-provoking.

Contributions from Videographe, a Montreal video centre, also emphasized issues of political consciousness. *La défaite jusqu'à la victoire*, by Jo Laforce and Réal Morisette documented the sharply flavoured humour of Quebec political satirists and entertainers in a "provincial" nightclub setting. Camille Maheux's *On a firme l'île aux grues* recorded the lifestyle and attitudes of a rural island people. In *S'Aimer tout une vie?* Lise Bélanger taped women's sessions of self-examination on matters of love, marriage, and divorce, while their husbands expressed their hopes and attitudes about their relationships.

Lise Noiseaux-Labrecque's *Les seins de Louise* was an exploration of cultural attitudes focusing on breasts—their size, beauty, and importance for a woman's self-image and self-esteem. Women walking in the streets, the sexual orientations of maga-

317

zines, methods of breast enlargement, interviews with men about preferred female dimensions—were intercut with Louise talking about her body and her lifestyle. The tape attempted to present an entire cultural history; it was, therefore, rather long and repetitive, with heavy doses of what has become consciousness-raising cliché. But the overriding impression was both politically feminist and personally expressive; the raw video realities of one woman's life were clearly presented, with occasional "poeticized" images using time-delay and feedback techniques.

Less politically oriented, Mousse Guernon's *Libidante* used feedback and synthesized effects along with a loosely narrative style to explore a lovers' relationship. Reversing traditional conventions of the nude, the camera lovingly explored the man's body, spread sensually across the video field. The tape ended, however, with the man and woman in their traditional places—he stopping mid-stride to light his cigarette, she musing pensively among her flowers—still the woman separated from the outside world, in an introspective, but protective garden.

In *Women and their Bodies*, Jill Bellos of Toronto documented the body-attitudes of several women. A poet spoke tenderly of the sagging lines of aging skin, a mother nursed her child, a girl discussed her abortion, and two strippers performed, one speaking matter-of-factly of her anger towards men, her refuge in the feminist community, and her return to the more honest realities of the strip joints and skid row.

Viva's tapes reflected a more personal approach to video documentation. The birth of her daughter was intercut with home-movie images of Viva's childhood, and one sequence moved with great intensity from Viva's hospitalized grandmother, to the grimacing newborn child, to Viva's own tearful face as the baby was placed in her arms. Another tape, in a somewhat less romantic mood, documented a listless orgy, where some couples watched in boredom while others rutted and groaned. Viva too appeared, camera in hand, drawing comments and instructions to her performers. At the festival she moved casually among the monitors, explaining the images to the audience. It reinforced the home-movie quality of

318

her style, understandable perhaps for an underground film-star. Video's facility enhances the aspect of life-as-performance, and with its unrefined intimacy is related to the characteristic and shocking element in Warhol's cinema style.

The Ann Arbor Women's Video Workshop, represented at the festival by Jan Zimmerman, showed *Reflections*, a study that suggested social investigation and exploration. The Women's Workshop taped various activities of an eighth-grade girl's group. Gangly teenagers were shown in gym class, picnicking, and in giggly discussion of themselves, friends, and "the Boys"—evoking all of the awkwardness and anxiety of those crucial, difficult years. The girls' own responses to the tape would have been interesting—indicating how the raw reportage of video can enhance or alter a group's self-image and goals.

Within the realm of video art there are yet again several genres or categories of expression. One of the most popular is based on feedback and synthesized techniques, or, as Gene Youngblood has labelled them, "synaesthesic" effects. The pictorial manipulation of the visual field closely relates this video genre to painting. And like painters, video artists using these methods tend to be insistently formalist in their aesthetic goals. Their intentions are also often avowedly to alter or revolutionize human awareness through an intense sensory bombardment of constantly changing images of extraordinary visual density and complexity. Combined with luminous, intense colour, these works frequently result in a mere technical tour-de-force, an overloaded, baroque barrage of effects that offers little poetic or artistic insight. Visually they are frequently reminiscent of psychedelia's strident tonalities (another art form that was going to "revolutionize" perception) or the light projections associated with the live rock shows of the 1960s.

The instantaneous monitoring and videotronic mixing of sound and image effects is synaesthesic indeed. Perceptions merge, mingle, and compound, and the heightened or intensified perceptual range creates a feeling of time "stretched"—the greater the sensory information available, the greater our awareness of time. Time stops and creates itself with an added clarity of its parts, so that

more of each moment is perceived and potentially understood. But whether or not this aspect of the medium will produce works of more than decorative interest remains to be seen. Aesthetically, a doctrinaire formalism often restricts itself to banal self-referential abstraction, kaleidoscopic superficialities of virtuosity and display. Certainly however, the work of Nam June Paik, the Vasulkas and others are resonant with poetry and impressive in their formal explorations and techniques.

In *Magic Journey*, Steina and Woody Vasulka expanded upon René Magritte's painting *Golden Voyage*, where loaves of bread float through the crenellations of a medieval castle. The loaves—at once primal, phallic, and funny—float through dream landscapes over seas and beaches, through castle walls and up from behind silhouetted skyscrapers, to tantalizingly circle around the recumbent body of a nude woman. She, in turn, reaches up to caress or grasp the mysterious loaf-creatures—the Michelangeloesque gesture of Adam reaching for the spark of life is a visual pun both humorous and touching. A variety of synthesized effects were used: images keyed-in from several monitors effectively animate the sequences, high intensity light and colour contrasts create expressive city views and landscapes. Sadly, the festival did not provide colour video equipment, limiting appreciation of a tape that was both playful yet powerfully primal in its fantasy.

Laurie McDonald's works reflect her interest in video experiment. *Take My Picture* showed men on street corners muttering and bantering about the video camera and themselves. High-contrast, superimposed portrait images melted and fused in smoky patches, and combined with electronic sound to suggest an "inner space" or haunted mind that was in direct contrast to the crude literalness of the actual street situation. In *Moog Synthesized Images #1*, shifting abstract veils (again, unfortunately not seen in colour) were controlled by the sounds of the Moog synthesizer to which the video system was keyed. This is perhaps video's most synaesthetic imagery, for as the sound determines and shapes the picture, the viewer experiences a transmutation of senses: sound is "seen". McDonald's most dramatic work was *Body Tape*, where the light-

ing was arranged so that body contours and edges received the most intense illumination. The camera was then swung pendulum-like from above and the tape run between two decks to effect a brief time delay. The resultant imagery, reversed so that the body's lit contours became black lines, was like a Matisse drawing come alive. Time-delayed pictures recurred and faded behind the primary image, increasing the rhythm and grace of an already powerful graphic drama. Images were at once extremely abstract—and photographically real; and hovering continuously between these two perceptual levels, they created a video poem of startling lyricism.

Jane and Walter Wright's *Pulaski Skyway* was presented on a diamond-shaped arrangement of six monitors. The tapes revealed the banalities of an American superhighway—cars, dumps, roadside sheds, landscapes—along with strongly structural images of the Pulaski Bridge. Moving shots of bridge beams produced an abstract geometry that contrasted with the realistic roadscape, the sounds of children crying during a long car trip, and symphonic music that was romantically "cosmic" in mood. High-contrast negative-reversed images created visual patterns that were amplified by the kaleidoscopic monitor pattern. The result was decorative, with movement, sound, and pattern producing a travelling fragmentation and recreation of the highway-bridge trip.

In Amy Greenfield's *Dervish*, a nude woman whirled continuously till exhausted, then dropped and rested. The only sounds were the motion of her feet, the rustle and flap of drapery, and the increasingly laboured rhythm of her breathing. Images were superimposed and dramatic patterns of light and form appeared with repeated close-ups of parts of the body or fabric folds. The climax of action and visual effect came with the dancer's resting body. Negative visual flaring moved over the body contours in time to her exhausted breathing, projecting a personalized and intimate sense of the dance. The multiple viewpoints and superimpositions of this piece brought the viewer into close relation with the dancer's body and movement. No music distracted from the raw sound of motion and breath, so that each nuance of gesture enlarged and

wholly characterized the visual/sound field, revealing a range of dance activity that was extraordinary in its closeness and fragility.

Conceptual video encompasses another important *genre* that, like feedback and synthesized effects, depends on an inherent formal video vocabulary. Many artists working this way have considerable experience in the visual arts—especially sculpture, and this may indicate the kind of values they find attractive in video. For if the "feedback-synthesizer" *genre* relates to a decorative and painterly visual sensibility, the conceptual mode often refers to a video-space. It is not so much the beauty of abstract patterning and design as the conceptual exploration of experience through a dramatic or sculptural video environment. Video-space is charged with a surreal intensity of focus, as all information, activity, and communication is read through the intervening realm of the monitor. Videotaped happenings or events, utilizing the medium's recording capacity, are ideally suited for focused attention to gestures or small-scale occurrences, dramatically emphasizing a specific conceptual range. And while video-expressed concepts are often confined to taped performance, live action is frequently introduced, extending exploration through audience participation or controlled performance that generally refers back to the monitored images. A unique, probing environment can be established, powerfully perforating and interpenetrating the video-visualized world and real space.

Works presented by Toronto A Space artists Lisa Steele, Julie Geiger, and Marien Lewis were oriented towards recording or documenting conceptually oriented events. Lisa Steele's wry humour seeped through her dead-pan approach to video and the super-serious vocabulary of science. (Conceptual art often employs a quasi-scientific, drily assertive, information-oriented tone.) *Turtle Transfer* and *Earthworms*, presented simultaneously on widely separated monitors, allowed the viewer to selectively fix his attention, tuning in or out as image and sound values flickered and changed—a skill most radio and T.V. watchers have developed to a high degree. Worms and turtles were monotonously described in readings from biology textbooks, while actual experiments were

322

performed in the blatantly real laboratories of bathtub and field. *Sleep Dream Vigil* monitored adjacent video spaces. Lisa appeared periodically in robe and slippers to read scientific information about sleep; cats preened and lazed about, and through a doorway, a figure slept, his breathing sounds amplified through the video system. The cameras rarely moved; there was an occasional pan or zoom, with a final close-up on the sleeper, and the feeling that one was either part of the dream or "active" participant along with the reader, cats, fishtank, and TV, in this double-faceted space and the vigil over the dreamer's sleep.

Julie Geiger's *Spring Sowing: Emergence* was the first of a two-part conceptual piece (the second phase—planting—has yet to be realized). In this videotaped event, sensitively photographed by Marien Lewis, a supine woman was slowly and carefully cut out of her clothes. The camera focused relentlessly on knife, hands, clothing and parts of the body, squeezing out of frame any reference to a whole person, or conventional portrait imagery. The dialogue and pacing were personal and informal, with commentary by the three women (cutter, "victim," and camera woman) on how things were proceeding, so that an easy chit-chat accompanied the event. Conversation with the camerawoman enhanced awareness of the video process, retaining a sense of intimacy; the calm pace and relaxed mood contrasted with the intensity of what was actually going on—a woman being cut out of her clothes. Slowly and deliberately, covering cloth was stripped away, so that when a naked and pensive woman rose from her cut-away shell, the psychic release was monumental. It was an assertive and liberating moment, at once poignant and ecstatic, as her former being lying empty beside her. *Spring Sowing* was a delicately passionate video moment.

Shigeko Kubota's work transcends the limits of any genre. At one time part of "Fluxus" a New York-based group of conceptual artists, her video pieces are tied to the notion of the medium as a context for information exchange, documentation, and viewer participation. In *Allen Ginsberg*, five channels of the poet singing were accompanied by Kubota, standing before the monitors in a

323

dress screened with Marilyn Monroe images, striking wooden blocks. At the same moment, she was monitored on a tiny screen, her projected image swaying back and forth in a visual statement of the total rhythm. When Ginsberg moved to a drone instrument, Kubota blew steadily into a harmonica, until, in the third phase of the piece, the monitor pictures gradually broke down into feedback patterns and high-contrast close-ups. The combination of monitors and live action—from poetry, song, and visual multiplicity, to live counterpoint, itself instantaneously visualized—produced intense rhythmic awareness that translated and expanded Ginsberg's performance. For *Europe on ¹/₂ inch a Day* (the ¹/₂ inch being the tape used in Portapak video recording) Kubota shot performance/art attractions in several European centers: the coin-collecting troubador of an Amsterdam street organ, a transvestite chorus line in Brussels, a Paris strip show interspersed with tourist shots of the Arc de Triomphe. A grotesquely sadomasochistic happening by German artist Herman Nitsch was contrasted with the lyrical play of Kubota's video camera searching through the crowned stones of a Rouen cemetery for the grave of Marcel Duchamp—his name modestly engraved among the family lists. It was a gentle and ironic comment on art and death, perhaps fitting after the Nitsch blood-letting, and appropriate in the name of Duchamp, champion of the art of contradiction and the absurd.

The preoccupation with Duchamp informs much of Kubota's work. A most effective tape was her *Duchamp-Cage: Electronic Chess Game*. Using stills of the well-known chess match, where the chess board was wired for sound so that it became a musical instrument with each move, Kubota dissolved from one photograph to another, effectively replaying the match, with accompanying score, and keying-in abstract patterns and feedback as counterpoint. What had been an avant-garde concert performance—a conceptual sound effect—was recreated with a new visual dimension. In other sections of the tape, John Cage's brainwaves are played through a Moog synthesizer and he describes his participation in Kubota's Duchamp memorial book. Kubota's interest in these two artists—Cage in sound and Duchamp in the

visual arts—is both documentary and creative. In this tape, she is the third conceptual "musketeer," as her video attentions add their comment to the original event.

Performance video is a *genre* that uniquely combines theatre with conceptual and synthesized video elements to create a special kind of happening or performance situation. Video recording allows performer or participants to be instantly translated into video-tronic images. But unlike the conceptual genre, the focus here is not so much the monitored imagery as the total environment, with the video screens serving only as one participating element in a larger aesthetic event. Performance video artists point out the difficulty of balancing several formal dimensions—sound, monitors, and live performers. Live action tends to capture audience attention and this is often controlled by concentrating on the small, discrete movements so appropriate to video's scale.

Elsa Tambellini's videotapes showed patterns of action and dance whose cyclical repetition enlarged the scale of monitored activity and monumentalized it to create a video theme or directive for her performers. The video portion of a dance event performed some months earlier showed brief action patterns—feet moving tentatively over weathered wood, a construction worker's jack-hammer, tumbling gymnasts. Multiplied on several screens they reiterated a rhythm and range of activity for the live dancers' response. For *Cats*, performed at the Toronto festival, the measured interaction of sound, taped images, live action, and direct video monitoring created a dramatic sense of imprisonment. On the bank of six monitors, tigers paced relentlessly, their sleek striped coats counterpointed with the thick black bars of their cage. Elsa Tambellini, "playing" the videodecks, occasionally switched in monkey cages, and with the hot airless echoes and screeches of the animal houses, eerily established a zoo. This mood was amplified by two performers armed with video cameras, who guardedly paced and stalked each other through the monitors. Two more silent figures quickly erected a rope cage between the audience and the "animals", who finally mutely turned their camera-eyes through the ropes on to the spectators. The dimensions of the cage

had gradually expanded—from the video screen through the perfomers to the audience, who, shot through the bars of rope, were now passively imprisoned in video-space amid the constantly pacing cats. Simple and direct, the piece was overwhelming in its deliberate statement of pent-up intensities—a documented prison of passions ready to explode into jungle.

To consider these video works within the context of their *genres* is not necessarily to permanently fix people in categories. Rather there was an enormously positive atmosphere generated by video artists at the Toronto festival as at other centres I have visited—a strong sense of community. The video viewing context is almost by definition casual and intimate, and what in Toronto initially felt like a "video as step-child" attitude, with the video theatre relegated to no more than a corner with monitors and floor cushions, was, in fact, the articulated demand and appeal of the medium. Video watchers "hang out" in a relaxed, intimate space, and at the festival there were certainly more casual meetings and conversations struck up before the monitors than in the monumental, darkened film theatre. Further, as Elsa Tambellini pointed out, video artists have always been turned off by the precious-object oriented, hungry rat-race of the conventional art scene. Marketing tapes as unique works of art was deliberately avoided, and video artists could not realize the commercial distribution that characterizes even the underground film scene. An open, community spirit became the norm, and the video community—distinctly under-exposed—is eager to talk about its work.

This situation—characteristic perhaps of any new *genre* or medium—is likely temporary. The distinctive means for video are potentially vast—larger than for other art, theatre, or film, with every home television set a receiver. Whether cable, public access, or the educational networks will actively explore video's possibilities remains to be seen. In the meantime, unable or unwilling to market their work as art objects, without a broadly committed theatre audience, producing video can be singularly unremunerative and frustrating. And, though interest is growing, video literature and criticism is sporadic and too often messianic or intellectually

326

opaque; among public galleries and museums only the Everson Museum in Syracuse maintains an exhibition programme and curator of video art. Merely keeping abreast of the video scene requires unusual energy and commitment.

Yet perhaps more than any medium encountered so far, video makes you want to make video; its instant replay and raw information pickup seems to thrust itself into the hands and mind of every viewer, whether his intent is home movies or aesthetic revolution. And while this may be a function of novelty, it seems just as likely part of the medium's essential sensibility. Video invites participation. If that is all there is, it is revolutionary in its generosity, and an aesthetic uniquely of our time.